DAVID BUSCH'S

SONY® CX a7R II/a7 II

GUIDE TO DIGITAL PHOTOGRAPHY

David D. Busch

rockynook

David Busch's Sony® (X a7R II/a7 II Guide to Digital Photography David D. Busch

Project Manager: Jenny Davidson

Series Technical Editor: Michael D. Sullivan

Layout: Bill Hartman

Cover Design: Mike Tanamachi Indexer: Valerie Haynes Perry Proofreader: Mike Beady

ISBN: 978-1-68198-060-7

1st Edition (1st printing, January 2016)

© 2016 David D. Busch

All images © David D. Busch unless otherwise noted

Rocky Nook Inc. 802 E. Cota Street, 3rd Floor Santa Barbara, CA 93103 USA www.rockynook.com

Distributed in the U.S. by Ingram Publisher Services
Distributed in the UK and Europe by Publishers Group UK

Library of Congress Control Number: 2015958926

All rights reserved. No part of the material protected by this copyright notice may be reproduced or utilized in any form, electronic or mechanical, including photocopying, recording, or by any information storage and retrieval system, without written permission of the publisher.

Many of the designations in this book used by manufacturers and sellers to distinguish their products are claimed as trademarks of their respective companies. Where those designations appear in this book, and Rocky Nook was aware of a trademark claim, the designations have been printed in caps or initial caps. All product names and services identified throughout this book are used in editorial fashion only and for the benefit of such companies with no intention of infringement of the trademark. They are not intended to convey endorsement or other affiliation with this book.

While reasonable care has been exercised in the preparation of this book, the publisher and author assume no responsibility for errors or omissions, or for damages resulting from the use of the information contained herein or from the use of the discs or programs that may accompany it.

This book is printed on acid-free paper. Printed in the U.S.A.

Acknowledgments

Thanks to everyone at Rocky Nook, including Scott Cowlin, managing director and publisher, for the freedom to let me explore the amazing capabilities of the Sony a7R II and a7 II cameras in depth. I couldn't do it without my veteran production team, including project manager, Jenny Davidson and series technical editor, Mike Sullivan. Also thanks to Bill Hartman, layout; Valerie Hayes Perry, indexing; Mike Beady, proofreading; Mike Tanamachi, cover design; and my agent, Carole Jelen, who has the amazing ability to keep both publishers and authors happy.

en de la composition La composition de la La composition de la

the minimal for the second state of the second seco

end there is seen to be a second of the seco

About the Author

With more than two million books in print, **David D. Busch** is the world's #1 best-selling camera guide author, and the originator of popular series like *David Busch's Pro Secrets*, *David Busch's Compact Field Guides*, and *David Busch's Quick Snap Guides*. He has written more than 50 hugely successful guidebooks for Sony and other digital SLR models, including the all-time #1 bestsellers for several different cameras, as well as many popular books devoted to photography, including *Mastering Mirrorless Interchangeable Lens Photography*. As a roving photojournalist for more than 20 years, he illustrated his books, magazine articles, and newspaper reports with award-winning images. He's operated his own commercial studio, suffocated in formal dress while shooting weddings, and shot sports for a daily newspaper and an upstate New York college. His photos and articles have appeared in *Popular Photography, Rangefinder, Professional Photographer*, and hundreds of other publications. He's also reviewed dozens of digital cameras for CNet and other CBS publications.

When About.com named its top five books on Beginning Digital Photography, debuting at the #1 and #2 slots were Busch's *Digital Photography All-In-One Desk Reference for Dummies* and *Mastering Digital Photography*. He has had as many as 18 books listed in the Top 100 of Amazon.com's Digital Photography Bestseller list—simultaneously! Busch's 200-plus other books published since 1983 include bestsellers like *Digital SLR Cameras and Photography for Dummies*.

Busch is a member of the Cleveland Photographic Society (www.clevelandphoto.org), which has operated continuously since 1887. Visit his website at http://www.dslrguides.com.

Contents

Preface	xxi
Introduction	xxiii
Chapter 1 Meet Your Sony Alpha a7R II/a7 II	1
Vive Les Différences	
What's the Fuss about BSI?	
Your Out-of-Box Experience	
Initial Setup	
Battery Included	
Charging the Battery	10
Final Steps	
Mounting the Lens	
Turn on the Power	
Adjusting the Diopter Setting	
Inserting a Memory Card	14
Formatting a Memory Card	15
Selecting a Shooting Mode	16
Choosing a Metering Mode	20
Choosing a Focus Mode	21
Selecting a Focus Area	
Other Settings	23
Adjusting White Balance and ISO	23
Using the Self-Timer	23
An Introduction to Movie Making	24
Reviewing the Images You've Taken	25
Switching between Still and Movie Playback	26
Transferring Files to Your Computer	27
Wireless File Transfer	28

Chapter 2	2.0
Your Camera Roadmap	29
Front View	30
The Sony a7R II/a7 II's Business End	33
LCD Panel Data Displays	39
Using the Quick Navi Function Menu	43
Going Topside	44
Underneath Your Sony a7R II/a7 II	46
Chapter 3	
Camera Settings Menu	47
Anatomy of the Menus	
Camera Settings Menu	50
Image Size	51
Aspect Ratio	52
Quality	
JPEG vs. RAW	54
RAW File Type	57
Panorama: Size	57
Panorama: Direction	
Vertical Orientation for Horizontal or Vertical Pans	59
Shooting Panoramas	60
File Format (Movies)	61
Record Setting (Movies)	62
Dual Video Record	63
Drive Mode	63
Bracket Settings (a7R II Only)	65
Flash Mode	65
Flash Compensation	
Red Eye Reduction	
Focus Mode	67
Focus Area	
Focus Settings	
AF Illuminator (Stills)	

AF Drive Speed (Movies) (a7R II Only)
AF Track Sensitivity (Movies) (a7R II Only)71
Exposure Compensation
Exposure Step
ISO73
ISO Auto Minimum Shutter Speed (a7R II Only)
Metering Mode
White Balance
DRO/Auto HDR
Creative Style
Picture Effect
Picture Profile
Zoom84
Using Zoom
Focus Magnifier
Long Exposure NR/High ISO NR
Context-Sensitive
Center Lock-On AF
Smile/Face Detection
Soft Skin Effect91
Auto Object Framing
Auto Mode92
Scene Selection
Movie93
SteadyShot
SteadyShot Settings
Color Space
Auto Slow Shutter
Audio Recording
Audio Rec Level
Audio Out Timing
Wind Noise Reduction
Memory Recall
Memory

Chapter	4

Custom Settings Menu	103
Custom Settings Menu	103
Zebra	104
MF Assist	106
Focus Magnifier Time	106
Grid Line	106
Marker Display	107
Marker Settings	107
Audio Level Display	108
Auto Review	108
DISP Button	109
Peaking Level	112
Peaking Color	112
Exposure Settings Guide	
Live View Display	
Display Continuous AF Area	
Phase Detect. Area	115
Pre-AF	
Zoom Setting	
Eye-Start AF	116
FINDER/MONITOR	
Release w/o Lens	118
Release w/o Card (a7R II Only)	118
Priority Set in AF-S/Priority Set in AF-C	118
AF w/Shutter	120
AEL w/Shutter	
Silent Shooting (a7R II Only)	121
e-Front-Curtain Shutter	122
Superior Auto Image Extraction	122
Exp. Comp. Set	123
Reset EV Comp	124
Bracket Order (a7 II Only)	
Face Registration	
APS-C Size (a7 II), APS-C/Super 35 (a7R II)	
AF Micro Adjustment	

	Lens Compensation	126
	Shading	
	Chromatic Aberration	
	Distortion	
	AF System (Stills) (a7R II Only)	
	Video Light Mode (a7R II Only)	
	Function Menu Set	
	Custom Key Settings	
	Basic Functions.	
	Other Buttons.	
	A Special Case	
	Other Useful Key Definitions	
	Dial Setup	
	Dial Ev Comp	
	Zoom Ring Rotate	
	MOVIE Button	138
	Dial/Wheel Lock	138
	hapter 5	
_		
	7' 1' 1 4 1' 1' 1' 1	139
W	7i-Fi and Application Menus	
W	Vi-Fi and Application Menus aking a Wi-Fi Connection	140
W	Wi-Fi and Application Menus aking a Wi-Fi Connection	140
W	Wi-Fi and Application Menus aking a Wi-Fi Connection	140
W	Wi-Fi and Application Menus aking a Wi-Fi Connection. Using WPS Push. Registering Manually. Selecting an Access Point Manually.	140 140 141 143
W Ma	Wi-Fi and Application Menus aking a Wi-Fi Connection. Using WPS Push. Registering Manually. Selecting an Access Point Manually Wi-Fi Settings.	140 140 141 143 144
W Ma	Wi-Fi and Application Menus aking a Wi-Fi Connection. Using WPS Push. Registering Manually. Selecting an Access Point Manually Wi-Fi Settings. i-Fi Functions.	140 140 141 143 144
W Ma	Aking a Wi-Fi Connection Using WPS Push Registering Manually Selecting an Access Point Manually Wi-Fi Settings. i-Fi Functions Sending Photos to a Smart Device	140 140 141 143 144 144
W Ma	Aking a Wi-Fi Connection. Using WPS Push. Registering Manually. Selecting an Access Point Manually Wi-Fi Settings. i-Fi Functions. Sending Photos to a Smart Device Wi-Fi Transfer to a Computer	140 140 141 143 144 145 146
W Ma	Aking a Wi-Fi Connection. Using WPS Push. Registering Manually. Selecting an Access Point Manually Wi-Fi Settings. i-Fi Functions. Sending Photos to a Smart Device Wi-Fi Transfer to a Computer Viewing Images on a TV	140 140 141 143 144 145 146 147
W Ma	Aking a Wi-Fi Connection Using WPS Push Registering Manually Selecting an Access Point Manually Wi-Fi Settings. i-Fi Functions Sending Photos to a Smart Device Wi-Fi Transfer to a Computer Viewing Images on a TV ne Application Menu	140 141 143 144 144 145 146 147 149
W Ma	Aking a Wi-Fi Connection. Using WPS Push. Registering Manually. Selecting an Access Point Manually Wi-Fi Settings. i-Fi Functions. Sending Photos to a Smart Device Wi-Fi Transfer to a Computer Viewing Images on a TV	140 141 143 144 144 145 146 147 149
W Ma	Aking a Wi-Fi Connection. Using WPS Push. Registering Manually. Selecting an Access Point Manually Wi-Fi Settings. i-Fi Functions. Sending Photos to a Smart Device. Wi-Fi Transfer to a Computer. Viewing Images on a TV ne Application Menu. Application List. Introduction.	140 140 141 143 144 145 146 147 149 149
W Ma	Aking a Wi-Fi Connection. Using WPS Push. Registering Manually. Selecting an Access Point Manually Wi-Fi Settings. i-Fi Functions. Sending Photos to a Smart Device. Wi-Fi Transfer to a Computer. Viewing Images on a TV ne Application Menu. Application List.	140 141 143 144 145 146 147 149 149 150
W Ma	Aking a Wi-Fi Connection. Using WPS Push. Registering Manually. Selecting an Access Point Manually. Wi-Fi Settings. i-Fi Functions. Sending Photos to a Smart Device. Wi-Fi Transfer to a Computer. Viewing Images on a TV. ne Application Menu. Application List. Introduction. Working with Applications. PlayMemories Camera Apps.	140 141 143 144 145 146 147 149 150 150
W Ma	Aking a Wi-Fi Connection. Using WPS Push. Registering Manually. Selecting an Access Point Manually Wi-Fi Settings. i-Fi Functions. Sending Photos to a Smart Device. Wi-Fi Transfer to a Computer. Viewing Images on a TV. ne Application Menu. Application List. Introduction. Working with Applications.	140 140 141 143 144 145 146 147 149 150 150 150
W Ma	Aking a Wi-Fi Connection. Using WPS Push. Registering Manually. Selecting an Access Point Manually. Wi-Fi Settings. i-Fi Functions. Sending Photos to a Smart Device. Wi-Fi Transfer to a Computer. Viewing Images on a TV. ne Application Menu. Application List. Introduction. Working with Applications. PlayMemories Camera Apps Application Management.	140 141 143 144 145 146 147 149 150 150 152 152
W Ma	Aking a Wi-Fi Connection Using WPS Push Registering Manually Selecting an Access Point Manually Wi-Fi Settings i-Fi Functions Sending Photos to a Smart Device Wi-Fi Transfer to a Computer Viewing Images on a TV ne Application Menu Application List Introduction Working with Applications. PlayMemories Camera Apps Application Management Downloading Apps.	140 141 143 144 145 146 147 149 150 150 150 152 152

Chapter 6	
Playback and Setup Menus	159
Playback Menu	
Delete	159
View Mode	
Image Index	
Display Rotation	
Slide Show	
Rotate	
Enlarge Image	
4K Still Image PB (a7 II Only)	
Protect	
Specify Printing	
Setup Menu	
Monitor Brightness	
Viewfinder Brightness	
Finder Color Temperature	
Volume Settings	
Audio Signals	
Upload Settings	169
Tile Menu	
Mode Dial Guide	170
Delete Confirm	
Display Quality	
Power Save Start Time	
NTSC/PAL Selector	
Cleaning Mode	
Demo Mode	
TC/UB Settings	
Remote Control	172
HDMI Settings	

 4K Output Selection (a7R II Only)
 174

 USB Connection
 175

 USB LUN Setting
 175

 USB Power Supply (a7R II Only)
 176

 Language
 176

Date/Time Setup	177
Area Setting	177
Copyright Info (a7R II Only)	177
Format	
File Number	
Select REC Folder	
New Folder	
Folder Name	
Recover Image Database	
Display Media Information	
Version	
Certification Logo (Non-U.S./Canada Models Only)	
Setting Reset	183
Chapter 7	
Shooting Modes and Exposure Control	185
Getting a Handle on Exposure	105
Getting a Handle on Exposure	183
•	
Equivalent Exposure	190
Equivalent Exposure	190 191
Equivalent Exposure	190 191
Equivalent Exposure	190 191 191
Equivalent Exposure	190 191 191 192 193
Equivalent Exposure How the a7 II Series Calculates Exposure Correctly Exposed Overexposed Underexposed	190 191 192 193 194
Equivalent Exposure How the a7 II Series Calculates Exposure Correctly Exposed Overexposed Underexposed The Importance of ISO.	190 191 192 193 194 195
Equivalent Exposure How the a7 II Series Calculates Exposure Correctly Exposed Overexposed Underexposed The Importance of ISO. Choosing a Metering Method	190 191 192 193 194 195 199
Equivalent Exposure How the a7 II Series Calculates Exposure Correctly Exposed Overexposed Underexposed The Importance of ISO. Choosing a Metering Method Choosing an Exposure Mode	190191192193194195199
Equivalent Exposure How the a7 II Series Calculates Exposure Correctly Exposed Overexposed Underexposed The Importance of ISO. Choosing a Metering Method Choosing an Exposure Mode Aperture Priority (A) Mode	190191192193194195199199
Equivalent Exposure How the a7 II Series Calculates Exposure Correctly Exposed Overexposed Underexposed The Importance of ISO. Choosing a Metering Method Choosing an Exposure Mode Aperture Priority (A) Mode Shutter Priority (S) Mode Program Auto (P) Mode Making Exposure Value Changes	190191192193194195199199201202
Equivalent Exposure How the a7 II Series Calculates Exposure Correctly Exposed Overexposed Underexposed The Importance of ISO. Choosing a Metering Method Choosing an Exposure Mode Aperture Priority (A) Mode Shutter Priority (S) Mode Program Auto (P) Mode Making Exposure Value Changes Manual Exposure (M) Mode	190191192193194195199199201202202
Equivalent Exposure How the a7 II Series Calculates Exposure Correctly Exposed Overexposed Underexposed The Importance of ISO. Choosing a Metering Method Choosing an Exposure Mode Aperture Priority (A) Mode Shutter Priority (S) Mode Program Auto (P) Mode. Making Exposure Value Changes Manual Exposure (M) Mode The Basic M Mode Technique	190191192193194195199199201202204
Equivalent Exposure How the a7 II Series Calculates Exposure Correctly Exposed Overexposed Underexposed The Importance of ISO. Choosing a Metering Method Choosing an Exposure Mode Aperture Priority (A) Mode Shutter Priority (S) Mode Program Auto (P) Mode Making Exposure Value Changes Manual Exposure (M) Mode The Basic M Mode Technique Long Exposures	190191192193194195199199201202204204
Equivalent Exposure How the a7 II Series Calculates Exposure Correctly Exposed Overexposed Underexposed The Importance of ISO. Choosing a Metering Method Choosing an Exposure Mode Aperture Priority (A) Mode Shutter Priority (S) Mode Program Auto (P) Mode. Making Exposure Value Changes Manual Exposure (M) Mode The Basic M Mode Technique	190191192193194195199199201202204204206

Exposure Bracketing	208
Continuous Bracketing	209
Single Bracketing	210
White Balance Bracketing	210
DRO Bracketing	210
Dealing with Digital Noise	211
High ISO Noise	
Long Exposure Noise	
Using Dynamic Range Optimizer	213
Working with HDR	
Auto HDR	216
Bracketing and Merge to HDR	
Exposure Evaluation with Histograms	
The Live Histogram	221
The Playback Histograms	
Tonal Range	
Histogram Basics	
Contrast, Too	
Understanding Histograms	225
Automatic and Specialized Shooting Modes	
Auto and Scene Modes	
Sweep Panorama Mode	231
Chapter 8	
	222
Mastering Autofocus Options	233
Getting into Focus	
Contrast Detection	234
Phase Detection	235
Comparing the Two Hybrid Components	237
Focus Modes and Options	239
Focus Pocus	241
Adding Circles of Confusion	241
Your Autofocus Mode Options	243
Single-Shot AF (AF-S) Mode	
Continuous AF (AF-C) Mode	
Automatic AF (AF-A) Mode	

Setting the AF Area Face Detection and Eye AF. Center Lock-On AF Lock-On AF.	248
Using Manual Focus	
Back-Button Focus	253
Activating Back-Button Focus	
Useful Menu Items for AF	254
Autofocus Summary	
Chapter 9	
Advanced Techniques	259
Exploring Ultra-Fast Exposures	259
Long Exposures	
Continuous Shooting	
The Buffer and Frame Rates	268
Autofocus and Continuous Shooting	
Customizing White Balance	270
Fine-Tuning Preset White Balance	273
Setting White Balance by Color Temperature	
Setting a Custom White Balance	
Using Creative Styles	275
Chapter 10	
Movie-Making Basics	279
Some Fundamentals	
Preparing to Shoot Video	281
Steps During Movie Making	284
More About Frame Rates and Bit Rates	285
Frame Rates	285
Bit Rates	287
Stop That!	289
Tips for Movie Making	290
Composition	292
Lighting for Video	295
Illumination	295
Creative Lighting	296
Lighting Styles	

xviii

Audio	298
Tips for Better Audio	
Lens Craft	
Depth-of-Field and Video	
Zooming and Video	
Chapter 11	
Advanced Video Features	303
More on Sensors and Crop Factors	303
Sensor Size	
Crop Factor	305
How Can 1440 × 1080p Be Widescreen?	306
Frame Guides	307
HD or UHD (a7R II Only)?	
Time Codes and User Bits	
Picture Profiles	
Gamma, Gamma Ding Dong	
S-Log2	313
Chapter 12	
Choosing and Using Lenses	315
Don't Forget the Crop Factor	316
The Crop Factor and the a7 II Series	
SteadyShot and You	
How It Works	
Choosing a Lens	
Sony FE Lenses	
A-Mount Lenses	
Zeiss Loxia Lenses	
Zeiss Batis Lenses	
Other Third-Party Lenses	
Using the LA-EA Series Adapters	
Other Lens Options	
Fine-Tuning the Focus of Your A-Mount Lenses	
Lens Tune-Up	337
Evaluate Current Focus	337

Chapter 14	
Essential Tips for Your a7R II/a7 II	383
Troubleshooting and Prevention	383
Upgrading Your Firmware	384
Protecting Your LCD	386
Troubleshooting Memory Cards	
All Your Eggs in One Basket?	387
What Can Go Wrong?	391
What Can You Do?	
Cleaning Your Sensor	393
Dust the FAQs, Ma'am	393
Identifying and Dealing with Dust	394
Avoiding Dust	
Sensor Cleaning	
Add-ons That Don't Cost an Arm or a Leg	
Battery Grips	
Tripod Plates and L-Brackets	
Flash Shoe Adapters	
LED Video Lights	
Filter Accessories	
Remotes	409
Macro Gear	410
Index	411

Preface

Since the Fall of 2015, the entire photographic industry has been buzzing about Sony's revolutionary full-frame mirrorless cameras. Indeed, the second generation of the Sony Alpha a7–series cameras are *all* truly game changers. The revamped lineup includes the ultra-high-resolution a7R II, which boasts an astonishing 42.4 megapixels of resolution, the more affordable 24-megapixel a7 II, and the a7S II, a special-purpose 12-megapixel camera with internal 4K video and unmatched high ISO performance suitable for professional movie making. All three have advanced autofocus features and five-axis image stabilization built into the camera body.

In a few short years, Sony has gone from being a Nikon and Canon competitor that offered warmedover Konica Minolta digital camera technology, to an acknowledged innovator with a lineup of cameras that are smaller, lighter, faster to focus, and loaded with cutting-edge features that many of us have been dreaming about. So, it's no wonder you're excited about your new Sony a7R II or a7 II camera, which are covered in this book. With all these features at your disposal, you don't expect to take good pictures with such a camera—you demand and anticipate *outstanding* photos.

Unfortunately, your gateway to pixel proficiency is dragged down by the limited instructions provided by Sony. Over the years, Sony has reduced the amount of useful information included in its printed guidebooks, often to a scant 100 pages or so, and relegated more detailed instructions to online HTML-based guides and PDF versions that are difficult to navigate. And, sad to say, not everything you need to know is included.

What you really need is a guide that explains the purpose and function of the cameras' basic controls, how you should use them, and *why*. That's what I am giving you in this book, which covers the a7R II and a7 II (but not the a7S II, which, although it shares many of the same features, is a more specialized camera). If you want a quick introduction to focus controls, flash synchronization options, how to choose lenses, or which exposure modes are best, this book is for you. If you can't decide on what basic settings to use with your camera because you can't figure out how changing ISO or white balance or focus defaults will affect your pictures, you need this guide.

Introduction

Sony certainly doesn't play it safe. When the company purchased Konica Minolta's Photo Imaging Division in 2006, it wasn't satisfied with sticking to the old digital camera paradigms and technology. At a time when the top dogs in the digital camera world are still mired in the race to produce the best digital SLRs, Sony has concentrated on distinctly different cameras, including the fixed-mirror SLT lineup (which includes the Sony Alpha a77 II), superb fixed-lens compacts like the Sony Cyber-Shot DSC-RX100 IV, and exciting mirrorless cameras with both APS-C "crop" sensors and models with full-frame sensors, like the a7 series, now in a Mark II generation.

With the a7 II cameras, Sony has packaged up the most alluring features of advanced digital SLRs and stuffed them into compact, highly affordable bodies, each of which boasts at least a few features you won't find at all, or implemented as well in cameras from other vendors. You can select the a7R II, which has a 42.4-megapixel sensor, the highest resolution of any mirrorless camera at this writing. If you don't need such outstanding resolution, the a7 II is virtually identical to the a7R II, but with 24 megapixels, and at a savings of around \$1,500. Those who want to shoot professional-quality 4K movies or who are willing to sacrifice some resolution to get a camera with ISO sensitivity up to 409,600 (and remarkably noise-free images at less stratospheric settings), the 12-megapixel a7S II stands alone.

Each of these models is loaded with facilities that few would have expected to find in mirrorless cameras just a few years ago, particularly in such a misleadingly small package. For those just dipping their toes into the advanced (deep) end of the digital pond, the experience is warm and inviting. Of course, once you've confirmed that you made a wise purchase, the question comes up, *how do I use this thing?* All those cool features can be mind-numbing to learn, if all you have as a guide is the mediocre manual furnished with the camera. Basic functions and options are explained, but there's really very little about *why* you should use particular settings or features, and the organization may make it difficult to find what you need. Multiple cross-references may send you flipping back and forth between two or three sections of the book to find what you want to know. The basic manual is also hobbled by black-and-white line drawings and tiny pictures that aren't very good examples of what you can do.

xxiv

Help is on the way. I sincerely believe that this book is your best bet for learning how to use your new camera, and for learning how to use it well. I've tried to make *David Busch's Sony Alpha a7R IIIa7 II Guide to Digital Photography* comprehensive, but easy to comprehend. The roadmap sections use large, color pictures to show you where all the buttons and dials are, and the explanations of what they do are longer and more detailed. I've tried to avoid overly general advice, including the checklists you'll find in other manuals on how to take a "sports picture" or a "portrait picture" or a "travel picture." If you want to know where you should stand to take a picture of a quarterback dropping back to unleash a pass, there are plenty of books that will tell you that. This one concentrates on teaching you how to select the best autofocus mode, shutter speed, f/stop, or flash capability to take, say, a great sports picture under any conditions.

What You'll Learn

This book is aimed at Sony veterans as well as newcomers to digital photography. Both groups can be overwhelmed by the options the a7 II series offers, while underwhelmed by the explanations they receive in their user's manual, which some suspect was written by a Sony employee who last threw together instructions on how to operate a camcorder or DVD player.

Given the number of pages allotted by Rocky Nook to this book, from necessity I will emphasize *still photography*. I intend to cram everything I know about full-frame mirrorless shooting into this book. As a result, you will not find *everything* you may want to know about movie making and video within these pages. Nor will I cover the a7S II at all. Those aspects deserve a book of their own. This book covers the a7R II and a7 II cameras exclusively.

However, I will devote a lot of space to helping you get up to speed on using the a7R II and a7 II models' video capabilities. After all, both are capable of shooting awesome, professional-level movies, and share many video features with their a7S II stablemate. But detailed advice about choosing between Internal UHD 4K30 and 1080p/120 fps recording, or technical information about S-Log3 gamma and display assist functions (pro-level features that make the a7S II something very special) are beyond the scope of this book. Given that I expect that only a relatively small—albeit important—segment of the readers of this book want or require such information, I'm going with Vulcan philosopher Spock Prime's observation early in *The Wrath of Khan* that "Logic clearly dictates that the needs of the many outweigh the needs of the few."

Who Am I?

After spending many years as the world's most successful unknown author, I've become slightly less obscure in the past few years, thanks to a horde of camera guidebooks and other photographically oriented tomes. You may have seen my photography articles in *Popular Photography, Rangefinder, Professional Photographer*, and dozens of other photographic publications. But, first, and foremost, I'm a photojournalist and made my living in the field until I began devoting most of my time to writing books. Although I love writing, I'm happiest when I'm out taking pictures, which is why I spend many winters ensconced in the Florida Keys, dividing my time between writing books and taking photographs. You'll find images of many of these visual treats within the pages of this guide.

Like all my digital photography books, this one was written by someone with an incurable photography bug. I've worked as a sports photographer for an Ohio newspaper and for an upstate New York college. I've operated my own commercial studio and photo lab, cranking out product shots on demand and then printing a few hundred glossy $8\times 10s$ on a tight deadline for a press kit. I've served as a photo-posing instructor for a modeling agency. People have actually paid me to shoot their weddings and immortalize them with portraits. I even prepared press kits and articles on photography as a PR consultant for a formerly dominant (and now vestigial) Rochester, NY company. My trials and travails with imaging and computer technology have made their way into print in book form an alarming number of times, including hundreds of volumes on photographic topics. I teach classes, and have branched out into online training courses.

Like you, I love photography for its own merits, and I view technology as just another tool to help me get the images I see in my mind's eye. But, also like you, I had to master this technology before I could apply it to my work. This book is the result of what I've learned, and I hope it will help you master your Sony a7R II or a7 II.

I'd like to ask a special favor: let me know what you think of this book. If you have any recommendations about how I can make it better, visit my website at www.sonyguides.com, click on the E-Mail Me tab, and send your comments, suggestions on topics that should be explained in more detail, or, especially, any typos. (The latter will be compiled on the Errata page you'll also find on my website.) I really value your ideas, and appreciate it when you take the time to tell me what you think! Some of the content of the book you hold in your hands came from suggestions I received from readers like yourself. If you found this book especially useful, tell others about it. Visit http://www.amazon.com/dp/1681980606/ and leave a positive review. Your feedback is what spurs me to make each one of these books better than the last, and if enough of you like what I've done, Rocky Nook may be moved to ask me to follow up with a new book the next time Sony introduces one of its photographic innovations. Thanks!

Meet Your Sony Alpha a7R II/a7 II

Don't panic if you opened this book to this introductory chapter and realized that you've already taken several hundred or a thousand (or two) photos. I realize that most of you didn't buy this book at the same time you purchased your Sony. As much as I'd like to picture thousands of avid photographers marching out of their camera stores with an a7R II/a7 II box under one arm, and my book in hand, I know that's not going to happen *all* the time.

It's more likely that you happily muddled your way through getting the camera revved up and working well enough to take a bunch of pictures without the universe collapsing. Eventually, though, you turned to this book when you realized that you can do an even better job with a little guidance.

I've framed this chapter with both the semi-experienced and rawest beginner in mind. Whether you're looking to improve your comfort level with the features of these well-designed (yet complex) cameras or are looking forward to starting from scratch, you'll find that the advice I'm about to offer useful. You can zip right through the basics, and then dive into learning a few things you probably didn't know about your a7R II/a7 II.

Fortunately, each of these cameras can be incredibly easy to use, right out of the box. Just flick the power switch to On; it's concentric with the shutter release button on top of the camera. Then, rotate the mode dial located just southwest of the switch to select the green Auto icon. (See Figure 1.1.) Frame the subject on the monitor (the rear LCD screen) or by looking through the viewfinder. Press the shutter release button when you're ready to take your first shot.

Preparing for those steps by charging the battery, mounting a lens, and inserting a formatted Secure Digital or Memory Stick card isn't exactly rocket science, either. If you rotate the mode dial to any

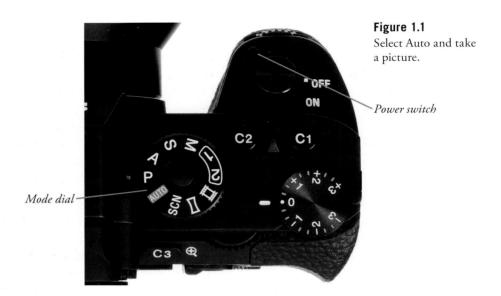

position, such as P, A, or S mode, the camera displays a screen on the LCD indicating the mode's name and purpose. If you set the mode dial to the SCN position, you can rotate the rear dial (located to the immediate right of the mode dial) to select a scene mode. An icon will appear in the upper-left corner of the LCD monitor screen or viewfinder to indicate which mode you've selected. The scene modes automatically select all camera settings to make it easy to take excellent shots of people, landscapes, flowers, night scenes, and more.

In practice, though, it's not a bad idea, once you've taken a few orientation pictures with your camera, to go back and review the basic operations of the camera from the beginning, if only to see if you've missed something. This chapter is my opportunity to introduce you to the cameras and review the setup procedures for those among you who are already veteran users, and to help ease the more timid (even those who have never before worked with an interchangeable-lens camera) into the basic pre-flight checklist that needs to be completed before you really spread your wings and take off. For the uninitiated, as easy as it is to use initially, your Sony a7R II/a7 II *does* have some dials, buttons, and menu items that might not make sense at first, but will surely become second nature after you've had a chance to review the instructions in this book.

But don't fret about wading through a manual to find out what you must know to take those first few tentative snaps. I'm going to help you hit the ground running with this chapter (or keep on running if you've already jumped right in). If you *haven't* had the opportunity to use your a7R II/a7 II yet, I'll help you set up your camera and begin shooting in minutes. You won't find a lot of operational detail in this chapter. Indeed, I'm going to tell you just what you absolutely *must* understand, accompanied by some interesting tidbits that will help you become acclimated. I'll go into more depth and even repeat some of what I explain here in later chapters, so you don't have to memorize everything you see. Just relax, follow a few easy steps, and then go out and begin taking your best shots—ever.

Vive Les Différences

As I write this, Sony is offering three Mark II versions of their flagship Alpha 7 full-frame mirrorless camera. Although Alpha is still officially part of the name in most countries, the convention is to refer to the cameras using slightly less unwieldy nomenclature: Sony a7R II, and a7 II. For the most part, I'll do the same. Outside the USA, Canada, and some other countries, the cameras are more commonly referred to by their international monikers: ILCE-7 MK2, ILCE-7R MK2, and ILCE-7S MK2. The first four letters stand for *Interchangeable Lens Camera E-mount*. The MK2 designation represents Mark II, or, simply II. In product listings and on the box you may also see suffixes such as /B or /K, which mean that the camera was sold as a *body only* or in a *kit* with an accompanying lens.

The two versions covered in this book, the a7R II/a7 II/ILCE-7RMK2 and a7R II/a7 II/ILCE-7MK2 are quite similar, differing in only a few respects that I'll list in the next section. The specialized high ISO/video model, the a7S II/ILCE-7SMK2 has a body and controls that are virtually identical, but differs from the other two in a variety of aspects, ranging from a reduced continuous shooting speed, its lack of a hybrid autofocus system, and the addition of several advanced HD and 4K movie-shooting features. As noted in the introduction, I will not be covering the a7S II in this book.

Note

In general, when describing the shared features and components of the two cameras covered in this book, I will refer to the Mark II models either by the nomenclature *a7 II series* or, simply *a7R III/a7 II*. When describing something that is different, such as resolution, I'll point that out, using terminology like *a7R II only* or *a7 II only*. All the camera photographs and menus in this book use the a7R II model as an example; in appearance, the a7 II is virtually identical, but it lacks an all-magnesium alloy case and is 26 grams lighter. **Menu items on the a7 II may appear on different tabs.** The chief differences in the two cameras lie in the intended target buyers for these models.

Here's a quick summary of the Sony full-frame mirrorless triplets:

■ Alpha a7S II. This is the most specialized camera in the lineup, priced (at the time I write this) at around \$2,999 for the body only. It's a niche camera intended for those who need advanced video features in addition to still photography capabilities. It has "only" 12.2 megapixels of resolution. The larger pixels in its full-frame sensor provide an extended dynamic ("exposure") range of 15.3 stops, and ISO settings up to 409,600. It has other video-friendly features, including an advanced XAVC S video format, 120 fps shooting, uncompressed 4K video output, a silent shutter for quiet capture, and other enhancements. If professional-quality video isn't your cup of tea, you probably would be happier with one of the other two models. Henceforth, I won't be referring to this camera much in this book as I concentrate on the two more general-purpose models.

- Alpha a7R II. This 42.4-megapixel model is priced at about \$3,199 for the body. That's quite a jump from the \$2,300 tariff on its predecessor, the original a7R, some of which you can blame on the upgraded sensor, which not only includes 6 million more pixels, but 399 phase detect AF points not found in the previous model. A stellar 5-axis in-body SuperShot image stabilization system also added to the price tag. The a7R II, like the other a7 II—series models, qualifies as the world's smallest full-frame interchangeable lens camera, boasts commendable low-light performance beyond what you'd expect from such a high-resolution model, and a full array of the customization features you'd expect in a pro-quality camera.
- Alpha a7 II. A relative bargain at around \$1,700 (body only), the a7 II is an affordable choice for those who find 24.3 megapixels sufficient. Other than its lower resolution and some composite (rather than magnesium alloy) body shell components, the a7 II and its controls appears to be virtually identical to the a7R II, and includes very cool features common to all three cameras, such as the 5-axis SuperShot that I'll describe later in this book.

Feature-wise, the few sacrifices involve capabilities that you may not miss at all, or may be willing to give up to save \$1,500 (which, if you choose, can be applied to a great lens). For example, the a7 II's ISO range is 50 to 25,600 (compared to 50 to 102,400 for the a7R II); it *does* have an optical low-pass filter over the sensor (which removes potential moiré patterns by adding a slight amount of blurring to the image), and has a simpler hybrid autofocus system with only 117 (not 399) phase detect AF points. The a7 II also lacks the totally silent full electronic shutter found in the other two a7 II—series models. My take is that if the a7 II were the only Sony full-frame mirrorless camera available, you'd be absolutely astonished at its features, and pleased with its price, so I expect this model to be very popular, indeed.

What's the Fuss about BSI?

The Sony a7R II (only) has an innovative back-side illuminated (BSI) EXMOR R sensor that gives it remarkable low-light performance with reduced noise, compared to other high-resolution sensors. Ordinarily, packing more light-gathering "pixels" (photosites) onto a sensor to produce high resolution requires using the tiniest "pixels" possible. Smaller pixels are less efficient at collecting light (photons), and processing the captured image to increase sensitivity results in more random artifacts. We call that "high ISO" noise. (A second type of visual noise is produced from long exposures.)

The a7R II reduces high ISO noise by increasing the relative size of the photosites. That's possible because with a traditional front-illuminated sensor (shown at left in Figure 1.2), the chip's image-processing circuitry occupies much of the surface, leaving only a small photosensitive area at the bottom of a deep "well." Sony's BSI sensor reverses the position of the circuitry and photodiode components, so that a larger area can be occupied by the photosites, with the electronics positioned underneath, closer to the back of the camera, rather than closer to the rear of the lens.

The figure shows a super-simplified rendition of what happens. (Actual sensors look *nothing* like this; the diagram includes only one set of three red, green, and blue photosites, is *not* to scale, and

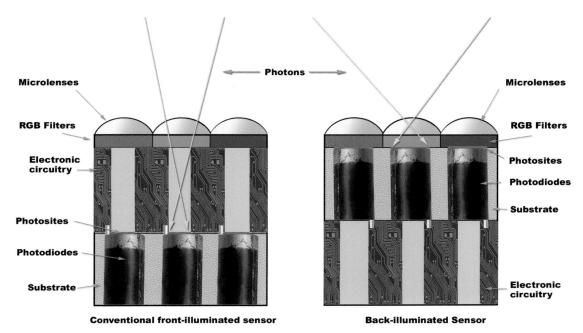

Figure 1.2 A conventional front-illuminated sensor (left), and a back-illuminated sensor (right).

I show only two "beams" of light arriving at the sensor, when photons actually come from multiple directions.) With the conventional front-illuminated sensor at left, incoming light passes through microlenses that focus it on the photosites, which are located at the bottom of a well that resides between the on-chip circuitry. Even accounting for the microlens' focusing properties, the relative angles that result in light falling on the photosensitive area are rather steep. Other photons (not shown) strike the sides of the wells or the area of the chip occupied by electronic circuitry, and bounce back or around.

This limitation on the angle of incidence accounts for why vendors have been forced to develop "digital" lenses, which, unlike lenses designed for film cameras, focus light on the sensor from less steep angles. That explains, in general, why the a7R functions better in this regard than most other digital cameras when using older "non-digital" lenses.

At right in the figure is a representation of a back-illuminated sensor. Like the conventional sensor, it includes gapless microlenses that focus the illumination before it passes through a red, green, or blue filter to the photosite. But unlike the front-illuminated sensor, there is no deep well, and, without the need for intervening circuitry, the photosensitive area is much larger. The electronics have been moved to the other side of the sensor.

A typical conventional full-frame sensor captures only 30 to 80 percent of the light striking it, whereas a BSI sensor can grab nearly 100 percent of the photons. The angle of incidence is not nearly as crucial, making BSI sensors more similar in that respect to old-time film grain technology. The combination of larger photosensitive surface area and improved acceptable angles for incoming

photons are the main factors in the Sony a7R II's superior low-light performance. Enhanced processing algorithms in the BIONZ X digital image processing chip also help.

I don't normally venture so deeply into techie territory in my camera guides, but BSI sensors (which previously have been used in other devices with especially tiny sensors, such as cell phone cameras) will henceforth play a major part in enthusiast photography technology.

Your Out-of-Box Experience

Your Sony a7R II/a7 II comes in an attractive box filled with stuff, including a multi-purpose USB/ charging cable, basic instructions, some pamphlets, and a few other items. The most important components are the camera and lens, battery/charger, and, if you're the nervous type, the neck strap. You'll also need a Secure Digital or Memory Stick card, as one is not included.

The first thing to do is to carefully unpack the camera and double-check the contents with the checklist on one side of the box. While this level of setup detail may seem as superfluous as the instructions on a bottle of shampoo, checking the contents *first* is always a good idea. It's better to know *now* that something is missing so you can seek redress immediately, rather than discover a few days later that the box didn't contain the cable protector—which keeps an HDMI cable securely attached to the camera.

So, check the box at your earliest convenience, and make sure you have (at least) the following:

- Sony a7R II/a7 II body. This is hard to miss. The camera is the main reason you laid out the big bucks, and it is tucked away inside a nifty protective envelope you should save for re-use in case the camera needs to be sent in for repair. It almost goes without saying that you should check out the camera immediately, making sure the color LCD on the back isn't scratched or cracked, the battery compartment and connection port doors open properly, and, when a charged battery is inserted and lens mounted, the camera powers up and reports for duty. Out-of-the-box defects in these areas are rare, but they can happen. It's probably more common that your dealer played with the camera or, perhaps, it was a customer return. That's why it's best to buy your camera from a retailer you trust to supply a factory-fresh camera.
- Lens. You may be able to buy the a7R II/a7 II with or without a lens, although many retailers may stock only the "kit" form that includes either the Sony FE 28-70mm f/3.5-5.6 OSS (about \$500) or Zeiss Vario-Tessar T* FE 24-70mm f/4 ZA OSS (about \$1,200). If you're looking to save funds, it's okay to go for the less-expensive mid-range zoom, because, as I'll note in Chapter 12, the pricey Zeiss isn't, let us say, the sharpest lens in the Sony E-mount arsenal.
 - My recommendation: If you use the middle zoom ranges from 24/28mm to 70mm frequently, opt for the 28-70mm f/3.5-5.6 OSS lens, *unless* you will need the Zeiss version's wider f/4 maximum aperture at the 70mm setting. Many shooters tend to "see" images as "wide-angle/perspective distortion/maximum depth-of-field" shots or, conversely, as "longer lens/selective focus" photos. If you are in either camp and don't use the focal lengths either kit lens encompasses, eschewing both and putting the money toward a different lens is a good option.

■ Info-Lithium NP-FW50 battery (two included). The power source for your Sony camera, a pair of batteries, is packaged separately. Both should be charged as soon as possible (as described next) and one of them inserted in the camera.

My recommendation: With the a7 II series, it's smart, nay, essential to have more than one battery pack, which is why Sony puts two in the box. Although tiny in size, these cameras gulp power, and, even with the generous standards Sony cites in its literature, each is likely to last for no more than 290–340 still shots or roughly 95 minutes of video. If you are a heavy user of the LCD monitor for review, expect even less longevity. Buy more, and stick to Sony-brand products; third-party batteries have been known to fail quickly, sometimes in potentially destructive ways. I have eight of these, but, then, I also own a Sony a6000 and a5000 that use the same batteries.

■ Sony BC-VW1 external charger. This handy device (see Figure 1.3), or the optional BC-TRW Quick Charger, allows you to recharge one battery while another is ensconced in your camera as you continue shooting.

My recommendation: I strongly prefer the external charger to the alternative USB cable charging method, so much that I purchased four of these (genuine Sony versions) from my favorite store in Japan, so I can charge a quartet of NP-FW50 batteries simultaneously.

■ Micro B USB 2.0 cable. Use this cable to link your Sony to a computer when you need to transfer pictures but don't have an optional card reader accessory handy. While the camera is connected with the cable,

Figure 1.3 The Sony BC-VW1 charger allows rejuvenating your battery outside the camera, so you can keep shooting with a spare battery.

the battery inside the body will also be charging. The USB cable can also be connected to the included AC adapter if you want to charge the battery using household power.

My recommendation: Sony stuck with USB 2.0 instead of the faster USB 3.0 protocol because the latter wouldn't allow charging the battery through the USB cable. Use an external charger, instead, and copy images to your computer with a USB 3.0 card reader, rather than a cable connection.

■ AC Adapter AC-UB10. This is the device (shown in Figure 1.4) that you'll use to charge the battery with household power while it's in the camera. The USB cable plugs into it and the adapter plugs into a wall socket. The cable can also be plugged into a computer's USB port to revitalize your battery.

My recommendation: The AC adapter is especially useful while traveling, as it eliminates the need to have a computer or laptop powered up to charge the battery.

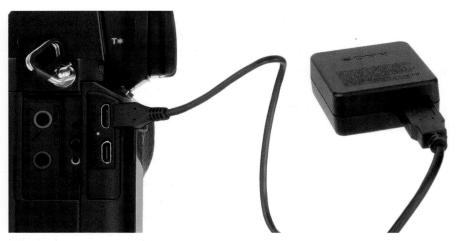

Figure 1.4
The AC Adapter
AC-UB10 takes several hours to provide
a normal charge to a
battery pack that
was completely
depleted.

■ **Shoulder strap.** Sony provides a suitable neck or shoulder strap, with the Sony logo subtly worked into the design.

My recommendation: While I am justifiably proud of owning a fine Sony camera, I never attach the factory strap to my camera, and instead opt for a more serviceable strap from UPstrap (www.upstrap-pro.com). If you carry your camera over one shoulder, as many do, I particularly recommend UPstrap (shown in Figure 1.5). It has a patented non-slip pad that offers reassuring traction and eliminates the contortions we sometimes go through to keep the camera from slipping off. I know several photographers who refuse to use anything else. If you do purchase an UPstrap, be sure to tell photographer-inventor Al Stegmeyer that I sent you hence.

Figure 1.5
Third-party neck straps, like this UPstrap model, are often preferable to the Sony-supplied strap.

- **Shoe cap.** This plastic piece slides into the camera's multi interface shoe on top (what we used to call a "hot shoe") and protects the contacts from dirt, moisture, and damage when you don't have an electronic flash, microphone, or other accessory attached.
 - My recommendation: If you use an external flash or microphone as much as I do, you can remove this piece and leave it off for the rest of your life. I've never had a hot shoe damaged, but I *have* lost shots while fumbling with protective covers, and manage to lose the shoe cap with alarming frequency.
- Eyepiece cup. This rubber accessory is already installed on the electronic viewfinder eyepiece when you receive the camera; if you want to remove it, slide it up.
- **Application software.** Sony no longer includes a software CD in the package. The first time you power up the camera, it will display the current URL for your country where you can download imaging software for the a7R II/a7 II, such as the PlayMemories utility.
- Printed instruction manual. The camera comes with a Wi-Fi/One Touch (NFC) connection guide and a brief printed instruction booklet; a longer guide to the camera's operation can be accessed from Sony's esupport.sony.com website. There will also be assorted pamphlets listing available accessories, lenses, as well as warranty and registration information.
- **Body cap.** This accessory will probably already be attached to the camera body if you purchase your a7R II/a7 II without a lens.
 - My recommendation: Purchase an extra body cap. With mirrorless cameras like the a7 II series, it is especially important not to leave the sensor unprotected. If you lose your body cap, mount a lens as a "body cap" until you purchase spares. A body cap is essential when packing your camera for compact travel.

Initial Setup

The initial setup of your Sony is fast and easy. You just need to charge the battery, attach a lens (if that hasn't already been done), and insert a memory card. I'll address each of these steps separately, but if you already feel you can manage these setup tasks without further instructions, feel free to skip this section entirely. You should probably at least skim its contents, however, because I'm going to list a few options that you might not be aware of.

Battery Included

Your Sony a7R II/a7 II is a sophisticated hunk of machinery and electronics, but it needs a charged battery to function, so rejuvenating the NP-FW50 lithium-ion battery pack should be your first step. A fully charged power source should be good for as many as 340 shots or 95 minutes of video under normal temperature conditions. However, I frequently (always) deplete my batteries more quickly. Sony's estimates are based on standard tests defined by the Camera & Imaging Products Association (CIPA). If you often use the camera's Wi-Fi feature (discussed later), you can expect to

take fewer shots before it's time for a recharge. This is an Info-Lithium battery, so the camera can display the approximate power remaining with a graphic indicator.

Remember that all rechargeable batteries undergo some degree of self-discharge just sitting idle in the camera or in the original packaging. Lithium-ion power packs of this type typically lose a small amount of their charge every day, even when the camera isn't turned on. Li-ion cells lose their power through a chemical reaction that continues when the camera is switched off. So, it's very likely that the battery purchased with your camera, even if charged at the factory, has begun to poop out after the long sea voyage on a banana boat (or, more likely, a trip by jet plane followed by a sojourn in a warehouse), so you'll want to revive it before going out for some serious shooting.

My recommendation: As I mentioned earlier, I own eight NP-FW50 batteries, and keep one in the camera at all times. Nevertheless, I always check battery status before I go out to shoot, as some juice may have been siphoned off while the camera sat idle. I go to the Wireless 1 menu and turn Airplane Mode on (as described in Chapter 5) when I don't need Wi-Fi features.

Charging the Battery

When you're ready to charge the battery, turn the camera Off. Then, plug one end of the USB cable (with the smaller connector) into the top port under the top door in the left end of the a7R II/a7 II; it will fit only when in the proper orientation. (See Figure 1.6.) Plug the other end (with the

familiar USB connector) into a computer's USB port. Turn the camera On and you'll see a note on the LCD screen, USB Mode; this confirms that the connection has been made. As discussed earlier, you can also connect the camera to the AC adapter and plug that into a wall socket.

Whether you charge from a computer's USB port or household power, a Charge light beneath the USB/charging port glows yellow, without flashing. It continues to glow until the battery completes the charge and the lamp turns off. In truth, the full charge is complete about one hour *after* the charging lamp turns off, so if your battery was really dead, don't stop charging until the additional time has elapsed. Be sure to plan for charging time before your shooting sessions, because it takes about several hours in a warm environment to fully restore a completely depleted battery. (With the optional Quick Charger BC-TRW accessory discussed earlier, that may take much less time; it sells for \$50 or less through major online photo retailers in the U.S.)

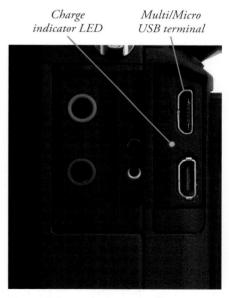

Figure 1.6 The charging cable is inserted into the Multi/Micro USB terminal.

If the charging lamp flashes after you insert the battery into the camera, that indicates an error condition. Make sure you have the correct model number of battery (it's possible you own other Sony devices which use a similar battery); remove it and re-insert it. To insert/remove it, slide the latch on the bottom of the camera, open the battery door, and press a blue lever in the battery compartment that prevents the pack from slipping out when the door is opened; then, ease the battery out. To insert it, do so with the three contact openings facing down into the compartment (see Figure 1.7).

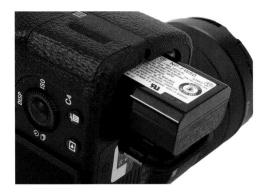

Figure 1.7 Install the battery in the camera; it only fits one way.

Fast flashing that can't be stopped by re-inserting the

battery indicates a problem with the battery. Slow flashing (about 1.5 seconds between flashes) means the ambient temperature is too high or low for charging to take place.

Charging the battery with the supplied BC-VW1 external charger is even easier; just slide the battery in, connect to AC power, and the charger's yellow status light will begin to glow. When the lamp turns off, the battery is charged.

Final Steps

Your Sony a7R II/a7 II is almost ready to fire up and shoot. You'll need to select and mount a lens (if not previously done) and insert a memory card. Each of these steps is easy, and if you've used any similar camera in the past, such as a Sony or other model, you already know exactly what to do. I'm going to provide a little extra detail for those of you who are new to the Sony or interchangeable-lens camera worlds.

Mounting the Lens

Most buyers purchase the camera in a kit including a lens, but you may have bought it as a "body-only" configuration; that allows you to select any compatible lens you may already own. You'll need a Sony E-mount lens, either standard E-mount (for Sony non-full-frame mirrorless models), or an E-mount lens with the FE (full-frame) designation.

My recommended lens mounting procedure emphasizes protecting your equipment from accidental damage, and minimizing the intrusion of dust. Select the lens you want to use and loosen (but do not remove) the rear lens cap. I generally place the lens I am planning to mount vertically in a slot in my camera bag, where it's protected from mishaps but ready to pick up quickly. By loosening the rear lens cap, you'll be able to lift it off the back of the lens at the last instant, so the rear element of the lens is covered until then.

After that, remove the body cap that protects the camera's exposed sensor by rotating the cap toward the shutter release button. You should always mount the body cap when there is no lens on the camera, because it helps keep dust out of the interior of the camera. Unlike traditional dSLRs, these cameras have no mirror or closed shutter to protect the sensor.

Once the body cap has been removed, remove the rear lens cap from the lens, set the cap aside, and then mount the lens on the camera by matching the raised white alignment indicator on the lens barrel with the white dot on the camera's lens mount (see Figure 1.8). Rotate the lens away from the shutter release side of the camera until it seats securely and clicks into place. (Don't press the lens release button during mounting.) Some lenses ship with a hood. If that accessory is included, and if it's bayoneted on the lens in the reversed position (which makes the lens/hood combination more compact for transport), twist it off and remount with the rim facing outward (see Figure 1.9). A lens hood protects the front of the lens from accidental bumps, and reduces flare caused by extraneous light arriving at the front element of the lens from outside the picture area.

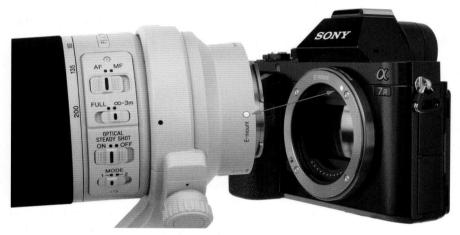

Figure 1.8
Match the raised
white dot on the lens
with the white dot
on the camera
mount to properly
align the lens with
the bayonet mount.

Figure 1.9
A hood protects the lens from extraneous light and from accidental bumps, but not all lenses include this accessory.

Turn on the Power

Locate the On/Off switch that is wrapped around the shutter release button and rotate it to the On position. The LCD display will be illuminated. If you bring the viewfinder up to your eye, a sensor will detect that action and switch the display to the built-in electronic viewfinder instead. (You can disable this automatic switching in the FINDER/MONITOR setting within the Custom Settings 4 menu, as I'll describe in Chapter 4.) After one minute of idling (the default), the a7R II/a7 II goes into the standby mode to save battery power. Just tap the shutter release button to bring it back to life. (You can select a longer time before power-save mode kicks in through the menu system, as I discuss in Chapter 5.)

When the camera first powers up, you may be asked to set the date and time. The procedure is fairly self-explanatory (although I'll explain it in detail in Chapter 5). You can use the left/right direction buttons to navigate among the date, year, time, date format, and daylight savings time indicator, and use the up/down buttons to enter the correct settings. When finished, *press the control wheel center button* to confirm the settings and return to the menu system.

Once the Sony Alpha is satisfied that it knows what time it is, you will be viewing a live view of the scene in front of the lens—on the LCD screen or in the viewfinder when that is held up to your eye—whenever you turn the camera on. The view is superimposed with many items of data over the display; these provide a quick method for checking many current camera settings, including current shutter speed and aperture (f/stop), shooting mode, ISO sensitivity, and other parameters.

Adjusting the Diopter Setting

The a7R II/a7 II is equipped with a built-in electronic viewfinder or EVF, a small high-resolution OLED (organic light-emitting diode) screen that can be used instead of the LCD screen for framing your photos or movies. A sensor detects your eye at the viewfinder and shuts off power to the LCD when you are using the EVF. Usually, when you're learning to use the camera's many features, you'll rely on the LCD screen's display, but when you're actually taking photos, you'll sometimes want to use the EVF instead. You can also use it to review your photos or video clips and navigate menu selections.

If you wear glasses and want to use the EVF without them, or if you find the viewfinder needs a bit of correction, rotate the diopter adjustment dial located to the right of the viewfinder window (and shown in Figure 1.10). Adjust the dial while looking through the viewfinder until the image appears sharpest.

Figure 1.10 Diopter adjustment dial.

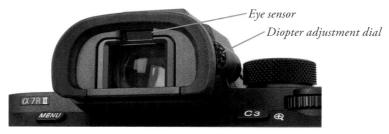

Inserting a Memory Card

You can't take actual photos without a memory card inserted in your Sony camera. If you don't have a card installed, the camera will sound as if it's taking a photo and it will display that "photo." However, the image is only in temporary memory and not actually stored; you'll get a reminder about that with a flashing orange NO CARD warning at the upper left of the LCD. If you go back later and try to view that image, it will not be there. So, be sure you have inserted a compatible card with adequate capacity before you start shooting stills or videos.

The a7R II/a7 II accepts Secure Digital (SD), Secure Digital High Capacity (SDHC), Secure Digital Extra Capacity (SDXC), and Sony Memory Stick Pro Duo (or Memory Stick Pro-HG Duo) cards. The newest type of SD card, the super-high-capacity (and super-fast) SDXC type, at this writing, is available in capacities as high as 256GB. The SDXC cards are more expensive, but equally fast SDHC cards (with capacity up to 32GB) are quite affordable. I've standardized on Lexar Professional 1000x 128GB SDXC cards, although I still have quite a few of my older 64GB Lexar cards. For a camera with a 42.4-megapixel sensor, larger cards make the most sense. (You can read about the "all your eggs in one basket myth" in Chapter 14.)

Whichever card you decide on, it fits in the single slot underneath the sliding door on the right side of the camera. You should remove the memory card only when the camera is switched off. Insert an SD card with the label facing toward the back side of the camera (as shown in Figure 1.11, left), or toward the front if inserting any type of Memory Stick Pro card (Figure 1.11, right). In either case, the metal contacts go into the slot first; the card simply will not fit into the slot if it is incorrectly oriented.

Close the door, and your pre-flight checklist is done! (I'm going to assume you'll remember to remove the lens cap when you're ready to take a picture!) When you want to remove the memory card later, just press down on the card edge that protrudes from the slot, and the card will pop right out.

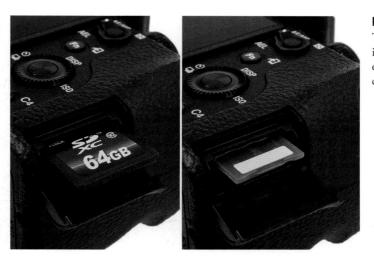

Figure 1.11
The memory card is inserted in the slot on the side of the camera.

Formatting a Memory Card

There are three ways to create a blank SD or Memory Stick Pro card for your Sony a7R II/a7 II, and two of them are at least partially wrong. Here are your options, both correct and incorrect:

- Transfer (move) files to your computer. You'll sometimes decide to transfer (rather than copy) all the image files to your computer from the memory card (either using a direct cable transfer or with a card reader and appropriate software, as described later in this chapter). When you do so, the image files on the card can be erased leaving the card blank. Theoretically. This method does *not* remove files that you've labeled as Protected (by choosing Protect from the Playback menu during review), nor does it identify and lock out parts of your card that have become corrupted or unusable since the last time you formatted the card. Therefore, I recommend always formatting the card, rather than simply moving the image files. The only exception is when you *want* to leave the protected/unerased images on the card for a while longer, say, to share with friends, family, and colleagues.
- (Don't) Format in your computer. With the memory card inserted in a card reader or card slot in your computer, you can use Windows or Mac OS to reformat the memory card. Don't even think of doing this! The operating system won't necessarily arrange the structure of the card the way the camera likes to see it (in computer terms, an incorrect *file system* may be installed). In particular, cards larger than 32GB must be initialized using the exFAT format, and while your computer may offer exFAT as an option, it may default to a different scheme. The only way to ensure that the card has been properly formatted for your camera is to perform the format *in the camera itself*. The only exception to this rule is when you have a seriously corrupted memory card that your camera refuses to format. Sometimes it is possible to revive such a corrupted card by allowing the operating system to reformat it first, then trying again in the camera to restore the proper exFAT system.
- **Setup menu format.** Use the recommended method to format a memory card in the camera, as described next.

To format a memory card, just follow these steps:

- 1. **Press the MENU button.** The a7R II/a7 II's "tile" menu screen will appear (unless you've disabled it, as I'll describe in Chapter 5). (See Figure 1.12.)
- 2. **Select Setup.** If the tile menu is visible, use the left/right directional buttons (the left/right edges of the control *wheel*) or the use rear dial (next to the C3 button on the back of the camera) to navigate to the Setup menu (a wrench/toolbox icon), and press the center button (located in the middle of the control wheel) to open up the menu. (If you've disabled the Tile menu, the conventional menu system will appear immediately, without the intermediate Step 2.)
- 3. **Navigate to the Setup 5 tab.** Once in the conventional menu, use the directional buttons or rear dial to move to the Setup icon (a toolbox) at the far right of the menu tabs. Then, press the down button to move into the Setup tab, followed by the left/right buttons to select Setup 5 (as shown in Figure 1.13, which shows the a7R II version).

Figure 1.12
Choose Settings in the Tile menu, or navigate to the Setup 5 menu.

Figure 1.13 The a7R II's Setup menu.

- 4. **Choose Format.** Rotate the control wheel on the back of the camera to highlight Format and press the center button.
- 5. **Confirm.** A display will appear asking if you want to delete all data. If you're sure you want to do so, press up/down to choose OK, and press the center button to confirm your choice. This will begin the formatting process.

Selecting a Shooting Mode

When it comes time to select the shooting mode and other settings on the a7R II/a7 II camera, you may start to fully experience the "feel" of the user interface. Thanks to the mode dial shown earlier in Figure 1.1, it's simple and quick to set a shooting mode. Just press the mode dial lock release button (on the a7R II only) and rotate the dial to the position you want, such as P (Program Auto). If you've enabled the Mode Dial Guide in the Setup menu, a screen appears with a brief summary

as to how that mode works. (You probably won't need the Mode Dial Guide after you've been using your camera for a few days, but I'll show you how to activate it in Chapter 6.)

When you rotate the dial to the SCN position (for the fully automatic scene modes) a brief description appears about Scene Selection but now you get another option (see Figure 1.14, left). Rotate the front dial and the Scene Selection screen appears (see Figure 1.14, right). If you later turn the camera on while it's set for SCN, rotate the front dial to reveal the screen that shows the available scene modes.

Use the front dial or control wheel to reveal the various available scene modes (Portrait, Landscape, Sports Action, Sunset, etc.). Stop scrolling when the one you want appears. This scene mode will now be the one that's active when you touch the shutter release button. Two specialized scene modes are particularly worth noting: Anti Motion Blur and Hand-held Twilight; they differ in some aspects but both can produce surprisingly fine JPEGs in low light when a high ISO level is used.

There is a fully automatic shooting mode, Auto, which includes two options: Intelligent Auto and Superior Auto, in addition to scene modes. In all of these, the camera makes most of the decisions for you (except when to press the shutter). You'll also find three semi-automatic modes (Program, Aperture Priority, and Shutter Priority), which allow you to provide more input over the exposure and settings the camera uses. Sony also provided a fully Manual mode. The final mode that you can select with the dial is Sweep Panorama (an automatic mode that allows you to make an ultrawide image assembled from a series of photos). You'll find a complete description of the various shooting modes in Chapter 7.

INSTANT HELP

The a7R II/a7 II will display information about each of the modes when a mode is selected with the mode dial. You can turn this help off using the Setup 2 menu entry Mode Dial Guide, as I'll explain in Chapter 6.

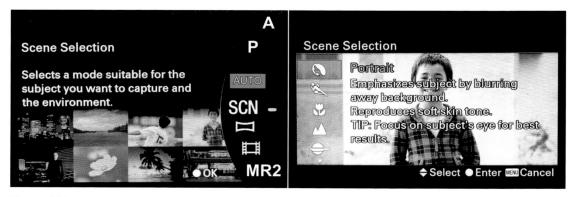

Figure 1.14 Rotate the mode dial to the SCN position (left). Select a scene mode (right).

If you're very new to digital photography, you might want to set the camera to the green Auto setting and start snapping away. Either of the two Auto modes (described next) will make all the appropriate settings for you for many shooting situations. If you have a specific type of picture you want to shoot, you can try one of the scene modes instead, indicated on the mode dial by SCN.

- Intelligent Auto. In Chapter 3 I'll show you how to use the Camera Setting 7 menu's Auto Mode entry to specify whether you want the a7R II/a7 II to shift into Intelligent Auto or Superior Auto when the mode dial is set to the green Auto position. In Intelligent Auto mode, the a7R II/a7 II makes the settings of aperture and shutter speed for you. You still can make some decisions on your own, though, such as whether to use single shots or continuous shooting through a drive mode setting, whether to use the flash, and whether to use autofocus or manual focus.
- Superior Auto. If you opt for Superior Auto instead, this mode provides an extra benefit. In scenes that include extremely bright areas as well as shadow areas, the camera can activate its Auto HDR (high dynamic range) feature to provide more shadow detail. I'll discuss this feature in Chapter 6. In very dark locations, it can activate the Anti Motion Blur feature to create a photo with minimal digital noise.
- Scene Selection. The SCN position on the dial lets you choose any of nine different scene modes, each suited for a different type of subject or lighting condition. In scene modes, you do not get to control any aspect of the camera, except for the choice of autofocus or manual focus and flash. An external flash will not fire when certain scene modes are in use. Here's a brief summary of the nine options.
 - Portrait. This is the first of the nine scene modes, selected as sub-choices under the SCN heading on the mode dial. With the Portrait setting, the camera uses settings to blur the background and sharpen the view of the subject, while using soft skin tones. External flash will fire in low light if you have attached it and powered it up.
 - **Sports Action.** Use this mode to freeze fast-moving subjects. The camera uses a fast shutter speed if possible; in a dark arena, for example, it simply won't be able to set a fast shutter speed so it will not be able to freeze the motion. The camera will fire continuously while the shutter button is held down. External flash will never fire in this mode.
 - Macro. This mode is helpful when you are shooting close-up pictures of a subject such as a flower, insect, or other small object. External flash will fire in low light if you have popped it into the up position, but the flash may be too bright for a subject that's very close to the camera.
 - Landscape. Select this scene mode when you want a maximum range of sharpness (instead of a blurred background) as well as vivid colors of distant scenes. External flash will never fire in this mode.

- **Sunset.** This is a great mode to accentuate the warm (red/orange) colors of a sunrise or sunset. External flash will never fire in this mode.
- **Night Scene.** This mode uses slower shutter speeds to provide a useful exposure, but without using flash. You should use a tripod to avoid the effects of camera shake that can be problematic with a slow shutter speed.
- Hand-held Twilight. This special mode is designed for use in low light. The camera will set a high ISO (sensitivity) level to enable it to use a fast shutter speed to minimize the risk of blurring caused by camera shake. (In extremely dark conditions however, the shutter speed may still be quite long.) When you press the shutter release button, the camera takes six shots in succession. The processor then composites them into one after discarding most of the digital noise (graininess) that is common in conventional photos made at high ISO. It provides one image that's of surprisingly fine quality. External flash is never fired in this mode.
- Night Portrait. Choose this mode when you want to illuminate a subject in the foreground with flash, but still allow the background to be exposed properly by the available light. Be prepared to use a tripod or to rely on the SteadyShot feature to reduce the effects of camera shake. If there is no foreground subject that needs to be illuminated by the flash, you may do better by using the Night Scene mode, discussed next. Remember that you must attach and power up the external flash before taking a shot if you want the flash to fire.
- Anti Motion Blur. Similar to Hand-held Twilight, this mode is also designed for use indoors or in low lighting, but it's more effective at reducing blurring that might be caused by a subject's motion or by a shaky camera. That's because the camera sets an even higher ISO level to be able to use an even faster shutter speed so you should not need to use a tripod. (Of course, in an extremely dark location, the shutter speed may still be a bit long.) It fires a series of six shots and composites them into one with minimal digital noise.
- Sweep Panorama. This special mode lets you "sweep" the camera across a scene that is too wide for a single image. The camera takes multiple pictures while you move it; after taking a series of shots, its processor combines them into a single, wide (or long) panoramic final product.
- Movie. Allows shooting movie clips.
- 1/2 (Memory Recall). These two positions on the mode dial, simply marked 1 or 2, aren't actually exposure modes. Instead, they correspond to either of two different groups of settings that you've previously stored in an internal memory storage "slot" (register) numbered 1 and 2. You can use the memory registers to set up the a7R II/a7 II for specific types of shooting scenes, and then retrieve those settings from the mode dial.

If you have more photographic experience, you might want to opt for one of the semi-automatic or manual modes, selecting it from the virtual mode dial. These, too, are described in more detail in Chapter 7. These modes, which let you apply more creativity to your camera's settings, are indicated

by the letters P, A, S, and M. All overrides are available and flash will always fire if it's mounted and powered up in any of the following:

- **P** (**Program auto**). This mode allows the a7R II/a7 II to make the basic exposure settings, but you can still override the camera's settings to fine-tune your image.
- A (Aperture Priority). Choose this mode when you want to use a particular lens opening (called an aperture or f/stop), especially to control how much of your image is in focus. The camera will set the appropriate shutter speed after you have set your desired aperture using the rear dial that's around the mode selector dial.
- **S** (**Shutter Priority**). This mode is useful when you want to use a particular shutter speed to stop action or produce creative blur effects. You dial in your chosen shutter speed with the rear dial, and the camera will set the appropriate aperture (f/stop) for you.
- M (Manual). Select this mode when you want full control over the shutter speed and the aperture (lens opening), either for creative effects or because you are using a studio flash or another flash unit not compatible with the camera's automatic flash metering. You also need to use this mode if you want to use the Bulb setting for a long exposure, as explained in Chapter 6. You select both the aperture (with the front dial) and the shutter speed aperture (with the rear dial on the camera back). There's more about this mode, and the others, in Chapter 6.

Choosing a Metering Mode

You might want to select a particular exposure metering mode for your first shots, although the default high-tech Multi (short for multi-zone or multi-segment) metering is probably the best choice while getting to know your camera. If you want to select a different metering pattern, you must not be using one of the scene modes, Superior Auto or Intelligent Auto; in these modes, the camera uses Multi metering and that cannot be changed. To change the metering mode, press the MENU button and navigate to the Camera Settings menu (the tab in the upper-left corner in Figure 1.13), and thence to the Camera Settings 5 menu to the Metering Mode entry. Press the center button, then scroll up/down with the directional buttons to reach Multi, Center (for center weighted), or Spot selections. Press the center button to confirm your choice and return the camera to shooting mode. The three metering options are as follows:

- Multi metering. In this standard metering mode, the camera attempts to intelligently classify your image and choose the best exposure based on readings from 1,200 different zones or segments of the scene. You can read about this so-called "evaluative" metering concept, as well as the other two options, in Chapter 7.
- **Center metering.** The camera meters the entire scene, but gives the most emphasis (or weighting) to the central area of the frame.
- **Spot metering.** The camera considers only the brightness in a very small central spot so the exposure is calculated only based on that area.

OPTION OPTIONS

You'll soon find that your a7R II/a7 II gives you multiple ways to select options. In this Quick Start chapter, I'll show you just one of them. For example, you can select a metering mode using the Camera Settings menu, as described, or you can press the Fn button and specify the metering method from the 12-item Function menu that pops up. Alternatively, when the "Quick Navi" screen is shown on the LCD monitor, you can press the Fn button to change the metering mode as well as most of the other shooting settings. I'll show you how to use the other optional methods in Chapter 2.

Choosing a Focus Mode

The Camera Settings menu also has entries to allow you to choose Focus Mode (Camera Settings 2) and Focus Area (Camera Settings 3), and are accessed using the same navigation steps described earlier. Focus Mode is the easiest to understand; it determines *when* focus is established.

If you're using a scene mode or one of the two Auto modes, you do not get any options under Autofocus Mode; in fact, it is grayed out since it's not available in these modes. The choices that are available when using P, A, S, or M mode are as follows:

- Single-shot AF (AF-S). This mode, sometimes called *single autofocus*, sets focus after you touch the shutter release button and the camera beeps to confirm focus (unless you've turned the beeps off). The active focus point(s) are shown in green on the screen and a green dot appears in the bottom-left corner of the display. The focus will remain locked as long as you maintain contact with the shutter release button, or until you take the picture. If the autofocus system is unable to achieve sharp focus (because the subject is too close to the camera, for example), the focus confirmation circle will blink. This mode is best when your subject is relatively motionless as when you're taking a portrait or landscape photo.
- Continuous AF (AF-C). This mode, sometimes called *continuous servo* or *continuous tracking* focus by photographers, sets focus when you partially depress the shutter button, but continues to monitor the frame and refocuses if the distance between the camera and the subject changes. (This allows it to continuously focus on a person walking toward you, for example.) No beep sound is provided. A green dot surrounded by two brackets (curved lines) appears to indicate that the camera is not having a problem achieving and maintaining focus. The brackets disappear when focus is achieved, leaving only the green dot. If the camera should fail to acquire focus, the green dot disappears and the brackets remain. Continuous AF is a useful mode for photographing moving subjects.
- DMF (Direct Manual Focus). Allows you to manually adjust focus after autofocus has been confirmed, using the focus ring on the lens.

- Automatic AF (AF-A). Choose this option and the camera will initiate autofocus using AF-S mode and lock focus immediately, but if your subject starts moving, it will switch to AF-C. This mode is useful for subjects such as children sitting quietly, but who might suddenly jump up and begin more active play. If focus is achieved, the active focus points will be illuminated in green. If focus cannot be achieved, the green focus confirmation light at lower left will blink.
- Manual Focus. Focus by rotating the focus ring on the lens. The a7R II/a7 II offers magnification and Focus Peaking as aids to manual focus. I'll describe their use in Chapter 3.

Selecting a Focus Area

The Sony a7R II/a7 II is equipped with a hybrid autofocus system that I'll explain in detail in Chapter 8. In scene modes, the focus area that will set focus is selected automatically by the camera; in other words, the AF system decides which part of the scene will be in sharpest focus. In the semi-automatic P, A, and S mode, and in the manual M mode, you can allow the camera to select the focus point automatically, or you can specify which focus point should be used with the Focus Area feature.

Set the camera to one of the four modes mentioned above and select Focus Area from the Camera Settings 3 menu. By default, it will be set to Wide (multi-point autofocus). Scroll up/down until you reach the option you want to use and press the center button to confirm your selection. There are four autofocus area options, described in Chapter 8. Once you're in the Camera Settings menu, navigate to the Focus Area selection in the Camera Settings 4 tab, then press the center button, and select one of these choices. Press the center button again to confirm. Here's a brief overview of the options.

- Wide. The a7R II/a7 II automatically chooses the appropriate focus area or areas; often several subjects will be the same distance from the camera as the primary subject. The active AF area or areas are then displayed in green on the LCD or in the viewfinder, depending on which display you're using.
- **Zone.** In this mode, a grid consisting of nine focus areas appears on the LCD while you're shooting. You can move this grid around the frame with the directional buttons, and the camera will select which of the focus areas to use to focus.
- Center. The camera always uses the focus area in the center of the frame, so it will focus on the subject that's closest to the center in your composition.
- Flexible Spot. After you select this option from Focus Area, you can use the left/right direction buttons to specify Small, Medium, or Large focus areas. Then, while viewing your subject, you can use the directional controls to move the focus frame (rectangle) around the screen to your desired location. Move the frame so it covers the most important subject in the scene; then press the center button to lock it into place. I'll discuss this topic in more detail in Chapter 8, where I'll cover many aspects of autofocus (as well as manual focus), including some not covered in this chapter.

- Expand Flexible Spot. If the camera is unable to lock in focus using the selected focus point, it will also use the eight adjacent points to try to achieve focus.
- Lock-On AF. In this mode, the camera locks focus onto the subject area that is under the selected focus spot when the shutter button is depressed halfway. Then, if the subject moves (or you change the framing in the camera), the camera will continue to refocus *on that subject*. You can select this mode only when the focus mode is set to Continuous AF (AF-C). You can activate it for any of the five focus area options described above. That is, once you've highlighted Lock-On AF on the selection screen, you can then press the left-right directional button and choose Wide, Zone, Center, Flexible Spot, or Expand Flexible Spot.

Other Settings

There are a few other settings you can make if you're feeling ambitious, but don't feel bad if you postpone using these features until you've racked up a little more experience with your Sony a7R II/a7 II. By default, these camera features will be at Auto so the camera will make a suitable setting.

Adjusting White Balance and ISO

If you like, you can custom-tailor your white balance (overall color balance) and the ISO level (sensitivity) as long as you're not using one of the Auto or SCN modes. To start out, it's best to leave the white balance (WB) at Auto, and to set the ISO to ISO 200 for daylight photos or to ISO 400 for pictures on a dark, overcast day or indoors when you'll be shooting with an external flash. You can adjust white balance with the White Balance entry in the Camera Settings 5 menu; the ISO can be set after pressing the ISO section of the control wheel (the right direction button). After accessing either feature, navigate (scroll) to make the desired setting with the direction buttons; that is the most convenient method, but you can also scroll by rotating the control wheel.

Using the Self-Timer

If you want to have time to get into the photo before the tripod-mounted camera takes the actual shot, the self-timer is what you need. You can get to this feature by pressing the drive mode button (the left direction button of the control wheel) and then scrolling up or down. The drive mode can also be selected from the Camera Settings menu, but it's quicker to use the direct access button.

When the Drive Mode screen is visible, scroll up/down through the various options until you reach the Self-timer 10 Sec option, which will provide a ten-second delay. Press the center button to confirm your choice and a self-timer icon will appear on the live view display. Press the shutter release to lock focus and exposure and to start the timer. The self-timer lamp will blink and the beeper will sound (unless you've silenced it in the menu) until the final two seconds when the lamp remains on and the beeper beeps more rapidly until the picture is taken.

There are a few options you can select to vary the operation of the self-timer. When the self-timer option is first highlighted, press the left/right keys to choose between 10-second and 2-second options. Also, on the Drive Mode screen, just below self-timer, there is an option labeled C3/C5; scroll to it and you'll see its called Self-timer (Cont.): 10 Sec. 3 Img (or 5 Img). That abbreviation means the camera will take three or five images after the self-timer's 10-second delay has run out. The multiple image option is handy if you are taking family group pictures with a few known inveterate blinkers to be pictured. Note that the self-timer setting is "sticky" and will still be in effect for multiple shots, even if you turn the camera off and power up again. When you're done using the self-timer, reset the camera to one of the other Drive Mode options.

In addition to the Self-timer, Continuous shooting, and Single-shot choices in the Drive menu, there also are exposure/white balance/dynamic range optimization bracketing options.

An Introduction to Movie Making

I'm going to talk in more detail about your movie-making options with the a7R II/a7 II camera in Chapters 10 and 11. For now, though, I'll give you enough information to get started, in case a cinematic subject wanders into your field of view before you get to that chapter. The overrides you have set for certain aspects while shooting still photos will apply to the video clip that you'll record; these include exposure compensation, the White Balance, any Picture Effect, and even the aperture if the camera is in A mode or the shutter speed if it's in S mode. You also get access to the settings for the movie file formats (AVCHD, MP4, and XAVCS HD; the a7R II has an additional XAVCS 4K mode we'll explore later in this book) and the resolution in the Record Setting item of the Camera Settings section of the menu.

After you start recording, you can change the aperture or the shutter speed; either step will make your movie brighter or darker as you'll notice while viewing on EVF or LCD while making the adjustments. However, you can also set plus or minus exposure compensation for that purpose while filming. The a7R II/a7 II provides an effective Continuous Autofocus in Movie mode and sound is recorded in stereo with the built-in mics located on the viewfinder housing on top of the camera.

Let's save the discussion of those aspects for Chapters 10 and 11. For the moment, let's just make a basic movie. With the camera turned on, aim at your subject and locate the red Movie record button in the right-hand corner of the body. (You don't have to switch to Movie mode using the mode dial; the Movie mode position simply gives you access to more movie-shooting controls.)

Compose as you wish and press that button once to start the recording, and again to stop it; don't hold the button down. You can record for up to about 29 minutes consecutively if you have sufficient storage space on your memory card and charge in your battery. The camera will adjust the focus and exposure automatically, and you can zoom while recording, if you have a zoom lens attached to the camera.

After you finish recording a video clip, you can view it by pressing the Playback button at the lower right of the LCD screen. Let's say you have taken some still photos after making a movie; in that case, the movie is not the latest item available to play. In order to play it, you will need to use the index screen; see the last bullet of the section below on "Reviewing the Images You've Taken" for that procedure. While a movie is being played back, certain camera controls act like DVD buttons, including the following:

- Pause/Resume. Press the center button.
- Fast-forward. Press the right direction button, or turn the control wheel to the right.
- Fast-reverse. Press the left direction button, or turn the control wheel to the left.
- Adjust sound volume. Press the bottom direction button to activate the volume control screen; scroll upward to make it louder or downward for less volume. (You can scroll either by rotating the control wheel or by using the control's top and bottom buttons.)
- Slow-forward. While paused, turn the control wheel to the right.
- **Slow-reverse.** While paused, turn the control wheel to the left.

Reviewing the Images You've Taken

The Sony a7R II/a7 II has a broad range of playback and image review options. I'll cover them in more detail in Chapter 2. Initially, you'll want to learn just the basics for viewing still photos so I'll assume you have taken only such images. After shooting some JPEG and/or RAW photos, here's how to view them, using controls shown in Figure 1.15:

- Press the Playback button to display the most recently taken image. (It's the small button with a > symbol located to the lower right of the LCD monitor screen.)
- Press the left direction button, or scroll the control wheel to the left, to view a previous image.
- Press the right direction button, or scroll the control dial to the right, to view the next image.
- While viewing a photo, press the DISP button (top direction button) repeatedly to cycle among the available displays: views that have no recording data, full recording data (f/stop, shutter speed, image quality/size, etc.), and a thumbnail image with histogram display. (I'll explain all these in Chapter 2.)
- Press the lower-right button, marked with a C4 (Custom 4) label and trash can icon, to delete the currently displayed image.
- While the image is displayed, press the MENU button and from the Playback 1 menu, select Rotate, followed by pressing the center button, to rotate the image on the screen 90 degrees. Successive presses of the center button rotate the image 90 degrees each time. (You won't likely need this feature unless you have disabled automatic rotation, which causes the camera to display your vertically oriented pictures already rotated. I'll explain how to activate/deactivate automatic rotation in Chapter 5.)

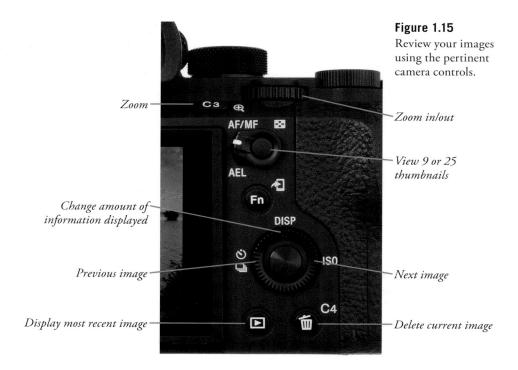

- Press the C3/Zoom button located to the right of the viewfinder window to zoom into the image. Rotating the rear dial on the back of the camera allows you to zoom in and out. You can also scroll around inside the image using the direction buttons. To exit this screen and return to normal view, press the MENU button.
- While in Playback mode, press the Index button (located in the center of the AF/MF/AEL switch) to display an index screen showing 9 or 25 thumbnail images (select the number using the Image Index option in the Playback 1 menu). Keep scrolling downward to view the thumbnails of the next images (assuming you have shot lots of photos). Scroll to the thumbnail of the photo you want to view and press the center button; the photo will then fill the screen. The a7R II/a7 II arranges index images by date shot, and includes a calendar view you can use to look for pictures taken on a specific date. I'll explain those options in more detail in Chapter 6.

Switching between Still and Movie Playback

If you have shot both still photos as well as movie clips, the a7R II/a7 II will show both in playback mode. Just press the control wheel's center button to play the movie. However, if you want to browse through your images/movies using Index mode, the behavior changes slightly.

When you press the Index button to display indexes, a screen like the one in Figure 1.16 appears, with stills and movies split into two panes—the upper for stills, and the lower for movie clips. The pane containing the last type of image/movie captured will be highlighted. To move between panes,

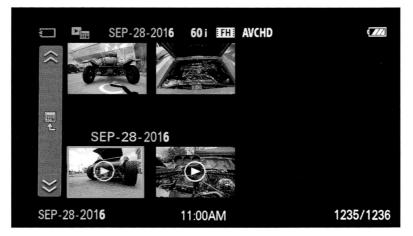

just press the up/down button. There are additional review options, including movies only, stills only, choice of folders, and a calendar view that shows captures on specific dates. Once we leave Quick Start mode, I'll explain those options, specifically in Chapter 6.

Transferring Files to Your Computer

The final step in your picture-taking session will be to transfer the photos and/or movies you've taken to your computer for printing, further review, or editing. (You can also take your memory card to a retailer for printing if you don't want to go the do-it-yourself route.) Your a7R II/a7 II allows you to print directly to PictBridge-compatible printers, without downloading the photos to a computer and to create print orders right in the camera. It also offers an option for selecting which images to transfer to your computer.

For now, you'll probably want to transfer your images by either using the USB cable from the camera to the computer or by removing the memory card from the a7R II/a7 II and transferring the images with a card reader. The latter option is ordinarily the best, because it's usually much faster and doesn't deplete the camera's battery. However, you might need to use a cable transfer when you have the cable and a computer but no card reader. (You might be using the computer at a friend's home or the one at an Internet café, for example.)

Here's how to transfer images from a memory card to the computer using a card reader:

- 1. Turn off the camera.
- 2. Slide open the battery compartment door, and press on the card, which causes it to pop up so it can be removed from the slot. (You can see a memory card being removed in Figure 1.11.)
- 3. Insert the memory card into a memory card reader accessory that is plugged into your computer. Your installed software detects the files on the card and offers to transfer them. The card can also appear as a mass storage device on your desktop; in that case, you can open that and then drag and drop the files to your computer.

To transfer images from the camera to a Mac or PC computer using the USB cable:

- 1. Turn off the camera.
- 2. Open the port door on the left side of the camera (the upper door, marked with the candelabralike USB symbol) and plug the USB cable furnished with the camera into the USB port inside that door. (See Figure 1.6, shown earlier in this chapter.)
- 3. Connect the other end of the USB cable to a USB port on your computer.
- 4. Turn on the camera. From this point on, the method is the same as in entry 3 in the card reader list above.

Wireless File Transfer

Your a7R II/a7 II is also equipped with built-in Wi-Fi, which provides many options, including a method for wireless transfer of image files to a Mac or Windows computer when connected to a wireless network. This is a multi-faceted topic so I won't begin to discuss it here; instead, you'll find full coverage in Chapter 5.

The camera is also compatible with the Eye-Fi-brand memory card that allows for wireless transfer of files to a computer. (It can also be used for wireless transfer to a smart device running a free app.) This card looks and acts exactly like an ordinary SDHC card, but with a big difference. Once you have the card set up with your local Wi-Fi (wireless) network, whenever you take a picture or record a movie with this card in the camera, the card wirelessly connects to your computer over that network and transmits the file to any location you have specified. For example, you might set the Eye-Fi card to send any new JPEG or RAW photos directly to the Pictures folder on your computer and video clips to the Movies folder.

Since the a7R II/a7 II already offers a wealth of Wi-Fi features, there's really no need to buy an Eye-Fi card. If you already own one for use with another camera however, it will work well with your Sony, too. This will initially preclude the need to learn how to use the camera's own Wi-Fi features, which can seem more complicated because of the sheer number of available options.

Your Camera Roadmap

While all the cameras in the a7 II series are quite straightforward to operate when using their basic features, they are unusually versatile cameras with some uncommon amenities. Because of this aspect, there is a lot of information that needs to be discussed about how these controls can help you reach the results you want with your still images and videos.

Given the tiny black-and-white drawings in the official Sony manuals, impaled with dozens of callouts, looking for information about a specific feature is a lot like being presented with a world globe when what you really want is to find the capital of Brazil. Rather than provide you with a satellite view, I'd rather give you a street-level map that includes close-up, full-color photos of the camera from several angles, with a smaller number of labels clearly pointing to each individual feature. And, I don't force you to flip back and forth among dozens of pages to find out what a particular component does. Each photo is accompanied by a brief description that summarizes the control, so you can begin using it right away. Only when a particular feature deserves a lengthy explanation do I direct you to a more detailed write-up later in the book.

So, if you're wondering what the left direction button on the control wheel does, I'll tell you up front, rather than have you flip to several pages. This book is not a scavenger hunt. But after I explain how to use the drive mode button to select continuous shooting, I *will* provide a cross-reference to a longer explanation later in the book that clarifies the use of the various drive modes, the self-timer, and exposure bracketing. Some readers write and complain about even my minimized cross-reference approach; they'd like to open the book to one page and read *everything* there is to know about bracketing, for example. Unfortunately, it's impossible to understand some features without having a background in what related features do. So, my strategy is to provide you with introductions in the earlier chapters, covering simple features completely, and relegating some of the really in-depth explanations to later chapters. I think this kind of organization works best for a camera as sophisticated as the Sony a7 II series.

By the time you finish this chapter, you'll have a basic understanding of every control and of the various roles it can take on. I'll provide a lot more information about items in the menus and submenus in Chapters 3, 4, 5, and 6, but the following descriptions should certainly satisfy the button pusher and dial twirler in you.

Front View

When thinking about any given camera, we always imagine the front view. That's the view that your subjects see as you snap away, and the aspect that's shown in product publicity and on the box. The frontal angle is, essentially, the "face" of a camera like the Sony a7R II/a7 II. But, not surprisingly, most of the "business" of operating the camera happens *behind* it, where the photographer resides. The front of the camera actually has very few controls and features to worry about. These few controls are most obvious in Figure 2.1:

- AF illuminator/Self-timer lamp. This bright LED flashes while your camera counts down the 2-second or 10-second self-timer. In 10-second mode, the lamp blinks at a measured pace off and on at first, then switches to a constant glow in the final moments of the countdown. When the self-timer is set to 2 seconds, the lamp stays lit throughout the countdown. It also serves as the AF (autofocus) Illuminator, emitting its orange-red glow in dark conditions to help the camera's autofocus system achieve sharp focus.
- Front dial. Adjusts various settings. It's often used in conjunction with the rear dial to control pairs of adjustments, such as shutter speed and aperture.

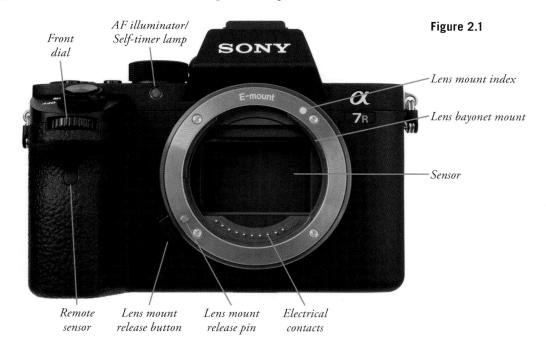

- Remote sensor. Detects infrared signals from the RMT-DSLR1 or RMT-DSLR2 Wireless Remote Commanders to take still pictures and (with the RMT-DSLR2 model only) to start/stop movie recording. I'll show you how to adjust the various remote control options in Chapter 6.
- Lens mount release button. Press and hold this button to unlock the lens so you can rotate it in order to remove the lens from the camera.
- Lens mount release pin. Retracts when the release button is pressed, to allow removing the lens.
- Lens mount index. Match this recessed, white index button with a similar white indicator on the camera's lens mount to line the two up for attaching the lens to the a7R II/a7 II.
- Lens bayonet mount. Grips the matching mount on the rear of the lens to secure the lens to the camera body.
- Electrical contacts. These metal contact points match up with a similar set of points on the lens, allowing for communication with the camera about matters such as focus and aperture.
- Sensor. This fairly ordinary-looking little rectangle is the heart and soul of your digital camera. On the Sony camera, this EXMOR sensor is a CMOS (complementary metal-oxide semiconductor) device, approximately 36mm × 24.0mm in size, with 42.4 megapixels of resolution in the a7 II and 24 megapixels in the a7 II.

On the right side of the a7R II/a7 II (as seen when you're holding the camera to shoot) are three important components, shown in Figure 2.2.

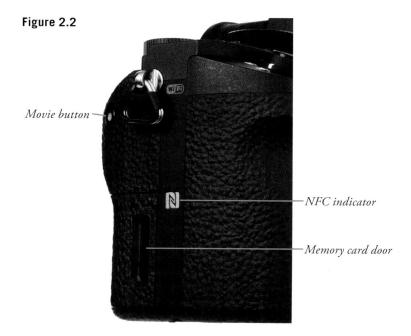

They are:

- Movie button. This button with a central red dot is located on the right-rear corner of the body and it's recessed. This design was intended to minimize the risk of inadvertently starting to record a video clip. When you want to make a movie, there is no need to change the Shooting mode, or to fiddle with menu systems, as with some other cameras. Simply press the record button; when you're finished, press it again to stop recording. I'll discuss your movie-making options in Chapters 10 and 11.
- Memory card door. Slide open to insert an SD card or memory stick.
- NFC indicator. This isn't a control per se; the label emblazoned on the side of the camera indicates the touch point for connecting the a7R II/a7 II with an NFC (Near Field Communication) device, such as an Android smartphone. When linked, the two devices can communicate directly using short-range wireless technology, as I'll describe in Chapter 5.

In Figure 2.3 you can see the pair of port covers that provide a modicum of protection from dust and moisture for the four internal connectors:

- **Port covers.** Fold back these covers to reveal the four ports, and a charge lamp, described next.
- **Microphone terminal.** Allows connecting an external microphone to provide better audio recording than the a7R II/a7 II's built-in mics.
- **Headphone terminal.** You can monitor audio as you shoot video, and listen to your movies during playback by plugging an external headphone into this jack.
- Multi/Micro USB terminal. Connect the a7R II/a7 II to your computer using this port, with the USB cable that's supplied with the camera. That connection can be used to upload images to the computer, to charge the battery while it's in the camera, and to upgrade the firmware to

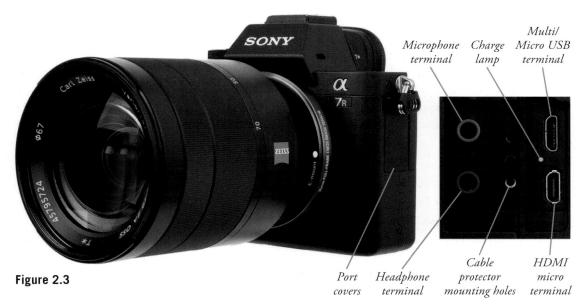

the latest version available for the a7R II/a7 II, using a file downloaded from the Sony support website (www.esupport.sony.com). The same port serves as a charging port when the USB cable is connected to the included charger, or plugged into a powered USB port.

- Charge lamp. This yellow LED flashes while battery charging is underway.
- Micro HDMI terminal. If you'd like to see the images from your camera on a television screen, you'll need to buy an HDMI cable (not included with the camera) to connect this port to an HDTV set or monitor. You can also link to an external video recorder when using DUAL REC mode to output 4K video to both the memory card and recorder. Be sure to get a Type D cable; it has a male micro-HDMI connector at the camera end and a standard male HDMI connector at the TV end. The cable protector packaged with your camera can be fitted to the two mounting holes located in the center of the port cluster, and used to keep the HDMI cable securely connected.

Once the cable is connected, you can not only view your stored images on the TV in Playback mode, you can also see what the camera sees by viewing your TV screen. So, in effect, you can use your HDTV set as a large monitor to help with composition, focusing, and the like.

Unfortunately, recent Sony cameras no longer support video output to an old-style TV's yellow composite video jack. If for some reason it's *really* important to you to connect the camera to one of those inputs, you'll need to find a device that can "down-scale" the HDMI signal to composite video. I have done this successfully with a device by Gefen called the HDMI to Composite Scaler, which costs somewhat more than \$200 at newegg.com, svideo.com, and other sites.

The good news is that if you own a TV that supports Sony's Bravia sync protocol, you can use your Bravia remote control to control image display, mark images for printing, switch to index view, or perform other functions.

The Sony a7R II/a7 II's Business End

The back panel of the Sony is where many of the camera's physical controls reside. There aren't that many of them, but, as I noted earlier, some of them can perform several functions, depending on the context. Most of the controls on the back panel of the a7R II/a7 II are clustered on the right side of the body, with several located on the top edge. The key components labeled in Figure 2.4 include:

- MENU button. Press to enter the multi-tabbed menu system. This button also serves to exit many functions, including menu settings, and playback zoom. A Menu/Exit label will appear in the viewfinder or LCD in that case.
- Viewfinder window. Look into this window to activate the eye-level electronic viewfinder (EVF), an internal OLED (organic LED) display with 2.4 million dots of resolution. It shows 100 percent of the frame at .78X magnification, making it equal or, in many cases, superior to the optical viewfinders found in traditional digital SLR cameras. I actually like it better in some circumstances, such as when shooting in dim light or when the view is quite bright. It's not as

useful for continuous shooting as the camera may not show the previous image rather than a "live" view. You can frame your composition and see the information on the electronic view-finder's display.

While some shooters will use the rear-panel LCD monitor for framing their photos instead of the electronic viewfinder, the latter offers some benefits. On sunny days, when the LCD display is often obliterated by glare, the EVF is definitely preferable. You might also want to use it for reviewing your images and video clips in Playback mode. Holding the camera pressed up against your face helps provide extra steadiness to reduce camera shake (and image blurring) at very slow shutter speeds. (Even the in-body 5-axis SteadyShot stabilization, or the optical SteadyShot included in some lenses, is not a panacea and is more effective when the camera is at least somewhat stable.) Both EVF and LCD monitors can be used with the camera's focus peaking and focus magnification features, which makes it easier to achieve sharp focus manually.

- Eye sensors. These solid-state devices sense when you (or anything else, unfortunately) approach the viewfinder; the camera then triggers a switch that turns off the back-panel LCD, activates the viewfinder screen, and starts the autofocus system. You can enable or disable either of these features, as I'll explain in Chapter 4.
- Eyepiece cup. This soft rubber frame seals out extraneous light when pressing your eye tightly up to the viewfinder, and it also protects your eyeglass lenses (if worn) from scratching. I prefer

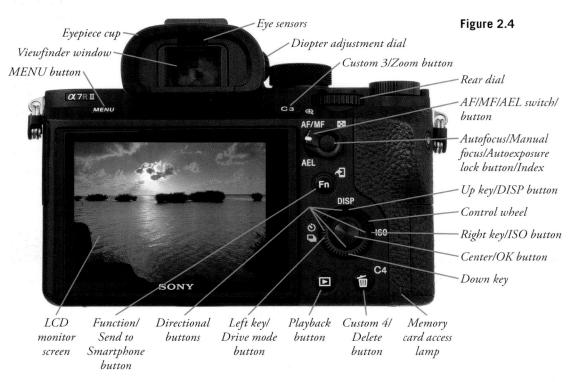

the eyepiece cup that comes with the camera, but if you want a larger one, Hoodman (www.hoodmanusa.com) has introduced a massive version that sells for about \$20.

- **Diopter adjustment dial.** As described in Chapter 1, you can spin this to adjust the built-in diopter correction to suit your vision. Since it's right beside the viewfinder window, it's a bit difficult to change the diopter setting while your eye is at the EVF, but it's worth taking the time to adjust it.
- **AF/MF/AEL switch/button.** Rotate this switch to change the function of the button located in the center of the switch.
 - AF/MF position. With the switch in this position, pressing and holding the button changes the focus method to the opposite method temporarily. If the camera is set for autofocus, holding the button switches to manual focus; if the camera is set for manual focus, holding the button down switches to autofocus and locks the focus. In Chapter 4, I'll show you how to adjust the behavior of this button so it simply toggles between AF and MF, without the need to hold the button down.
 - **AEL position.** Rotating the switch to the AEL position and pressing the button locks exposure. An asterisk appears in the lower-right corner of the LCD or viewfinder to show you exposure has been locked.
 - In Playback mode. When you're reviewing images, the position of the switch doesn't matter; the camera will always "zoom out" the image display. If you've zoomed in on a photo, the button will zoom out to full-frame view, and thence to display the thumbnail Index screen with either 9 or 25 images, followed by a calendar display if you press it another time.
- **Custom 3/Zoom button.** This button has different functions, depending on whether you are taking pictures, or reviewing images in Playback mode.
 - Shooting mode. The default behavior produces the Focus Mode screen, allowing you to select from AF-S, AF-C, Direct Manual Focus, or Manual focus. You can redefine the button to do something else, as I'll explain in Chapter 4.
 - Playback mode. While reviewing pictures, pressing the C3 button activates the zoom feature. You can then rotate the rear dial to zoom in and out of the image, or press the C3 button again to zoom in, and the AF/MF/Index button to zoom out. To exit zooming, press the MENU button.

Note

Many buttons, including C1 and C2 (located on the top surface of the camera) as well as C3 and C4 (on the back panel), can be redefined to some other action, allowing you to tailor the camera's operation so it best suits your needs using the Custom Settings 7 menu. However, keep in mind that customizing your camera's behavior can lead to confusion—both for you and for others you may allow to use the camera.

- Function/Send to Smartphone button. In Shooting mode, press the Fn button to produce a screen with shooting setting options, as seen in Figure 2.5. By default, the 12 functions shown are displayed. However, as I'll describe in Chapter 4, you can choose exactly which functions you'd like to display; you aren't locked into twelve. If you prefer, you can define a single row of six favorite functions, or include some other number/combinations of choices. To adjust any of the functions, just follow these steps.
 - 1. Press the Fn button and use the directional keys to highlight one of the options.
 - 2. When your setting is highlighted:
 - Press the center button to produce an adjustment screen with all the choices shown. You might need to do this as you are learning to use your camera and would like to see all your options arrayed in a vertical column. Then use the directional buttons to select the one you want. If a choice has multiple options, it will be accompanied by a right-pointing or left-pointing arrow. For example, if you choose the self-timer, you can press the left/right buttons to select timer durations of either 5 or 10 seconds.
 - Optionally, you can rotate the control wheel *or* the front dial to cycle among the available choices, which will appear one by one as you spin. Some of the choices have multiple options in this mode as well, which will appear on the screen below the main selections. Rotate the *rear* dial to select one of these.
 - 3. Press the center button to confirm your choice. You'll be returned to the Function menu (press MENU to exit), or will exit the settings entirely.

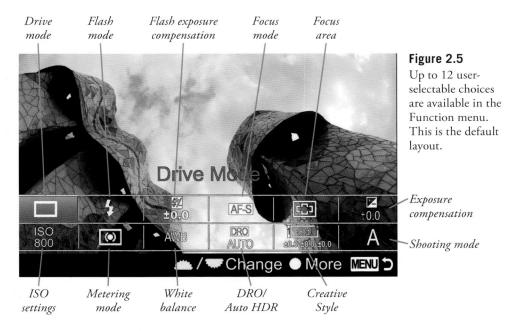

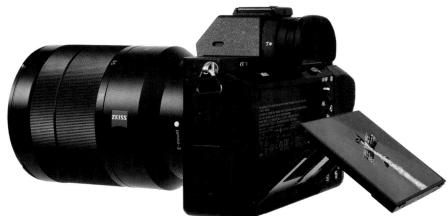

- LCD monitor screen. This swiveling screen can be used to preview images and to view them afterward, and to display/navigate menus. The LCD monitor has 3:2 proportions, which is perfect for previewing/shooting/reviewing stills. When you're shooting movies or using the 16:9 aspect ratio for stills, black bars appear at the top and bottom of the screen.
 - You can set the LCD monitor brightness with an item in the Setup menu, to be discussed in Chapter 6; there's a special feature that provides a super-bright display, useful on bright days when the screen would otherwise be difficult to view. The monitor swivels upward or downward to provide a waist-level view (Figure 2.6) or, by flipping the camera upside down, shoot images in "periscope" mode with the camera held overhead.
- Playback button. Displays the last picture taken. Thereafter, you can move back and forth among the available images by pressing the left/right direction buttons or spinning the control wheel (on the back of the camera) or front dial (on front of the camera) to advance or reverse one image at a time. To quit playback, press this button again. The a7R II/a7 II also exits Playback mode automatically when you press the shutter release button halfway (so you'll never be prevented from taking a picture on the spur of the moment because you happened to be viewing an image).
- Control wheel with directional buttons. This ridged dial, which surrounds the large center button, also has multiple functions, depending on the camera's mode. In both Shooting and Playback modes it can be useful for navigating menu screens to get to the item or option you want to use.

The control wheel performs several important functions and is the only control on the camera that can be activated in two different ways: you can turn the ridged part of the wheel to perform certain actions (such as navigation or setting exposure controls), and you can press on the various edges at top, bottom, left, and right. In that mode the edges serve as directional buttons for navigating through menu screens, for example.

- Playback mode. When an image is magnified in Playback mode, all four buttons can be
 used to move the viewing area around within the magnified image and within the index
 screens during playback. When the image is not magnified, the left/right buttons move to
 the previous/next image on your memory card in Playback mode.
- Shooting mode. When the camera is in Shooting mode, rotating the control wheel itself has no special function; the four directional buttons are used to make adjustments. For example, when the Autofocus Area is set to Flexible Spot, you can use all four of the direction buttons to move the focus bracket to any of its available positions on the screen.

Each direction button also has a default specific purpose that activates when pressed, and that function is labeled on the area outside the wheel itself. You can also redefine any of these keys using the Custom Keys entry in the Custom Settings menu, as described in Chapter 4. Here's a brief summary of their default definitions:

- **Up key/DISP button.** The up key is labeled as DISP, for Display Contents, and it provides display-oriented functions, which vary depending on your Shooting/Playback mode:
 - ▲ **Shooting mode.** When the camera is in Shooting mode, press the DISP button repeatedly to cycle among the three screens that display data in the electronic viewfinder display or the six screens that display information about current settings on the LCD screen.
 - The default display for the LCD is called Display All Info. This provides a full information display with a great deal of data overlaid over the live preview to show the settings in effect. The data provided when the camera is in a SCN mode or either Auto mode is quite limited; use P, A, S, or M mode to view all of the available data in each display option. Not all the information shown in the figure will be displayed at all times.
 - When you keep pressing the DISP button, the camera LCD cycles through other viewing modes, including No Display Info, which actually provides a few bits of data, a Graphic Display that shows the shutter speed and aperture on two related scales along with some recording information, and a basic display with a histogram in the bottom right of the screen. There is also a For Viewfinder/Quick Navi text information screen that omits the thumbnail and shows only shooting information. When you press the Fn button when the For Viewfinder screen is visible, you can then select and change settings, as I'll describe shortly. You can enable/disable each of these information displays using the DISP entry within the Custom menu, as I'll explain in Chapter 4.
 - ▲ Playback mode. In Playback mode, the DISP button offers different display options, as you would expect. When viewing still images during playback, press the DISP button to cycle among the three available playback screens: full recording data, histogram with recording data, and no recording data. When displaying a movie on the screen, the DISP button produces only two screens: with or without recording information. There is no histogram display available.
- **Down key.** By default, the down key has no special function, but you can define one of your choices using the Custom Keys entry in the Custom Settings menu, as described in Chapter 4.

- Left key/Drive mode button. One press of this button in a compatible Shooting mode leads to a series of options that let you set the self-timer, enable the camera to shoot one frame at a time or continuously at a fast or very fast rate, or set up exposure bracketing. The latter causes the camera to automatically take a series of shots, varying the exposure for each to ensure you get the best exposure possible.
 - When you scroll to the Self-timer or Bracket item, you can press the right key to adjust options for those drive modes, as discussed in Chapter 5.
- **Right key/ISO button.** When not helping you navigate to the right through menus and other screens, this button lets you activate the ISO screen in a compatible Shooting mode. You can then scroll up/down among the options by rotating the camera's rear dial or control wheel or by pressing the wheel's direction buttons.
- Center/OK button. The center button functions as the selection button; press it to select or confirm a choice from a menu screen.
- Custom 4/Delete button. This button has no default behavior in Shooting mode (although you can specify one using the Custom Keys feature). In Playback mode, the button serves as a delete key.
- Memory card access lamp. Flashes red while the memory card is being written to. It is located near the battery/memory card cover door on the underside of the camera that you must open before removing a memory card, so you should notice its red glow *before* you make the mistake of changing cards before the current image(s) are saved.

LCD Panel Data Displays

The Sony a7R II/a7 II provides a tilting and expansive 3-inch color LCD with high resolution to display everything you need to see, from images to a collection of informational data displays. Some of the data is shown only when you are viewing the Display All Info screen, but even then, not every item of data will be available all the time. (See Figure 2.7.) As discussed earlier, the electronic view-finder display options provide much less data in order to avoid cluttering the live preview with numerals and icons during serious photography.

Here's a description of the most important information that the camera can display in the LCD in Display All Info when it's set for P, A, S, or M mode; less data is available in other display modes and when other Shooting modes are being used. The For Viewfinder/Quick Navi text-only displays (shown only on the LCD monitor and not in the viewfinder) are pictured in Figures 2.8 and 2.9.

- **Shooting mode.** Shows whether you're using Program Auto, Aperture Priority, Shutter Priority, Manual, Panorama, one of the scene modes, or one of the two Auto modes.
- Memory card/Uploading status. Indicates whether a memory card is in the camera. (If you remove the card, a blinking NO CARD indicator will appear instead.) If the camera is connected using Wi-Fi, the indicator will display icons representing the upload status.

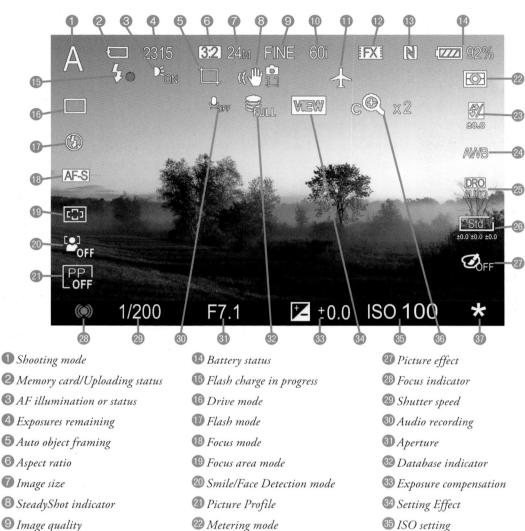

Trame rate

Airplane mode

12 Movie recording setting

13 NFC active indicator

2 Metering mode

23 Flash exposure compensation

36 Zoom

3 AE Lock

2 White balance

25 Dynamic range optimizer/HDR

26 Creative Style

Figure 2.7 The Display All Info screen on the LCD.

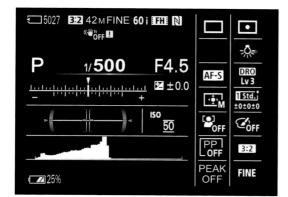

Figure 2.8 The For Viewfinder/Quick Navi information screen is available only for the LCD monitor and is not shown in the viewfinder.

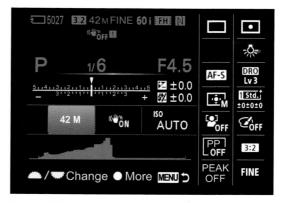

Figure 2.9 The Quick Navi screen allows changing settings.

- Exposures remaining. Shows the approximate number of shots available to be taken on the memory card, assuming current conditions, such as image size and quality. When shooting a movie, the recordable time remaining is shown instead.
- Aspect ratio/Image size. Shows whether the camera is set for the 3:2 aspect ratio or wide-screen 16:9 aspect ratio (the image size icon changes to a "stretched" version when the aspect ratio is set to 16:9) and whether you're shooting Large, Medium, or Small resolution images. When the camera is set to the 16:9 aspect ratio, the display has black bands at the top and the bottom, as you would expect with the longer/narrower format vs. the 3:2 aspect ratio which is closer to square in shape.
- Image quality. Your image quality setting (JPEG Extra Fine, JPEG Fine, JPEG Standard, RAW, or RAW & JPEG) is displayed.
- Frame rate/Movie recording setting. These icons show what movie settings are in use such as 60i FH (full HD video at 60i). I'll discuss your movie-making options, including file formats and size, in Chapter 10.
- NFC active indicator. Shows when your a7R II/a7 II is linked to another device using Near Field Communications.
- Battery status. The remaining battery life (in percent) is indicated by this icon.
- **Metering mode.** The icons represent Multi, Center, or Spot metering. (See Chapter 9 for more detail.)
- Flash exposure compensation. This icon is shown whenever an external flash is active to indicate the level of flash exposure compensation, if any, that you have set.
- White balance. Shows current white balance setting. The choices are Auto White Balance, Daylight, Shade, Cloudy, Incandescent, Fluorescent, Flash, Color Temperature, and Custom. I'll discuss white balance settings and adjustments in Chapter 4.

- Dynamic Range Optimizer/HDR. Indicates the type of dynamic range optimization (highlight/shadow detail enhancement) in use: Off, Auto DRO, levels 1–5 of DRO, or the special Auto HDR feature, all described in Chapter 9.
- Creative Style. Indicates which of the six Creative Style settings (Standard, Vivid, Portrait, Landscape, Sunset, or Black-and-White) is being applied.
- Picture effect. Shows which of the special effects, such as Toy Camera, Pop Color, or Posterization, is being applied. I'll explain these options in Chapter 3.
- SteadyShot indicator. Provides information as to whether the image stabilizer is On or Off if you're using a lens with the SteadyShot mechanism, and warns you that the shutter speed will be too long for the stabilizer to fully compensate for camera shake.
- Flash charge in progress. This lightning bolt icon appears on the screen when the flash unit is active; a solid orange dot beside it indicates the flash has recycled (charged) and is ready to fire.
- **AF illuminator status.** This icon appears when conditions are dark enough that the AF illuminator will be needed in order to light up the area so that the autofocus system can operate properly.
- Flash mode. Provides flash mode information when an external flash is active. The possible choices are Flash Off, Autoflash, Fill Flash, Slow Sync, Rear Curtain, and Wireless. Not all of these choices are available at all times. I'll discuss flash options in more detail in Chapter 13.
- **Drive mode.** Shows whether the camera is set for Single-shot, Continuous shooting, Speed Priority Continuous shooting, Self-timer, Self-timer with continuous shooting, or Exposure bracketing. There is one additional option available: Remote Commander, which sets up the camera to be controlled by an infrared remote control.
- **AE Lock.** Appears when autoexposure has been locked at the current setting.
- **ISO setting.** Indicates the sensor ISO sensitivity currently set, either Auto ISO or a numerical value. I'll discuss this camera feature in Chapter 9.
- **Exposure compensation.** This indicator shows the amount of exposure compensation, if any, currently set.
- **Aperture.** Displays the current f/stop set by the camera or, in Manual or Aperture Priority mode, as set by the user. If you're viewing the Graphic display, icons indicate that wider apertures produce less depth-of-field (a "blurry" background) while smaller apertures provide a greater range of acceptable sharpness (increasing the odds of a more distinct background).
- **Shutter speed.** Shows the current shutter speed, either as set by the camera's autoexposure system or, in Manual or Shutter Priority mode, as set by the user. If the camera's Graphic display is used, the screen illustrates that faster shutter speeds are better for action and slower speeds are fine for scenes with less movement.
- Focus indicator. Flashes while focus is underway, and turns a solid green when focus is confirmed.

- Focus mode. Shows the currently selected focus mode, such as AF-S, AF-C, DMF (Direct Manual Focus), or MF (Manual Focus), as explained in Chapter 9.
- Focus area mode. Displays the active focus area mode, such as Wide, Zone, Center, or Flexible Spot, as explained in Chapter 9.
- Smile/Face Detection mode. Shows status of Smile or Face Detection modes. When these features are activated, the camera attempts to detect faces in the scene before it, and, if it does, it adjusts autofocus, exposure, and white balance accordingly. When the Face Registration feature is also in use, and if the camera has detected a face that you have registered as a favorite, the icon will differ slightly from the Face Detection icon. Smile Shutter looks for smiles and automatically takes a picture. I'll discuss these features in Chapter 9.
- Picture Profile. If you've specified a picture profile image customization setting in the Camera Setting 6 menu, your choice (from PP1 to PP7) is indicated here. I discus picture profiles in Chapter 3.
- **Auto object framing.** This icon indicates whether this camera feature is currently in use; if it's On, the camera will automatically crop a photo of a person for a more pleasing composition.
- **Zoom.** Shows when digital zoom modes are active.
- **Setting Effect.** Indicates whether the LCD shows the effects of any adjustments, including exposure, white balance, or Picture Effects in Shooting mode.
- **Database indicator.** This warning appears when your memory card's image database is full or has errors.
- Audio recording. Shows whether sound recording is enabled/disabled for movie shooting.
- Airplane mode. Appears when Airplane mode has disabled Wi-Fi and NFC communications.

Some of the same items of data are also available when other display options are selected with the DISP button, as discussed earlier in this chapter. When the Graphic Display option is used, the camera provides an illustration of the value of a small or wide aperture, and a fast or slow shutter speed, as discussed in the previous section.

Using the Quick Navi Function Menu

If you select the Quick Navi screen by pressing the DISP button until it appears, the LCD monitor shows the For Viewfinder/Quick Navi display, with only the data and no live view of the scene, as you can see in Figure 2.8. When the Quick Navi screen is shown, you can use the left/right/up/down directional buttons to highlight any of the settings that are not grayed out. (See Figure 2.9.)

Once an option is highlighted, you can rotate the control wheel to change its settings quickly, or press the OK button to produce a screen with all the options. Use directional buttons and the OK button to select the option you want. The Quick Navi screen is, in effect, a more fully featured Function menu. When the Quick Navi display is visible on the LCD monitor, you must compose images using the electronic viewfinder.

Going Topside

The top surface of the a7R II/a7 II has several frequently accessed controls of its own. They are labeled in Figure 2.10:

- Sensor focal plane. Precision macro and scientific photography sometimes requires knowing exactly where the focal plane of the sensor is. The symbol etched on the top of the camera marks that plane.
- Multi-interface shoe. This "standard" accessory shoe is used for electronic flash units, and contains extra electrical contacts for use with Sony-brand microphones, such as the Sony ECM-XYSTM1 microphone and other accessories. However, it is also compatible with the ISO-518 hot shoe used by virtually all other camera manufacturers.

The multi-interface shoe replaces the non-standard Minolta-style proprietary "iISO" shoe used by Sony for many of its cameras until about 2012. The older shoe required adapters to use non-Sony accessories. The new multi-interface connector can still be used with older Sony flash units and accessories, but requires an adapter of its own for backward compatibility. If you own no older Sony electronic flash or accessories, you can simply move forward and purchase gear for the new, more standard hot shoe.

- **Stereo microphones.** A pair of microphones on the top panel of the camera can capture stereophonic audio while making movies.
- **Speaker.** Sounds emanating from your camera emerge here.

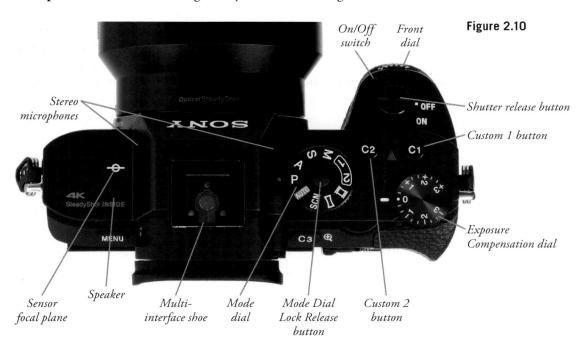

- Mode dial/Mode Dial Lock Release button. Press the center Lock Release button (which is found on the a7R II only) and rotate this dial to select Shooting modes including Manual exposure, Shutter Priority, Aperture Priority, Program Auto, Auto (either Superior Auto or Intelligent Auto, as you specify in the Auto Mode setting of the Camera Settings 7 menu), scene modes, Panorama, Movie mode, and the Memory Recall positions, numbered 1 and 2 (which allow you to choose from up to four predefined groups of settings).
- Exposure Compensation dial. Rotate this dial to add or subtract up to three stops' worth of exposure.
- Front dial. Don't confuse this with the rear dial or control wheel on the back of the camera. It's used, often in conjunction with the rear dial, to provide additional options. For example, in Manual exposure mode, by default the front dial adjusts the aperture, while the rear dial sets the shutter speed.
- On/Off switch. Rotate to the right to turn the camera on; to the left to switch it off.
- Shutter release button. Partially depress this button to lock in exposure and focus. Press it all the way to take the picture. Hold this button down to take a continuous stream of images when the drive mode is set for Continuous shooting. Tapping the shutter release when the camera's power save feature has turned off the autoexposure and autofocus mechanisms reactivates both. When a review image or menu screen is displayed on the LCD, tapping this button removes that display, returning the camera to the standard view and reactivating the autoexposure and autofocus mechanisms.
- Custom 1 button. By default, this summons the white balance menu. The Custom 1 button can also be re-defined to perform any of several different functions, such as metering mode, creative style, drive mode, focus mode, flash mode, flash compensation, focus area, exposure compensation, and more than 50 (count 'em!) other behaviors. You can also select Not Set to deactivate it entirely. In Chapter 4, I'll show you how to redefine this button in the Custom Key Settings entry of the Custom Settings menu.
- Custom 2 button. By default, this button activates focus settings (described in more detail in Chapter 8):
 - In Autofocus or Direct Manual focus, turn the front dial to move the focus frame up or down, and the rear dial to move it left/right. The control wheel chooses the type of focus area (wide, zone, center, or flexible spot).
 - In Manual focus mode, the front dial moves the area to be magnified up or down; the rear dial or control wheel moves the magnified area left/right.

The Custom 2 button can also be re-defined to perform any of several different functions, such as drive mode, focus mode, flash mode, flash compensation, focus area, exposure compensation, and more than 50 other behaviors. As with the other Custom buttons, you can also select Not Set to deactivate it entirely.

Underneath Your Sony a7R II/a7 II

The bottom panel of your a7R II/a7 II has only a few components, illustrated in Figure 2.11.

- **Tripod socket**. Attach the camera to a vertical grip, flash bracket, tripod, monopod, or other support using this standard receptacle. The socket is positioned roughly behind the optical center of the lens, a decent location when using a tripod with a pan (side rotating) movement, compared to an off-center orientation. For most accurate panning, the socket would ideally be placed a little forward (actually in *front* of the camera body) so the pivot point is located *under* the optical center of the lens, but you can't have everything. There are special attachments you can use to accomplish this if you like.
- Battery compartment door. Slide the door open to access the battery. This door can be removed when you attach an optional battery grip, as described in Chapter 14.
- Connection plate cover. When using the Sony AC-PW20 AC adapter, the connection plate replaces the battery in the camera body, and the cord passes through the opening protected by this cover.

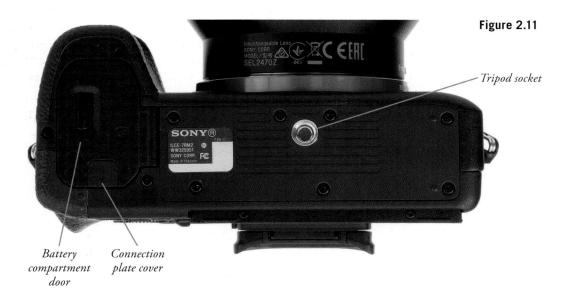

Camera Settings Menu

The a7 II—series cameras have a remarkable number of features and options you can use to customize the way your camera operates. Not only can you change settings used at the time the picture is taken, but you can adjust the way your camera behaves. This chapter and the next three will help you sort out the settings for all of the menus. These include the Camera Settings, Custom Settings, Wireless, Application, Playback, and Setup menus. This chapter details options with the Camera Settings menu; the Custom Settings menu will be covered in Chapter 4; the Wireless and Application menus in Chapter 5; and the Playback and Setup menus will be addressed in Chapter 6.

Why four entire chapters just on the menus, when other sources may have just a single chapter with a line or two about each menu entry explaining what they do? As you're discovering, the a7R II and a7 II are incredibly versatile cameras with up to 150 different menu entries, many of which have submenus and multiple options. Even if you're a Sony veteran or an advanced photo enthusiast, you want more than just a brief explanation of what all the menu options do. You also need to know what they *don't* do, *when* to use each one, and, most importantly, when *not* to use them.

And, I'll bet, you purchased this book because you also wanted to know *my* personal preferences for settings and how I use these features. When I share what I know in person at workshops and other sessions with groups of photographers, I always tell them my informal motto: *I make terrible mistakes, so you don't have to!* I like to push cameras to their limits and, in the process, discover exactly what they can do, and what they can't.

So, like most of the rest of this book, Chapters 3 to 6 will cover both aspects in some detail. I'm not going to waste a lot of space on some of the more obvious menu choices in these chapters, especially those with only On/Off or Enable/Disable options. Instead, I'll concentrate on the more complex aspects of setup, such as autofocus. I'll start with an overview of using the camera's menus themselves.

Anatomy of the Menus

The menu system is quite easy to navigate. Press the MENU button and a Tile menu with icons for each of the six main menu headings may appear. (See Figure 3.1.) That screen is essentially useless, as the only thing you can do with it is move to the conventional menu system. If it appears, I recommend you immediately eliminate the extra step, using the Setup 2 menu's Tile Menu setting to disable it, described in Chapter 6.

Thereafter, pressing the MENU button takes you without further ado directly to a screen similar to the one shown in Figure 3.2. Rotate the rear dial to move from one main menu or tab to the next. When a tab is active, the currently selected menu tab will be highlighted in black, as you can see in the figure, and the other tabs given a gray background. Press the down button or rotate the front dial or the control wheel to move the highlighting down into the selected tab to the entry you want to work with. You can choose any item in the displayed tab, and press the center button to produce a screen where you can adjust the highlighted entry. While navigating any menu tab, use the left/right keys or control wheel to move to the next tab in that menu group, and then to wrap around to the first tab in the next group.

A7R II/A7 II MENU DIFFERENCES

While I am providing menu screen shots and tab numbers throughout this book, the a7R II is used as an example in every case. Menu entries for the a7 II may appear on different tab numbers. If you have the a7 II, you may have to scroll to the next tab to find a particular entry. Sony's manuals don't provide any tab numbers at all, which is much more inconvenient. My approach seemed a better compromise than using clumsy instructions like "navigate to the Custom Settings 6 menu (Custom Settings 7 menu on the a7 II).

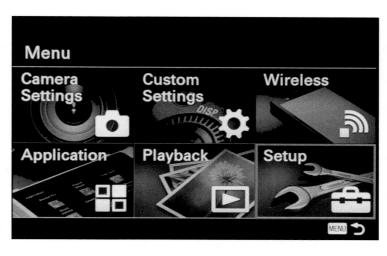

Figure 3.1
Pressing the MENU button by default reveals the Tile menu, which displays icons representing the six menu categories.

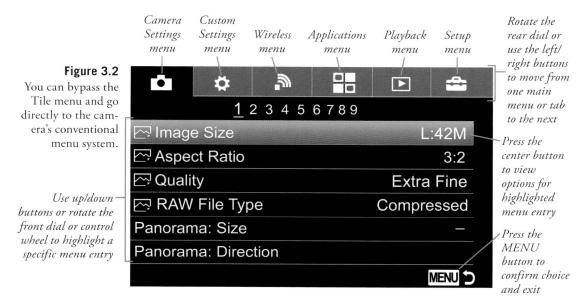

For example, if you're using the Camera Settings menu, the right key will take you from Camera Settings 1 to Camera Settings 2, and thence onward. Note that each of the main tabs may have several sub tabs: the Wireless and Playback menus have two, numbered 1 and 2, while the Application menu has just one. The advantage to having so many menu tabs is that the entries for a given page can be shown on a single screen.

Of course, not everything has to be set using these menus. The a7 II series has some convenient direct setting controls, such as the buttons of the control wheel that provide quick access to the drive modes, display information, and the ISO options. These and other buttons can be assigned other direct-access functions—more than 50 different functions in all. These control features allow you to bypass the multi-tabbed menus for many of the most commonly used camera functions.

There is also a Function menu that appears when you press the Fn button, with a set of shooting setting options. Although the Fn menu has a default set of 12 functions, you can redefine those entries as well. Your a7R II/a7 II offers a remarkable degree of customization.

At times you will notice that some lines on various menu screens are "grayed out;" you cannot select them given the current camera settings. For example, if you decide to shoot a panorama photo, you may find that the Panorama: Size and Panorama: Direction choices are grayed out. Want to know why? Scroll to the grayed out item and press the center button. The camera then displays a screen that explains why this feature is not available: because the feature is not available when Shutter Priority shoot mode is active, in this example. Unfortunately, that's not very helpful. The screen *should* have instead told you that the Panorama settings are not available when the Shoot mode is anything *other* than Sweep Panorama. Given the incomplete information (and lacking this book), you might have spent several frustrating minutes switching to other shooting modes, still to find that no Panorama settings are possible. Thanks, Sony!

ABOUT THOSE ICONS

Menu entries are preceded by an icon, such as the "mountain" icon shown next to the Image Size, Aspect Ratio, and Quality entries in Figure 3.2. A mountain icon indicates that the particular menu entry applies *only* to still photography; an icon resembling a film frame shows that the menu entry applies *only* to movie making. Presumably, entries without any icon can be used with both. The Enlarge entry in the Playback menu, and Language entry in the Setup menu are preceded by magnifying glass and text icons, respectively, and are apparently used just for decorative purposes.

Camera Settings Menu

Figure 3.2, earlier, shows the first screen of the Camera Settings menu. As you can see, at most only a half dozen items are displayed at one time. The items found in this menu include:

- Image Size
- Aspect Ratio
- Quality
- RAW File Type (May require firmware update.)
- Panorama: Size
- Panorama: Direction
- File Format (Movies)
- Record Setting (Movies)
- Dual Video REC
- Drive Mode
- Bracket Settings (a7R II only)
- Flash Mode
- Flash Compensation
- Red Eye Reduction
- Focus Mode
- Focus Area
- Focus Settings

- AF Illuminator (Stills)
- AF Drive Speed (Movies) (a7R II only)
- AF Track Sensitivity (Movies) (a7R II only)
- Exposure Compensation
- Exposure Step
- ISO
- ISO Auto Minimum Shutter Speed (a7R II only)
- Metering Mode
- White Balance
- DRO/Auto HDR
- Creative Style
- Picture Effect
- Picture Profile
- Zoom
- Focus Magnifier
- Long Exposure Noise Reduction

- High ISO Noise Reduction
- Center Lock-on AF
- Smile/Face Detection
- Soft Skin Effect
- Auto Object Framing
- Auto Mode
- Scene Selection
- Movie
- SteadyShot
- SteadyShot Settings
- Color Space
- Auto Slow Shutter
- Audio Recording
- Audio Rec Level
- Audio Out Timing
- Wind Noise Reduction
- Memory Recall
- Memory

Image Size

Options: L, M, S

Default: L

My preference: L

Here you can choose between the a7R II/a7 II's Large, Medium, and Small settings for JPEG still pictures. The larger the size that's selected, the higher the resolution: the images are composed of more megapixels. (If you select RAW or RAW & JPEG for Quality [described shortly], you'll find that the Image Size option is grayed out, because the camera will always shoot large photos.)

As you scroll among the options, you'll note that the size for Large, Medium, and Small is shown in megapixels, as shown for the a7R II in Table 3.1. The number of pixels will vary, depending on the *aspect ratio* you've chosen. For example, with the a7R II, you'll get 42 MP in Large mode using the 3:2 aspect ratio, and 36 MP in Large mode using the 16:9 aspect ratio. If you are using the cropped APS-C/Super 35mm mode with the a7R II, the image is cropped, giving you an 18 MP Large image at 3:2 aspect ratio, or a 15 MP image with the 16:9 aspect ratio. The a7 II's resolutions at various sizes and with/without the APS-C/Super 35mm crop are shown in Table 3.2.

Scroll to this Image Size menu item, press the center button, and scroll to the desired option: L, M, or S. Then press the center button to confirm your choice. As I noted, the actual size of the images depends on the aspect ratio you have chosen in the subsequent menu item (discussed below), either the standard 3:2 or the wide-screen 16:9 format. Additional image sizes result when you are using Sweep Panorama, which I'll explain later in this chapter.

Table 3.1 Image Sizes Available—a7R II						
Image Size	Megapixels 3:2 Aspect Ratio	Resolution 3:2 Aspect Ratio	Megapixels 16:9 Aspect Ratio	Resolution 16:9 Aspect Ratio		
a7R II Full Frame						
Large (L)	42 MP	7952 × 5304 pixels	36 MP	7952 × 4472 pixels		
Medium (M)	18 MP	5168 × 3448 pixels	15 MP	5168 × 2912 pixels		
Small (S)	11 MP	3984×2656 pixels	8.9 MP	3984 × 2240 pixels		
a7R II APS-C				e		
Large (L)	18 MP	5168 × 3448 pixels	15 MP	5168 × 2912 pixels		
Medium (M)	11 MP	3984 × 2656 pixels	9 MP	3984 × 2240 pixels		
Small (S)	4.5 MP	2592 × 1728 pixels	3.8 MP	2592 × 1456 pixels		

Table 3.2 Image Sizes Available—a7 II						
Image Size	Megapixels 3:2 Aspect Ratio	Resolution 3:2 Aspect Ratio	Megapixels 16:9 Aspect Ratio	Resolution 16:9 Aspect Ratio		
a7 II Full Frame						
Large (L)	24 MP	6000×4000 pixels	20 MP	6000 × 3376 pixels		
Medium (M)	10 MP	3936 × 2624 pixels	8.7	3936 × 2216 pixels		
Small (S)	6 MP	3008×2000 pixels	5.1 MP	3008 × 1688 pixels		
a7 II APS-C						
Large (L)	10 MP	3936 × 2624 pixels	8.7 MP	3936 × 2216 pixels		
Medium (M)	6 MP	3008 × 2000 pixels	5.1 MP	3008 × 1688 pixels		
Small (S)	2.6 MP	1968 × 1312 pixels	2.2 MP	1968 × 1112 pixels		

There are few reasons to use a size other than Large with this camera, even if reduced resolution is sufficient for your application, such as photo ID cards or web display. Starting with a full-size image gives you greater freedom for cropping and fixing problems with your image editor. An 800×600 –pixel web image created from a full-resolution (large) original often ends up better than one that started out as a small JPEG.

Of course, the Medium and Small settings make it possible to squeeze more pictures onto your memory card. Indeed, the a7R II and a7 II images at medium resolution still amount to 18 MP and 10 MP, respectively, and that's nothing to sneeze at; both approach the *maximum* of some very fine dSLR cameras that were available a few years ago. The smaller image sizes might come in handy in situations where your memory cards are almost full and/or you don't have the opportunity to offload the pictures you've taken to your computer. For example, if you're on vacation and plan to make only 4×6 —inch snapshot prints of the photos you shoot, setting a lower resolution will stretch your memory card's capacity. Even then, it makes more sense to simply buy and carry memory cards with higher capacity and use your a7 II—series camera at its maximum resolution.

Aspect Ratio

Options: 3:2, 16:9 aspect ratios

Default: 3:2

My preference: 3.2; you can always crop to 16:9 in your image editor

The aspect ratio is simply the proportions of your image as stored in your image file. The standard aspect ratio for digital photography is approximately 3:2; the image is two-thirds as tall as it is wide, as shown by the outer green rectangle in Figure 3.3. These proportions conform to those of the most common snapshot size in the USA, 4×6 inches. Of course, if you want to make a standard

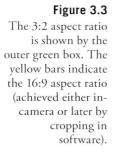

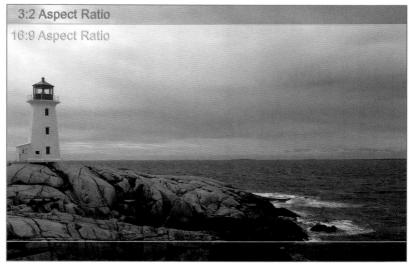

 8×10 —inch enlargement, you'll need to trim some of the length of the image area since this format is closer to square; you (or a lab) would need 8×12 —inch paper to print the full image area. The 3:2 aspect ratio was also the norm in photography with 35mm film.

If you're looking for images that will "fit" a wide-screen computer display or a high-definition television screen, you can use this menu item to switch to a 16:9 aspect ratio, which is much wider than it is tall. The camera performs this magic by cutting off the top and bottom of the frame (as illustrated by the yellow boundaries in Figure 3.3), and storing a reduced resolution image (as shown in Table 3.1). Your 42/24 MP image (on the a7R II, and a7 II, respectively) becomes a 36 MP and 20 MP shot if you set the camera to shoot in 16:9 aspect ratio instead of using the default 3:2 option. If you need the wide-screen look, this menu option will save you some time in image editing, but you can achieve the same proportions (or any other aspect ratio) by trimming a full-resolution image with your software. The 16:9 option is most useful if you plan to take a *lot* of photos that will work best in that format.

Quality

Options: RAW, RAW & JPEG, Extra Fine, Fine, Standard

Default: Fine

My preference: Extra Fine

This menu item lets you choose the image quality settings that will be used by the a7R II/a7 II to store its still photo files. You have five options: RAW, RAW & JPEG, Extra Fine, Fine, and Standard. In truth, RAW is a file format and not a quality specification at all, but nearly all cameras include this option in the Quality section of their menus. (The Extra Fine, Fine, and Standard options are relevant only to JPEGs.)

Here's what you need to know to choose intelligently:

- JPEG compression. To reduce the size of your image files and allow more photos to be stored on a given memory card, the camera's processor uses JPEG compression to squeeze the images down to a smaller size. This compacting reduces the image quality a little, so you're offered your choice of Extra Fine, Fine, and Standard compression. Standard compression is quite aggressive; the camera discards a lot of data. While Fine is, well, just fine, you'll find that Extra Fine provides even better results so it should really be your *standard* when shooting JPEG photos.
- JPEG, RAW, or both. You can elect to store only JPEG versions of the images you shoot (Extra Fine, Fine, or Standard), or you can save your photos as "unprocessed" RAW files, which consume several times as much space on your memory card. Or, you can store both file types at once as you shoot. The JPEG will then be Large/Fine; the camera provides no options for modifying JPEG size or quality in the RAW & JPEG option.

Many photographers elect to shoot *both* a JPEG and a RAW file (RAW & JPEG), so they'll have a JPEG version that might be usable as-is, as well as the original "digital negative" RAW file in case they will later want to make some serious editing of the photo with imaging software for reasons discussed shortly. If you use the RAW & JPEG option, the camera will save two different versions of the same file to the memory card: one with a .JPG extension, and one with the .ARW extension that signifies Sony's proprietary RAW format that consists of raw data.

As I noted under Image Size, there are some limited advantages to using the Medium and Small resolution settings, and similar space-saving benefits accrue to the Standard JPEG compression setting. All of these options help stretch the capacity of your memory card so you can shoehorn quite a few more pictures onto a single card. That can be useful when you're away from home and are running out of storage, or when you're shooting non-critical work that doesn't require full resolution (such as photos taken for real estate listings, web page display, photo ID cards, or similar applications).

But for most work, using lower resolution and extra compression is false economy. You never know when you might actually need that extra bit of picture detail. Your best bet is to have enough memory cards to handle all the shooting you want to do until you have the chance to transfer your photos to your computer or a personal storage device.

JPEG vs. RAW

You'll sometimes be told that RAW files are the "unprocessed" image information your camera produces, before it's been modified. That's nonsense. RAW files are no more unprocessed than your camera film is after it's been through the chemicals to produce a negative or transparency. A lot can happen in the developer that can affect the quality of a film image—positively and negatively—and, similarly, your digital image undergoes a significant amount of processing before it is saved as a RAW file. Sony even applies a name (BIONZ X) to the digital image processor used to perform this magic in Sony cameras.

A RAW file is closer in concept to a film camera's processed negative. It contains all the information, with no compression, no sharpening, no application of any special filters or other settings you might have specified when you took the picture. Those settings are stored with the RAW file so they can be applied when the image is converted to JPEG, TIF, or another format compatible with your favorite image editor. However, using RAW converter software such as Adobe Camera Raw (in Photoshop, Elements, or Lightroom) or Sony's Image Data Converter (available for download from various Sony websites worldwide), you can override a RAW photo's settings (such as White Balance and Saturation) by applying other settings in the software. You can make essentially the same changes there that you might have specified in your camera before taking a photo.

Making changes to settings such as White Balance is a non-destructive process in a RAW converter since the changes are made before the photo is fully processed by the software program. Making a change in settings does not affect image quality, except for changes to exposure, highlight or shadow detail, and saturation; the loss of quality is minimal however, unless the changes you make for these aspects are significant.

The RAW format exists because sometimes we want to have access to all the information captured by the camera, before the camera's internal logic has processed it and converted the image to a standard file format. Oddly enough, though, all the cameras in the a7 II series initially used a RAW format that actually *discarded* some of the camera information before storing the information on the memory card.

COMPRESSED VS. UNCOMPRESSED RAW

Techie Alert: Until firmware updates issued in October and November 2015, even the latest a7 II–series cameras used a non-optional *lossy* two-step compression scheme when storing RAW files. The camera's Bionz digital image processing chip begins with the captured image file, which in all but a few cases contain 14-bits of information, and squeezes it down to fit into an 11-bit "space," discarding a small amount of useful information and reducing the dynamic range (the range of tones that can be captured). The second stage of RAW compression divides the image up into 16-pixel stripes for each color channel, and then stores only the brightest and darkest value in each stripe, rather than individual values for every pixel. Unless all the pixels in a stripe have more or less the same values, this step can discard additional information. Ordinarily, you won't notice this loss when processing the photo in your image editor, but it can be problematic when working with high-contrast edges.

With the Firmware 2.00 update, an optional uncompressed RAW format is available that eliminates the compressed version's information loss. That's good news for the minority of shooters who found the lossy compression unacceptable. Oddly enough, though, the 14-bit captures are still stored as two eight-bit bytes—16 bits—which makes the files about 14 percent larger than theoretically possible.

Note that in some modes, such as bracketing, bulb exposures, and continuous shooting, the cameras still use 12-bit capture and its lossy two-stage compression scheme.

A RAW photo does take up more space than a JPEG and, in uncompressed mode, preserves all the information captured by your camera after it's been converted from analog to digital form. Since we can make changes to settings after the fact while retaining optimal image quality, errors in the settings we made in-camera are much less of a concern than in JPEG capture. When you shoot JPEGs, any modification you make in software is a destructive process; there is always some loss of image quality, although that can be minimal if you make only small changes or are skilled with the use of adjustment layers.

JPEG provides smaller files by compressing the information in a way that loses some image data. The lost data is reconstructed when you open a JPEG in a computer, but this is not a perfect process. If you shoot JPEGs at the highest quality (Extra Fine) level, compression (and loss of data) are minimal; you might not be able to tell the difference between a photo made with RAW capture and a Large/Fine JPEG. If you use the lower quality level, you'll usually notice a quality loss when making big enlargements or after cropping your image extensively.

So, why don't we always use RAW? Although some photographers do save only in RAW format, it's more common to use either RAW plus the JPEG option or to just shoot JPEG and eschew RAW altogether. While RAW is overwhelmingly helpful when an image needs to be modified, working with a RAW file can slow you down significantly. The RAW images take longer to store on the memory card so you cannot shoot as many in a single burst. Also, after you shoot a series, the camera must pause to write them to the memory card so you may not be able to take any shots for a while (or only one or two at a time) until the RAW files have been written to the memory card. When you come home from a trip with numerous RAW files, you'll find they require more post-processing time and effort in the RAW converter, whether you elect to go with the default settings in force when the picture was taken or make minor adjustments.

Those who often shoot long series of photos in one session, or want to spend less time at a computer, may prefer JPEG over RAW. Wedding photographers, for example, might expose several thousand photos during a bridal affair and offer hundreds to clients as electronic proofs on a DVD disc. Wedding shooters take the time to make sure that their in-camera settings are correct, minimizing the need to post-process photos after the event. Given that their JPEGs are so good, there is little need for them to get bogged down working with RAW files in a computer. Sports photographers also avoid RAW files because of the extra time required for the camera to record a series of shots to a memory card and because they don't want to spend hours in extra post-processing. As a bonus, JPEG files consume a lot loss memory in a hard drive.

My recommendation: As I mentioned earlier, when shooting sports, I'll switch to shooting Large/ Extra Fine JPEGs (with no RAW file) to minimize the time it takes for the camera to write a series of photos to the card; it's great to be able to take another burst of photos at any time, with little or no delay. I also appreciate the fact that I won't need to wade through long series of photos taken in RAW format.

In most situations however, I shoot virtually everything as RAW & JPEG. Most of the time, I'm not concerned about filling up my memory cards, as I usually carry at least three 128GB memory

cards with me. If I know I may fill up all those cards (say, on a long trip), I'll also carry a notebook computer and an external 2 terabyte hard drive to back up my files.

RAW File Type

Options: Compressed, Uncompressed

Default: Compressed

My preference: Uncompressed

This option, introduced through a firmware update (V. 2.00) in October 2015, allows selecting either 12-bit compressed RAW format, or 14-bit uncompressed RAW, as described above. I tend to favor the 14-bit uncompressed mode in order to avoid the artifacts that can appear in 12-bit compressed images. In practice, however, it's unlikely you'll notice the difference, and you may want to use the compressed format to save a small amount of storage space. If you do not see this option in your menu, you need to upgrade to firmware version 2.00 or later.

Panorama: Size

Options: Standard, Wide

Default: Standard

My preference: Wide! If you're shooting panoramas, go for it.

This item is available only when the shooting mode is set to Sweep Panorama mode (usually abbreviated as Panorama). This item offers only two options: the default Standard and the optional Wide, which can produce a longer/taller panorama photo.

With the Standard setting, if you are shooting a horizontal panorama, the size of your images will be 8192×1856 pixels. If your Standard panorama photos are vertical, the size will be 3872×2160 pixels. (The options for panorama direction are covered in the next section.) If you activate the Wide option instead, horizontal panoramas will be at a size of 12416×1856 pixels, and vertical panoramas will be 5536×2160 pixels. Of course, vertically panned panorama photos are actually "tall" rather than wide regardless of the option you select.

Panorama: Direction

Options: Right, Left, Up, Down

Default: Right

My preference: Right

When the shooting mode is set to Sweep Panorama, this menu item gives you four options for the direction in which the camera will prompt you to pan: right, left, up, or down. Note that when the live view screen is displayed on the LCD or EVF, you can cycle among the four shooting directions by rotating the front dial.

The camera actually is processing the image pieces you have already captured *as you continue to shoot*, so you have to select one of these directions so the camera will know ahead of time how to perform this processing of the many JPEGs you'll shoot while panning. Within seconds of finishing the capture, all your shots will be aligned and stitched together into the final panorama photo. The default, right, is probably the most natural way to sweep the camera horizontally, at least for those of us who read from left to right. Of course, you may have occasions to use the other options, depending on the scene to be photographed; for a panorama photo of a very tall building, for example, you'd want to use one of the vertical options (up or down).

The a7R II and a7 II use identical cropping schemes to produce their panorama pictures, so the resulting images have the same pixel dimensions/resolution regardless of which camera was used to produce them. Table 3.3 shows the size and resolution of Wide and Standard panoramas in both horizontal and vertical camera orientations.

Table 3.3 Sweep Panorama Image Sizes Available					
a7R II/a7 II	Megapixels	Resolution			
Standard Panorama—Horizontal	15 MP	8192 × 1856			
Wide Panorama—Horizontal	23 MP	12416 × 1856			
Standard Panorama—Vertical	8.4 MP	2160 × 3872			
Wide Panorama—Vertical	12 MP	2160 × 5536			

With the camera held in the horizontal (landscape) orientation and panned *left to right* or *right to left*, the resulting panorama proportions are shown in Figure 3.4 for Standard (top) and Wide (bottom) options. Both versions are 1856 pixels tall, but measure 8192 and 12416 pixels wide, respectively.

Figure 3.4 Horizontal standard format (green box) and wide format (yellow box), produced by panning left or right.

Figure 3.5
Vertical standard
format (green box)
and wide format
(yellow box), produced by panning
up or down.

If you hold the camera in the horizontal orientation and pan *up* or *down*, different proportions result, as seen in Figure 3.5. Standard and Wide versions are each 2160 pixels wide, but measure 3872 and 5536 pixels tall, respectively. In practice, your a7R II/a7 II gives you four different panorama proportions.

Vertical Orientation for Horizontal or Vertical Pans

There are actually two more techniques for shooting panoramas. You can rotate your camera to the *vertical* (portrait) orientation and pan left or right, or up or down. I find the former technique most useful: vertical camera orientation, but left/right horizontal pan. Because each of the frames that are captured have a 2:3 aspect ratio, rather than the standard 3:2 aspect ratio, you'll end up with a pano that's less wide, and encompasses more of the scene vertically. Simply set Panorama: Direction to Down and pan left to right, or Up and pan right to left when the camera has been rotated 90 degrees counterclockwise. You'll end up with a different aspect ratio that is less widescreen in appearance, as you can see in Figure 3.6, which compares the normal Standard pan with the camera held horizontally and the Standard pan with the camera rotated vertically.

Figure 3.6 Horizontal panorama with the camera rotated to vertical orientation, and Panorama: Size set to Standard (top); at bottom is a Standard horizontal panorama.

Shooting Panoramas

I spent last winter in the Florida Keys and expended a lot of time taking panoramas with this camera, as you can see from the figures. While the process is simple in concept, it can be frustrating in execution, chiefly because it's easy for your "sweeping" motion to be too fast or too slow, and you may be 80 percent through the process when the camera informs you that your movement was at the wrong pace. Here's a procedure that will help you minimize the frustration.

- 1. Know that if your a7 II—series camera is set to RAW or RAW & JPEG, the camera will temporarily switch to JPEG mode for the panorama (panos cannot be shot using RAW format), but will restore your original setting when you rotate the mode dial out of the Panorama position.
- 2. Your "wide" panorama will encompass roughly 220 degrees, so plant your feet firmly such that the center of your picture is straight in front of you. Keep the camera as near to your body as possible (use the EVF—please don't shoot panos with the LCD monitor!) so that the rotation point as your body twists is as close as possible to the sensor plane. Technically, the pivot point should be located underneath the center point of the lens, but it's easier to use the back of the camera as a reference.
- 3. Lock focus and exposure before you start shooting, as the camera doesn't adjust once capture begins.

- 4. With your feet securely anchored, twist your body as far as you can toward the angle you'll use for the beginning of the exposure. That is, if you choose Right, twist as far as you can to the right.
- 5. While viewing through the electronic viewfinder, begin shooting, slowly "untwisting" to pan the camera until you're facing forward again.
- 6. Continue twisting smoothly toward the finish position. It's important to keep a constant speed.
- 7. As you shoot, the camera will provide a highlighted view of the area currently being captured, as it takes a series of overlapping shots. An arrow is shown on the screen to indicate the direction you should be moving.
- 8. If you rotate too slowly or too quickly, a message that the camera could not shoot the panorama will appear, advising you to move more slowly or more quickly.
- 9. You'll finish twisted all the way in the opposite direction from your initial position. When you have successfully captured a panorama, the screen will blank for a few seconds while the camera stitches your exposures together. It will then display your finished shot.
- 10. The preview shows a reduced-size version of the entire panorama; press the center button to see a scrolling display of the entire shot.

There are a couple aspects of panorama shooting that you might not have considered:

- "Multiple" exposures. Panoramas are best rendered with subjects that do not move. If something is in motion as you sweep the camera, you may get multiple renditions of that subject.
- Collateral "damage" from cropping. Avoid including very important information at the very top and bottom of your frames (when shooting in left/right mode, for example). Because you probably won't hold the camera perfectly level as you pan, the camera will automatically try to align your images as they are stitched together, and there will often be some "excess" image above and/or below that is cropped out to produce a seamless image.

File Format (Movies)

Options: XAVC S 4K (a7R II only), XAVC S HD, AVCHD, MP4

Default: AVCHD **My preference:** MP4

This is the first entry on the second page of the Camera Settings 2 menu (with the a7R II; see Figure 3.7). The a7 II series offers full HD (high-definition) video recording in the AVCHD format in addition to the somewhat lesser quality MP4 format. Advanced video shooters can also choose from the XAVC S 4K (a7R II only) or XAVC S HD (both a7R II and a7 II) formats, which support faster recording speeds for improved quality, as I'll explain in Chapter 10.

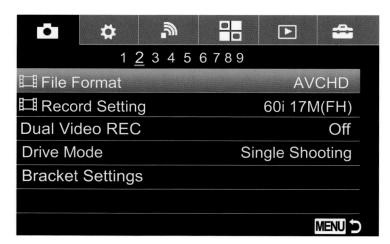

Figure 3.7 File Format is the first entry in the a7R II's Camera Settings 2 menu.

By default, movies are recorded in AVCHD, but this menu item allows you to switch to XAVC S 4K/XAVC S HD or MP4. The latter is a format that you can edit with many software programs and is more likely to be supported by older computers than AVCHD or either XAVC S choice. The MP4 format is also more "upload friendly;" in other words, it's the format you'll want to use if you plan to post video clips on a website. I prefer it for those just getting into movie making.

XAVC S 4K (on the a7R II only) and XAVC S HD are high-resolution formats you'll want to use for your pro-level video. In either case, you'll need a fast memory card of at least 64GB capacity to support the higher frame rates possible with these pro formats. The XAVC S 4K format, in particular, is especially demanding because of its ultra-high 3840×2160 –pixel resolution (roughly four times that of full HD). Note that, because of these demands, certain features such as HDMI Info. Display, Smile/Face Detection, and Center Lock-on AF (all discussed later) are disabled.

Record Setting (Movies)

Options: Varies

Default: AVCHD: 60i (FX) 24M

My preference: MP4: 1920 × 1080 60p 28M

This item allows you to choose from various options if you are using AVCHD, XAVC S, or MP4. Your choices are shown in the left-hand column of each of the tables that follow. Note that the frame rates apply to countries using the NTSC system, such as the U.S., Japan, and some other countries. For countries that use the PAL system, 25, 50, and 100 frame rates replace 30, 60, and 120 fps respectively. I'll explain frame rates, scanning, and bit rates in Chapters 10 and 11. All of the terminology and concepts will make more sense when you read Chapters 10 and 11, which provide more of an education on many aspects of movie making. See Tables 10.1 to 10.4 in Chapter 10 for a detailed listing of the resolution, frame rate, and bit rate of each setting.

Dual Video Record

Options: On, Off

Default: Off

My preference: Off

When switched On, the camera will record an MP4 format version of your video at the same time it captures the AVCHD or XAVC S video (as specified in the File Format entry above). You might want a lower-quality MP4 version for quick review, rough editing, or some other purpose, and still have a high-quality AVCHD or XAVC S version for final editing. You'll want to use a large, fast memory card when capturing two versions of a video simultaneously. One oddity: If you select Date View in View Mode (in the Playback 1 menu), the pair of video clips will be played back side-by-side.

Drive Mode

Options: Single Shooting, Cont. Shooting, Self-timer (2/10 seconds), Self-timer Continuous (3 or 5 shots), Continuous Bracket (3 or 5 images at 0.3/0.7/1.0/2.0/3.0 increments), Single Bracket (3 or 5 images at 0.3/0.7/1.0/2.0/3.0 increments), White Balance Bracket (Lo/Hi), DRO Bracket (Lo/Hi)

Default: Single Shooting

My preference: N/A

Just as with the drive (left) button on the back of the camera, there are several choices available through this single menu item. Your choices include:

- Single shooting. Takes one shot each time you press the shutter release button.
- Continuous Shooting. Captures images at a rate of either 5 or 2.5 frames per second. When this option is highlighted, press the left/right directional buttons to switch between Hi (up to 5 fps) or Lo (up to 2.5 fps). Exposure is set for the first shot, and retained for subsequent images as long as you hold down the shutter button. Focus can adjust during the burst if you set Focus Mode to Continuous AF and AEL w/Shutter to Off or Auto.
 - Continuous shooting is disabled if the shooting mode is set to Sweep Panorama or a scene mode (other than Sports Action), and when Picture Effect is set to Soft Focus, HDR Painting, Rich-Tone Mono, Miniature, Watercolor, or Illustration. It's also unavailable when using Auto HDR, Multi Frame Noise Reduction, Smile Shutter, or Silent Shooting (all discussed later in this chapter) are used.
- Self Timer (2 sec., 5 sec. (a7R II only), 10 sec.). Takes a single picture after two, five (with the a7R II only), or ten seconds have elapsed. When this choice is highlighted, press the left/right buttons to toggle between the two durations. The self-timer is unavailable when you're using the Sports Action scene mode, Smile Shutter, or Sweep Panorama.

- **Self-Timer Continuous.** The self-timer counts down, and then takes either 3 or 5 images. The left/right buttons toggle between the two. You can cancel the timer by pressing the Drive button and selecting Single Shooting, or by tapping the shutter button a second time.
- Continuous Bracket. Captures three, five, or nine images in one burst when the shutter release is held down, bracketing them 0.3, 0.7, 1.0, 2.0, or 3.0 stops apart. The left/right buttons are used to select the increment and number of shots. In Manual exposure (when ISO Auto is disabled), or in Aperture Priority, the shutter speed will change. If ISO Auto is set in Manual exposure, the bracketed set will be created by changing the ISO setting. In Shutter Priority, the aperture will change. Use continuous mode when you want all the images in the set to be framed as similarly as possible, say, when you will be using them for manually assembled high dynamic range (HDR) photos. You can use an external flash when continuous bracketing is active, but, because of the time required for the flash to recycle, you'll need to press the shutter button each time to take subsequent images (effectively switching the camera into Single Bracket mode, described next).

Only the last shot in the set is displayed when using Auto Review. With all types of bracketing, the exposure/bracket scale at the bottom of the EVF or LCD monitor (in Display All Info mode) will display indicators showing the number of images shot and the relative amount of under/overexposure. Don't forget that you can dial in exposure compensation, and *that* will affect the amount of over/underexposure applied while bracketing. Continuous bracketing (and Single Bracketing) is disabled when using Superior Auto, Scene modes, or Sweep Panorama.

- Single Bracket. Captures one bracketed image in a set of three, five, or nine shots each time you press the shutter release, bracketing them 0.3, 0.7, 1.0, 2.0, or 3.0 stops apart. The left/right buttons are used to select the increment and number of shots. In this mode, you can separate each image by an interval of your choice. You might want to use this variation when you want the individual images to be captured at slightly different times, say, to produce a set of images that will be combined in some artistic way.
- White Balance Bracket. Shoots three image adjustments to the color temperature. While you can't specify which direction the color bias is tilted, you can select Lo (the default) for small changes, or Hi, for larger changes using the left/right buttons. Only the last shot taken is displayed during Auto Review.
- DRO Bracket. Shoots three image adjustments to the dynamic range optimization. While you can't specify the amount of optimization, you can select Lo (the default) for small changes, or Hi, for larger changes, using the left/right buttons. Again, only the last shot taken is displayed during Auto Review.

Bracket Settings (a7R II Only)

Options: Self-timer during Bracketing: Off, 2 sec., 5 sec., 10 sec.; Bracket Order: 0-+, -0+

Default: Off, 0-+ **My preference:** N/A

This item has two entries that let you customize how bracketing is applied. **Note:** With the a7 II, Bracket Order is found in the Custom Settings menu, as discussed in Chapter 4.

- Self-timer during bracketing. You can choose delays of 2, 5, or 10 seconds before bracketing begins, or disable the self-timer during bracketing. This clever option solves a problem: how to use the self-timer (say, to avoid shaking a camera mounted on a tripod) when bracketing (which resides in the same Drive menu). With continuous bracketing, all exposures will be taken after the self-timer delay; if you're using single bracketing, the delay takes place before each shot in the bracket set is exposed.
- Bracket order. The default is metered exposure > under exposure > over exposure. However, if you're shooting photos that will later be manually assembled into an HDR photo, you might find it more convenient to expose in order of progressively more exposure: under exposure > metered exposure > over exposure. The order you choose will also be applied to white balance bracketing.

Flash Mode

Options: Flash Off, Auto Flash, Fill Flash, Slow Sync., Rear Sync., Wireless

Default: Depends on shooting mode

My preference: N/A

The first entry in the a7R II's Camera Settings 3 menu (see Figure 3.8), this item offers options for the several flash modes that are available. Not all of the modes can be selected at all times, as shown in Table 3.4. I'll describe the use of flash in detail in Chapter 13.

Flash Compensation

Options: -3 to +3 in 1/3 or 1/2 EV steps

Default: 0.0

My preference: N/A

This feature controls the flash output. It allows you to dial in plus compensation for a brighter flash effect or minus compensation for a subtler flash effect. If you take a flash photo and it's too dark or too light, access this menu item. Scroll up/down to set a value that will increase flash intensity (plus setting) or reduce the flash output (minus setting) by up to three EV (exposure value) steps.

You can select between 1/3 and 1/2 EV increments in the Exposure Step entry described later in this chapter. Flash compensation is "sticky" so be sure to set it back to zero after you finish shooting. This feature is not available when you're using Intelligent Auto, Superior Auto, Scene, or Sweep Panorama modes. I'll discuss this and many other flash-related topics in detail in Chapter 13.

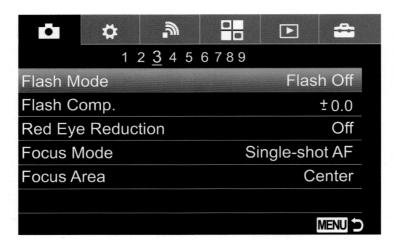

Flash Mode is the first entry in the a7R II's Camera Settings 3 menu.

Table 3.4 Flash Modes								
Exposure Mode	Flash Off	Auto Flash	Fill Flash	Slow Sync.	Rear Sync.	Wireless	Flash Exposure Compensation	Red-Eye Reduction
Intelligent Auto	Yes	Yes	Yes	No	No	No	No	Yes
Superior Auto	Yes	Yes	Yes	No	No	No	No	Yes
Program Auto	No	No	Yes	Yes	Yes	Yes	Yes	Yes
Aperture Priority	No	No	Yes	Yes	Yes	Yes	Yes	Yes
Shutter Priority	No	No	Yes	Yes	Yes	Yes	Yes	Yes
Manual Exposure	No	No	Yes	Yes	Yes	Yes	Yes	Yes

Red Eye Reduction

Options: On, Off

Default: Off

My preference: Off

When flash is used in a dark location, red-eye is common in pictures of people, and especially of animals. Unfortunately, your camera is unable, on its own, to totally *eliminate* the red-eye effects that occur when an electronic flash bounces off the retinas of your subject's eyes and into the camera lens. The effect is worst under low-light conditions (exactly when you might be using a flash) as the pupils expand to allow more light to reach the retinas. The best you can hope for with this option is to *reduce* or minimize the red eye effect. After all, the feature is called red eye *reduction*, not red eye *elimination*.

It's fairly easy to remove red eye effects in an image editor (some image importing programs will do it for you automatically as the pictures are transferred from your camera or memory card to your computer). But, it's better not to have glowing red eyes in your photos in the first place.

To use this feature, you first have to attach an external flash to the multi-interface shoe. When Red Eye Reduction is turned on through this menu item, the flash issues a few brief bursts prior to taking the photo, theoretically causing your subjects' pupils to contract, reducing the red eye syndrome. It works best if your subject is looking toward the flash. Like any such system, its success ratio is not great.

Focus Mode

Options: Single-shot AF (AF-S), Automatic AF (AF-A), Continuous AF (AF-C), DMF (Direct Manual Focus), MF (Manual Focus)

Default: Single-shot AF (AF-S)

My preference: Automatic AF (AF-A)

This menu item can be used to set the way in which the camera focuses. I'll discuss focus options in detail in Chapter 8.

- Single-shot AF (AF-S). With this default setting, the camera will set focus and it will keep that focus locked as long as you maintain slight pressure on the shutter release button; even if the subject moves before you take the photo, the focus will stay where it was set. If you use this setting for still photos and then switch to Movie mode, the camera switches temporarily to AF-C.
- Automatic AF (AF-A). Begins to focus using AF-S, but will switch to continuous autofocus (AF-C) if your subject is moving. This is a good all-purpose setting when you aren't sure whether your subject will suddenly begin moving around as you shoot.

- Continuous AF (AF-C). The camera will continue to adjust the focus if the camera-to-subject distance changes, as when a cyclist approaches your shooting position. The camera will constantly adjust focus to keep the subject sharply rendered. It uses predictive AF to predict the moving subject's position at the time you'll take the next shot and focusing at that distance. This option is useful when you're photographing sports, active children, animals, or other moving subjects, making it possible to get a series of sharply focused shots.
- Direct Manual Focus (DMF). Press the shutter button halfway down to let the camera start the focusing process; then, keeping the button pressed halfway, turn the focusing ring to fine-tune the focus manually. You might want to use DMF when you are focusing from a short distance on a small object, and want to make sure the focus point is exactly where you want it. If you use this setting for still photos and then switch to Movie mode, the camera switches temporarily to AF-C.
- Manual Focus (MF). If you select Manual Focus, you turn the focusing ring on the lens to achieve the sharpest possible focus. With both DMF and Manual Focus, the camera will show you an enlarged image to help with the focusing process, if you have the MF Assist option turned on in the Custom Settings 1 menu (described later).

Focus Area

Options: Wide, Zone, Center, Flexible Spot, Expand Flexible Spot, Lock-On AF

Default: Wide

My preference: Wide for general use; Lock-On AF Wide for sports and action

When the camera is set to Autofocus, use this menu option to specify where in the frame the camera will focus when you compose a scene in still photo mode, using the focus area selection you specify. I'll explain these options, the special requirements, and include illustrations of the focusing areas in Chapter 8.

- Wide. The camera uses its own electronic intelligence to determine what part of the scene should be in sharpest focus, providing automatic focus point selection. A green frame is displayed around the area that is in focus. Even if you set one of the other options, Wide is automatically selected in certain shooting modes, including both Auto and all SCN modes.
- **Zone.** Select one of nine focus areas (described in Chapter 9), and the camera chooses which section of that zone to use to calculate sharp focus. You can move the focus zone by holding down the defined Focus Settings button (the default is C2) and then rotating the front or rear dial or pressing the directional buttons.
- Center. Choose this option if you want the camera to always focus on the subject in the center of the frame. Center the primary subject (like a friend's face in a wide-angle landscape composition); allow the camera to focus on it; maintain slight pressure on the shutter release button to keep focus locked; and re-frame the scene for a more effective, off-center, composition. Take the photo at any time and your friend (who is now off-center) will be in the sharpest focus. Use

this option instead of manually selecting a focus point to quickly lock focus on the center of the frame, then press the defined AF lock button to fix the focus at that point so you can recompose the image as you prefer.

- Flexible Spot. This mode allows you to move the camera's focus detection point (focus area) around the scene to any one of multiple locations using the directional buttons. When this option is highlighted, use the left/right directional buttons or control wheel to change the size range of the spot among Small (S), Medium (M), and Large (L).
 - This mode can be useful when the camera is mounted on a tripod and you'll be taking photos of the same scene for a long time, while the light is changing, for example. Move the focus area to cover the most important subject, and it will always focus on that point when you later take a photo.
- Expand Flexible Spot. If the camera is unable to lock in focus using the selected focus point, it will also use the eight adjacent points to try to achieve focus.
- Lock-On AF. In this mode, the camera locks focus onto the subject area that is under the selected focus spot when the shutter button is depressed halfway. Then, if the subject moves (or you change the framing in the camera), the camera will continue to refocus *on that subject*. You can select this mode only when the focus mode is set to Continuous AF (AF-C). Note that Lock-On AF is different from Center Lock-On AF, discussed later in this chapter, and in more detail in Chapter 8.

This option is especially powerful because you can activate it for any of the five focus area options described above. That is, once you've highlighted Lock-On AF on the selection screen, you can then press the left-right directional button and choose Wide, Zone, Center, Flexible Spot, or Expand Flexible Spot.

Focus Settings

Options: Move focus frame; select focus area

Default: None

My preference: Assign to a key of your choice using Custom Keys in the Custom Settings 7 menu

This menu item is the first in the a7R II's Camera Settings 4 menu (see Figure 3.9). It's most useful when you define one of the Custom keys or another button to activate it without wending through the menu thicket. When it's active, you can quickly make focus adjustments using the front and rear dials, and control wheel:

- In any Autofocus or Direct Manual focus mode:
 - Front dial/up/down buttons. Moves the focus frame up/down.
 - Rear dial/left/right buttons. Moves the focus frame left/right.
 - **Control wheel.** Rotating the wheel selects a specific focus area from any of the choices described in the Focus Area entry above.

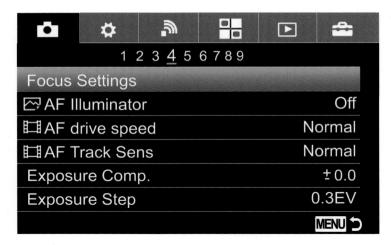

Figure 3.9
Focus Settings is the first entry in the a7R II's Camera Settings 4 menu.

- In Manual focus mode:
 - Front dial/up/down buttons. Moves the magnified focus area up/down.
 - Rear dial/left/right buttons. Moves the magnified focus area left/right.
 - Control wheel. Rotating the wheel moves the magnified area up/down.

AF Illuminator (Stills)

Options: Auto, Off

Default: Auto

My preference: Auto

The AF illuminator is a red light activated when there is insufficient light for the camera's autofocus mechanism to zero in on the subject. This light emanates from the same lamp on the front of the camera that provides the indicator for the self-timer and the Smile Shutter feature. The extra blast from the AF illuminator provides a bright target for the AF system to help the camera set focus. This menu item is a still-photos-only option, as the illuminator does not operate while shooting movies.

The default setting, Auto, allows the AF illuminator to work any time the camera judges that it is necessary. Turn it off when you would prefer not to use this feature, such as when you don't want to disturb the people around you or call attention to your photographic endeavors. The AF illuminator doesn't work when the camera is set for manual focus or to AF-C (Continuous autofocus), when shooting movies or panoramas, or in certain other shooting modes, including the Landscape, Night View, or Sports Action varieties of SCN mode.

AF Drive Speed (Movies) (a7R II Only)

Options: Fast, Normal, Slow

Default: Fast

My preference: Normal for most scenes, Fast for sports and action

This entry is a movies-only setting for the a7R II that is used to adjust how quickly the camera focuses while capturing video. It's used in conjunction with AF Track Duration, described next. Unlike stills, when focus changes while shooting movies it is apparent in the clip, and can be undesirable. Your three options are as follows:

- Fast. The camera focuses as quickly as possible, but with slightly less precision. This setting is good for sports, action, photojournalism, and street photography, and any situation where it's important to keep the main subjects in focus as they move around. In such situations, the automatic focus adjustments add to the feeling of following the action; any delay in refocusing would be disconcerting.
- **Normal.** The AF responds smoothly to subject movement by refocusing gradually. With scenes that are not filled with constant action, this mode may be the least noticeable to the viewer.
- Slow. Focusing is much less speedy, and is a good choice if your subjects are moving at a constant rate of speed and direction. This setting will allow the a7R II/a7 II to smoothly follow focus. Choose Slow to be on the safe side, in such situations, particularly when using older lenses that are themselves somewhat pokey in achieving focus.

AF Track Sensitivity (Movies) (a7R II Only)

Options: High, Normal

Default: Normal

My preference: Normal

This is another movies-only setting, which works hand-in-hand with AF Drive Speed just described. The previous option determines how quickly the camera locks in focus; this one determines how quickly the camera unlocks focus from the subject it is currently tracking, and focuses instead on another subject that intervenes. For example, if you're shooting a football game as a running back is breaking through the line and a referee bolts along the sideline in front of you. With this feature set to High, the camera will very quickly switch to the ref, and then should return its attention to the running back—but often, not quickly enough. A better choice would be to use Normal, so that the camera briefly ignores the referee, who is likely to have moved on in a second or two. Focus tracking will remain on your running back. Your options include:

■ **High.** The camera quickly responds to new subjects that cross the frame. This is the best setting to use for fast-moving subjects, such as sports or frenetic children, as long as you don't expect intervening subjects. The camera will smoothly follow your subjects, especially if AF Drive Speed has been set to Fast, too.

72

■ Normal. Response to movement is a bit slower, so that the camera doesn't constantly refocus as subjects move about the frame. This is the default, and should be used when there is only moderate movement, and especially if the movement is across the width or height of the frame (rather than coming toward you or away from you), and when you're using a small f/stop, because the increased depth-of-field will eliminate the need for most re-focusing.

Exposure Compensation

Options: From +5 to -5

Default: 0.0

My preference: N/A

If you decide to access this item from the menu instead of using the other available access methods (such as the Fn button/Function menu), go into the exposure compensation screen and scroll up/down using the control wheel or the left/right direction buttons. Scroll until you reach the value for the amount of compensation you want to set to make your shots lighter (with positive values) or darker (with negative values). I'll discuss exposure compensation in more detail in Chapter 9.

Remember that any compensation you set will stay in place until you change it, even if the camera has been powered off in the meantime. It's worth developing a habit of checking your display to see if any positive or negative exposure compensation is still in effect; return to 0.0 before you start shooting. Exposure compensation cannot be used when the camera is set to Intelligent Auto, Superior Auto, or one of the SCN modes. The EV changes you make will be in either 1/3 or 1/2 EV increments, depending on the step size you specify in the Exposure Step entry.

Exposure Step

Options: 1/3 EV, 1/2 EV

Default: 1/3 EV

My preference: 1/3 EV

This setting specifies the size of the exposure change for both exposure compensation and flash exposure compensation. The 1/3-stop default allows fine-tuning exposure more precisely, while selecting 1/2 EV lets you make larger adjustments more quickly, which is useful when you are trying to capture more dramatic exposure changes. The actual difference between 1/3-stop and 1/2-stop changes is relatively small, so this setting is primarily a convenience feature that's most useful when you plan to, say, use exposure compensation and want to move from 0.0 to plus or minus several whole stops in bigger jumps. I'm never in that much of a hurry, so I opt for the greater precision of the 1/3 EV steps.

IS₀

Options: ISO Auto (with upper/lower limits); Settings from 50 to 25600 (a7 II) or 50 to 102400 (a7R II); Multi Frame Noise Reduction

Default: ISO Auto

My preference: ISO Auto, set to ISO 100 Minimum/ISO 1600 Maximum

This menu item is the first on the a7R II's Camera Settings 5 menu (see Figure 3.10). It can also be accessed by pressing the right (ISO) button on the front dial. It allows you to use the ISO setting (sensor sensitivity) in one of three ways:

■ Multi Frame NR (Noise Reduction). The camera takes 4 or 12 shots and first aligns them (because, hand-held, there is probably some camera movement between shots) and sorts out the image pixels that are common to all the shots (and which remain more or less the same in each individual shot) from the random visual noise pixels (which will be different in each shot, because they are *random*). It then creates an image that (in theory) uses only the image pixels, with much less visual noise. The processing takes a few seconds, so you wouldn't want to use it when you plan to take multiple shots within a short period of time.

To activate Multi Frame NR, highlight the entry (which is by default confusingly labeled ISO Auto, rather than Multi Frame Noise Reduction). (See Figure 3.11.) You can then press the right button to highlight the left option at the bottom of the figure (the maximum ISO setting you want to use), and the amount of multi frame noise reduction to be applied (High or Standard). The camera will take and combine 12 shots if you choose High, and 4 shots if you select Standard.

Figure 3.10
ISO is the first entry
in the a7R II's
Camera Settings 5
menu.

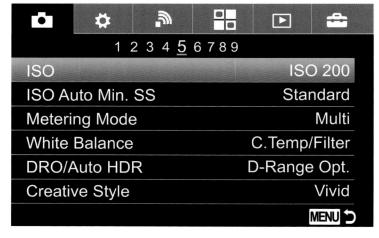

74

Multi Frame NR can only be used when Image Quality is set to JPEG, and is unavailable when D-Range Optimizer or Auto HDR are activated. **Note:** the camera also offers a Hand-Held Twilight scene mode, which doesn't let you choose shutter speed, ISO setting, white balance, and other parameters, but produces comparable (or sometimes even better) images. If your image suits the automated settings of the Hand-Held Twilight mode, it's certainly faster and requires fewer decisions from you.

- ISO Auto. The true Auto ISO setting is the second entry from the top. You can press the right button and choose a minimum ISO to be used as well as the maximum ISO applied (which prevents the camera from taking a clutch of pictures at, say, ISO 25600, unbeknownst to you). For general shooting, I use ISO 100 and ISO 1600 for my limits and raise the upper end to ISO 3200 or 6400 for indoor subjects (especially sports, which can benefit from faster shutter speeds and/or smaller f/stops). (See Figure 3.12.)
- Fixed ISO settings. You can select ISO settings from 50 to 25600, and the camera will take all its shots at that sensitivity. Strictly speaking, ISO 100 is the lowest real sensitivity the camera can produce; that's the "native" sensitivity of the sensor. The 50/64/80 settings are "interpolated" and produce slightly higher contrast and lower quality. I recommend using those ersatz values only when you really need a lower sensitivity, say, to use a wider f/stop in very bright conditions, or when you want to use a slower shutter speed to intentionally produce blur of, perhaps, a waterfall. A neutral-density filter attached to your lens can also reduce the amount of light reaching the sensor.

Your choices are restricted when you're using Panorama mode or fully automatic and scene modes since the camera always uses ISO Auto. Note too that ISO Auto is not available in M mode; you must set a numerical value. Settings up to 25600 are available in still mode, and up to 12800 for movies. (If you've selected a higher sensitivity when you switch to movie-making mode, the camera will automatically change to 12800.)

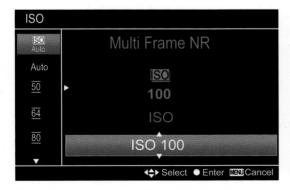

Figure 3.11 Choosing ISO speed for Multi Frame Noise Reduction.

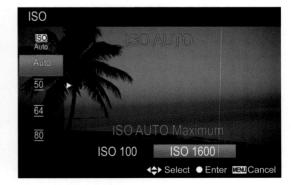

Figure 3.12 ISO Auto allows specifying minimum and maximum ISO sensitivity.

ISO Auto Minimum Shutter Speed (a7R II Only)

Options: Faster, Fast, STD, Slow, Slower, 1/8000th-30 seconds

Default: STD (Standard)

My preference: STD (Standard)

Use this entry with the a7R II to specify the shutter speed that activates the ISO Auto feature described above. You'll want to use ISO Auto most frequently to avoid having the camera select a blur-inducing slow shutter speed when using P (Program Auto) or A (Aperture Priority) modes. (You always select the shutter speed yourself in S and M modes.) Depending on how well you can handhold the camera, or your level of trust for the lens and/or in-body image stabilization, you can choose which shutter speed you deem "too slow," and your a7R II/a7 II will boost the ISO sensitivity as required when ISO Auto is active. You can choose from values that the camera calculates, or supply a specific shutter speed, below which Auto ISO will start to do its stuff.

The camera-calculated minimum speeds are very cool because they are based on the focal length of your lens, giving you faster minimum speeds with telephoto lenses, and longer minimum speeds with wide angles. The Fast and Fastest settings increase the minimum shutter speed by 1 and 2 stops (respectively) from the standard setting for a particular focal length. The Slow and Slower settings lower the minimum shutter speed for that focal length by 1 and 2 stops (respectively).

- Faster/Fast. When you highlight this entry, you can press the left/right directional buttons to choose between Faster and Fast, STD (Standard), Slow, or Slower. The a7R II will activate ISO Auto at shutter speeds that are faster than the "standard" setting (which is calculated individually based on the focal length or zoom setting of your lens). This is a more conservative setting.
- STD (Standard). The camera detects the current focal length/zoom setting and selects a minimum shutter speed that takes into account the effect the focal length has in magnifying the degree of blur. That is, a 200mm lens calls for higher shutter speeds than, say, a 50mm lens.
- **Slow/Slower.** This is a more liberal setting that allows slightly slower shutter speeds than specified by STD before ISO Auto kicks in. Use if you have an extraordinarily steady hand.
- 1/8000th—30 seconds. You can bypass the camera's internal algorithm mumbo-jumbo and directly select a shutter speed that you want to use to activate ISO Auto. If you choose 1/8000th second, ISO Auto will effectively be active all the time (except when 1/8000th second is used as the shutter speed). Select 30 seconds, and ISO Auto will not activate at all.

Metering Mode

Options: Multi, Center, Spot

Default: Multi

My preference: Multi

The metering mode determines how the camera will calculate the exposure for any scene. The camera is set by default to Multi, which is a multi-zone or multi-segment metering approach. No other options are available in either Auto mode or in SCN modes or when you're using digital zoom or the Smile Shutter.

- Multi. Evaluates many segments of the scene using advanced algorithms; often, it will be able to ignore a very bright area or a very dark area that would affect the overall exposure. It's also likely to produce a decent (if not ideal) exposure with a light-toned scene such as a snowy land-scape, especially on a sunny day. While it's not foolproof, Multi is the most suitable when you must shoot quickly and don't have time for serious exposure considerations.
- Center. Center-weighted metering primarily considers the brightness in a large central area of the scene; this ensures that a bright sky that's high in the frame, for example, will not severely affect the exposure. However, if the central area is very light or very dark in tone, your photo is likely to be too dark or too bright (unless you use exposure compensation).
- **Spot.** When using Spot metering, the camera measures only the brightness in a very small central area of the scene; again, if that area is very light or very dark in tone, your exposure will not be satisfactory; it's important to spot meter an area of a medium tone. You'll learn how metering mode affects exposure in Chapter 7, which covers exposure topics in detail.

White Balance

Options: Auto (AWB), Daylight, Shade, Cloudy, Incandescent, Fluorescent (4 options), Flash, Underwater Auto, C.Temp/Filter, Custom, Custom Setup

Default: Auto (AWB)

My preference: Auto (AWB)

The various light sources that can illuminate a scene have light that's of different colors. A house-hold lamp using an old-type (not Daylight Balanced) bulb, for example, produces light that's quite amber in color. Sunlight around noon is close to white but it's quite red at sunrise and sunset; on cloudy days, the light has a bluish bias. The light from fluorescents can vary widely, depending on the type of tube or bulb you're using. Some lamps, including sodium vapor and mercury vapor, produce light of unusual colors.

The Auto White Balance feature works well, particularly outdoors and under artificial lighting that's daylight balanced. Even under lamps that produce light with a slight color cast such as green or blue, you should often get a pleasing overall color balance. One advantage of using AWB is that you don't have to worry about changing it for your next shooting session; there's no risk of having the camera set for, say, incandescent light, when you're shooting outdoors on a sunny day.

The a7R II/a7 II also lets you choose a specific white balance option—often called a preset—that's appropriate for various typical lighting conditions, because the AWB feature does not always succeed in providing an accurate or the most pleasing overall color balance. Your choices include:

- Daylight. Sets white balance for average daylight.
- Shade. Compensates for the slightly bluer tones encountered in open shade conditions.
- Cloudy. Adjusts for the colder tones of a cloudy day.
- Incandescent. Indoor illumination is typically much warmer than daylight, so this setting compensates for the excessive red bias.
- Fluorescent (four types). You can choose from Warm White, Cool White, Day White, and Daylight fluorescent lighting.
- Flash. Suitable for shooting with the a7R II/a7 II's external electronic flash unit.
- Underwater Auto. Although you may find a vendor offering an underwater housing for your a7R II/a7 II, it's more likely that your "underwater" shooting will involve photographing fish and other sea life through the glass of an aquarium of the commercial variety. This setting partially tames the blue-green tones you can encounter in such environments (see Figure 3.13, top), producing a warmer tone that some (but not all) may prefer (see Figure 3.13, bottom).
- C.Temp/Filter/Custom/Custom Setup. These advanced features provide even better results once you've learned how to fine-tune color balance settings, which I'll explain in Chapter 9.

When any of the presets are selected, you can press the right button to produce a screen that allows you to adjust the color along the amber (yellow)/blue axis, the green/magenta axis, or both, to fine-tune color rendition even more precisely. The screen shown in Figure 3.14 will appear, and you can use the up/down and left/right buttons to move the origin point in the chart shown at lower right to any bias you want. The amount of your amber/blue and/or green/magenta bias are shown numerically above the chart. You'll find more information about White Balance in Chapter 9.

My recommendation: If you shoot in RAW capture, though, you don't have to be quite as concerned about white balance, because you can easily adjust it in your software after the fact. Here again, as with ISO and exposure compensation, the white balance item is not available in either Auto mode or in SCN modes; when you use any of those, the camera defaults to Auto White Balance.

Figure 3.13
The Underwater
Auto setting can
reduce the blue cast
of typical subsurface
photos.

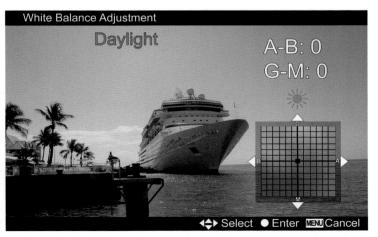

Figure 3.14
Fine-tune the color bias of your images using this screen.

DRO/Auto HDR

Options: DRO Off, DRO Auto, DRO Levels 1–5, AUTO HDR (1–6 EV interval)

Default: DRO Off

My preference: DRO Off

The brightness/darkness range of many images is so broad that the sensor has difficulty capturing detail in both bright highlight areas and dark shadow areas. That's because a sensor has a limited dynamic range. However, the a7R II/a7 II is able to expand its dynamic range using extra processing when dynamic range optimization (DRO) is active. It's on by default at the Auto level where the camera evaluates the scene contrast and decides how much extra processing to apply; this is the only available setting in certain automatic camera modes. In other modes, you can turn DRO off, or set it manually to one of five intensity levels. There's also an Auto HDR feature discussed in a moment.

When the DRO Auto option is highlighted, you can press the left/right keys to set the DRO to a specific level of processing, from 1 (weakest) to 5 (strongest). You'll find that DRO can lighten shadow areas; it may darken bright highlight areas too, but not to the same extent. By level 3, the photos you take will exhibit much lighter shadow areas for an obviously wide dynamic range; DRO Auto will never provide such an intense increase in shadow detail.

In addition, you'll find the Auto HDR (High Dynamic Range) feature, available only in the P, A, S, and M shooting modes (Program, Aperture Priority, Shutter Priority, and Manual). If you select this option instead of DRO, the camera will take three photos, each at a different exposure level, and it will combine them into one HDR photo with lighter shadow areas and darker highlight areas than in a conventional shot. You can control the intensity of this feature. After scrolling to Auto HDR, press the left/right buttons to choose an exposure increment between shots, from 1.0 to 6.0 EV. The one you select will specify the difference in exposure among the three photos it will shoot: 1 EV (minor exposure difference) for a slight HDR effect to 6 EV (a huge exposure difference) for a dramatic high dynamic range effect. If you don't choose a level, the camera selects an HDR level for you. I'll provide tips and examples of DRO and HDR in Chapter 7.

Creative Style

Options: Standard, Vivid, Neutral, Portrait, Landscape, Black & White; adjustable versions of these, plus Clear, Deep, Light, Night, Autumn, Sepia, and Sunset

Default: Standard

My preference: Standard

This option gives you six basic Creative Styles with fixed combinations of contrast, saturation, and sharpness. They each have a number prefix on the screen: 1: Standard, 2: Vivid, 3: Neutral, 4: Portrait, 5: Landscape, 6: B&W. Each *also* appears a second time (without the number prefix) and with the addition of Clear, Deep, Light, Night, Autumn, Sepia, and Sunset. You can adjust the contrast, saturation, and sharpness of the non-numbered versions using the left/right buttons to

choose an attribute, and the up/down buttons to adjust that attribute. You can apply Creative Styles when you are using any shooting mode except Superior Auto, Intelligent Auto, or any of the scene modes. I discuss the use of this option in Chapter 9.

Picture Effect

Options: Off, Toy Camera, Pop Color, Posterization, Retro Photo, Soft High-key, Partial Color, High Contrast Monochrome, Soft Focus, HDR Painting, Rich Tone Monochrome, Miniature, Watercolor, Illustration

Default: Off

My preference: Off

This camera feature, the first in the a7R II's Camera Settings 6 menu (see Figure 3.15), allows you to create JPEG photos with special effects provided by the camera's processor in JPEG capture mode (but not in RAW or RAW & JPEG) when the camera is in P, A, S, or M mode. It's not available for use when shooting movies. Scroll through the options in this item and watch the change in the preview image display that reflects the effect that each option can provide if you activate it; if you find one that looks interesting, press the center button or touch the shutter release button to confirm your choice and return to shooting mode.

When some effects are highlighted, left/right triangles will appear next to their label, indicating you can press the left/right keys to select an option available for that effect. Not all provide this extra benefit.

- Toy Camera. Produces images like you might get with a Diana or Holga "plastic" camera, with vignetted corners, image blurring, and bright, saturated colors. It's at Normal by default but when you press the left/right buttons you can select Normal, Cool, Warm, Green, or Magenta.
- **Pop Color.** This setting adds a lot of saturation to the colors, making them especially vivid and rich looking. When used with subjects that have a lot of bright colors, the effect can be dramatic. Duller subjects gain a more "normal" appearance; try using this setting on an overcast day to see what I mean.
- **Posterization.** This option produces a vivid, high-contrast image that emphasizes the primary colors (as shown in Figure 3.16, upper left) or in black-and-white, with a reduced number of tones, creating a poster effect. The default rendition is Color, but a monochrome option also appears if you press the left/right keys.
- **Retro Photo.** Adds a faded photo look to the image, with sepia overtones.
- **Soft High-key.** Produces bright images.
- Partial Color. Attempts to retain the selected color of an image, while converting other hues to black-and-white. (See Figure 3.16, upper right.) It's set at Red by default, indicating that photos will retain red tones, but you can also choose Blue, Green, or Yellow.

Figure 3.15
Picture Effect is the first entry in the a7R II's Camera Settings 6 menu.

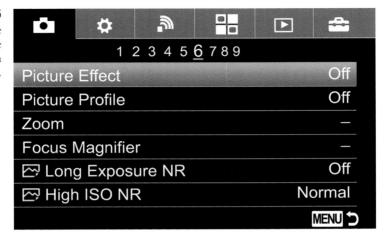

Figure 3.16 Clockwise, from upper left: Posterization, Partial Color, High Contrast Monochrome, Miniature.

- **High Contrast Monochrome.** Converts the image to black-and-white and boosts the contrast to give a stark look to the image. (See Figure 3.16, lower left.)
- **Soft Focus.** Creates a soft, blurry effect. It's at Mid by default (for a medium intensity); press the left/right buttons to specify Lo or Hi intensity.
- HDR Painting. Produces a painted look by taking three pictures consecutively and then using HDR techniques to enhance color and details. It's at Mid by default (for a medium intensity); press the left/right buttons to specify Lo or Hi intensity. The camera will quickly shoot three photos, at varying exposures, and combine them into one. (This is most suitable for static subjects; do not move the camera until all three shots have been fired.)
- Rich-Tone Monochrome. Uses the same concept as HDR Painting but creates a long-gradation black-and-white image (by darkening bright areas but keeping dark tones rich) from three consecutive exposures.
- Miniature. You select the area to be rendered in sharp focus using the Option button. The effect is similar to the tilt-shift look used to photograph craft models. (See Figure 3.16, lower right.) Press the left/right keys to position the blurry area to the left, right, top, bottom, or middle of the image; watch the preview display while scrolling among them to get a feel for the effect that each one can provide.
- Watercolor. Creates a look with blurring and runny colors, as if the image were painted using watercolors.
- **Illustration.** Emphasizes the edges of an image to show the outlines more dramatically. The left/right buttons can be used to adjust the effect from Low, to Mid, or High levels.

Picture Profile

Options: Picture Profiles PP1-PP7, Off

Default: Off

My preference: Off

Picture Profiles are a great tool for advanced movie shooters. You can customize the picture quality, including color and gradation of your movies by defining the parameters included in each of seven different Picture Profiles. To make these adjustments, connect the camera to a TV or monitor using the HDMI port, and use the picture on the screen as a guide while making your changes. After connecting the camera to your HDTV/monitor, navigate to this menu entry and select which Picture Profile you want to modify. Press the right button to access the index screen, then press the up/down buttons to select the parameter to be changed. Then make your adjustments and press the center button to confirm.

Even a short course in how each of the parameters affects video images, and a discussion of how to select the best settings would require a chapter or two of technical discussion, and is thus beyond the scope of this book. I'm going to provide a quick listing of each type of setting for a reminder; your Sony manual provides more information about each of these.

The seven Picture Profile presets already have default values:

- **PP1:** Example setting using [Movie] gamma
- PP2: Example setting using [Still] gamma
- PP3: Example setting of natural color tone using the ITU709 gamma
- **PP4:** Example setting of a color tone faithful to the [ITU709] standard
- PP5: Example setting using [Cine1] gamma
- **PP6:** Example setting using [Cine2] gamma
- PP7: Example setting using [S-Log2] gamma

The parameters you can adjust include:

- Black Level. Sets the black level (–15 to +15). Black level is the level of brightness at which no light is emitted from a screen, resulting in a pure black screen. Adjustment of this parameter ensures that blacks are seen as black, and not a dark shade of graph.
- **Gamma.** Selects a gamma curve, a formula that corrects for the nonlinear relationship between the brightness (*luminance*) captured by a sensor and the brightness of the image as it's displayed on a monitor. In other words, correction is needed to make what you see on a screen more closely resemble what the camera captured in real life. You can choose from nine different gamma curves.
- Black Gamma. Corrects gamma in low-intensity areas, using Range and Level controls.
- **Knee.** Sets "knee point" and slope for video signal compression to prevent overexposure by limiting signals in high-intensity areas of the subject to the dynamic range of your camera. In short, a higher knee level produces more detail in the highlights; a lower knee level produces fewer details in the highlights.
- **Mode.** In Auto mode, the knee point and slope are set automatically; in Manual mode, they are set manually.
- **Auto Set.** When Auto is selected, values are automatically chosen by the camera for the maximum knee point, sensitivity, manual settings, knee point, and knee slope.
- Color Mode. Sets type and level of colors, from among Movie, Still, Cinema, Pro, ITU-709 Matrix, Black & White, and S-Gamut.
- **Saturation.** Sets the color saturation, from -32 to +32 values.
- Color Phase. Sets the color phase (-7 to +7).
- Color Depth. Sets the color depth for each color phase.
- **Detail.** Sets parameters including Level, and Detail adjustments including Mode, Vertical/ Horizontal Balance, B/W Balance, Limit, Crispning (sic), and Hi-Light Detail.
- Copy. Copies the settings of the picture profile to another picture profile number.
- **Reset.** Resets the picture profile to the default setting. You cannot reset all picture profile settings at once.

Zoom

Options: Smart or ClearImage Zooming in shooting mode

Default: None

My preference: None

This feature adds an ersatz "power zoom" control to the a7R II/a7 II, which otherwise lacks one. It's useful once you understand what it does and how it works, but Sony has done its best to make the feature as confusing as possible, including tucking it away here in the Camera Settings 6 menu, while hiding the Zoom Setting entry (which controls how it works) in the Custom Settings 3 menu. Fortunately, you don't need to jump back and forth between menus often, even though *descriptions* of the two relevant entries are necessarily in separate sections of this book.

Some other cameras in the Sony mirrorless lineup, such as the a5100, actually have a physical zoom lever located concentrically with the shutter release. None of the a7 II—series models has this feature. But, in effect, you still have *five* different ways to zoom while you're taking still photographs or movies. This list will sort out the options for you:

- Optical zoom with zoom ring. Zoom lenses always have a ring around their barrel that can be rotated back and forth to zoom in or out on your subject. The sole exception is lenses that have a power zoom lever that takes the place of the zoom ring.
- Optical Power Zoom. Certain E-mount lenses include a PZ (power zoom) designation in their name. These include the Sony E PZ 16-50mm f/3.5-5.6 OSS lens, Sony E PZ 18-200mm f/3.5-6.3 OSS lens, and Sony E PZ 18-105mm f/4 G OSS lens. They all have a zooming motor built in that can be activated by sliding a switch on the lens barrel itself. Alternatively, you can zoom these lenses using a camera's zoom switch (if you own a model that has one).
- **Smart Zoom.** This is one of three zoom options that take you beyond the true optical zoom range of your lens into the realm of digitized zooming, which produces a zoom *effect* by taking the pixels in the center of the original image and filling the frame with them.
 - Smart Zoom is available only when you have set the camera to M (medium) or S (small) image size. It provides a limited amount of zooming, but, technically, requires no quality-reducing interpolation. The camera simply produces each "zoomed" image by cropping the photo to the zoomed size. The resolution of your final image corresponds to the resolution of the Medium or Small image size, as explained in Chapter 2. When using Smart Zoom, an S label appears in the viewfinder or LCD monitor zoom scale to indicate that the feature is in effect.
- ClearImage Zoom. When using this option, some quality is lost, as this kind of zooming doesn't produce any actual additional information; it just *interpolates* the pixels captured optically to simulate a zoomed-in perspective. Pixels are created to fill the frame at the resolution of the given Image Size setting (Large, Medium, or Small). ClearImage Zoom has many options, and I'll explain them later in this chapter. When a zoom scale is shown in the view-finder or on the LCD monitor, a C label appears whenever you leave optical zooming behind

- and enter the ClearImage realm. When ClearImage Zoom is used alone, you'll typical achieve 1X to 2X magnifications *over and above* whatever optical zoom setting you've used.
- **Digital Zoom.** This option gives you even higher magnifications than ClearImage Zoom, with an additional decrease in image quality. When a zoom scale is shown in the viewfinder or on the LCD monitor, a D label appears when you are using digital zoom. I'll explain the options later in the chapter. When Digital Zoom is active, it takes up where ClearImage Zoom leaves off, giving you up to 4X magnification *beyond* the optical zoom focal length you've selected when using Large image size. At Medium image size, you can zoom up to 5.7X; with Small image size, up to 8X.

Using Zoom

My basic recommendation is to use optical zoom only most of the time, and this feature might not be available. If you've set the camera for Optical Zoom Only in the Zoom Settings entry of the Custom Settings 3 menu, as described in Chapter 4, then this Zoom feature is not available at all if Image Size is set to Large. If ClearImage Zoom is set to On, you can use ClearImage zooming; if Digital Zoom is set to On, you can use both. When Image Size is set to Medium or Small, then Smart Zoom is also available for all three Zoom Settings options. After you've sorted out which of the zoom methods you want to use, using the Zoom feature while shooting is fairly easy. Just follow these steps:

- 1. Navigate to the Camera Settings 6 menu. Select Zoom, and press the center button.
- 2. **Preview image.** A live view of your sensor image appears in the EVF and LCD monitor, with a zoom scale at lower right, as shown in Figure 3.17.
- 3. **Zoom in or out.** You can rotate the control wheel, or use the left/right direction keys to zoom in or out.

Figure 3.17

The zoom scale shows the amount of magnification and type of zoom in use.

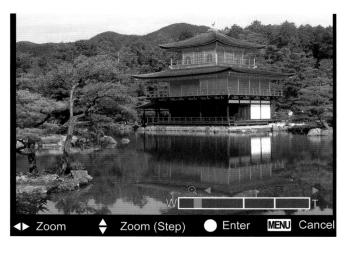

- 4. **Change zoom steps.** Press the up/down keys to change the size of the zoom increment, from 1X to 1.4X to 2X.
- 5. **Confirm or cancel.** When you're satisfied with the zoom level, press the center button to confirm, or the MENU button to cancel. You can then continue to shoot at the new zoomed magnification.

Focus Magnifier

Options: Activate

Default: Off

My preference: N/A

If you like to focus manually, this is a very useful aid, one of several that Sony generously offers to enhance the chore of achieving sharp focus without using autofocus features. To use the Focus Magnifier, just follow these steps:

- 1. **Enable Focus Magnifier.** The automatic function of the Focus Magnifier can be enabled with the MF Assist entry of the Custom Settings 1 menu, described in Chapter 4. When set to On, the magnifier kicks in whenever you are using manual focus.
- 2. **Switch to manual focus.** When MF Assist is activated, the Focus Magnifier operates automatically when the camera is set to manual focus. You can change to MF by pressing the AF/MF button when its switch is set to the AF/MF position.

Confusion alert: The function of the AF/MF button changes, depending on focus mode.

- **AF Mode.** When the camera is set to an AF mode, pressing the AF/MF button switches to manual focus *while you hold the button down*. As long as the button is held down, you can use the Focus Magnifier feature; when the button is released, autofocus is active again, and the Focus Magnifier cannot be used.
- Manual Focus Mode. When the camera is set to Manual focus mode, the *reverse* is true: the a7R II/a7 II is *by default* in MF mode, so the Focus Magnifier is automatically used. Pressing and holding the AF/MF button *temporarily* switches to autofocus until the button is pressed.

Note: You can also switch to manual focus by pressing the Fn button and using the Function menu to choose MF from among the focus mode choices. Manual focus can also be chosen by accessing the Focus Mode entry in the Camera Settings 3 menu, described earlier.

- 3. **Rotate the focus ring of your lens.** The image is enlarged, and a navigation window appears at lower left showing an orange rectangle that represents the current location of the blown-up section. (See Figure 3.18.)
- 4. **Adjust the magnified area.** A quartet of triangles surrounds the image, indicating that you can move the enlarged window around with the frame. Press and release the center button, and then use the left/right/up/down keys to move the enlarged area.

Figure 3.18
The focus magnifier makes manual focusing easier.

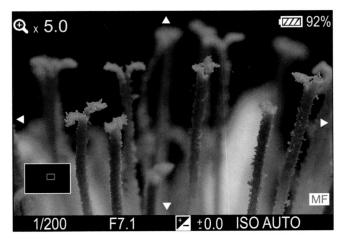

- 5. **Center the magnifier.** You can press the Trash button to center the magnified section back in the center of the frame.
- 6. Zoom in/out. Pressing the center button enlarges the image from 1X to 5X and 12.5X.
- 7. **Manually focus.** Rotate the lens's focus ring to achieve sharp focus. A scale along the bottom of the screen shows the approximate focus distance.
- 8. (Optional) Return to autofocus. Remember to return to autofocus when you no longer want to focus on your subject manually.

Long Exposure NR/High ISO NR

Long Exposure NR: Options: On/Off; Default: On

High ISO NR: Options: Normal, Low, Off; Default: Normal

My preference: Off for both

I've grouped these two menu options together because they work together, each under slightly different circumstances. Moreover, the causes and cures for noise involve some overlapping processes. Digital noise is that awful graininess that shows up as multicolored specks in images, and these menu items help you manage it. In some ways, noise is like the excessive grain found in some high-speed photographic films. However, while photographic grain is sometimes used as a special effect, it's rarely desirable in a digital photograph.

The visual noise-producing process is something like listening to a CD in your car, and then rolling down all the windows. You're adding sonic noise to the audio signal, and while increasing the CD player's volume may help a bit, you're still contending with an unfavorable signal-to-noise ratio that probably mutes tones (especially higher treble notes) that you really want to hear.

The same thing happens when the analog signal is amplified: You're increasing the image information in the signal, but boosting the background fuzziness at the same time. Tune in a very faint or distant AM radio station on your car stereo. Then turn up the volume. After a certain point, turning up the volume further no longer helps you hear better. There's a similar point of diminishing returns for digital sensor ISO increases and signal amplification as well.

Your a7R II/a7 II can reduce the amount of grainy visual noise in your photo with noise reduction processing. That's useful for a smoother look, but NR processing does blur some of the very fine detail in an image along with blurring the digital noise pattern. These two menu items let you choose whether or not to apply noise reduction to exposures of longer than one second and how much noise reduction to apply (Normal or Low) when shooting at a high ISO level (at roughly ISO 1600 and above).

High ISO NR is grayed out when the camera is set to shoot only RAW format photos. The camera does not use this feature on RAW format photos since noise reduction—at the optimum level for any photo—can be applied in the software you'll use to modify and convert the RAW file to JPEG or TIFF. (If you shoot in RAW & JPEG, the JPEG images, but not the RAW files, will be affected by this camera feature.) As well, high ISO Noise Reduction is never applied when the camera is set to Sweep Panorama, or continuous shooting, continuous bracketing, Sports Action, Hand-held Twilight, Anti Motion Blur scene mode, or when the ISO is set to Multi Frame Noise Reduction.

Digital noise is also created during very long exposures. Extended exposure times allow more photons to reach the sensor, but increase the likelihood that some photosites will react randomly even though not struck by a particle of light. Moreover, as the sensor remains switched on for the longer exposure, it heats up, and this heat can be mistakenly recorded as if it were a barrage of photons. To minimize the digital noise that can occur during long exposures, the a7R II/a7 II uses a process called "dark frame subtraction." After you take the photo, the camera fires another shot, at the same shutter speed, with the shutter closed to make the so-called dark frame. The processor compares the original photo and the dark frame photo and identifies the colorful noise speckles and "hot" pixels. It then removes (subtracts) them so the final image saved to the memory card will be quite "clean."

Context-Sensitive

The a7 II series has a novel "context-sensitive" noise-reduction algorithm that examines the image to identify smooth tones, subject edges, and textures, and apply different NR to each. This processing works best with areas with continuous tones and subtle gradations, and does a good job of reducing noise while preserving detail. Because the BIONZ X digital processing chip is doing so much work, you may see a message on the screen while NR is underway. You cannot take another photo until the processing is done and the message disappears. If you want to give greater priority to shooting, set Long Exposure NR and High ISO NR to Off.

Long Exposure NR works well, but it causes a delay; roughly the same amount of time as the exposure itself. That would be a long 10 seconds after a 10-second exposure. During this delay the camera locks up so you cannot take another shot. You may want to turn this feature off to eliminate that delay when you need to be able to take a shot at any time. This feature is Off by default in continuous shooting, bracketing, Panorama mode, and two scene modes, Sports Action and Handheld Twilight.

You might want to turn off noise reduction for long exposures and set it to a weak level for high ISO photos in order to preserve image detail. (NR processing blurs the digital noise pattern, but it can also blur fine details in your images.) Or, you simply may not need NR in some situations. For example, you might be shooting waves crashing into the shore at ISO 200 with the camera mounted on a tripod, using a neutral-density filter and long exposure to cause the pounding water to blur slightly. To maximize detail in the non-moving portions of your photos, you can switch off long exposure noise reduction.

Center Lock-On AF

Options: On, Off

Default: Off

My preference: Off

This setting, the first in the a7R II's Camera Settings 7 menu (shown in Figure 3.19), tells the camera to detect a subject positioned in the center of the frame and then adjust focus as the camera tracks its movement. A pair of white boxes appear in the EVF and LCD monitor. Move the camera to center the box on the subject you want to track and press the center button. The camera will then track that object as you reframe, or the subject moves, until you take a picture. Center Lock-On AF is not available at all when focus is set to manual.

Figure 3.19
Center Lock-on AF
is the first choice in
the a7R II's Camera
Settings 7 menu.

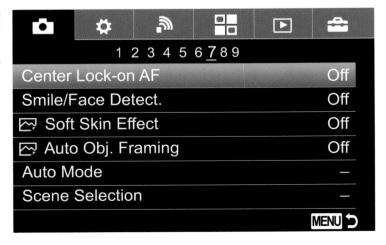

Like the Focus Magnifier function, this feature isn't "live" all the time once you've set it. It requires a trip to the Camera Settings menu each time you want to use it, unless you define a custom key to summon it. You can use the Custom 2 button if you don't want to apply it to the Focus Magnifier. Alternatively, choose another button that you don't use much while shooting. In my case, that's the ISO (right directional) button.

This feature is different from the Lock-On AF option, described in Chapter 4. They key differences:

- Menu/Key Access. Center Lock-On AF must be selected from this menu, or summoned with an assigned custom key. Lock-On AF, when active, can be triggered simply by pressing the shutter release halfway.
- Fixed Zone. Center Lock-On AF always uses the center of the frame to lock onto a subject. Lock-On AF can be set for any of the available focus area options, including Wide, Zone, Center, Flexible Spot, and Expand Flexible Spot.
- Available in Movie Mode. Center Lock-On AF, unlike Lock-On AF, can be used in Movie mode.

Smile/Face Detection

Options: Face Detection Off, Face Detection On (Registered Faces), Face Detection, Smile Shutter (Normal Smile, Slight Smile, Big Smile)

Default: Off

My preference: Off

Your camera can detect faces and zero in its focusing prowess on them. You can also tell the camera to use face detection to identify a face and look for a smile; it takes a photo each time it sees a smile (actually, it's just looking for an array of pearly white teeth). This is an interesting high-tech feature, because the subject's smile acts as a sort of remote control.

With this option activated, the camera will survey the subjects before it and try to determine if it is looking at any human faces. If it decides that it is, it sets focus, flash, exposure, and white balance settings for you. When a face is detected, the camera will select a main subject and place a white frame around that face. Press the shutter release halfway, and the frame around the priority face will turn green as the settings lock in. Other faces in the picture will be framed in gray, or, if that face has been logged using Face Registration, a magenta frame will appear. Your options include:

- Face Detection Off. Disables all face detection.
- Face Detection On (Registered Faces). When set to On (Registered Faces), any faces previously logged will be given priority. As you press the shutter button to take the picture, the camera will attempt to set the exposure and white balance using the face it has selected as the main subject. If that result is not what you want, you can start over, or you may want to take

control back from the camera by choosing Flexible Spot or Center for the Autofocus Area and placing the focus spot exactly where you want it.

You'll need to register faces you want to recognize separately using a Face Registration option, and even assign a priority for up to eight faces (ranking them 1 to 8 on your face recognition speed dial). Sony has hidden the registration feature, as you might guess by now, in a completely different menu, specifically the Custom Settings 6 menu. Happy hunting! I'll describe the process in Chapter 4.

- Face Detection. In this mode, the camera diligently looks for any human face it can find, and doesn't care who it belongs to. Use this option if you have few friends, or, more than eight that you don't want to offend.
- Smile Shutter. Activate this feature, and press the left/right buttons to specify Normal Smile (the default), Big Smile, and Slight Smile. Set Big Smile, for example, and the camera won't take a photo when the detected face smiles only slightly; it will wait for a serious toothy grin. You will need to experiment to find out which level to use. The sensitivity of this feature depends on factors such as whether the subject shows his or her teeth when smiling, whether the eyes are covered by sunglasses, and others. I suggest leaving it at Normal Smile, changing it only if that does not work as you had expected.

There is no limit to the number of smiles and images you can take with this feature; you, or whoever is in front of the camera, can keep smiling repeatedly, and the camera will keep taking more pictures until it runs out of memory storage or battery power. Of course, the main purpose of this feature is not to act as a remote control; it's really intended to make sure your subject is smiling before the photo is taken. Whenever Smile Shutter triggers the shutter release, it also flashes the red light of the AF Illuminator as a signal to the person that a picture is being taken.

Soft Skin Effect

Options: Off/On (Lo, Mid, Hi)

Default: Off

My preference: Off

This item can be used to instruct the camera's processor to minimize blemishes and wrinkles in the detected face, which usually helps produce a more flattering picture. I find it more suitable for photos of women than of men. If you choose On, press the left/right buttons and select the low, middle, or high intensity for skin softening. This effect does not work when shooting movies or in any continuous shooting mode, including bracketing and continuous self-timer, nor when using the Sports Action scene mode, Sweep Panorama, or RAW capture mode.

Auto Object Framing

Options: Off/Auto

Default: Auto

My preference: Off

When this feature is active, the a7R II/a7 II analyzes three types of images: close-up shots, images taken using Center Lock-On AF (discussed earlier), and images containing faces (only when Face Detection is activated). When it's On and the camera detects a close-up subject, tracked object, or face, it takes the photo as you composed it but also makes another image and saves that to the memory card as well. This second photo is made after cropping the photo you had composed into one that the camera thinks is a more pleasing composition. If you have Setting Effect On specified in the Live View Display entry of the Custom Settings 2 menu, a white frame appears to show the cropped area before it is stored. The camera's processor uses the Rule of Thirds compositional technique when making its cropping decision so the eyes will not be in the center of the image area, for example.

Since cropping makes the image smaller, the processor adds pixels to ensure that the photo will be full size. It uses Sony's By Pixel Super Resolution Technology for the "up sampling"; this technology maintains very good image quality.

My recommendation: Certainly, Auto Object Framing is a feature intended to attract novices and inveterate snap shooters, but I find it useful at parties when taking quick shots of friends; in most cases, the photo with automatic cropping is preferable to the original (sloppily composed) shot. Of course, both photos are available on the memory card so you can use either of them.

Auto Mode

Options: Intelligent Auto, Superior Auto

Default: Intelligent Auto

My preference: Superior Auto

This entry allows you to specify which of the camera's two fully auto modes (Intelligent Auto and Superior Auto) is activated when the mode dial is moved to the Auto position. Most users of a camera as sophisticated as this one won't use either one very often, so Sony has uncluttered the mode dial by allowing you to specify which of the two Auto modes you'd like to activate by default. This entry is grayed out (unavailable) if the mode dial is not set to the Auto position.

Scene Selection

Options: Select Scene Modes

Default: None

My preference: N/A

This entry is available *only* when the mode dial is set to SCN. It provides an alternate method for choosing among the available scene modes. Rotate the front or rear dials, the control wheel, or use the up/down buttons to select the scene mode you would like to use. It would have been brilliant if Sony had made Scene Selection one of the definable actions for a custom key (at least for those who use scene modes a lot) as there are already 50 choices, but no such luck. However, this entry is here if you want to use it.

Movie

Options: Program Auto, Shutter Priority, Aperture Priority, Manual Exposure

Default: Program Auto

My preference: Program Auto works well for me when shooting movies

This setting is the first on the a7R II's Camera Settings 8 menu. (See Figure 3.20.) It is available only when the mode dial is in the Movie position and allows you to specify which exposure mode is used (from among P, S, A, and M options) when shooting movies; the mode you select can be different from the one set for still photography mode.

Figure 3.20 The a7R II's Camera Settings 8 menu.

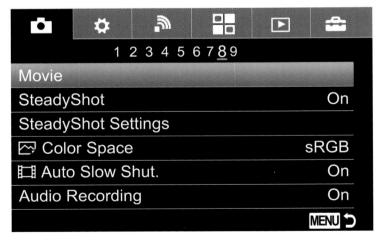

SteadyShot

Options: On, Off

Default: On

My preference: On

The a7 II—series cameras are the first Sony mirrorless cameras that have both in-body image stabilization (the awesome 5-axis SteadyShot that so many of us are crazy about), and the ability to use optical image stabilization (Optical SteadyShot or OSS) built into certain lenses. Both systems work well with each other and can be used simultaneously. If for some reason you want to disable SteadyShot, you can use this menu entry.

SteadyShot is on by default to help counteract image blur that is caused by camera shake, but you should turn it off when the camera is mounted on a tripod, as the additional anti-shake feature is not needed, and slight movements of the tripod can sometimes "confuse" the system. In other situations, however, I recommend leaving SteadyShot turned on at all times.

SteadyShot Settings

Options: Auto, Manual

Default: Auto

My preference: Auto

This setting allows the camera to adjust the behavior of SteadyShot, based on the amount of image stabilization typically required at particular focal lengths. That is, telephoto lenses "magnify" camera shake and thus can benefit from more aggressive image stabilization. Indeed, this aspect is one reason why in-lens IS is often touted as superior to in-body stabilization. Your a7R II/a7 II gives you the opportunity to benefit from both!

- **Auto.** When this default setting is chosen, the camera receives focal length information electronically from the lens, and can activate the appropriate amount of SteadyShot anti-shake.
- Manual. You can enter the focal length of the lens or the zoom position from the range 8mm to 1000mm. This is especially useful if you're working with a teleconverter, which produces magnification beyond that which the camera can detect from the supplied lens data alone. It's also a good option if you are using a lens (possibly a "foreign" lens with an adapter) that cannot communicate focal length to the a7R II/a7 II.

Color Space

Options: sRGB, Adobe RGB

Default: sRGB

My preference: sRGB

This menu item gives you the choice of two different color spaces (also called color gamuts). One is named Adobe RGB, an abbreviation for Adobe RGB (1998), so named because it was developed by Adobe Systems in 1998, and the other is sRGB, supposedly because it is the *standard* RGB color space. These two color gamuts define a specific set of colors that can be applied to the images your Alpha captures.

You're probably surprised that the a7 II—series cameras don't automatically capture all the colors we see. Unfortunately, that's impossible because of the limitations of the sensor and the filters used to capture the fundamental red, green, and blue colors, as well as that of the LEDs used to display those colors on your camera and computer monitors. Nor is it possible to print every color our eyes detect, because the inks or pigments used don't absorb and reflect colors perfectly.

Instead, the colors that can be reproduced by a given device are represented as a color space that exists within the full range of colors we can see. That full range is represented by the odd-shaped splotch of color shown in Figure 3.21, as defined by scientists at an international organization back

Figure 3.21
The outer figure shows all the colors we can see; the two inner outlines show the boundaries of Adobe RGB (black triangle) and sRGB (white triangle).

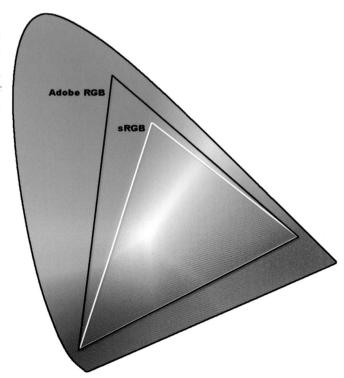

ADOBE RGB vs. sRGB

You might want to use sRGB, which is the default for the Sony camera, as it is well suited for the colors displayed on a computer screen and viewed over the Internet.

(It is possible to buy a specialized and very expensive computer monitor that's specifically designed to display nearly the entire Adobe RGB (1998) color gamut, such as the EIZO SX2762W, which sells for about \$1,500 in the U.S., but I doubt that many readers own a monitor of that type.) As well, images made in sRGB color space are fine for use with inexpensive inkjet printers that use three ink colors in a single cartridge. Note too that most mass market print-making services (including kiosks and online photofinishers) have standardized on sRGB because that is the color space that 95 percent of their customers use.

Adobe RGB's expanded color space is preferable for professional printing. Because it can reproduce a wider range of colors than sRGB, it's definitely a better choice if you own a high-end inkjet photo printer that employs five or more color ink cartridges. Since pro and custom printing labs also use machines of this type, they'll provide the best results in prints made from images in the Adobe color space. You'll get slightly richer cyan-green mid tones, a bit more detail in dark green tones, and more pleasing orange-magenta highlights (as in a sunset photo).

So, if you often make inkjet prints using a high-end machine, or order prints from custom or pro labs, it makes sense to set the camera to Adobe RGB. Later, if you decide to use some of the photos on a website, you can convert them to sRGB in your image-editing software.

in 1931. The colors possible with the camera's Adobe RGB option are represented by the larger, black triangle in the figure, while the sRGB gamut is represented by the smaller, white triangle. As the illustration indicates, Adobe RGB (1998) is an expanded color space, because it can reproduce a range of colors that is spread over a wider range of the visual spectrum.

Regardless of which triangle—or color space—is used by the Sony a7 II–series camera, you end up with 16.8 million different colors that can be used in your photograph. (No one image will contain all 16.8 million!) But, as you can see from the figure, the colors available will be different.

Auto Slow Shutter

Options: On, Off

Default: On

My preference: Off

When shooting movies in very dark locations, the best way to ensure that the video clips are bright is to use a slow shutter speed. When this menu item is On, the camera can automatically switch to a slower shutter speed than its default. This is a useful feature, since it works in any camera operating mode; there's no need to use S mode and set a slow shutter speed yourself in dark locations. I

like to leave it off, because when I am capturing video with a slow shutter speed, I want to make sure I have the camera mounted on a tripod, and the need to activate this feature manually is a reminder to me that I need to do so.

Audio Recording

Options: On, Off

Default: On

My preference: On

Use this item to turn off sound recording when you're shooting videos, if desired. In most cases you'll want to leave the setting On, in order to capture as much information as possible; the audio track can be deleted later, if desired, with software. However, there could be occasions when it's useful to disable sound recording for movies, for example, if you know ahead of time that you will be dubbing in other sound, or if you have no need for sound, such as when panning over a vista of the Grand Canyon. At any rate, this option is there if you want to use it.

Audio Rec Level

Options: On, Off

Default: On

My preference: On

This is the first entry on the a7R II's Camera Settings 9 menu. (See Figure 3.22.) You can adjust the recording level of the camera's built-in or external microphones using this entry, which also enables/disables the audio level overlay on the screen while movies are captured.

Figure 3.22 The a7R II's Camera Settings 9 page.

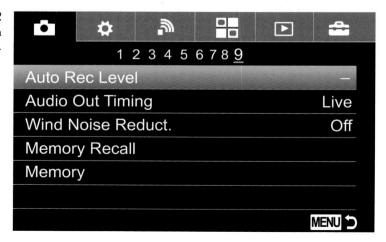

To use this feature, just follow these steps:

- 1. Rotate the mode dial to the Movie position.
- 2. Navigate to the Camera Settings 9 menu, highlight Audio Rec Level, and press the center button.
- 3. The screen shown in Figure 3.23 appears. Rotate the front or rear dials or control wheel, or use the left/right buttons to adjust the volume level up or down.
- 4. Press the center button to confirm and exit the screen.
- 5. Alternatively, you can use the up/down buttons to highlight Reset to return the recording level to the default value. Then press MENU to exit.
- 6. If Audio Recording and Audio Level Display are set to On, an overlay appears at the lower left of the EVF or LCD monitor showing the current audio levels for the left/right channels (Ch1/Ch2).

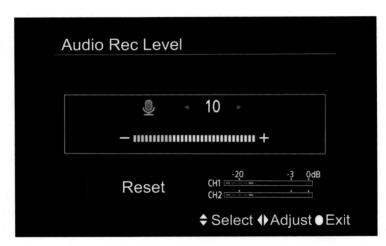

Figure 3.23 Set Audio level.

Audio Out Timing

Options: Live, Lip Sync

Default: Live

My preference: Live

With the a7 II series, *audio out* refers to the sound signal you hear when monitoring the recording through the camera's headphone jack. In this mode, the sound you hear may be slightly out of sync with the video, because the video has to be processed by the camera's digital processing chip before you see it on the LCD or EVF. Sony offers two different audio modes that can ignore or compensate for this lag.

- Live mode. Allows you to hear the sound being recorded in real time, with no delay. Use this mode if you are watching the action in the scene directly, rather than through the viewfinder or EVF.
- Lip Sync mode. In this mode, the audio and video shown while the movie is being captured are delayed by the same amount, and will be in sync with each other if you monitor using headphones in conjunction with the EVF or LCD.

Wind Noise Reduction

Options: On, Off

Default: Off

My preference: Off

Designed to muffle the howling sound produced by a loud wind passing over the built-in microphones, this item (when On) is for use when recording video. It's off by default because Wind Noise Reduction (provided by the camera's processor) does degrade sound quality, especially bass tones, and the recording volume is reduced. I recommend setting it to On only when shooting in a location with loud wind noises.

Memory Recall

Options: Select register to store settings

Default: None

My preference: N/A

The a7R II/a7 II give you the option of storing up to two different groups of settings in separate registers, and then recalling those settings for use later. Note that you can *store* sets of settings when using any shooting modes (using the Memory entry that follows). But to *recall* a set of stored settings, you must rotate the mode dial to one of the two Memory positions, marked with a 1 and a 2 on the dial. I'll explain recalling settings here, and show you how to store them under the next menu entry, Memory.

This item is a powerful and useful tool. It enables you to save almost all of the settings that you use for a particular shooting situation, and then recall them quickly. This function lets you save a pair of distinct sets of camera settings. Each will be a custom-crafted set that you can activate at any time. Simply activate the set that fits your current needs. For example, you might set up Register 1 with the settings you use while shooting volleyball in an indoor arena and Register 2 for use in landscape photography outdoors. Whenever you encounter any of those three types of scenes, activate the memory channel with the suitable settings for that situation. You can then begin shooting immediately.

There are two ways to activate saved settings:

- **Mode dial.** Simply rotate the mode dial to the 1 or 2 position. A set of settings for each of those positions is stored internally in the camera. When the mode dial is switched to 1 or 2, the settings in that camera register automatically become active.
- Memory Recall. This menu entry allows you to recall *additional* memory settings, numbered M1, M2, M3, and M4, which are stored on the memory card currently in the camera. You can load the M1, M2, M3, or M4 settings into the 1 or 2 mode dial positions. That may be confusing at first, but the bottom line is that the a7R II/a7 II can use *either of two memory registers* (1 and 2), but either of those two can be loaded with any of four sets of settings *on your current memory card*. Switch memory cards, and you can access four more! Remove your card (or reformat it), and those extra four settings are lost! (Smart move, Sony.)

SETTINGS LIBRARY

You can keep separate memory cards for each type of photography you like to do, and store M1, M2, M3, and M4 settings on each of them. But remember when you reformat the card, those settings are lost.

To recall settings previously stored on your memory card using Memory Recall, just follow these steps:

- 1. **Rotate the mode dial to the 1 or 2 positions.** Select the position containing the settings you would like to recall.
- 2. Access the Memory Recall entry. Navigate to this menu entry. When you press the center button, a screen similar to the one shown in Figure 3.24 appears.

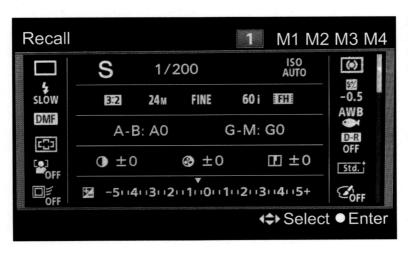

Figure 3.24
Recall settings
stored on your memory card.

- 3. Choose your stored settings. The 1 highlighted in orange in the figure indicates that the mode dial has been set to the 1 position. The M1, M2, M3, and M4 entries represent four different sets of settings stored and associated with the 1 position. Highlight the settings stored on your memory card that you want to recall.
- 4. **Confirm.** Press the center button to confirm your choice and exit. Your settings are now active in the camera.

Memory

Options: Store settings on your memory card

Default: None

My preference: N/A

The power of the memory feature stems from the fact that so many shooting settings can be saved for instant recall in any memory register. Before you access the Memory item in the menu, make the desired settings in terms of camera operating mode, drive mode, ISO, white balance, exposure compensation, metering mode, and focus mode. Then, to save your current settings on your memory card in one of the M1, M2, M3, or M4 slots, just follow these steps:

- 1. **Set up your camera.** Set your camera to the shooting mode, and adjust the camera to use the settings you'd like to store. The register can preserve shooting mode, aperture, shutter speed, and settings from the Camera Settings menu.
- 2. **Navigate to Memory entry.** Select the Memory entry in the Camera Settings 9 menu, and press the center button. A screen like the one shown in Figure 3.25 appears.

Figure 3.25 Store settings in the 1 or 2 mode dial positions, or as M1, M2, M3, or M4 on your memory card.

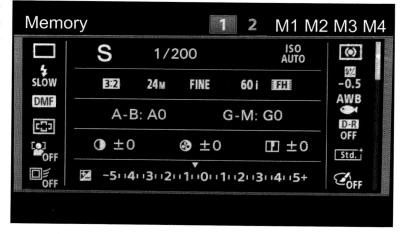

- 3. **Review settings.** Use the up/down buttons to scroll through the current settings to make sure they are satisfactory. A great deal more information is available than is shown in the figure (note the scroll bar at right). You can press the up/down buttons to view additional screens with detailed listings of your current settings. Exit and change desired settings, then start again at Step 2.
- 4. **Choose Register.** Press the left/right buttons to select which of the memory locations you'd like to store your current settings in.
 - If you choose 1 or 2, the settings will be loaded into the camera's memory and will be available regardless of which memory card is in the camera.
 - If you choose M1, M2, M3, or M4, the settings will be stored on the memory card and will be available *only* when that memory card resides in the camera.
- 5. **Proceed or cancel.** Press the center button to confirm and store your settings, or the MENU button to cancel.
- 6. Activate register. To use your stored settings, rotate the mode dial to Register 1 or Register 2.

Custom Settings Menu

Additional shooting options are available from the Sony a7R II/a7 II's Custom Settings menu. Custom Settings are adjustments that you generally don't make during a particular shooting session, but need to tweak more often than those in the Setup menu, which is described in Chapter 6. This menu has some very cool features, including the ability to assign as many as 63 different behaviors to 11 different keys on your camera or lens.

Custom Settings Menu

There are 43 different Custom Settings for the a7R II and 38 for the a7 II (which lacks a full electronic shutter for silent shooting). They are used to adjust a variety of autofocus and manual settings (12 of those, in all), as well as exposure, display, and other options.

- Zebra
- MF Assist
- Focus Magnifier Time
- Grid Line
- Marker Display
- Marker Settings
- Audio Level Display
- Auto Review
- DISP Button
- Peaking Level
- Peaking Color
- Exposure Settings Guide

- Live View Display
- Display Continuous AF Area
- Phase Detect, Area
- Pre-AF
- Zoom Setting
- Eye-Start AF
- FINDER/MONITOR
- Release w/o Lens
- Release without Card (a7R II Only)
- Priority Set in AF-S

- Priority Set in AF-C
- AF w/Shutter
- AEL w/Shutter
- Silent Shooting (a7R II Only)
- E-Front-Curtain Shutter
- Superior Auto Image Extraction
- Exposure Compensation Set.
- Reset EV Compensation
- Bracket Order (a7 II Only)

- Face Registration
- APS-C/Super 35mm
- AF Micro Adjust
- Lens Compensation
- AF System (Stills) (a7R II Only)

- Video Light Mode (a7R II Only)
- Function Menu Set.
- Custom Key Settings
- Dial Setup
- Dial Ev Comp

- Zoom Ring Rotate
- MOVIE Button
- Dial/Wheel Lock

7ehra

Options: Off, IRE 70, 75, 80, 85, 90, 95, 100, 100+

Default: Off

My preference: 80

This feature, the first entry in the Custom Settings 1 menu (shown in Figure 4.1), warns you when highlight levels in your image are brighter than a setting you specify in this menu option. It's somewhat comparable to the flashing "blinkies" that digital cameras have long used during image review to tell us, after the fact, which highlight areas of the image we just took are blown out.

Zebra patterns are a much more useful tool, because you are given an alert *before* you take the picture, and can actually specify exactly how bright *too bright* is. The Zebra feature has been a staple of professional video shooting for a long time, as you might guess from the moniker assigned to the unit used to specify brightness: IRE, a measure of video signal level, which stands for *Institute of Radio Engineers*.

When you want to use Zebra pattern warnings, access this menu entry and specify an IRE value from 70 to 100, or 100+. Once you've been notified, you can adjust your exposure settings to reduce the brightness of the highlights, as I'll describe in Chapter 7.

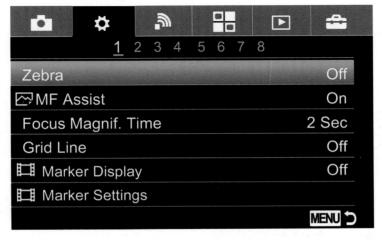

Figure 4.1Zebra is the first entry in the Custom Settings 1 menu.

So, exactly how bright *is* too bright? A value of 100 IRE indicates pure white, so any Zebra pattern visible when using this setting (or 100+) indicates that your image is extremely overexposed. Any details in the highlights are gone, and cannot be retrieved. Settings from 70 to 90 can be used to make sure facial tones are not overexposed. As a general rule of thumb, Caucasian skin generally falls in the 80 IRE range, with darker skin tones registering as low as 70, and very fair skin or lighter areas of your subject edging closer to 90 IRE. Once you've decided the approximate range of tones that you want, to make sure you do *not* blow out, you can set the camera's Zebra pattern sensitivity appropriately and receive the flashing striped warning on the LCD of your camera. (See Figure 4.2.) The pattern does not appear in your final image, of course—it's just an aid to keep you from blowing it, so to speak.

Figure 4.2
The flashing stripes show an area is overexposed.

MF Assist

Options: On, Off

Default: On

My preference: On

When you are using manual focus or manual focus in the DMF mode, the camera enlarges the screen so you can better judge by eye whether the important part of your subject is in sharp focus. As you begin to focus manually by rotating the focus ring on the lens, the image on the LCD will appear at five times its normal size (press the center button to zoom in to 12.5X). This is called the Focus Magnifier, and was described in Chapter 3. It is available only for still photography. You can then scroll around the image using the four direction buttons. This feature makes it easier to check whether the most important subject area is in the sharpest focus. When you stop turning the focus ring, the image on the LCD display will revert back to normal (non-magnified) so you can see the entire area that the camera will record. You can turn this feature Off however, if you find that you don't need it, and adjust the magnifier time-out using the entry described next.

Focus Magnifier Time

Options: 2 sec., 5 sec., No Limit

Default: 2 sec.

My preference: 5 sec.

This entry can be used to specify the length of time that the MF Assist feature will magnify the image during manual focusing. If you find that it takes you longer than two seconds to manually focus using MF Assist, you can change the time to five seconds, or to No Limit; the latter will cause the image to remain magnified until you tap the shutter release button (you don't need to actually take a picture).

Grid Line

Options: Rule of 3rds Grid, Square Grid, Diag.+Square Grid, Off

Default: Off

My preference: Off

This feature allows you to activate one of three optional grids, so it's superimposed on the LCD or EVF display. The grid pattern can help you with composition while you are shooting architecture or similar subjects. I sometimes use the Rule of Thirds grid to help with composition, but you might want to activate another option when composing images of scenes that include diagonal, horizontal, and perpendicular lines. (See Figure 4.3.)

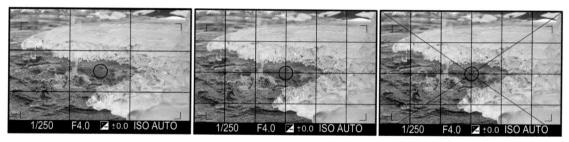

Figure 4.3 Grid lines can help you align your images on the LCD.

Marker Display

Options: On, Off

Default: On

My preference: N/A

When shooting video that will end up being displayed in other than HDTV's 16:9 ratio, it's useful to know exactly where the boundaries of other types of frames are, so the image can be composed to keep important subject matter contained within those boundaries. This setting lets you turn the display of any of four different types of markers on or off, as described in the Market Settings entry that follows.

Marker Settings

Options: Center, Aspect Ratio, Safety Zone, Guide Frame

Default: Center

My preference: N/A

This entry allows you to choose which markers are displayed during video capture. You can select any or all of the following, if you like, although using more than one or two markers is likely to be confusing. Your choices (shown in Figure 4.4) are as follows:

- Center—On/Off. Whether or not the center marker is shown in the middle of the shooting screen. The default value is Off.
- Aspect Ratio—Off / 4:3 / 13:9 / 14:9 / 15:9 / 1.66:1 / 1.85:1 / 2.35:1. This activates a marker showing your preferred aspect ratio. The default is Off.
- Safety Zone—Off / 80% / 90%. Sets the safety zone display that represents the standard range that can be received by a household standard-definition television.
- **Guide Frame**—**On/Off.** Enables/disables a guide frame that can be used to verify whether a subject is parallel or perpendicular.

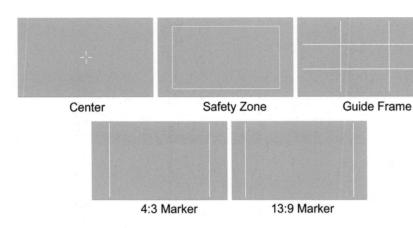

Figure 4.4 Video guide markers.

Audio Level Display

Options: On, Off

Default: On

My preference: N/A

The first entry in the Custom Settings 2 menu (see Figure 4.5) enables/disables display of audio level indicator bars, so you can monitor sound recording levels visually. The volume bars do not appear when Audio Recording is set to Off, or the DISP setting is set to No Disp. Info.

Auto Review

Options: Off, 2 sec., 5 sec., 10 sec.

Default: 2 sec.

My preference: N/A

When this item is set to 2, 5, or 10 seconds, the camera can display an image on the LCD or view-finder for your review immediately after the photo is taken. (When you shoot a continuous or bracketed series of images, only the last picture that's been recorded will be shown.) During this display, you can delete a disappointing shot by pressing the Delete button, or cancel picture review by tapping the shutter release button or performing another function. (You'll never be prevented from taking another picture because you were reviewing images.) This option can be used to specify whether the review image appears for 2, 5, or 10 seconds, or not at all.

Depending on how you're working, you might want a brief display or you might prefer to have time for a more leisurely examination (when you're carefully checking compositions). Other times, you might not want to have the review image displayed at all, such as when you're taking photos in a darkened theater or concert venue, and the constant flashing of images might be distracting to others. Turning off picture review or keeping the duration short also saves battery power. You can always review the last picture you took at any time by pressing the Playback button.

DISP Button

Options (Monitor): Graphic Display, Display All Info., No Disp. Info., Histogram, Level, For Viewfinder

Options (Viewfinder): Graphic Display, Display All Info., No Disp. Info., Histogram, Level **Default:** Graphic Display, Display All Info., No Disp. Info.

My preference: Activate all but Graphic Display

Use this item to specify which of the available display options will—and will not—be available in Shooting mode when you use the LCD or viewfinder and press the DISP button to cycle through the various displays. Choose from Monitor or Viewfinder and mark or unmark the screens you want to enable or disable. The Monitor selection (see Figure 4.6, left) includes a For Viewfinder option that displays a text/graphic display of your current settings on the back panel LCD. (See Figure 4.7.)

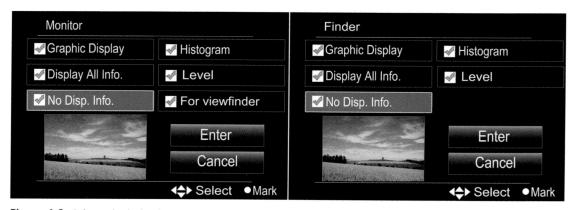

Figure 4.6 Select which display screens are shown on the LCD monitor (left) or viewfinder (right).

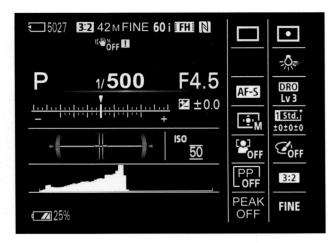

Figure 4.7
For Viewfinder Display.

You can use this menu item to deselect one or more of the display options so it/they will never appear on the LCD when you press the DISP button. To make that change, scroll to an option and press the center button to remove the check mark beside it. Naturally, at least one display option must remain selected. If you de-select all of them, the camera will warn you about this and it will not return to Shooting mode until you add a check mark to one of the options. If you turn the camera off while none are selected, the camera will interpret this as a Cancel command and return to your most recent display settings.

The same screens (other than For Viewfinder) are shown in the electronic viewfinder with slight differences. At the bottom of the viewfinder version is an analog exposure indicator; and the viewfinder/monitor displays can be different. That is, you can choose to view the Graphic Display in the EVF, and Display All Info on the LCD monitor.

Here's a recap of the available display options for the monitor.

- For Viewfinder. This display can be shown only on the LCD monitor. When visible, you can press the Fn button to produce the Quick Navi screen, which I explained in Chapter 2.
- **Graphic Display.** When selected, this display shows basic shooting information, plus a graphic display of shutter speed and aperture (except when Sweep Panorama is the mode in use). If you learn how to interpret it, you'll note that it indicates that a fast shutter speed will freeze motion, that a small aperture (large f/number) will provide a great range of acceptably sharp focus, and other information of this type. (See Figure 4.8.)
- **Display All Info.** The default screen when you first turn the camera on, this option displays data about current settings for a complete overview of recording information. (See Figure 4.9.) Not all of the information in the figure may be displayed at one time, and there are additional icons not shown because they occupy the same space on the screen as another indicator.

- **No Disp. Info.** In spite of its name, this display option provides the basic shooting information as to settings, in a conventional size. (See Figure 4.10.)
- **Histogram.** Activate this option if you want to be able to view a live luminance histogram to assist you in evaluating the exposure before taking a photo, a feature to be discussed in Chapter 9. The basic shooting data will appear in addition to the histogram. (See Figure 4.11.)
- Level. This display shows how much the camera is rotated around the lens axis (horizontal tilt) as well as how far it is tilted forward and backward. When the camera is not perfectly level, orange indicators show the amount of forward/backward and horizontal tilt. (See Figure 4.12.) When the camera is level in both directions, the indicators turn green. (See Figure 4.13.)

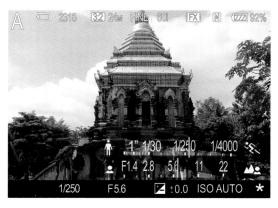

Figure 4.8 Graphic Display.

Figure 4.10 The No Display Information option actually does provide some data.

Figure 4.9 Display All Information.

Figure 4.11 Histogram Display.

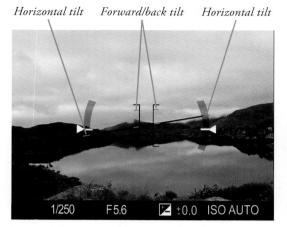

Figure 4.12 Orange indicators show the amount of tilt.

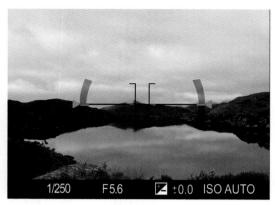

Figure 4.13 When the camera is level, the indicators turn green.

Peaking Level

Options: High, Mid, Low, Off

Default: Off

My preference: High

This is a useful manual focusing aid (available only when focusing in Manual and Direct Manual modes) that's difficult to describe and to illustrate. You're going to have to try this feature for yourself to see exactly what it does. *Focus peaking* is a technique that outlines the area in sharpest focus with a color; as discussed below, that can be red, white, or yellow. The colored area shows you at a glance what will be very sharp if you take the photo at that moment. If you're not satisfied, simply change the focused distance (with manual focus). As the focus gets closer to ideal for a specific part of the image, the color outline develops around hard edges that are in focus. You can choose how much peaking is applied (High, Medium, and Low), or turn the feature off.

Peaking Color

Options: White, Red, Yellow

Default: White

My preference: N/A

Peaking Color allows you to specify which color is used to indicate peaking when you use manual focus. White is the default value, but if that color doesn't provide enough contrast with a similarly hued subject, you can switch to a more contrasting color, such as red or yellow. (See Figure 4.14 for an example using a butterfly.)

Figure 4.14
You can choose any of three colors for peaking color (for manual focus), but only if you have activated the Peaking Level item. For this butterfly, red was a better choice than white or yellow.

Exposure Settings Guide

Options: On, Off

Default: On

My preference: N/A

This feature is of most use to those with poor eyesight, but a convenience for all. All it does is show a scrolling scale on the LCD or viewfinder with an enlarged rendition of the current shutter speed or aperture highlighted in orange. It more or less duplicates the display of both that already appears on the bottom line of the screen, but in a larger font and with the next/previous setting flanking the current value. In Aperture Priority, the scale shows f/stops. In Shutter Priority, you see shutter speeds. In Program mode, both are visible. When using Manual exposure, a single scrolling line appears showing shutter speed *or* aperture, depending on whether you rotate the rear or front dials. I like to leave it switched on, as the display is a reminder of which parameter I'm fooling with at the moment.

Live View Display

Options: Setting Effect ON, Setting Effect OFF

Default: Setting Effect ON

My preference: Setting Effect ON, unless using flash in manual mode.

This is the first entry in the Custom Settings 3 menu (see Figure 4.15). As a mirrorless camera, the a7 II—series cameras are always in a "live view" mode, showing you what the sensor sees. This entry lets you specify whether the camera should apply any exposure settings or effects that you've selected to the image before presenting it to you as a preview.

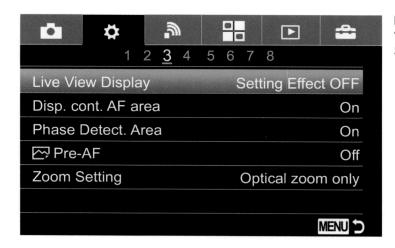

Figure 4.15
The Custom
Settings 3 menu.

There are times when you don't want to see the effects of the settings you've made on the screen/ EVF. For example, when you are using flash in manual mode, the camera has no way of knowing exactly how much light will be illuminating your scene. That f/16 aperture may be ideal for a shot exposed by your studio strobes, but the a7R II/a7 II will, when Setting Effect is set to ON, show you a preview based on the ambient light, rather than the flash. The result? Your viewfinder or LCD monitor image is very, very dim. You'll want to select Setting Effect OFF so the camera will boost the electronic image to viewable levels.

When Setting Effects are active, the live view display in the EVF or the LCD reflects the *exact* effects of any camera features that you're using to modify the view, including as exposure compensation and white balance. In that mode, this allows for an accurate evaluation of what the photo will look like and enables you to determine whether the current settings will provide the effects you want.

The ON option can be especially helpful when you're using any of the Picture Effects, because you can preview the exact rendition that the selected effect and its overrides will provide. It's also very useful when you're setting some exposure compensation, as you can visually determine how much lighter or darker each adjustment makes the image. And when you're trying to achieve correct color balance, it's useful to be able to preview the effect of your white balance setting.

If you'd like to preview the image without the effect of settings visible, you can set this feature to OFF. Naturally, the display will no longer accurately depict what your photo will look like when it's taken. So, for most users, ON is the most suitable option. Unfortunately, this setting has caused more than a few minutes of head-scratching among new users who switch to Manual exposure mode and find themselves with a completely black (or utterly white) screen. The black screen, especially, may fool you into thinking your camera has malfunctioned.

Display Continuous AF Area

Options: On, Off

Default: On

My preference: On

This item determines whether the previewing display on the monitor or EVF shows the active Wide or Zone focus areas when you're using Continuous AF. It has no effect on their display if you're using Center or Flexible Spot in Continuous AF area modes, or autofocus modes other than AF-C.

Sometimes too much information can be distracting. That's especially true in AF-C mode, because if you've framed a moving subject, the camera can continue to change the active focus areas if your subject is moving. In Wide mode, you may be treated to a dancing array of green rectangles squirming around on your screen as the a7R II/a7 II focuses and refocuses in anticipation of you eventually pressing the shutter release all the way down and taking a picture. I think that the constantly shifting focus requires less continual feedback about what focus areas are being used, so you may want to switch the feature off. In my case, I don't mind the display, and I tend to leave it on most of the time, even though it consumes a little more battery power.

Phase Detect. Area

Options: On, Off

Default: On

My preference: On

The a7R II and a7 II both have phase detection points embedded in their full-frame sensors; there are 399 in the a7R, and 117 included in the sensor of the a7 II. This entry allows you to enable or disable *display* of the phase detect points on the viewing screen. The area is not shown when the camera is set for APS-C crop mode, nor when shooting movies.

Pre-AF

Options: Off, On

Default: Off

My preference: N/A

This setting tells the camera to attempt to adjust the focus even before you press the shutter button halfway, giving you a head start that's useful for grab shots. When an image you want to capture appears, you can press the shutter release and take the picture a bit more quickly. However, this pre-focus process uses a lot of juice, depleting your battery more quickly, which is why it is turned off by default. Reserve it for short-term use during quickly unfolding situations where the slight advantage can be useful.

Zoom Setting

Options: Optical Zoom Only, ClearImage Zoom, Digital Zoom

Default: Optical Zoom Only

My preference: Optical Zoom Only

As I mentioned in Chapter 3 when describing the Camera Setting menu's Zoom entry, the a7 II series has three different types of zoom settings: Optical Zoom, ClearImage Zoom, and Digital Zoom, and you can choose any *one* of them here. My preference is to stick with optical zoom only. I own lots of great lenses, and don't hesitate to switch to one of them when I need some extra reach. Neither ClearImage nor Digital Zoom give me the image quality I am looking for. However, if you don't own a lens with enough telephoto magnification and/or don't need the best quality for some applications, the two electronic zoom modes are available.

They are most practical with the a7R II, as its 42.2-megapixel sensor has resolution to waste. Of course, you can always shoot without the electronic zoom features and crop to the effective magnification you want in your image editor. ClearImage Zoom and Digital Zoom are not available when using Sweep Panorama, Smile Shutter, or when Image Quality is set to RAW or RAW & JPEG. When working with those ersatz zooms, the metering mode is locked at Multi, and Focus Area setting is disabled (the focus area frame in the zoomed image is shown by a dotted line).

Eye-Start AF

Options: On, Off

Default: Off

My preference: Off

This is the first entry in the Custom Settings 4 menu (see Figure 4.16). The feature is set to Off by default, but when turned On, the camera will start autofocusing the instant you move the view-finder to your eye. The display on the LCD vanishes, the camera adjusts autofocus, and, if you're using any operating mode other than Manual, it sets the shutter speed and/or aperture so you're ready to take the shot. You don't even need to touch the shutter release button or another button to summon autofocus. Of course, it's not magic. There are two sensors just above the viewfinder window that detect when your face (or anything else) approaches the finder.

This is useful because it increases the odds of capturing a fleeting moment. On the other hand, some people find this feature annoying. When it's On, the camera will begin to autofocus every time a stray hand or other object passes near the viewfinder. Also, if you're wearing the camera around your neck, you may hear a continuous clicking as the camera rubs against your body, triggering the focusing mechanism. When this happens frequently, it will consume a significant amount of battery power.

After experimenting with this feature, you may decide to turn Eye-Start AF off. After you do so, the a7R II/a7 II reverts to its boring old behavior of not initiating focus until you partially depress

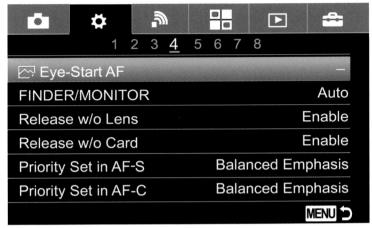

the shutter button (or another defined button). Naturally, the electronic viewfinder will still activate when your eye (or anything else) is near the sensors (if the FINDER/MONITOR setting, described next, is set to Auto). But you won't get autofocus until you're certain you want AF to start.

FINDER/MONITOR

Options: Auto, Viewfinder, Monitor

Default: Auto

My preference: N/A

This also uses the eye sensors located above the viewfinder window, but it controls only whether the camera turns off the LCD and switches the view to the viewfinder when your eye comes near the EVF. With the default setting of Auto, the screen goes blank and the viewfinder activates when your eye (or any other object) approaches the Eye-Start sensors.

Switch to the Viewfinder or Monitor options and the eye sensors no longer initiate a switch from one display to the other. The display is then *always* sent to the viewing device you selected, and the other one is turned off. You might want to use the Monitor option if you are doing work involving critical focusing using the LCD, and as you examine the screen closely, your face will frequently be close to the back of the camera where the Eye-Start sensor might detect it. Or, perhaps, you are shooting at a concert or other venue where the bright LCD can be distracting to others. Choose Viewfinder, and the shooting preview, menus, photos displayed for review during playback, and so forth will be shown only in the EVF.

Of course, if you disable automatic switching between the two, you'll still want to have the option of activating the viewfinder or monitor displays manually. To do that, you'll need to assign the FINDER/MONITOR switching function to a key. I'll show you how to do that later in this chapter, when I describe the Custom Key option in the Custom Settings 7 menu.

Release w/o Lens

Options: Disable, Enable

Default: Disable

My preference: Enable

By default, the a7R II/a7 II will refuse to try to take a photo when a lens is not mounted on the camera; this is a logical setting, especially for distracted folks who fail to notice that they have a lens-less camera body hanging around their necks. If you chose Enable, however, the a7 II series will open its shutter when you depress the shutter release button when no lens is mounted. This option will be useful if you attach the camera to some accessory such as a telescope or a third-party optic that's not recognized as a lens. I prefer to select Enable, because I frequently use oddball third-party and "foreign" lenses on my camera, such as my favorite Lensbaby distortion lens or a fisheye lens designed with a different camera mount.

Release w/o Card (a7R II Only)

Options: Disable, Enable

Default: Disable

My preference: Disable

The ability to trip the shutter without having a memory card installed is not especially useful, unless you want to hand your camera to someone for demonstration purposes and do not want to give them the capability of actually taking a picture. This happens frequently at trade shows, where vendors want you to try out their equipment, but would prefer you not leave the premises with any evidence/image samples, especially if the memory card in question belongs to the vendor rather than you.

On the contrary, it's more likely that you'd prefer to have your own camera inoperable if you've forgotten to insert a memory card. It's easy to miss the orange No Card warning that flashes when the non-picture is taken. Disabling release when a card is absent can help you avoid losing a card (you removed it to load some pictures onto someone else's computer) or having to sheepishly ask the bride and groom if they would be willing to re-stage their wedding.

Priority Set in AF-S/Priority Set in AF-C

Options: AF, Release, Balanced Emphasis

Default: Balanced Emphasis

My preference: Release

These are two separate entries, one for AF-S and one for AF-C autofocus, but functionally they are identical, differing only in the autofocus mode they are applied to. It makes sense to describe them together.

This feature lets you specify whether the camera *waits* to actually take the picture until it has achieved sharp focus (when using an autofocus mode, not manual focus mode); whether it takes the picture immediately, even if sharp focus is not guaranteed; or using a balanced approach somewhere between the two. For most kinds of candid photography, sports, or photojournalism, most of us would rather get the shot rather than lose a fleeting moment, and so Release is often your best choice. If you have a little more time, and the shot won't be affected by a short delay (perhaps half a second, on average), Balanced Emphasis, the default, will do the job. If you're looking for the best sharpness your camera can provide, the AF choice might be your best option. The three choices are as follows:

- **AF.** The shutter is not activated until sharp focus is achieved. This is best for subjects that are not moving rapidly.
 - AF-S. When using AF-S, most prefer to set this to AF, because in this focus mode the subject is usually not moving rapidly, and it makes sense to allow a slight extra delay to get the best focus possible. However, I find that with the a7R II, when equipped with a lens having a built-in focus motor, in combination with the hybrid AF system, focus is fast enough that I can choose Release instead. If your camera/lens combination is slower to focus, you'll want to stick with the AF setting.
 - AF-C. When working in AF-C focus mode, if you select AF, the a7R II/a7 II will continue to track your subjects' movement, but the camera won't take a picture until focus is locked in. An indicator in the viewing screen will flash green until focus can be achieved. You might miss a few shots, but you will have fewer out-of-focus images. Sports shooters probably won't choose AF priority for AF-C. Instead, they'll select release priority, discussed next.
- Release. When this option is selected, the shutter is activated when the release button is pushed down all the way, even if sharp focus has not yet been achieved. As I noted, I definitely prefer this option for AF-C mode, as Continuous Focus focuses and refocuses constantly when autofocus is active, and even though an image may not quite be in sharpest focus, at least I got the shot. Use this option when taking a picture is more important than absolute best focus, such as fast action or photojournalism applications. (You don't want to miss that record-setting home run, or the protestor's pie smashing into the governor's face.) Using this setting doesn't mean that your image won't be sharply focused; it just means that you'll get a picture even if autofocusing isn't *quite* complete. If you've been poised with the shutter release pressed halfway, the camera probably has been tracking the focus of your image.
- Balanced Emphasis. In this mode, the shutter is released when the button is pressed, with a slight pause if autofocus has not yet been achieved. It can be selected for both AF-S and AF-C modes, and is probably your best choice if you want a good compromise between speed of activation and sharpest focus. However, you would not want to use this setting if the highest possible continuous shooting rates are important to you.

AF w/Shutter

Options: On/Off

Default: On

My preference: N/A

This is the first entry in the Custom Settings 5 menu. (See Figure 4.17.) As you know, a gentle touch on the shutter release button causes the camera to begin focusing when using an autofocus mode. There may be some situations in which you prefer that the camera not re-focus every time you touch the shutter release button, such as when you want to work with *back button focus*, which I'll explain in detail in Chapter 8.

Let's say you are taking multiple pictures in a laboratory or studio with the subject at the same distance; you have no need to refocus constantly, and there is no need to put an extra burden on the autofocus mechanism and on the battery. But, you don't want to switch to manual focus. Instead, you can set AF w/Shutter to Off. From then on, the camera will never begin to autofocus, or to change the focus when the shutter release is pressed. You can still initiate autofocus by pressing a key that you've assigned the AF-On function (as I'll describe later under Custom Keys). The user-defined AF-On button will start autofocus at any point, independent of the shutter release. Pressing the shutter release still locks *exposure* (unless you've disabled that function, too, using the AEL w/ Shutter entry described next).

AEL w/Shutter

Options: On, Off

Default: On

My preference: N/A

This item is On by default so the a7R II/a7 II can lock the exposure (as well as the focus in AF-S mode) when you apply light pressure to the shutter release button. Point the camera at your primary subject, and maintain contact with the button while re-framing for a better composition. This technique will ensure that both focus and exposure are optimized for the primary subject.

Set this item to Off and light pressure on the shutter release button will lock only focus, and *not* the exposure. After choosing Off, you'll need to depress a defined AEL button (I'll show you how to assign that behavior later in this Custom Settings section) when you want to lock the exposure. (Light pressure on the shutter release button will still lock focus.) The only method for locking the exposure will be to press the AEL button you have set up.

You might want to choose the Off option because this will allow you to lock focus on one subject in the scene while locking the exposure for an entirely different part of the scene. To use this technique, focus on the most important subject and keep the focus locked by keeping your finger on

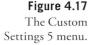

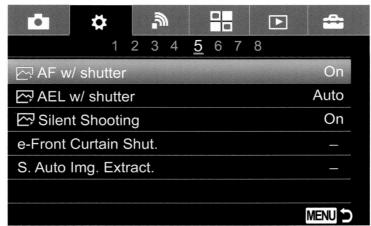

the shutter release button while you recompose. You can then point the lens at an entirely different area of the scene to read the exposure, and lock in the exposure with pressure on the AEL button you've defined using the Custom Key Settings option in the Custom Settings 7 menu. Finally, reframe for the most pleasing composition and take the photo.

In your image, the primary subject will be in sharpest focus while the exposure will be optimized for the area that you metered. This technique makes the most sense when your primary subject is very light in tone like a snowman or very dark in tone like a black Lab dog. Subjects of that type can lead to exposure errors, so you might want to expose for an area that's a middle tone, such as grass. I'll discuss exposure in detail in Chapter 5; then, the value of this menu option will be more apparent.

Silent Shooting (a7R II Only)

Options: On, Off

Default: On

My preference: Off

Because the a7R II model has an electronic front-curtain shutter (described next), you can take still photographs without the audible clunk that the physical shutter makes. You can turn the silent shutter feature on or off using this menu entry. Note that even with silent shutter activated, the camera will not be totally silent. The opening and closing of the aperture as the f/stop changes may make a faint noise, and the focusing motor and zoom motor (in power zoom lenses) may also be heard. However, I've spooked a few colleagues when they saw me take a picture, and could not hear the familiar shutter click. One thing to keep in mind is that silent shooting forces the a7R II to capture your photos as 12-bit files instead of 14-bit images; you may not notice the difference in most cases.

e-Front-Curtain Shutter

Options: On, Off

Default: On

My preference: N/A

This feature reduces the lag time between when you press the shutter, and when the picture is actually taken. It can also reduce a certain type of blurring due to slight camera motion when the physical shutter "clunks" open. When set to On, the electronic front shutter curtain is used by the camera at the start of the exposure, rather than the mechanical shutter. (The physical rear shutter curtain is still used to conclude the exposure.)

Although e-front-curtain shutter usually works very well, when you are using an unusually wide aperture, such as the Sony/Zeiss T* FE 55mm f/1.8 ZA lens, for example, and a very fast shutter speed, areas of the photo may exhibit a secondary (ghost) image. When that happens, set this menu item to Off and the camera will use only its mechanical shutter mechanism, and the problem will not occur. Sony also recommends turning the e-curtain Off when you are using a lens made by another manufacturer, as exposure may be uneven or incorrect.

The problems pop up because the e-curtain is, in effect, *too* fast. It reduces the shutter lag to the point that the iris may not have sufficient time to close completely before the exposure begins. So, the f/stop used at the beginning of the exposure can be different from the one used for the rest of the exposure (after the iris closes down to the correct aperture completely). The overall exposure will thus be incorrect, regardless of shutter speed. In addition, at higher shutter speeds, *exposure grading*, can occur. At those higher speeds, the "slit" (the gap between the front and rear curtains) is increasingly small as the shutter speed becomes faster, and parts of the image exposed initially will receive more exposure than those exposed later.

Exposure grading is worse with lenses that need a longer time to close their irises, and so is more likely with non-Sony lenses, older Sony lenses, and Sony/Minolta/third-party A-mount lenses used with one of the LA-EA adapters. The irises of those lenses aren't designed to respond at the speeds demanded by an electronic front-curtain shutter. In addition, even theoretically compatible lenses may have slower iris response due to dust/grit infiltration. You'll want to use newer, good condition E-mount lenses, or adapted lenses that are manually stopped down to the "taking" aperture prior to exposure.

Superior Auto Image Extraction

Options: Auto, Off

Default: Auto

My preference: Auto. I don't use Superior Auto much, but when I do, I use Auto.

Superior Auto is much smarter than Intelligent Auto! As you shoot, the camera evaluates a scene and selects a relevant SCN mode. If appropriate, the camera can snap off three consecutive shots

when the shutter button is pressed, and then choose one or create a composite that has a higher dynamic range or improved digital noise than you'd get with Intelligent Auto alone. By default, only the final image is saved to the memory card, which makes a lot of sense. But if you want the camera to record all three of the photos it fired, as well as the final photo, choose the Off option. **Note:** No composite image can be saved if Image Quality is set to RAW or RAW & JPEG. When using Hand-Held Twilight, only one image is saved, even if this entry is set to Off. With Auto Object Framing active, two images are always saved, even if you select Auto here.

Exp. Comp. Set

Options: Ambient & Flash, Ambient Only

Default: Ambient & Flash

My preference: Ambient & Flash

This is the first entry in the Custom Settings 6 menu. (See Figure 4.18.) When this item is at the default setting, any exposure compensation value that you set will apply to both the ambient light exposure and to the flash exposure when using flash. You'd want to stick to this option in flash photography when you find that both the available light exposure and the flash exposure produce an image that's too dark or too light. Setting plus or minus exposure compensation will affect both. However, in another situation when using flash, you might want to control only the brightness of the ambient light exposure and not the flash exposure.

The Ambient Only option allows you to control only the brightness of the background, such as a city skyline behind a friend when you're taking flash photos at night in a scene of this type. Setting exposure compensation will now allow you to get a brighter or a darker background (at a + and – setting, respectively) without affecting the brightness of your primary subject who will be exposed by the light from the flash. (Any exposure compensation you set will have no effect on the flash intensity.)

Figure 4.18
The Custom
Settings 6 menu.

Reset EV Comp.

Options: On, Off

Default: On

My preference: N/A

Here you can select whether the camera "remembers" any exposure compensation settings you have made when you turn the camera off. Choose Maintain, and any exposure compensation dialed in will still be in effect after you turn the camera off, and then on again. Select Off, and exposure compensation will be restored to 0. You might want to use this option during long shooting sessions in which you frequently turn the camera off to reduce battery consumption, but you still want to retain your exposure compensation settings.

For example, when shooting sports, I like to keep the camera ready to shoot for long periods when some exciting action is likely to take place at any time. I use the Pwr Save Start Time setting in the Setup 2 menu and specify the longest possible timeout (30 minutes). With that setting, the camera doesn't go into power-saving mode for half an hour, so I'm ready to shoot quickly and without delay. However, during long time-outs or at halftime, I can turn off my camera to conserve power. With Reset EV Comp set to On, when I power back up again, any EV compensation I've used is still in effect.

Bracket Order (a7 II Only)

Options: 0-+, -0+

Default: 0-+

My preference: N/A

This item corresponds to the Bracket Order option in the Bracket Settings entry of the a7R II's Camera Settings menu described in Chapter 3. The default is metered exposure > under exposure > over exposure. However, if you're shooting photos that will later be manually assembled into an HDR photo, you might find it more convenient to expose in order of progressively more exposure: under exposure > metered exposure > over exposure. The order you choose will also be applied to white balance bracketing.

Face Registration

Options: New Registration, Order Exchanging, Delete, Delete All

Default: None

My preference: N/A

This menu entry is used to log into your camera's Face Detection memory the visages of those you photograph often. New Registration allows you to log up to eight different faces. Line up your victim (subject) against a brightly lit background to allow easier detection of the face. A white box

appears that you can use to frame the face. Press the shutter button. A confirmation message appears (or a Shoot Again warning suggests you try another time). When Register Face? appears, choose Enter or Cancel, and press the MENU button to confirm.

The Order Exchanging option allows you to review and change the priority in which the faces appear, from 1 to 8. The a7R II/a7 II will use your priority setting to determine which face to focus on if several registered faces are detected in a scene. You can also select a specific face and delete it from the registry (say, you broke up with your significant other!) or delete *all* faces from the registry (your SO got custody of the camera). Face data remains in the camera when you delete individual faces, but is totally erased when you select Delete All.

APS-C Size (a7 II), APS-C/Super 35 (a7R II)

Options: On, Off, Auto

Default: On

My preference: N/A

This entry tells the a7R II/a7 II whether to automatically switch to the APS-C/Super 35mm "crop" mode when a lens not designed for full-frame coverage is mounted on the camera. (APS-C is a still-image format; Super 35mm is a movie format.) In Chapter 12, I'll fully explain crop mode, which effectively captures pictures using only the center portion of the image, corresponding to the APS-C area used by Sony cameras that are *not* full-frame models like the a7 II series, and for Super 35mm film mode. There are three options within this menu entry:

- On. The camera *always* captures only the APS-C size area. If you're using a non-FE E-mount lens, then the image will correspond to what you'd see with an ASP-C camera, such as the Sony a5100 or a6000. The cropped image will have the same field of view as a lens with 1.5X the actual focal length. That is, if you're using the Sony 16-50mm f/3.5-5.6 power zoom "kit" lens often supplied with the a5100 and other models, the effective focal length will be 24-75mm, and the cropped image will have a resolution of 18 MP on the a7R II and 10.2 MP on the a7 II. Because the On setting always activates the cropping effect, even if you're using a full-frame FE lens (such as the Sony FE 70-200mm f/4 lens), the effective focal length will be 105-200mm. This APS-C crop "boost" works best with the a7R II, because its 18 MP image in crop mode is still quite respectable.
- **Off.** With this setting, the camera *never* crops the image. If you are using a non-FE, non-full-frame lens, you'll probably end up with severe vignetting in the corners. (I'll show you this effect in Chapter 12.) I sometimes use this setting when working with lenses intended for APS-C cameras, because some lenses do cover the full frame (even if just barely) at some focal lengths.
- **Auto.** When you use this setting, the a7R II/a7 II will (often) detect whether you've mounted an FE or APS-C E-mount lens, and either crop or not crop as appropriate. It may not detect *all* E-mount lenses, particularly those from third-party vendors, so it's often safest to use the On option when you know you will be using an APS-C-type lens and want to avoid vignetting.

AF Micro Adjustment

Options: AF Adjustment Setting, Amount, Clear

Default: None

My preference: N/A

If you've sprung for the \$300 to \$400 (in the U.S.) required to purchase the optional LA-EA2 or LA-EA4 mount adapters and are using A-mount lenses on your a7R II/a7 II, you may find that some slight autofocus adjustment is necessary to fine-tune your lens.

This menu item allows choosing a value from -20 (to focus closer to the camera) to +20 (to change the focus point to farther away). You can enable/disable the feature, and clear the value set for each lens. The camera stores the value you dial in for the lens currently mounted on the camera, and can log up to 30 different lenses (but each lens must be different; you can't register two copies of the same lens). Once you've "used up" the available slots, you'll need to mount a lesser-used lens and clear the value for that lens to free up a memory slot. This adjustment works reliably only with Sony, Minolta, and Konica-Minolta A-mount lenses. I'll show you how to use this feature in Chapter 12.

A-MOUNT ADAPTERS ONLY

You'll note that no such adjustment is supplied for E-mount lenses. That's because the a7R II/a7 II cameras calculate focus using *actual data collected at the sensor*—whether operating in contrast detect or phase detect mode. Front- or back-focus issues don't exist. The LA-EA2 and LA-EA4 adapters, on the other hand, use their separate SLT-style AF sensors, and slight alignment issues *can* make a difference. Sony recognizes this and has kindly provided this feature.

Lens Compensation

Options: Auto, Off

Default: Auto

My preference: N/A

This is the first entry in the Custom Settings 7 menu (see Figure 4.19). This trio of submenus optimizes lens performance by compensating for optical defects; they're useful because very few lenses in the world are even close to perfect in all aspects. All three items work only with E-mount lenses and not when using A-mount lenses with an adapter accessory.

Shading

One key defect is caused by a phenomenon called *vignetting*, which is a darkening of the four corners of the frame because of a slight amount of fall-off in illumination at those nether regions. This menu option allows you to activate built-in "shading" compensation, which partially (or fully) compensates for this effect. Depending on the f/stop you use, the lens mounted on the camera, and the focal length setting, vignetting can be non-existent, slight, or may be so strong that it appears you've used a too-small hood on your camera. (Indeed, the wrong lens hood can produce a vignette effect of its own.)

Vignetting, even if pronounced, may not be much of a problem for you. I actually *add* vignetting, sometimes, in my image editor when shooting portraits and some other subjects. Slightly dark corners tend to focus attention on a subject in the middle of the frame. On the other hand, vignetting with subjects that are supposed to be evenly illuminated, such as landscapes, is seldom a benefit. Figure 4.20 shows an image without shading correction at top, and a corrected image at the bottom. I've exaggerated the vignetting a little to make it more evident on the printed page.

Chromatic Aberration

The second defect involves fringes of color around backlit objects, produced by *chromatic aberration*, which comes in two forms: *longitudinal/axial*, in which all the colors of light don't focus in the same plane; and *lateral/transverse*, in which the colors are shifted in one direction. (See Figure 4.21, top.) When this feature is enabled, the camera will automatically correct images taken with one of the supported lenses to reduce or eliminate the amount of color fringing seen in the final photograph. (See Figure 4.21, bottom.)

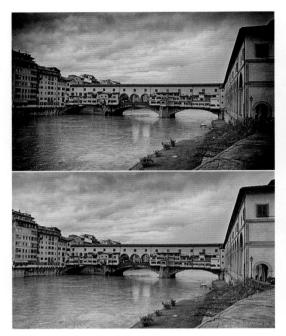

Figure 4.20 Vignetting (top) is undesirable in a landscape photo. The camera's shading correction feature can fix these dark corners (bottom).

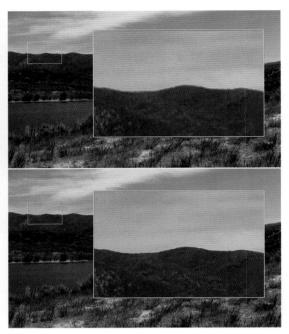

Figure 4.21 Lateral chromatic aberration, which shows as color fringes (top), can be corrected using the lens aberration correction feature (bottom).

Distortion

Distortion is the tendency of some lenses to bow outward (most often wide-angle lenses) or curve inward (found in some telephoto lenses). Figure 4.22 shows an exaggerated version of the outward curving variety, called *barrel distortion*, exhibited by many wide-angle lenses—especially in fisheye optics, where the distortion is magically transformed into a feature.

In Figure 4.23, you can see inward bowing, or *pincushion distortion*, as found in many telephoto lenses. Both types can be partially fixed using Photoshop's Lens Correction or Photoshop Elements' Correct Camera Distortion filters. Or, you can apply this in-camera feature to fix mild distortion. You should realize that correcting lens distortion involves warping pixels, mostly at the edges of the frame, providing a little less sharpness in those areas. The image area of your final picture will be slightly smaller than the frame you composed, and, during playback the active focus point is not shown in the review image.

In addition, applying distortion correction involves extra processing, which can reduce the number of consecutive shots possible. Because the correction is applied *after* you take the picture, the effect is not displayed on the screen when shooting in live view.

Figure 4.22
Barrel distortion in wide-angle lenses becomes a useful feature with fisheye lenses.

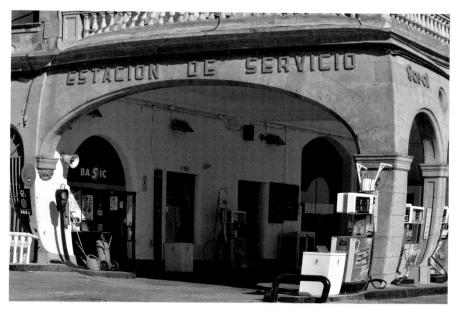

Figure 4.23
Pincushion distortion causes straight lines at the edges of the frame to curve inward.

AF System (Stills) (a7R II Only)

Options: Phase Detection AF, Contrast Detection AF

Default: Phase Detection AF

My preference: N/A

This stills-only item lets you choose whether you want to use phase detection or contrast detection autofocus when you're using a compatible A-mount lens with the Sony LA-EA1 or LA-EA3 A-mount to E-mount adapter. The available adapters and the lenses they can be used with is complicated, so I'm devoting some of Chapter 12 to explaining what works, and when. I'll explain the difference between phase detection and contrast detection in Chapter 9. If this menu entry does not appear on your a7R II/a7 II, you may need a firmware update that was released in November 2015. In a nutshell, you need to know this:

■ LA-EA1/LA-EA3 adapters only. This menu entry is available *only* if you are using the LA-EA1 or LA-EA3 A-mount adapters. The EA-1 version allows you to use APS-C A-mount lenses, while the EA-3 model has a larger opening that makes it possible to use full-frame lenses on the a7 II—series cameras. In both cases, full autoexposure features are available.

Neither adapter has autofocus capabilities built in (unlike the EA2 and EA4 versions), and *must* use either the phase detection or hybrid phase/contrast detection system built into the a7R II/a7 II. This entry allows you to select which mode will be used.

■ Compatible lenses only. Autofocus operates *only* if the A-mount lens has a built-in autofocus motor (designated SSM or SAM) so the EA1 or EA3 adapter can adjust focus electronically. If your A-mount lens uses a screw drive connection between the camera body (look for a "slot" on the lens's mount, roughly opposite the electronic contacts), then you *must* use the EA2 or EA4 adapters, which have their own internal phase detect AF system and AF motor needed to focus the lenses). I'll explain these details in Chapter 12.

This menu item is not available if you are using an E-mount lens, or your adapter/A-mount lens doesn't meet the above requirements. By default, the entry activates the hybrid Phase Detect system, which uses the 399 phase detect AF points on the a7R II sensor, or 169 points on the a7 II's sensor plus the 25 contrast detection zones to produce the speediest autofocus available with your camera/ lens combination. If you are experiencing slow autofocus, switch to Contrast Detection AF instead, and you may find that the "slower" method works faster than the hybrid system. As always, your results may vary.

Note that when Phase Detection AF is active, only Wide, Center, and Flexible Spot focus area modes are available. You cannot choose Zone, Expand Flexible Spot, or Lock On AF. In addition, only AF or Release priorities can be selected in Priority Set in AF-S (described earlier in this chapter). If you have previously chosen Balanced Emphasis, the camera will switch to AF. Further, Eye AF is disabled.

But wait, there's more! If you choose Contrast AF with this entry, then the AF-C (Continuous AF) focus mode is disabled. Your a7 II—series camera has impressive autofocus capabilities, but the permutations can be mind-boggling. I'll be looking at other parameters in Chapter 8.

Video Light Mode (a7R II Only)

Options: Power Link, REC Link, REC Link & Standby, Auto

Default: Auto

My preference: Auto

Sony offers video lighting units for its camcorders and digital cameras, such as the HVL-LVPC (about \$200), which is a battery-operated LED video light. This menu entry allows you to control when the light illuminates. Your choice is a matter of personal preference, depending on how you operate. Your choices are as follows:

- Power Link. Turns on when the camera is powered up, and off when the camera is powered down. Use this if you'll be shooting more or less continually and don't need to save battery power between sequences.
- REC Link. Video light turns on when movie recording starts, and off when you stop capture. This setting will preserve your battery. I like to use it when I definitely want to use the video light at all times during movie capture, such as when I am shooting exclusively indoors, or am outdoors and want some fill light to illuminate shadows for close-ups.
- **REC Link & STBY.** Illuminates when movie capture is underway, and dims at other times. Operates like the previous choice, but stretches the life of your battery.
- Auto. The video light turns on under dim lighting conditions. You might want to use this if you intend to shoot movies under both dim and bright lighting conditions (say, indoors and out) and want the light to come on only under reduced illumination.

Function Menu Set.

Options: 36 different Function menu settings

Default: Top row: Drive Mode, Flash Mode, Flash Compensation, Focus Mode, Focus Area, Exposure Compensation; Bottom row: ISO, Metering Mode, White Balance, DRO/Auto HDR, Creative Style, Shoot Mode

My preference: N/A

When you press the Fn button, a screen like the one shown in Figure 4.24 pops up, with six settings each in two rows arrayed along the bottom. The default options are illustrated. This entry allows you to change the function of any of the 12 positions in the Function menu, so you can display only those you use most, and arrange them in the order that best suits you. There are 36 different functions available. Browse through the list below, and decide which 12 you want to display on the Function menu.

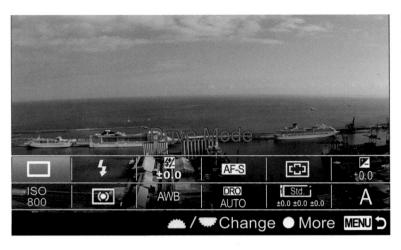

Figure 4.24 Function menu default settings.

When you highlight Function Menu Set. and press OK, the first of two screens appears, as shown in Figure 4.25. The screen has an entry for each of the positions in the top row, along with the current function (the second screen shows the positions in the bottom row). Highlight the position you want to modify and press OK. You can then select from among these options, all explained in detail elsewhere in this book:

- Drive Mode
- Self-Timer During Bracket
- Flash Mode
- Flash Comp.
- Focus Mode
- Focus Area
- Focus Settings
- Exposure Comp.
- ISO
- ISO Auto Minimum Shutter Speed
- Metering Mode
- White Balance

- DRO/Auto HDR
- Creative Style
- Shoot Mode
- Picture Effect
- Picture Profile
- Center Lock-on AF
- Smile/Face Detect
- Soft Skin Effect
- Auto Obj. Framing
- Image Size
- Aspect Ratio
- Quality

- SteadyShot
- SteadyShot Adjustment
- SteadyShot Focal Length
- Auto Rec Level
- Zebra
- Grid Line
- Marker Display
- Audio Level Display
- Peaking Level
- Peaking Color
- Silent Shooting
- Not Set

Note that you can select Not Set to leave a position blank if you want to unclutter your screen, or even duplicate an entry in multiple positions, accidentally or on purpose.

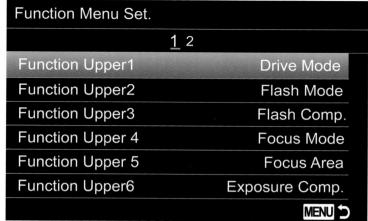

Custom Key Settings

Options: Up to 63 different definitions for Control Wheel, Custom Buttons 1–4, Center Button, Left/Right/Down Buttons, AEL Button, AF/MF Button, Focus Hold Button

Default: Various **My preference:** N/A

This entry allows further customization of as many as 11 buttons of the camera, and one additional button, Focus Hold, found on some lenses. Indeed, the following is a list of the only buttons on the camera that you *cannot* redefine to perform some other function:

- **Shutter release.** It is always used to take a picture and will initiate autofocus (although you can assign AF-ON and other AF functions to a different key).
- Mode dial lock release. This is a mechanical button that unlocks the mode dial, and has no electronic functions at all.
- **Up directional button.** It is used to change your information display in shooting and Playback modes, and as a directional button in menus.
- Playback button. Activates picture review.
- Fn (Function) button. Always summons the Function menu, and in Playback mode sends the current image to a smart device.
- Movie button. Starts/stops movies. However, you can specify whether you want the button to commence video capture always, or only when the mode dial is set to the Movie position. I'll explain that in the description of the Custom Settings 8 menu later in this chapter.

Your custom key definitions override any default definitions for those buttons when in Shooting mode; they retain their original functions in Playback mode. Because button definition is such a personal choice, I steer away from recommending particular definitions for each of the 11 buttons, even though certain functions can be accessed *only* by assigning them to a custom key setting. Our fingers and agility vary, so, while buttons like C3 or the AF/MF button are traditionally used for something like back-button focus, you may prefer to assign that function to a different key.

When assigning definitions to keys, keep in mind that certain behaviors can be used *only* if have made them available using a custom key definition. For example, if you want to use the Bright Monitoring feature, which temporarily turns the Live View Setting Effect to Off to increase the brightness level of the screen in dark locations, you must assign it to a key.

Basic Functions

These functions are available for the AEL button, AF/MF Button, and Custom Buttons 1, 2, 3, and 4. In all cases, choosing Not Set deactivates that button.

- Drive Mode
- Self-timer during Bracket
- Flash Mode
- Flash Comp.
- Focus Mode
- Focus Area
- Focus Settings
- Exposure Comp.
- ISO
- ISO Auto Minimum Shutter Speed
- Metering Mode
- White Balance
- DRO/Auto HDR
- Creative Style
- Picture Effect
- Picture Profile
- Smile/Face Detect
- Soft Skin Effect
- Auto Obj. Framing
- SteadyShot
- Steady Shot Adjustment

- SteadyShot Focal Length
- Auto Rec Level
- Image Size
- Aspect Ratio
- Quality
- In-Camera Guide
- Memory
- AEL Hold
- AEL Toggle
- FEL Lock Hold
- FEL Lock Toggle
- FEL Lock/AEL Hold
- FEL Lock/AEL Toggle
- Center AEL Hold
- Center AEL Toggle
- AF/MF Control Hold
- AF/MF Control Toggle
- Center Lock-On AF
- Eye AF
- AF On
- Focus Hold
- Aperture Preview

- Shot. Result Preview
- Bright Monitoring
- Zoom
- Focus Magnifier
- Deactivate Monitor
- MOVIE
- Zebra
- Grid Line
- Marker Display Selection
- Audio Level Display
- Peaking Level
- Peaking Color
- Silent Shooting (a7R II only)
- FINDER/MONITOR Selection
- Send to Smartphone
- Download Application
- Application List
- Monitor Brightness
- TC/UB Display Switch
- Not Set

Other Buttons

The other buttons have limitations on the functions that can be assigned to them. In all cases, selecting Not Set deactivates that button.

- Left, Right, Down buttons. All the basic functions listed above are available, except for the following 10, which require holding the button down to access the feature. They are: AEL Hold, FEL Lock Hold, FEL Lock/AEL Hold, Center AEL Hold, AF/MF Control Hold, Eye AF, AF On, Focus Hold, Aperture Preview, and Shot. Result Preview.
- Control wheel. The only functions that can be assigned to the rotation of the control wheel for Shooting mode are Aperture, Shutter Speed, ISO, White Balance, Creative Style, Picture Effect, and Not Set.
- Center button. All the basic functions can be assigned, plus Standard, which leaves the control wheel at its standard behavior as an OK/Enter button.

There are 10 buttons you can assign specific functions to:

- Control wheel. Default: Not Set.
- **AF/MF button.** Default: When the AF/MF/AEL lever is set to the AF/MF position, the button switches between autofocus and manual focus while the button is held down.
- **AEL button.** Default: When the AF/MF/AEL lever is set to the AEL position, this button uses the AEL hold behavior; autoexposure is locked while the button is held down.
- Custom button 1. Default: White Balance
- Custom button 2. Default: Press to produce the Focus Settings screen.
- Custom button 3. Default: Press to produce the Focus Mode screen.
- Custom button 4. Default: Not set in Shooting mode; Trash in Playback mode.
- Center button. Default: Activates Eye AF; the camera starts autofocus when the viewfinder is held up to the eye.

VARIATIONS ON A THEME

You have several options for assigning the very useful autoexposure lock (AEL) functions to one of the definable keys.

- **AEL hold.** Exposure is locked while the button is held down.
- **AEL toggle.** The AEL button can be pressed and released, and the exposure remains locked until the button is pressed again.
- Center Point AEL hold. Exposure is locked on the center point of the frame while the button is held down.
- Center Point AEL toggle. Toggles exposure lock on/off using the center point of the frame.

- Left button. Default: Drive mode. If you rarely change drive modes, or are willing to visit the menu to do so, feel free to redefine this button. I like to use it for Aperture Preview, which provides a quick depth-of-field preview to show range of sharpness.
- Right button. Default: ISO. Use this to quickly adjust the sensitivity setting as you shoot.
- **Down button.** Not set. Most of us use exposure compensation frequently to make subsequent pictures darker or lighter, so redefining this key to activate exposure compensation might be a good idea. I'll give you another suggestion later in this section.

A Special Case

One very cool possibility that is often overlooked is the dual functions of the AF/MF-AEL button. This same button has two different functions, depending on the position of the switch. By default, when the switch is in the up position, the camera toggles between autofocus and manual focus; when it's down, it acts as an autoexposure lock. The problem with that configuration is that if you happen to need to toggle between AF and MF *and* lock exposure frequently in the same session, you must remember to flip the switch appropriately to use your desired function. It actually makes more sense to make some button assignments to make the dual-purpose button more useful.

- Reassign default functions. If you really do use both AF/MF toggle and autoexposure lock frequently, start by reassigning those functions to different buttons, so each will be available all the time without switch flipping. The Down and Custom 4 buttons have no default definitions and are located close to each other. I assign the AEL function to the Down button, because it is easy to locate with my thumb, and set the Custom 4 button to toggle between AF and MF, because I use that feature less often.
- Assign the former AF/MF-AEL button to a pair of related functions. You can then quickly flip the switch to jump from one mode to the other, and press the button to activate the assigned feature. One possible, easy-to-remember pair is the Focus Area and Focus Mode functions. With the lever in the up position, press the button to change from one focus area to another as you shoot. Or, flip it down and press the button to switch focus modes. Other useful combinations might be Image Size/Quality, Center Lock-On/Eye AF, or Exposure Compensation/Flash Compensation.

Other Useful Key Definitions

Here are some other possible custom key definitions you might find useful:

- FINDER/MONITOR switch. If you turn off automatic switching between finder and monitor, you'll want to have a button that will quickly toggle between the two. The down button has no default behavior, and FINDER/MONITOR is a good choice.
- Fast ISO change. Assign ISO to the control wheel, and as you shoot you can spin the wheel to adjust your ISO setting on the fly. While the a7R II/a7 II's Auto ISO feature works well (especially when you're shooting fast and quickly), at times the photographer can do a better job of adjusting sensitivity to suit the task at hand.

- More pairs. The control wheel and its center button can also be assigned pairs of related functions. For example, if you've set the control wheel to change ISO sensitivity, the center button can be used to specify ISO Auto Minimum Shutter Speed when you select ISO Auto with the wheel. Image Size/Quality is another good pair for the wheel/center button combination.
- Freed-up keys. Once you assign ISO to the control wheel, that leaves the right button, formerly used to set ISO, free for a new definition. You could assign it to Metering Mode or another function.

Dial Setup

Options: Reverse functions

Default: Front Dial: Aperture; Rear Dial: Shutter Speed

My preference: N/A

By default, in Manual exposure mode the front dial controls the f/stop, and the rear dial adjusts the shutter speed. This entry allows you to reverse those functions for Manual exposure only if you prefer. (Either the front or rear dials can be used to adjust shutter speed (in Shutter Priority mode) and aperture (in Aperture Priority mode). You may have a special reason for wanting to reverse the dial directions, but you're better off leaving it alone.

Dial Ev Comp

Options: Off, Front Dial, Rear Dial

Default: Off

My preference: N/A

This is the first entry of the Camera Settings 8 menu. (See Figure 4.26.) If you like, you can use the front or rear dial to control exposure compensation using this entry. Or, select Off and neither will have the Ev comp function. Assigning the exposure compensation behavior to a dial overrides any other function you might have defined for that dial. Moreover, dialing in exposure comp with a dial takes priority over any exposure compensation you might have set using a menu. In Manual exposure mode, the defined dial is disabled if ISO sensitivity is set to ISO Auto.

Zoom Ring Rotate

Options: Left/Right (Wide-Tele), Right/Left (Wide-Tele)

Default: On

My preference: N/A

This setting controls whether power zooming (with PZ-designated lenses that have a power zoom feature) proceeds from wide-angle to telephoto settings when the zoom control is pressed from left to right, or in the reverse direction, from right to left. The setting is compatible only with power zoom lenses that support this feature.

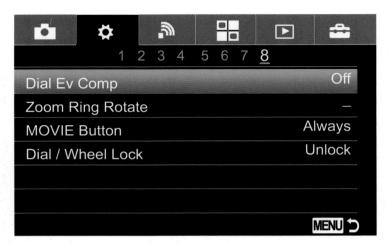

Figure 4.26 Camera Settings 8 menu.

MOVIE Button

Options: Always, Movie Mode Only

Default: Always

My preference: Always

Movie recording can be started in any operating mode by pressing the Movie record button. This feature is on by default, but if you find that you occasionally press the button inadvertently, you might want to choose the Off option. After you do so, pressing the button will have no effect; when you want to record a movie you'll need to rotate the mode dial to the Movie position. I prefer Always, because I find that impromptu video-capture situations are more frequent than accidental movie start-ups.

Dial/Wheel Lock

Options: Lock, Unlock

Default: Unlock

My preference: Unlock

If you want to avoid accidentally changing settings by inadvertently rotating the front/rear dials or control wheel, you can implement this locking option. Choose Lock and both dials are frozen whenever the Fn button is pressed and held down. A "Locked" indicator appears on the screen. If the default Unlock option is selected, pressing the Fn button has no effect on the dials or control wheel.

Wi-Fi and Application Menus

Your a7R II/a7 II is equipped with a built-in Wi-Fi system that can be used for transferring files to a networked computer, a networked HDTV, or a smartphone/tablet computer. As we'll see later, there's also an option (with an app) to use the smartphone or tablet as a remote controller for the camera. The a7R II/a7 II includes both traditional Wi-Fi capabilities and, with Android devices, a newer protocol called Near Field Communications (NFC), which allows linking devices directly without an intervening network.

While basic Wi-Fi has become available with an increasing number of digital cameras, your a7R II/a7 II goes a giant step further. Once connected to a network or hotspot, you can download apps (some free; others for \$4.99 or \$9.99) from a Sony website for increased versatility. These apps can expand existing features with extra options or add entirely new functions. For example, one app enables you to retouch JPEGs to improve them while two others allow for direct uploading (via Wi-Fi) from the a7R II/a7 II to certain social media sites on the Internet.

This chapter provides an introduction to NFC and making Wi-Fi connections. You'll learn how to transfer photos to a computer or to a smart device. Later, I'll discuss downloading and installing apps, the available apps, and other benefits provided by the wireless connectivity available with Wi-Fi from your home network or from a Wi-Fi hotspot. These days, you can find numerous hotspots where Wi-Fi is provided (often free of charge), at restaurants, supermarkets, stores, and theme parks, for example.

As the Application menu hints, the a7R II/a7 II is Wi-Fi compatible and can run apps downloaded from the Sony Entertainment app store. In fact, quite a few menu items are relevant to the Wi-Fi feature; they're available only after you have connected the a7 II—series camera to a Wi-Fi network.

Although this chapter will cover the Wireless and Application menus in detail, I'm not going to explain each entry in the exact order in which it appears in the camera. Some later entries, such as

Access Point Set in the Wireless 2 menu, must be accessed first to set up the Wi-Fi connectivity required to use *other* entries, such as "Send to Smartphone." So this chapter will take a more practical approach and describe the entries in the order that will approximate more closely your actual workflow.

Making a Wi-Fi Connection

The first step, of course, is to establish Wi-Fi connectivity. Setting up a link to a network/hotspot can be done in two different ways: manually or using a simplified alternative called WPS (Wi-Fi Protected Setup) Push. Your best bet is to start with WPS, if it's available with your router, before taking the more traditional route, described later in this chapter.

Using WPS Push

Wi-Fi Protected Setup works only when you're in range of a network provided by a wireless router that is equipped with a WPS button. Not all are. Examine your router and look for a button labeled WPS, or with a symbol. Or, find the owner's manual for your router or use a Google search (try "routername manual PDF") in order to locate the WPS button, if one is available. Some routers that support WPS provide it with software instead of a physical button; in that case, you'll need to access the router's control panel using a computer and click the button on the WPS page. The WPS Push tactic is great, but it would not work at a Wi-Fi hotspot in a supermarket, for instance, since the network owner is unlikely to use the WPS feature for hundreds of customers.

Just follow these steps:

- 1. **Access Wireless 1 menu.** If your router provides WPS, scroll to the WPS Push item in the camera's Wireless 1 menu and press the center button. (See Figure 5.1.)
- 2. **Press router's WPS button.** A screen will appear advising you to press the router's WPS button within 2 minutes. When you press the button (or use the software) to do so, the camera should be able to establish connectivity.
- 3. **Confirm registration.** Once the connection is established, a screen reporting "Registered. SSID *network name*" appears. Press the center button to confirm.

WHAT'S WPS?

The abbreviation WPS indicates Wi-Fi Protected Setup. This is a security standard that makes it easier and quicker to connect a device, including your a7R II/a7 II, to a wireless home network. It eliminates the need to key in the password. Because it's possible for an aggressive hacker to recover the WPS PIN number, some experts suggest turning the router's WPS feature off when you're not actually using it; this may not be possible with all router models but check the owner's manual for the one you own.

Registering Manually

You can also select an access point manually when within range of a wireless network; you'll need to know the network password, if one is in place, in order to do so. Just follow these steps:

- 1. Access the Wireless 2 menu and scroll to Access Point Set. Press the center button. A Wi-Fi Standby screen will appear confirming that the camera is searching for available access points. (See Figure 5.2.)
- 2. Wait for the camera to find your network. The a7R II/a7 II will find the nearby access points (networks) in less than a minute. (See Figure 5.3.) If there is more than one network or available access point, all of those found will be shown. If your smartphone has a hotspot feature and it's turned on, that "network" may appear as well.
 - When several networks are displayed, some may belong to nearby businesses or your neighbors, and you can ignore them (their signal strength is probably weaker than your own network in any case, even if your neighbor's network is not protected by a password). In my case, my wireless router resides in my office; in other, more distant rooms is a wired access point, and, on the second floor, a wireless repeater. Scroll to the one you intend to use and press the center button to confirm.
- 3. **Input the password (if necessary)**. The next screen that appears may have a field for entering your network password, if your router/access point is set up to require one. If not, proceed to Step 4. Otherwise, press the center button and a virtual keyboard will appear. Using this keyboard, enter the password for your network. The keyboard works a bit like the physical multitap keyboard found on some (older) cell phones. Use the directional buttons to highlight a letter group, such as abc, def, ghi, and press the center button once to enter the first character in the group, twice for the second character, three times for the third character, and four times for the fourth. Some of the virtual keys allow you to backspace, delete characters, and toggle between uppercase and lowercase. When finished, highlight OK and press the center button.

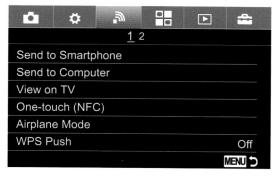

Figure 5.1 WPS Push, located at the bottom of the Wireless 1 menu, is the fastest way to connect to a network.

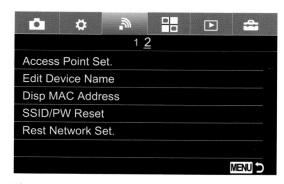

Figure 5.2 Access Point Settings can be used to select an access point/hotspot.

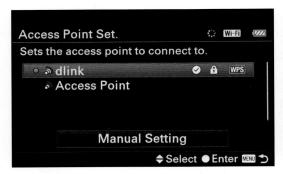

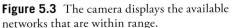

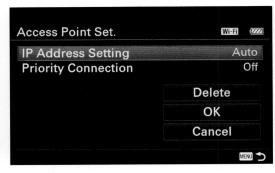

Figure 5.4 You can enter the IP address manually.

- 4. **IP Address Setting.** The next screen will appear, showing the IP Address Setting as Auto and Priority Connection as Off. (See Figure 5.4.) These defaults should work perfectly. Select OK and press the center button. A screen will appear showing the camera trying to connect to the network.
 - If the Auto IP Address Setting option does not work, and you have some networking expertise, change from Auto to Manual, and a screen appears that allows you to enter the IP address, Subnet Mark, and Default Gateway. You can safely leave the Priority Connection parameter set to Off. Fortunately, you probably won't have to resort to these additional steps.
- 5. **Confirm connectivity.** After the Wi-Fi connectivity has been made, a screen will appear confirming that your network has been registered. The screen will look like the one in Figure 5.3, but an orange dot will appear next to the connected network. If you get a screen with a note stating *cannot authenticate*, or that the *input value is invalid*, you'll need to start again at step 1; make sure you have the correct password for the network and be extra careful when keying it in. Remember that when a capital letter is required, you must use the shift feature (an arrow pointing upward) on the virtual keyboard.
- 6. Try it again later. After you have established Wi-Fi connectivity, you can revert to using the a7R II/a7 II as usual; a touch of the shutter release button returns it to shooting mode. The camera will retain the connection to the network until you turn it off or it goes into power-saving sleep mode; Wi-Fi is then temporarily disconnected. When you're ready to use Wi-Fi again, activate the a7R II/a7 II while in range of the same network, scroll to Access Point Settings in the Wireless menu, and press the center button. The camera will quickly find your network to re-establish Wi-Fi connectivity.

If you're connecting to a public Wi-Fi hotspot, the steps should be the same, but you'll most likely find a screen that requires you to agree to the hotspot's terms and conditions. Some hotspots may not require you to enter a password.

Selecting an Access Point Manually

If the desired access point (network) is not displayed on the screen as described in Step 2 above, you may need to enter it yourself. Just follow these steps:

- 1. **Choose Manual Setting.** Scroll down to Manual Setting (visible at the bottom of Figure 5.3) and press the center button. The screen shown in Figure 5.5 appears.
- 2. **Select Manual Registration.** Press the center button to begin the manual registration process. The screen shown in Figure 5.6 appears.
- 3. **Enter SSID.** On the Manual Registration screen, there's a field for entering the SSID name of the access point (network) you plan to use. Press the center button when this field is visible and the virtual keyboard appears. Enter the data. When you're finished press the center button.
- 4. **Change Security (if necessary).** Again, if you have some networking expertise, you'll know if the security setting on your router is WPA (Wi-Fi Protected Access, the default), WEP (Wired Equivalent Privacy, an older, easily "hacked" protection scheme), or None (effectively, no security). If you want to change the Security setting, highlight that field and press the center button. The screen shown in Figure 5.7 appears. Select your choice and press the MENU button to return.
- 5. **Enter password.** The next screen will ask for your password, which you can enter using the virtual keyboard.
- 6. **Enter WPS PIN (if necessary).** If your WPS connection requires a PIN, you can enter it using the screen shown in Figure 5.8.

Take care not to lose the network connection by inadvertently using the Initialize or the Reset Network Settings item of the Wireless menu. If you do so, the camera will eliminate all of your network settings and you'll need to repeat the steps in this section.

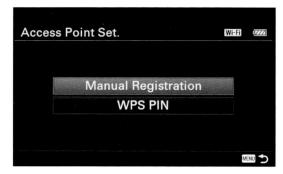

Figure 5.5 Manual registration requires you to complete extra steps.

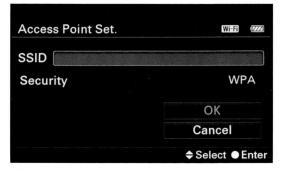

Figure 5.6 Enter the SSID (network/access point name).

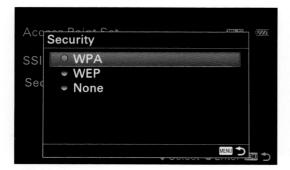

Figure 5.7 You can change the security protocol used.

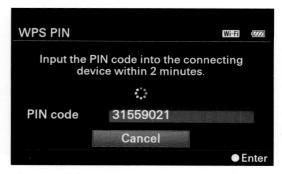

Figure 5.8 If your router requires a WPS PIN, enter it here.

Wi-Fi Settings

The Wireless 2 menu, shown earlier in Figure 5.2, has additional entries beyond those we've used so far. Their functions should be fairly obvious:

- Edit Device Name. By default, your camera is assigned the device name ILCE-7MK2 or ILCE-7RMK2. Select this entry and you can change it to something else.
- **Disp MAC Address.** Each device on a network has a unique Media Access Control number. You generally have no need to know this, unless you want to block a particular device from your network and use the MAC address to identify the unwanted device.
- **SSID/PW Reset.** Deletes the current SSID and password. You might want to do this for security reasons (say, you load/give/sell your a7R II/a7 II to someone else), or need to start over in registering your camera with a network.
- Reset Network Set. Removes all network settings from the camera.

Wi-Fi Functions

Once Wi-Fi connectivity has been established, you can consider using other features that I mentioned earlier. Begin by transferring some photos from the a7R II/a7 II to your computer that's also connected to the same wireless network. Do note that you must first download and install Sony's PlayMemories Home for Windows, or Sony's Wireless Auto Import for Mac to your computer.

The functions you can access are shown in the Wireless 1 menu, as seen in Figure 5.1:

- **Send to Smartphone.** Transfer files to a smart device.
- **Send to Computer.** Send files to a computer.
- **View on TV.** View images with a wireless connection to a compatible HDTV.

- One-touch (NFC). Near Field Communications with a compatible Android phone.
- Airplane Mode. Disable all wireless functions.
- WPS Push. Register your camera, as described at the beginning of this chapter.

Sending Photos to a Smart Device

To transfer photos from your camera to a smartphone or tablet, the device must be running the free PlayMemories Mobile app for Android or iOS; you can get it from your usual app store. After you have downloaded the PlayMemories Mobile app (for iOS or Android) and are running it in your smart device, you can send one or more images to the smart device. (The app, and hence the camera's Wi-Fi features like this one, are not available in a few countries where many aspects of Internet use are restricted.) This feature does not work for video clips. Here are the steps you'll follow:

- 1. **Turn on the camera and the smart devices.** Ensure that both the a7R II/a7 II and the smart device have found your network. With the a7R II/a7 II, you'll do so using the Access Point Settings as discussed earlier.
- 2. **Use the View on Smartphone item**. Access this Wireless 1 menu item in the camera. (The term smartphone actually means smart *device* since it works with a tablet computer, too, in the same manner.) The a7R II/a7 II will display a screen with three options: This Image, All Images on This Date, and All Images in the Device. Scroll to the one that specifies the types of files you want to transfer to the smart device and press the center button.
- 3. Enter the SSID and password in the smart device. At this point, the a7R II/a7 II will be displaying both its unique ID (SSID) and a Password. Using the smart device's virtual keyboard, enter the SSID and password that your a7R II/a7 II is displaying. Remember, it's all case sensitive so use capital letters when necessary. If you get an *incorrect password* message from the smart device, start again using greater care to be accurate. Click on Join or whatever command your device requires in order to proceed.
- 4. **Run the PlayMemories Mobile app in the smart device.** After starting the app in your smartphone or tablet, wait for it to find the a7R II/a7 II. Your device's screen will indicate that it's searching for the camera. When that's finished, the image transfer from the camera to the smart device will begin.
- 5. **View the Images**. After the smart device has completed importing files from the a7R II/a7 II, you can view the thumbnails on its screen. Naturally, you can enlarge any photo so it fills the device's screen.
- 6. **Use the smart device to send photos, etc.** You can now use any of the smart device's capabilities: modify any of the images, send it to friends via e-mail, upload it to any website, and so on.

Wi-Fi Transfer to a Computer

You can transfer photos from the a7R II/a7 II to a computer that's also connected to the same wireless network. Do note that you must first install Sony's PlayMemories Home for Windows, or Sony's Wireless Auto Import for Mac to your computer.

Use this Wireless menu item when you're ready to transfer images from the a7R II/a7 II via Wi-Fi to a computer that is connected to the network. (Review the items under the Making a Wi-Fi Connection heading for advice on establishing Wi-Fi connectivity between your camera and a network.)

Before you can transfer photos to a computer with Wi-Fi, be sure to install the PlayMemories Home software on a Windows computer or Wireless Auto Import to a Mac; you can download the latter from http://support.d-imaging.sony.co.jp/imsoft/Mac/wai/us.html. Then, you'll need to register the a7R II/a7 II in the software; this will also instruct the camera as to where photos should be sent in the future, using Wi-Fi. The process is automatic after you connect the camera to the computer with the USB cable; the software will recognize it after a few seconds and proceed to register it. Afterward, image transfer will be possible without cable connection.

Use the following steps. These are based on the ones I used with PlayMemories Home in a Windows PC; they may be slightly different if you own a Mac computer and are using the Wireless Auto Import software.

1. **Begin to authenticate your a7R II/a7 II**. Before using Wi-Fi, you must sync the two devices. Launch the Sony software, connect the camera to the computer with the USB cable, and turn the camera on to start the process. (If any auto run wizard opens, offering to transfer images, close it.) The Sony Software in the computer will recognize the a7R II/a7 II and confirm it; you'll also see a screen on your computer monitor indicating that a compatible device has been found. If the computer software displays a screen indicating that the USB mode must be changed (to Mass Storage), click on Yes. (Surprisingly, this was necessary for me although the USB mode in the camera was at Auto which should have worked without any problem.)

NOTE

When you open the Wireless Auto Import software on a Mac, you will be presented with a screen that says if you want to set this computer as the device that imports files from your camera wirelessly, click Set on the screen. Do so. Then it will ask for your computer's password. Provide it and connect the camera to the computer via a USB cable, and the software will let you set up an account and download any needed software from Sony, as shown on the camera screen.

- 2. **Proceed with the software-recommended step.** When you see the screen on your computer monitor asking how you want to set up Wi-Fi import, the Recommended item will be checked. Click on Next. A Settings Completed screen will appear. Click on Finish.
- 3. **Disconnect the camera**. Since you'll be sending photos from the a7R II/a7 II to the computer using Wi-Fi, there's no need for any cable connection from this point on.
- 4. Access the Send to Computer menu item. Turn the a7R II/a7 II on, access the Wireless menu and scroll to this item; then, press the center button. The camera will find the network and connect to it; it will then find your computer and make that connection, using Wi-Fi. This can take a minute or two. The camera's LCD will display a confirmation that files are being shared with the computer via Wi-Fi. PlayMemories Home in your computer will display a bar on your monitor confirming the wireless connection to the a7R II/a7 II and that it's importing (bringing in) the files on the memory card.
- 5. Wait for the file transfer to finish. There is no method for importing only certain files to a computer. The transfer process can be very time consuming if the memory card contains numerous images, especially RAW photos and long movie clips. The camera should shut down automatically after saving the files to your computer; if not, turn it off yourself.
- 6. **Confirm that the files have arrived**. Use any software to access the drive/folder that was the destination for the photos and video clips. You should find them in the expected location, in individual folders. Delete any files that you do not want to keep.

BYPASS SECURITY SOFTWARE

If during Step 4 you get a note on the a7R II/a7 II's display screen indicating that the camera could not connect to your computer, the problem is being caused by a computer firewall and you'll need to make a change to allow incoming data to be received. For example, my Norton 360's firewall was set by default to Block incoming data. I changed that to Allow and then all went exactly as discussed in the steps. After the data transfer has been completed, it's essential that you re-activate the blocking features of the firewall so it will again provide full security.

Viewing Images on a TV

As with any current digital camera, it's possible to view JPEG photos and video clips on an HDTV when you connect the a7R II/a7 II to the TV using an HDMI cable. This is an extra-cost accessory. Buy the Type D cable with a micro HDMI connector at one end (for plugging into the camera) and a conventional HDMI plug (to connect to the TV's HDMI port). An inexpensive cable is fine; there's no need to pay more for one of the premium brands unless you need a cable that's longer than about 6 feet. Make the cable connection and you can now display photos and movies on the oversized screen.

After the Wi-Fi connection has been made with a Digital Living Network Alliance/DLNA-compatible (network-enabled or Wi-Fi Direct-enabled) HDTV, you can use this menu item, on the second screen of Wireless options. Use it to display photos on the HDTV without cable connection after Wi-Fi connectivity has been confirmed. The benefit of Wi-Fi Direct is that you do not need to register your access point on the camera before doing so; in other words, the TV need not be connected to the network if you are using Wi-Fi Direct. Movie clips cannot be transferred to a TV for display over Wi-Fi; to show those, connect the camera to the HDTV using an optional Type D HDMI cable.

Use the menu options to instruct the camera as to which device (TV) it should send to, which photos to display (all or only those in a specific folder), and whether the display time should be long or short if using the slide show feature. Press the center button if you do want to use the slide show feature. At any time, you can move to another image for the display by scrolling to the left or right.

It's also possible to transfer JPEG photos, but not videos, to an HDTV without cable connection. If you have a networked TV (or a network-friendly game machine such as PlayStation or Xbox), you can view the images in your camera on that display without using the HDMI cable.

Of course, the HDTV must be DLNA (Digital Living Network Alliance) compliant and it must first be connected to your home network via Wi-Fi as per the instructions that came with the device. The a7R II/a7 II must also be communicating with your network via Wi-Fi, of course. (Use the steps provided earlier.)

Tip

There is an exception to the DLNA rule. Some HDTVs are Wi-Fi Direct enabled; if yours is, then it need not be connected to your network. Mine is not, so I have not been able to try this feature.

There are simply too many types of Wi-Fi-enabled HDTV's to provide full specifics on exactly how you'll transfer JPEGs to the device. Sony's published documents specifically recommend their Bravia HDTV, as you might expect, but you can use any DLNA (or Wi-Fi-Direct) enabled TV. A Bravia HDTV does provide a few extra display features that are possible only when using a Sony camera.

In any event, start by accessing the View on TV item in the camera's Wireless menu and press the center button. The camera will confirm the Wi-Fi connection to your network and it will search for a compatible TV. Be sure to consult your TV's instructions for setting the media display component to receive information from the camera. When connectivity with the TV has been confirmed, you can begin the sharing process using connection controls similar to those described earlier in this chapter.

The Application Menu

Unlike most other cameras with Wi-Fi, the a7R II/a7 II can download apps from the Sony Entertainment PlayMemories Camera Apps website while Wi-Fi connectivity is active. (Sony does not plan to offer its Camera apps via the other app stores.) This enables you to add extra functions to existing features or to arm the camera with some entirely new functions to expand its versatility. When you connect to the Internet, you can use your camera's simple built-in browser to access the Sony PlayMemories Camera Apps page and download any that are of interest to you.

Set up an account with the Sony Entertainment Network website using your computer or tablet. In North America, you can find that website at http://www.sony.net/pmx. There you fill out an online form and set a password, and download/install a browser add-on. Once you've created an account, you can connect your a7R II/a7 II to your computer with the included USB cable and download apps directly from your computer through the browser plug-in.

Or, you can establish Wi-Fi communication between your camera and your home network using the Wireless menu as described earlier in this chapter, and download apps over your network to the camera without the need for a direct connection to your computer. After the Wi-Fi connection has been made, scroll to the Application menu (see Figure 5.9) where you'll see two choices: Application List and Introduction.

Application List

Options: N/A
Default: N/A

My preference: N/A

Select Application List and a screen similar to Figure 5.10 appears. It displays any apps you have installed, plus two management entries: PlayMemories Camera Apps and Application Management.

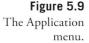

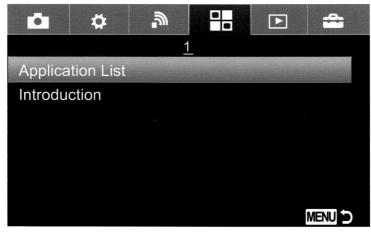

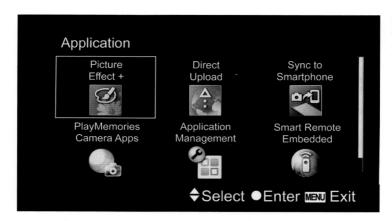

Figure 5.10The Application List.

Introduction

Options: Service Introduction, Service Availability

Default: N/A

My preference: N/A

Introduction provides two sections. Service Introduction shows you where to find the Sony Entertainment website and mentions that it's not available in a few countries; my camera shows www.sony.net/pmca as the shortcut to it. Service Availability provides details as to countries where Sony can supply apps.

Working with Applications

In general, you'll browse, purchase, and run apps from the Application List screen shown in Figure 5.10. You have the options to load applications shown in the list, browse available applications with PlayMemories Camera Apps, or use Application Management. In all three cases, just highlight an icon and press the center button.

PlayMemories Camera Apps

Options: N/A

Default: N/A

My preference: N/A

After you have established Wi-Fi communication and opened an account with the Sony Entertainment Network website, scroll to PlayMemories Camera Apps and press the center button. A screen will appear indicating the camera is searching for an access point (your wireless network). When that's found, the camera will display a screen like the one shown in Figure 5.11.

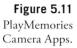

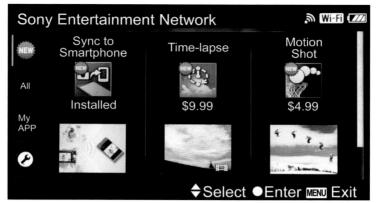

You can press the left/right buttons to move between the applications list at right, and the menu icons at left:

- New. Displays the most recent (new) apps.
- **All.** Shows all available apps, including free apps.
- **My App.** Shows only the apps installed on your camera.
- Settings. Allows you to sign into the Sony network or select your Country/Region.

Select an app that's already installed and press the center button to activate it. Or, scroll to an app you want to install, such as Picture Effect+ (which is free of charge) and press the center button. On the next screen, scroll to Install and press the center button; this takes you to a screen where you enter your e-mail address to start the sign-in process (for the Sony app site). Scroll to the bottom of the page and enter your password in the field that appears, again using the on-screen keyboard that appears after you press the center button. (This is the password you had created with the Sony online app store.) Basically you follow the on-screen process, which is quite intuitive although it is tedious to use the on-screen keyboard without a touch-screen LCD.

Scroll to Done and press the center button again. On the following screens agree to everything (if you do want to proceed) and the camera will begin downloading the app. Afterward, you'll see a screen indicating that the installation was successful. Scroll down to Use the Installed App, and it will appear. Picture Effect+ (for example) is similar to what you'd see if you had accessed the camera's conventional Picture Effect item, but there are some entirely new options that you can choose. Scroll among the options and a Help Guide will provide a brief summary of the one you scrolled to.

Application Management

Options: Sort, Manage and Remove, Display Account Information

Default: N/A

My preference: N/A

This section can be used after you have installed apps; it allows you to sort the apps, manage and remove apps (as shown in Figure 5.12), and to display your account information. The latter also provides instructions on how to delete your account; the Initialize > Factory Reset item will do so, in addition to re-setting all camera functions to the factory defaults.

Downloading Apps

Here's how you can do so, step by step:

- 1. **Sign up for a service account at http://www.sony.net/pmca using a computer**. This is an essential first step and will include specifying a credit card that will be charged for any apps that are not free. You can also check out the available apps (on your large computer monitor) in order to appreciate the features they will provide if you later install them in your a7R II/a7 II.
- 2. Log into the app store from the a7R II/a7 II. While the camera is connected to a network via Wi-Fi, scroll to the PlayMemories Camera Apps item in the Application menu. Press the center button and wait a few seconds until you're connected to the Sony Entertainment Network app store.
- 3. Find the available apps with the a7R II/a7 II. You'll now be viewing a screen on the camera with tabs along the left side. You can scroll to: New (list only the new camera apps), All (list all available camera apps), and My App (list any apps already downloaded to the camera). Start by scrolling to All; press the center button and you'll be able to view a display of all available apps. Not all of the many icons are visible at any one time so scroll down to view the others. The price for each is shown. If an app is available free of charge, the word Install appears below it instead of the price. If you have previously installed an app, the word Installed appears under it.

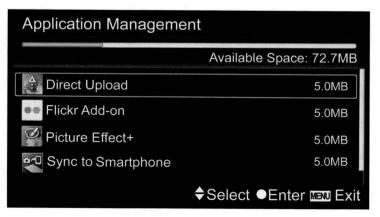

Figure 5.12 Application Management.

A TRADITIONAL ALTERNATIVE TO DOWNLOADING APPS

If you prefer not to use Wi-Fi for uploading apps to your a7R II/a7 II, it's also possible to do so with the camera connected to a computer with the USB cable. After making that connection, access the www.sony.net/pmca app store and open an account. Scroll to an app displayed on your computer monitor (by the Sony Entertainment website), and click on Install. (If there's a fee, you'll need to agree to pay that.) The transfer to the a7R II/a7 II will then start; it's automatic and simple. When it's finished, you'll see a note on your computer monitor (from the Sony app store) confirming that the installation has been completed. Disconnect the a7R II/a7 II (using the safe eject feature). The new app will appear in the list of apps in the camera's Application menu.

- 4. **Download and install an app.** Scroll to an app you might want to try. Go for a free one initially, such as Direct Upload and press the camera's center button. A screen will appear with information about that app and how it works. If you do want this app, scroll to the Install bar and press the camera's center button.
- 5. Complete the Sign In process. You'll need to sign in using the password you created while connected to the Sony website with your computer in step 1. When you scroll to a field and press the center button the virtual keyboard appears so you can enter the data. When you have finished entering your data in a field, scroll down to END and press the center button.
- 6. Wait for the app to upload to your a7R II/a7 II. This can take up to a minute for some apps; a note on the camera's screen will keep you advised as to the status. Do not turn the camera off during the process. When the app has been installed, you'll get a screen confirming it was successful.
- 7. **Try the new app.** If you're ready to do so, scroll down to the Use the Installed Application bar and press the camera's center button. The other option, View Other Applications, is useful in case you want to download other apps right away.
- 8. Access your apps. Access the camera's Application menu to find the list of apps that you have already installed. If there are several, you may need to scroll down to reveal any that are not immediately visible in the display. Scroll to one you want to try and press the center button. This will take you to a screen that will provide guidance on how to proceed with the app.

Downloading Applications

Since the a7R II/a7 II allows for direct download of apps, I recommend becoming familiar with that procedure instead of using a computer to do so. If you accept this advice, here are a few more comments about the process. When you're ready to download an app with the a7R II/a7 II (using Wi-Fi connectivity), you'll need to enter your ID and password. You'll get a confirmation on the camera's screen after an app has been successfully installed.

Current Sony Apps

At the time of this writing, Sony offered a series of conventional apps, some free and others priced at \$4.99 or \$9.99 in the U.S.; prices in other countries may be entirely different. Additional apps (all free) were in Beta test mode: Snapshot Me, Time Lapse LE, Catch Light, Stop Motion, and ID Photo were available in the U.S. (The Beta apps are not available in all countries.) I won't discuss the Beta series since they may no longer be available when you read this. Of course, it's also possible that some other, entirely new conventional apps will be available then.

Tip

Sony provides sample video clips, and occasionally still photos, that illustrate how most of the following apps work, how to install them, and the effects you can expect. Check them out at www.sony.net/Products/playmemories/pm/pmca.html.

Several of the conventional apps are various free keyboards such as International, Chinese, Japanese, and Korean; these are self-explanatory so I won't provide a summary. In any event, here's a brief overview of the most popular conventional apps available in the U.S. and Canada at the time I wrote this chapter.

- Direct Upload (free). Use this app to upload photos directly from the a7R II/a7 II to Facebook or to the Sony PlayMemories site via Wi-Fi. (Perhaps other sites will be added in future.) Of course, the camera must be connected to a network to do so. Because the 16-megapixel images are huge, they're automatically downsized to 2 megapixels. Select the photos you want to upload and you can specify the destination album. If you're uploading to Facebook, you can also add a comment to each photo, if desired. (You will need to key in your ID and password and that can be tedious; you might consider checking the box that instructs the app to remember this data to eliminate the need to sign in every time.)
- Flickr Add-On (free). This is a companion app to Direct Upload and available only after you have installed that one. This app merely adds the ability to upload images directly to Flickr. It becomes part of Direct Upload in the camera's Application menu.
- Picture Effect+ (free). The camera already provides many special effects options but this app adds others and modifies some existing effects for greater versatility.
- Multi Frame Noise Reduction (\$4.99). As the name implies, this app is similar in concept to the two SCN modes that provide high ISO photos by taking a burst of multiple JPEG frames and compositing them into one after discarding much of the digital noise data. (See Chapter 4 for a discussion of the Anti Motion Blur and Hand-held Twilight modes.) The app is available for use when the camera is set to P, A, S, or M mode so you get a lot more versatility in terms of camera settings than you do with the fully automatic SCN modes. You can set a desired ISO level, exposure compensation, and a Creative Style plus its overrides, for example.

- Photo Retouch (free). This app enables you to modify the technical aspects of JPEG photos you've already taken. A variety of tools are available for adjusting aspects such as brightness, saturation, and contrast while you view the photo. The app also offers resizing (downsizing an image), horizon correction, skin softening, and applying the auto portrait framing feature.
- Smart Remote Embedded (free). Get this app to take advantage of an important feature provided by Wi-Fi: control of the a7R II/a7 II from a smart device that's running the PlayMemories Mobile app. (The a7R II/a7 II becomes the access point.) Set up the camera pointing toward a bird's nest for example, and you can get a live preview of the scene on the device's LCD screen. You can control the exposure if the camera is set for A or P mode, activate a self-timer, use exposure compensation, and trip the shutter from the smart device to take photos. (You cannot control camera features such as zooming, ISO level, mode, etc.) (See Figure 5.13.)
- **Bracket Pro (\$4.99).** The a7R II/a7 II already provides a feature for autoexposure bracketing, but this app provides a lot more bracketing options. It expands the exposure range to +/-5 EV and provides a simplified interface. More importantly, the app provides additional features: focus bracket (three shots at various focused distances), shutter speed bracket (three shots, each at a different shutter speed), aperture bracket (three shots at various f/stops), and flash bracketing (two shots, one with and one without flash).

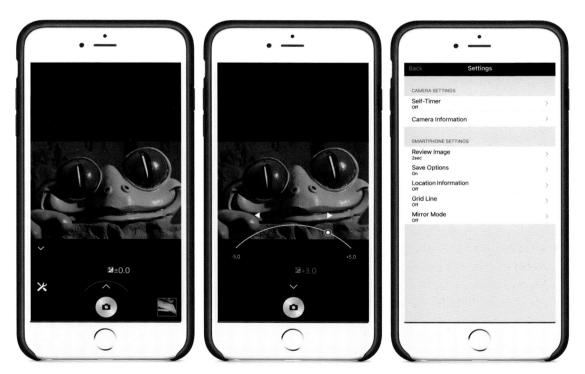

Figure 5.13 Link your camera to your smartphone using the PlayMemories Home app, and you can use the phone as a remote to take pictures (left), adjust exposure compensation (center), and specify other parameters (right).

- Cinematic Photo (\$4.99). This app is unusual in that it creates *cinemagraphs*, still photos of which a portion is animated. In other words, it provides a video in which most of the frame is a still photo but with a single animated element.
 - For example, your subject might be a friend pouring milk from a clear bottle. The camera will fire 18 JPEGs and then it will provide a preview image with a brush tool that you can use to specify the area that will be animated: depicted as moving in the cinemagraph. In this example, you would brush only the area of the flowing milk so it would be the area depicted as moving; your friend would be static. The painting process is slow since you'll be using the control wheel. After you finish your artistic work, you can view the finished video; if it's not quite right, you can start again with the painting process. A cinemagraph video is about 20 seconds long and 640×360 pixels in resolution.
- Time Lapse (\$9.99). Activate this really cool app to automatically shoot a series of photos at various intervals with settings made automatically by the camera; use it to record the opening of a blossom during the period from 8 am to 10 am, for example. Because the exposure is locked after the first shot, this feature works best when the brightness of the light will not change (as on a cloudy day) while the series of photos are being made. You can set the interval between shots, the number of photos to be taken, and whether the self-timer will be used. After the series is finished, it's combined into one HD video clip.
 - If you don't want a video, you can choose to have the camera merely save the still images as a series. You get seven presets, each providing a different look: Cloudy Sky, Night Sky, Night Scene, Sunset, Sunrise, Miniature, and Standard. There's also a Custom option with more user control.
- Lens Compensation (\$9.99). The a7R II/a7 II already includes some lens compensation features that make minor changes automatically to correct certain optical flaws that are inherent to every lens to some extent. This app is more versatile, enabling you to manually select correction values for lens peripheral shading (darkening at the corners of an image), chromatic aberration, and distortion. I'd recommend this app only for photographers with some expertise in these issues.
- Multiple Exposure (\$4.99). Some other cameras offer a feature that lets the user take several photos that are composited into one, a straightforward function. Add this app and the a7R II/a7 II can also do so, but you get far more versatility. You can select a theme and the app will automatically composite your series of photos into one, after optimizing the exposure. Seven themes are available: Easy Silhouette, Sky, Texture, Rotate, Mirror, Soft Filter, and Manual. If you choose Manual, you can preview the results you'd get with any of the five options and then select the one that will provide the results you prefer.

- Motion Shot (\$4.99). Also a type of multiple exposure app, this is intended for photos of moving subjects, such as race cars, cyclists, or runners. After you take a sequence of shots with continuous drive, they're composited into one. You can choose the first and last images of the sequence, adjust spacing between the images to be composited, and customize other settings. All of the photos, including the composite, are saved to the memory card. (Check out the sample that Sony provides at https://www.playmemoriescameraapps.com/portal/.)
- Portrait Lighting (\$4.99). This app can accentuate people's faces by adjusting the contrast and brightness. It can also lighten or darken the background. You can select any of five lighting levels or use a custom setting; the latter lets you choose from six levels of emphasis on either the person or the background. When experimenting, start by making a portrait photo of a friend and use this app to brighten the face and darken the surroundings for a dramatic effect.
- Light Shaft (\$4.99). Perhaps a bit gimmicky, this app can add a *splash of light* to your photos in one of four different light shapes: Ray, Star, Flare, and Beam. You get some control since you can specify where you want the light shape to fall as well as adjust its intensity, length, width, and number of light rays.

As mentioned earlier, any apps you download will be available for access in the camera's Application menu. If many have been installed, you may need to scroll down to find the icon for the app you want to use. The a7R II/a7 II includes an Application Management item as well. This feature offers options that allow you to sort your apps, delete any of them, and display your Sony account information. When you scroll to one of these options, on-screen guidance is provided, such as the steps required to remove an app. (If you remove an app, you can later re-install it if you decide that you do want it—at no extra charge.) All of this is quite intuitive so experiment with the available options. Pressing the up directional button at any time will return you to the previous screen.

Near Field Communications (NFC)

If you know Bluetooth, then you already understand much of what you need to know about One-Touch (Near Field Communications). Like Bluetooth, NFC is a radio communications protocol that allows smart devices to establish a link with each other simply by touching them together or moving them close to each other (a few inches is sufficient). Currently, NFC is supported only by Android devices and cameras using a compatible operating system, including the a7R II/a7 II.

Pairing your smart device and your camera couldn't be easier:

- 1. Download PlayMemories Mobile to your Android device.
- 2. Activate the NFC function of the smart device. An N-like icon should be displayed on your device's screen when NFC is available.
- 3. Locate the NFC marking on the right side of the a7R II/a7 II (when you're holding the camera in shooting position).

- 4. Touch the marking to the corresponding mark on the smart device for about 1 to 2 seconds.
- 5. When the devices are paired, the PlayMemories Mobile app launches on the smart device.
- 6. You may now select One Touch (NFC) in the Wireless 1 menu. The option cannot be used if the camera is in Airplane Mode.
- 7. You can access applications using NFC, or transfer images on the camera to the smart device.

Playback and Setup Menus

Even more options are available from the Sony a7R II/a7 II's Playback and Setup menus, which allow you to further tailor the camera's behavior; view, print, and protect images; and adjust important camera settings, such as monitor brightness or audio volume.

Playback Menu

This menu controls functions for deleting, protecting, displaying, and printing images. You can bring it up on your screen more quickly by pressing the Playback button first, then the MENU button, which causes the Playback icon to be highlighted on the main menu screen. The first set of items that are visible on the screen when you activate the Playback menu are shown in Figure 6.1.

■ Delete

■ View Mode

■ Image Index

■ Display Rotation

■ Slide Show

■ Rotate

■ Enlarge Image

■ 4K Still Image PB (a7 II Only)

■ Protect

■ Specify Printing

Delete

Options: Multiple Img., All in Movie or Still Folder, by AVCHD, or by Date

Default: Multiple Img.

My preference: N/A

Sometimes we take pictures or video clips that we know should never see the light of day. Maybe you were looking into the lens and accidentally tripped the shutter. Perhaps you really goofed up your settings. You want to erase that photo *now*, before it does permanent damage to your

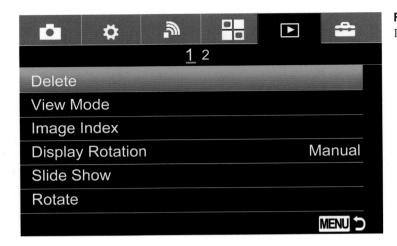

Figure 6.1
Playback 1 menu.

reputation as a good photographer. Unless you have turned Auto Review off through the Setup menu, you can delete a photo immediately after you take it by pressing the Trash key (Delete button). Also, you can use that method to delete any individual image that's being displayed on the screen in Playback mode.

However, sometimes you need to wait for an idle moment to erase all pictures that are obviously not "keepers." This menu item makes it easy to remove selected photos or video clips (Multiple Images), or to erase all the photos or video clips taken, sorted by your currently active view mode (such as folder or date). (Change the type of view using the View Mode option, described next.) Note that there is no delete method that will remove images tagged as Protected (as described below in the section on "Protect").

To remove one or more images (or movie files), select the Delete menu item, and use the up/down directional buttons, front dial, rear dial, or the control wheel to choose the Multiple Images option. Press the center button, and the most recent image *using your currently active view* (Date View, Folder View (Still), Folder View (MP4), or AVCHD View) will be displayed on the LCD.

Scroll left/right through your images and press the center button when you reach the image you want to tag for deletion; a check mark then appears beside it and an orange check mark appears in the bottom-right corner of the screen. You can press the DISP button to see more information about a particular image.

The number of images marked for deletion is incremented in the indicator at the lower-right corner of the LCD, next to a trash can icon. When you're satisfied (or have expressed your dissatisfaction with the really bad images), press the MENU button, and you will be asked if you're sure you want to proceed. To confirm your decision, press the center button. The images (or video clips) you had tagged will now be deleted. If you want to delete *everything* on the memory card, it's quicker to do so by using the Format item in the Setup menu, as discussed later in this chapter.

View Mode

Options: Date View, Folder View (Still), Folder View (MP4), AVCHD View, XAVC S HD View, XAVC S 4K View

Default: Folder View (Still)

My preference: Folder View (Still)

Adjusts the way the camera displays image/movie files, which is useful for reviewing only certain types of files, or for deleting only particular types, as described above. You can elect to display files by Date View, Folder View (still photos only), Folder View (MP4 clips only), AVCHD View (just AVCHD movies), or XAVCS clips in both HD (high definition) and 4K modes.

Image Index

Options: 9, 25

Default: 9

My preference: 25

You can view an index screen of your images on the camera's LCD by pressing the down direction, button (Index button) while in Playback mode. By default, that screen shows up to 9 thumbnails of photos or movies; you can change that value to 25 using this menu item. Remember to use the View Mode menu item first, to identify the folder (stills, MP4, or AVCHD) that the index display should access; by default, it will show thumbnails of still photos, but you might want to view thumbnails of your movie clips instead.

As I noted in Chapter 1, if you have captured both still photos and movie clips, the a7R II/a7 II will show both in Playback mode's index view. The screen is split into two panes. Stills are shown in the upper pane, and movies in the lower. The pane containing the last type of image/movie captured will be highlighted. To move between panes, just press the up/down button. Press the left directional button to move to a selection bar that allows you to choose calendar view.

Display Rotation

Options: Auto, Manual, Off

Default: Auto

My preference: Auto

You can use this function to determine whether a vertical image is rotated automatically during picture review. If you want to rotate the image more, use the Rotate entry, described later in this section.

Your options are

■ **Auto.** The image will be shown in the orientation indicated by information in the image, no matter how the camera itself is rotated during picture review. For example, a vertical image will be shown in the correct orientation, as shown at left in Figure 6.2 when the camera is held horizontally. It will be shown smaller in size in order to fit the long dimension of the image into the short dimension of the screen. Rotate the camera 90 degrees, and the a7R II/a7 II will automatically rotate the photo so it's *still* shown in the correct orientation, but it will now fill the LCD screen, as you can see in Figure 6.2, right.

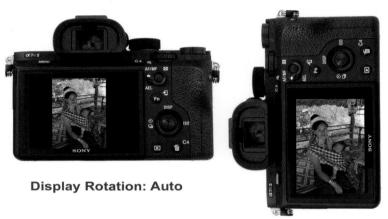

Figure 6.2Display Rotation: Auto.

■ Manual. With this setting, the image is always displayed on the LCD in the same orientation it was taken. That is, a vertically oriented photo will be displayed in a smaller size, just as it is when using Auto, as shown at left in Figure 6.3. However, when you rotate the camera during picture review, the a7R II/a7 II does *not* automatically rotate the image at the same time, so it will be shown with an incorrect orientation (see Figure 6.3, right).

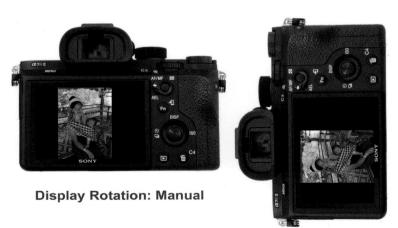

Figure 6.3
Display Rotation:
Manual.

■ Off. With this setting, both vertical and horizontal images are displayed to fill the screen as much as possible with the image. Vertical shots are larger, as shown at right in Figure 6.4, but the camera must be rotated.

Figure 6.4 Display Rotation: Off.

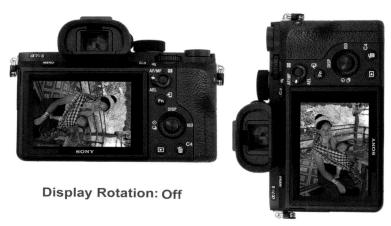

Slide Show

Menu Options: Repeat (On/Off), Interval: 1 second, 3 seconds, 5 seconds, 10 seconds, 30 seconds

Default: 3 seconds **My preference:** N/A

Use this menu option when you want to display all the still images on your memory card in a continuous show. You can display still images in a continuous series, with each one displayed for the amount of time that you set. Choose the Repeat option to make the show repeat in a continuous loop. After making your settings, press the center button and the slide show will begin. You can scroll left or right to go back to a previous image or go forward to the next image immediately, but that will stop the slide show. The show cannot be paused, but you can exit by pressing the MENU button.

Rotate

Options: None
Default: N/A

Delault. IV/A

My preference: N/A

When you select this menu item, you are immediately presented with a new screen showing the current or most recently reviewed image along with an indication that the center button can be used to rotate the image. (This feature does not work with movies.) Scroll left/right to reach the image

you want to rotate. Successive presses of the center button will now rotate the image 90 degrees at a time. The camera will remember whatever rotation setting you apply here. You can use this function to rotate an image that was taken with the camera held vertically, when you have set Display Rotation to Manual. Press the MENU button to exit.

Enlarge Image

Options: None **Default:** N/A

My preference: N/A

This is the first entry on the second page of the Playback menu (see Figure 6.5). Whenever you are playing back still images (not movies), you can use this menu entry to magnify the image. Use the control wheel to zoom in and out, and you can scroll around inside the enlarged image using the four directional buttons.

4K Still Image PB (a7 II Only)

Options: None
Default: N/A

My preference: N/A

This is a specialized entry that is available only when the camera is connected by a mini HDMI cable to an HDTV that is 4K compatible. Connect the camera to the TV, turn both devices on, play back the image you want to view, and press the down directional button to show the image in 4K resolution.

Figure 6.5
The second page of the Playback menu.

Protect

Options: Multiple Images, All with Current View Mode, Cancel All Images

Default: None

My preference: N/A

You might want to protect certain images or movie clips on your memory card from accidental erasure, either by you or by others who may use your camera from time to time. This menu item enables you to tag one or more images or movies for protection so a delete command will not delete it. (Formatting a memory card deletes everything, including protected content.) This menu item also enables you to cancel the protection from all tagged photos or movies.

To use this feature, make sure to specify whether you want to do so for stills or movies; use the View Mode item in the Playback menu to designate the desired view mode, as described earlier. Then, access the Protect menu item, choose Multiple Images, and press the center button. An image (or thumbnail of a movie) will appear; scroll among the photos or videos using the control wheel to reach the photo you want to tag for protection; press the center button to tag it with an orange check mark at the bottom-left corner of the image. (If it's already tagged, pressing the button will remove the tag, eliminating the protection you had previously provided.)

After you have marked all the items you want to protect, press the MENU button to confirm your choice. A screen will appear asking you to confirm that you want to protect the marked images; press the center button to do so. Later, if you want, you can go back and select the Cancel All Images option to unprotect all of the tagged photos or movies.

Specify Printing

Options: Multiple Images, Cancel All, Print Setting

Default: N/A

My preference: N/A

Most digital cameras are compatible with the DPOF (Digital Print Order Format) protocol, which enables you to tag JPEG images on the memory card (but not RAW files or movies) for printing with a DPOF-compliant printer; you can also specify whether you want the date imprinted as well. Afterward, you can transport your memory card to a retailer's digital photo lab or do-it-yourself kiosk, or use your own DPOF-compatible printer to print out the tagged images in the quantities you've specified.

Choose multiple images using the View Mode filters described earlier to select to view either by Date or by Folder. Press the center button to mark an image for printing with an orange check mark, and the MENU button to confirm when you're finished. The Print Setting entry lets you choose to superimpose the date onto the print. The date will be added during printing by the output device, which controls its location on the final print.

Setup Menu

Use the lengthy Setup menu to adjust infrequently changed settings, such as language, date/time, and power-saving options. The first five items in the Setup menu are shown in Figure 6.6.

- Monitor Brightness
- Viewfinder Bright.
- Finder Color Temp.
- Volume Settings
- Audio Signals
- Tile Menu
- Mode Dial Guide
- Delete Confirm
- Display Quality
- Power Save Start Time
- NTSC/PAL Selector
- Cleaning Mode

- Demo Mode
- TC/UB Settings
- Remote Ctrl
- HDMI Settings
- 4K Output Selection (a7R II Only)
- USB Connection
- USB LUN Setting
- USB Power Supply (a7R II Only)
- Language
- Date/Time Setup
- Area Setting

- Copyright Info (a7R II Only)
- Format
- File Number
- Select REC Folder
- New Folder
- Folder Name
- Recover Image Database
- Display Media Information
- Version
- Certification Logo (non-U.S./Canada models only)
- Setting Reset

Monitor Brightness

Options: Manual, Sunny Weather

Default: Manual

My preference: Manual

When you access this menu item, two controls appear. The first is a Brightness bar (shown just above the grayscale/color patches in Figure 6.7). It's set to Manual adjustment by default, but press the center button and you can change it to Sunny Weather for a brighter display. You might resort to this setting if you're shooting outdoors in bright sun and find it hard to view the LCD even when shading it with your hand.

If you set Sunny Weather, the LCD brightness will automatically increase, making the display easier to view in very bright light. This makes the display unusually bright so use it only when it's really necessary. Remember too that it will consume a lot more battery power, so have a spare battery available.

Figure 6.7 Adjust monitor brightness.

The grayscale steps and color patches can be used as you manually adjust the screen brightness using the left/right direction buttons. Scroll to the right to make the LCD display brighter or scroll to the left to make the LCD display darker, in a range of plus and minus 2 (arbitrary) increments. As you change the brightness, keep an eye on the grayscale and color chart in order to visualize the effect your setting will have on various tones and hues. The zero setting is the default and it provides the most accurate display in terms of exposure, but you might want to dim it when the bright display is distracting while shooting in a dark theater, perhaps. A minus setting also reduces battery consumption but makes your photos appear to be underexposed (too dark).

I prefer to choose Manual but then leave the display at the zero setting. This ensures the most accurate view of scene brightness on the LCD for the best evaluation of exposure while previewing the scene before taking a photo.

Viewfinder Brightness

Options: Auto, Manual

Default: Auto

My preference: Manual

This entry operates exactly the same as the Monitor Brightness option just described, except that there is no need for a Sunny Weather entry for the electronic viewfinder. A notice will appear on the LCD monitor advising you to look through the viewfinder and make your adjustments.

Finder Color Temperature

Options: +2 to -2

Default: 0

My preference: N/A

While looking through the viewfinder, press the left/right buttons to adjust the color balance of the finder to make it appear warmer (using the left button) or colder/bluer (using the right button), according to your preference.

Volume Settings

Options: 0–15

Default: 2

My preference: N/A

This menu item affects only the audio volume of movies that are being played back in the camera. It's grayed out unless you have selected movies, as opposed to stills, with the Still/Movie Select menu item. When you select Volume Settings, the camera displays a scale of loudness from 0 to 15; scroll up/down to the value you want to set and it will remain in effect until changed.

You might want to use this menu item to pre-set a volume level that you generally prefer. However, you can also adjust the volume whenever you're displaying a movie clip, to set it to just the right level. To do so, press the down direction button and use the up/down direction buttons to raise or lower the volume.

Audio Signals

Options: On, Off

Default: On

My preference: N/A

Use this item to turn off sound recording when you're shooting videos, if desired. Of course, the audio track can be deleted later, if desired, with software. However, there could be occasions when it's useful to disable sound recording for movies, if you know ahead of time that you will be dubbing

in other sound, or if you have no need for sound, such as when panning over a vista of the Grand Canyon. At any rate, this option is there if you want to use it.

Upload Settings

Options: On, Off

Default: On

My preference: Off

The Upload Settings for Eye-Fi cards does not appear in the menu unless you have inserted an Eye-Fi card into the camera's memory card slot. An Eye-Fi card is a special type of SD card that connects to an available wireless (Wi-Fi) network and uploads the images from your memory card to a computer on that network. The Upload Settings option on the Setup menu lets you either enable or disable the use of the Eye-Fi card's transmitting capability. So, if you want to use an Eye-Fi card just as an ordinary SD card, simply set this item to Off, which saves a bit of power drawn by the card's Wi-Fi circuitry.

Tile Menu

Options: On, Off

Default: Off

My preference: Off

This is the first entry on the second page of the Setup menu. (See Figure 6.8.) The Tile menu is a holdover from the NEX era, and features icons representing the six main menu tabs. While it might be marginally useful when you first begin working with your a7R II/a7 II, it's really an unnecessary intermediate step. Turn it Off and when you press the MENU button, you'll be whisked to the conventional menu system, where you can quickly navigate to the tab you want.

Figure 6.8 The Setup 2 menu.

Mode Dial Guide

Options: On, Off

Default: On

My preference: Off

The On setting activates an on-screen description of the current Shooting mode as you rotate the mode dial. You might want to enable this extra help when you first begin using your camera, and turn it off after you're comfortable with the various mode dial settings.

Delete Confirm

Options: Delete First, Cancel First

Default: Cancel First

My preference: Delete First

Determines which choice is highlighted when you press the trash button to delete an image. The default Cancel First is the safer option, as you must deliberately select Delete and then press the center button to actually remove an image. Delete First is faster; press the trash button, then the center button, and the unwanted image is gone. You'd have to scroll down to Cancel if you happened to have changed your mind or pressed the trash button by mistake.

Display Quality

Options: Standard, High

Default: Standard

My preference: Standard

You can specify the image quality of the display, switching from the default Standard to High (which uses more battery power). While you might discern a small difference when viewing on an external monitor, most of the time the camera display isn't reliable for judging images anyway, so sticking to Standard quality is usually your best bet.

Power Save Start Time

Options: 30 minutes, 5 minutes, 2 minutes, 1 minute, 10 seconds

Default: 1 minute

My preference: 5 minutes

This item is more critical than you might think, given the a7R II/a7 II's predilection for gobbling power from the tiny battery. It lets you specify the exact amount of time that should pass before the camera goes to "sleep" when not being used. The default of 1 minute is a short time, useful to

minimize battery consumption. You can select a much longer time before the camera will power down, or a much shorter time. I use 5 minutes most of the time to avoid having to "waken" the camera frequently. If I'm wandering around with long periods of time between shots, I may set it to 2 minutes. In street photography or sports mode, I use 30 minutes to make sure my camera will always be ready for action. But, of course, I tend to carry at least two spare batteries with me at all times.

NTSC/PAL Selector

Options: NTSC, PAL

Default: Depends on the country where the camera is sold

My preference: N/A

Allows you to switch the camera between the two major television video systems, NTSC (used in North and South America, Korea, Japan, and some other Pacific countries), and PAL, which is used in Europe, the Middle East, and elsewhere. To switch from one video system to another, you must be using a memory card that was formatted while the camera was using that video system. Otherwise, you'll be prompted to reformat the card or use a different card. Your camera will be set up at the factory to default to the video system used in your country. If you switch to the alternate system, the start-up screen will display a message "Running on NTSC" or "Running on PAL" to make sure you're aware of the change. Note that a few countries in South America (Brazil, Argentina, Paraguay, and Uruguay) use a modified PAL system, while others, including Bulgaria, France, Greece, Guiana, Iran, Iraq, Monaco, Russia, and Ukraine use a third system, called SECAM.

Cleaning Mode

Options: None

Default: None

My preference: N/A

This is the first item on the third page of the Setup menu. (See Figure 6.9.) Use this entry when you want to use the camera's auto image sensor cleaning feature.

Demo Mode

Options: On, Off

Default: Off

My preference: N/A

This is a semi-cool feature that allows your camera to be used as a demonstration tool, say, when giving lectures or showing off at a trade show. When activated, if the camera is idle for about one minute it will begin showing a protected AVCHD movie, which is not impressive on the camera's

Figure 6.9
The Setup 3 menu.

built-in LCD, but can have a lot more impact if the camera is connected to a large-screen HDTV through the HDMI port. You may not have seen this feature discussed much in other guides; that's because it can only be used if you happen to own the optional AC-PW20 AC Adapter. Most of us have no need for it, but if you do want to do demos, or if you shoot time-lapse images over long periods of time, you'll want to buy one. If you're properly equipped, just follow these steps:

- 1. Use the File Format entry in the Camera Settings 2 menu and select AVCHD as the movie format, as explained in Chapter 3. Demo Mode works only with AVCHD files.
- 2. Shoot the clip that you want to use as your demonstration, in AVCHD format.
- 3. In the Playback 1 menu, access the View Mode and select AVCHD View so that only AVCHD videos will appear.
- 4. In the Playback 2 menu, choose Protect and select the demo clip, which should be the movie file with the oldest recorded date and time.
- 5. Connect the camera to the optional AC-PW20 AC adapter. Because Demo Mode uses a lot of juice, it operates only when the external power source is connected.
- 6. Demo Mode will no longer be grayed out in the Setup 2 menu. Select it and choose On.
- 7. After about one minute of idling, the demo clip will begin playing. Note that, because the AC adapter is connected, your automatic power-saving setting is ignored, and Demo Mode will not operate if no movie file is stored on your memory card.

TC/UB Settings

Options: TC/UB Display Settings, TC Preset, UB Preset, TC Format, TC Run, TC Make

Default: TC/UB Display Settings: Counter

My preference: N/A

The Time Code (TC) and User Bit (UB) settings are information that can be embedded and used to sync clips and sound when editing movies. I'll describe this advanced feature in a little more detail in Chapter 11, but pro movie-making techniques are largely beyond the scope of this book.

Remote Control

Options: On, Off

Default: Off

My preference: N/A

The a7R II/a7 II can be operated using the Sony RMT-DSLR1 and RMT-DSLR2 Wireless Remote Commander controls (and an array of third-party remotes that I haven't had the opportunity to test). Constantly "looking" for the IR signal using the sensor on the front of the camera can sap battery power (because the a7R II/a7 II does not go into power save mode), so it's wise to turn the remote control feature on only when it's actually needed. Choose On, and you can take pictures using the Shutter, 2 Sec., Start/Stop buttons on the RMT-DSLR1/2 controls, plus the Movie button found on the RMT-DSLR2 control. The RMT-DSLR1 model cannot be used to shoot movies; the RMT-DSLR2 remote can be used to activate movie shooting as long as the Movie button on the camera is not set to Off in the Custom Settings 6 menu.

HDMI Settings

Options: HDMI Resolution, 24/60p Output, HDMI Info. Display, TC Output, REC Control, CTRL for HDMI

Default: HDMI Resolution: Auto; 24/60p Output: 60p; HDMI Info. Display: On; TC Output: Off; CTRL for HDMI: On

My preference: N/A

Several HDMI settings that previously had their own menu entries with earlier a7-series cameras, plus several new ones, have been combined under this heading. You can view the display output of your camera on a high-definition television (HDTV) when you connect it to the a7R II/a7 II if you make the investment in an HDMI cable (which Sony does not supply); get the Type C with a mini-HDMI connector on the camera end. (Still photos can also be displayed using Wi-Fi, without cable connection, as discussed earlier.) When connecting HDMI-to-HDMI, the camera automatically makes the correct settings. If you're lucky enough to own a TV that supports the Sony Bravia synchronization protocol, you can operate the camera using that TV's remote control when this item is On. Just press the Link Menu button on the remote, and then use the device's controls to delete

174

images, display an image index of photos in the camera, display a slide show, protect/unprotect images in the camera, specify printing options, and play back single images on the TV screen.

- HDMI Resolution (Auto, 2160/1080p, 1080p, 1080i). The camera can adjust its output for display on a high-definition television when at the Auto setting. This usually works well with any HDTV. If you have trouble getting the image to display correctly, you can set the resolution manually here to 2160/1080p (for 4K and Full HD), 1080p, or 1080i.
- 24p/60p Output. You can select either 60p or 24p output to the HDMI port when connected to a 1080 60i—compatible television and Record Setting (described in Chapter 4) has been set to 24p 24M (FX), 24p 17M (FH), or 24p 50M. If a different setting was used, this setting is ignored, and the output conforms to the HDMI Resolution setting above instead.
- HDMI Info. Display. Choose On or Off. Choose On if you want the shooting information to display when the camera is connected to an HDTV television/monitor using an HDMI cable. Select Off if you don't want to show the shooting information on the display. You might want to suppress the shooting information when you're showing your images as a slide show.
- **TC Output.** Choose on or off to enable/disable including time code in the HDMI output signal. Use On if you are outputting to professional video equipment and want to include the time code information. Note that the time code is *data* and will not actually appear on the screen. If this setting is on and you are sending the signal to a television or some other device, the image may not appear properly. Change this setting to off when outputting to devices not equipped to handle TC information.
- REC Control. This setting is available only when TC Output is set to on. Choose on or off. The setting allows you to start and stop REC Control—compatible external video recorders connected to the camera. A REC or STBY icon will be displayed on the camera's screen as appropriate.
- CTRL for HDMI. This option can be useful when you have connected the camera to a non-Sony HDTV and find that the TV's remote control produces unintended results with the camera. If that happens, try turning this option Off, and see if the problem is resolved. If you later connect the camera to a Sony Bravia sync-compliant HDTV, set this menu item back to On.

4K Output Selection (a7R II Only)

Options: Memory Card+HDMI, HDMI Only (30p), HDMI Only (24p), HDMI Only (25p)

Default: N/A

My preference: N/A

When your a7R II is connected to an external video recorder or playback device and set to Movie mode, you can use this setting to specify how 4K movies are recorded and output. Note that when using one of these choices, the camera's movie counter does not appear on the screen. If Dual Video REC is on, Smile/Face Detection, Lock-on Autofocus, Center Lock-on Autofocus, and Eye AF are disabled.

Your choices are:

- Memory Card+HDMI. A 4K movie in 30p is saved on the camera's internal memory card *and* output to the external device. Use this if you want two copies of your video, including one on the memory card. Reminder: Use a fast memory card for these huge files!
- HDMI Only (30p). A 4K movie in 30p is output only to the external device, and not recorded on your memory card. HDMI Info. Display is disabled.
- HDMI Only (24p). A 4K movie in 24p is output only to the external device. HDMI Info. Display is disabled.
- HDMI Only (25p). If the NTSC/PAL Selector described earlier is set to PAL, you can use this option to shoot a 4K movie in 25p, and output only to the external device. HDMI Info. Display is disabled.

USB Connection

Options: Auto, Mass Storage, MTP, PC Remote

Default: Auto

My preference: N/A

This entry, the first in the Setup 4 menu, allows you to select the type of USB connection protocol between your camera and computer. (See Figure 6.10.)

- **Auto.** Connects your camera to your computer or other device automatically, choosing either Mass Storage or MTP connection as appropriate.
- Mass Storage. In this mode, your camera appears to the computer as just another storage device, like a disk drive. You can drag and drop files between them.
- MTP. This mode, short for Media Transfer Protocol is a newer version of the PTP (Picture Transfer Protocol) that was standard in earlier cameras. It allows better two-way communication between the camera and the computer and is useful for both image transfer and printing with PictBridge-compatible printers.
- **PC Remote.** This setting is used with Sony's Remote Camera Control software to adjust shooting functions and take pictures from a linked computer.

USB LUN Setting

Options: Multi, Single

Default: Multi

My preference: N/A

This setting specifies how the camera selects a Logical Unit Number when connecting to a computer through the USB port. Normally, you'd use Multi, which allows the camera to adjust the LUN as necessary, and is compatible with the PlayMemories Home software. Use Single to lock in

a LUN if you have trouble making a connection between your camera and a particular computer. PlayMemories Home software will usually not work when this setting is active. But don't worry; Single is rarely necessary.

USB Power Supply (a7R II Only)

Options: On, Off

Default: On

My preference: On

When set to on, the camera receives charging power from a connected computer or other device through the micro USB cable link. Use this setting if you want to charge the a7R II's battery when connected to a computer or other device. Set to off, and power is not supplied. You'd want to use this to avoid draining power from the computer host. Although I most frequently connect my camera to a desktop computer, if I am using a laptop, I set this to off, as I have plenty of NP-FW50 batteries and recharging the laptop is sometimes inconvenient.

Language

Options: English, French, Italian, Spanish, Japanese, Chinese languages

Default: Language of country where camera is sold

My preference: N/A

If you accidentally set a language you cannot read and find yourself with incomprehensible menus, don't panic. Just find the Setup menu, the one with the red tool box for its icon, and scroll down to the line that has a symbol that looks like an alphabet block "A" to the left of the item's heading.

Figure 6.10 The Setup 4 menu.

No matter which language has been selected, you can recognize this menu item by the "A." Scroll to it, press the center button to select this item, and scroll up/down among the options until you see a language you can read.

Date/Time Setup

Options: Year, Day, Month, Hour, Minute, Date Format, Daylight Savings Time

Default: None

My preference: N/A

Use this option to specify the date and time that will be embedded in the image file along with exposure information and other data. Having the date set accurately also is important for selecting movies for viewing by date. Use the left/right direction buttons to navigate through the choices of Daylight Savings Time On/Off, year, month, day, hour, minute, and date format. You can't directly change the AM/PM setting; you need to scroll the hours past midnight or noon to change that setting. Use the up/down direction buttons or rotate the control wheel to change each value as needed.

Area Setting

Options: World time zones

Default: None

My preference: N/A

When you select this option, you are presented with a world map on the LCD. Use the left/right direction buttons to scroll until you have highlighted the time zone that you are in. Once the camera is set up with the correct date and time in your home time zone, you can use this setting to change your time zone during a trip, so you will record the local time with your images without disrupting your original date and time settings. Just scroll back to your normal time zone once you return home.

Copyright Info (a7R II Only)

Options: Write Copyright Info, Set Photographer, Set Copyright, Display Copyright Info

Default: Off

My preference: N/A

This is the first item on the Setup 5 menu. (See Figure 6.11.) Your choices include:

■ Write Copyright Info. Turn On to embed copyright information in your image file; Off to disable this feature. If you choose On, a copyright symbol will appear on the shooting screen to indicate that copyright data is being written to the image file.

Figure 6.11
The Setup 5 menu.

- Set Photographer. Enter the name of the photographer. Highlight this and press the center button to move to the next screen, where a blank line appears. Highlight that and press the center button, and the text entry screen appears. It functions much like the multi-tap cell phone keypads in the pre-smartphone era: highlight a button and press the center button multiple times to enter a particular character. For example, if you highlight the "abc" button, pressing once inserts an a, twice a b, and three times a c. When finished, highlight OK and press the center button to return to the initial screen, where you can highlight OK again and press the center button a last time to confirm.
- **Set Copyright.** Define your copyright terms, such as *Cpr. 2016 David D. Busch*. Strictly speaking, "Cpr." should be used rather than a lowercase c between two parentheses. Text is entered as described above.
- Disp. Copyright Info. Displays whatever copyright information you've specified.

Format

Options: OK, Cancel

Default: None

My preference: N/A

As you'd guess, you'll use Format to re-format your memory card while it's in your a7R II/a7 II. To proceed with this process, choose the Format menu item and select "OK" and press the center button to confirm, or Cancel to chicken out.

Use the Format command to erase everything on your memory card and to set up a fresh file system ready for use. This procedure removes all data that was on the memory card, and reinitializes the card's file system by defining anew the areas of the card available for image storage, locking out defective areas, and creating a new folder in which to deposit your images. It's usually a good idea to reformat your memory card in the camera (not in your camera's card reader using your

computer's operating system) before each use. Formatting is generally much quicker than deleting images one by one. Before formatting the card however, make sure that you have saved all your images and videos to another device; formatting will delete everything, including images that were protected.

File Number

Options: Series, Reset

Default: Series

My preference: N/A

The default for the File Number item is Series, indicating that the a7R II/a7 II will automatically apply a file number to each picture and video clip that you make, using consecutive numbering; this will continue over a long period of time, spanning many different memory cards, and even if you reformat a card. Numbers are applied from 0001 to 9999; when you reach the limit, the camera starts back at 0001. The camera keeps track of the last number used in its internal memory. So, you could take pictures numbered as high as 100-0240 on one card, remove the card and insert another, and the next picture will be numbered 100-0241 on the new card. Reformat either card, take a picture, and the next image will be numbered 100-0242. Use the Series option when you want all the photos you take to have consecutive numbers (at least, until your camera exceeds 9999 shots taken).

If you want to restart numbering back at 0001 frequently, use the Reset option. In that case, the file number will be reset to 0001 *each* time you format a memory card or delete all the images in a folder, insert a different memory card, or change the folder name format (as described in the next menu entry). I do not recommend this since you will soon have several images with exactly the same file number.

Select REC Folder

Options: Folder

Default: None

My preference: N/A

This entry allows you to create a new storage folder. Although your camera will create new folders automatically as needed, you can create a new folder at any time, and switch among available folders already created on your memory card. (Of course, a memory card must be installed in the camera.) This is an easy way to segregate photos by folder. For example, if you're on vacation, you can change the Folder Name convention to Date Form (described next). Then, each day, create a new folder (with that date as its name), and then deposit that day's photos and video clips into it. A highlighted bar appears; press the up/down buttons to select the folder you want to use, and press the center button.

New Folder

Options: N/A

Default: None

My preference: N/A

This item will enable you to create a brand-new folder. Press the center button, and a message like "10100905 folder created" or "102MSDCF folder created" appears on the LCD. The alphanumeric format will be determined by the Folder Name option you've selected (and described next), either Standard Form or Date Form.

Folder Name

Options: Standard Form, Date Form

Default: Standard Form

My preference: N/A

If you have viewed one of your memory card's contents on a computer, you noticed that the top-level folder on the card is always named DCIM. Inside it, there's another folder created by your camera. Different cameras use different folder names, and they can co-exist on the same card. For example, if your memory card is removed from your Sony camera and used in, say, a camera from another vendor that also accepts Secure Digital or Memory Stick cards, the other camera will create a new folder using a different folder name within the DCIM directory.

By default, the Alpha creates its folders using a three-number prefix (starting with 100), followed by MSDCF. As each folder fills up with 999 images, a new folder with a prefix that's one higher (say, 101) is used. So, with the "Standard Form," the folders on your memory card will be named 100MSDCF, 101MSDCF, and so forth.

You can select Date Form instead, and the Alpha will use a xxxymmdd format, such as 10060904, where the 100 is the folder number, 6 is the last digit of the year (2016), 09 is the month, and 04 is the day of that month. If you want the folder names to be date-oriented, rather than generic, use the Date Form option instead of Standard Form. This entry allows you to switch back and forth between them, both for folder creation (using the New Folder entry described above) and REC folder preference (also described above).

Tip

Whoa! Sony has thrown you a curveball in this folder switching business. Note that if you are using Date Form naming, you can *create* folders using the date convention, but you can't switch among them when Date Form is active. If you *do* want to switch among folders named using the date convention, you can do it. But you have to switch from Date Form back to Standard Form. *Then* you can change to any of the available folders (of either naming format). So, if you're on that vacation, you can select Date Form, and then choose New Folder each day of your trip, if you like. But if, for some reason, you want to put some additional pictures in a different folder (say, you're revisiting a city and want the new shots to go in the same folder as those taken a few days earlier), you'll need to change to Standard Form, switch folders, and then resume shooting. Sony probably did this to preserve the "integrity" of the date/folder system, but it can be annoying.

Recover Image Database

Options: OK, Cancel

Default: None

My preference: N/A

This is the first entry in the Setup 6 menu. (See Figure 6.12.) The Recover Image DB function is provided in case errors crop up in the camera's database that records information about your movies. According to Sony, this situation may develop if you have processed or edited movies on a computer and then re-saved them to the memory card that's in your camera. I have never had this problem, so I'm not sure exactly what it would look like. But, if you find that your movies are not playing correctly in the camera, try this operation. Highlight this menu option and press the center button, and the camera will prompt you, "Check Image Database File?" Press the center button to confirm, or the MENU button to cancel.

Display Media Information

Options: None

Default: None

My preference: N/A

This entry gives you a report of how many still images and how many movies can be recorded on the memory card that's in the camera, given the current shooting settings. This can be useful, but that information is already displayed on the screen when the camera is being used to shoot still photos (unless you have cycled to a display with less information), and the information about minutes remaining for movie recording is displayed on the screen as soon as you press the Record button. But, if you want confirmation of this information, this menu option is available.

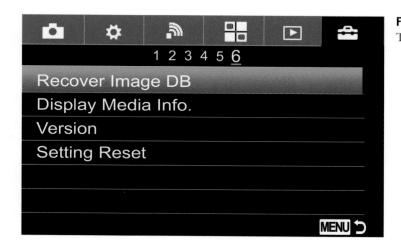

Figure 6.12
The Setup 6 menu.

Version

Options: None
Default: N/A

My preference: N/A

Select this menu option to display the version number of the firmware (internal operating software) installed in your camera. From time to time, Sony updates the original firmware with a newer version that adds or enhances features or corrects operational bugs. When a new version is released, it will be accompanied by instructions, which generally involve downloading the update to your computer and then connecting your camera to the computer with the USB cable to apply the update. It's a good idea to check occasionally at the Sony website, www.esupport.sony.com, to see if a new version of the camera's firmware is available for download. (You can also go to that site to download updates to the software that came with the camera, and to get general support information.) You'll find more on updating firmware in Chapter 14.

Certification Logo (Non-U.S./Canada Models Only)

Options: None
Default: N/A

My preference: N/A

This information-only entry displays various certification logos indicating the camera has met specifications mandated by other countries. It's included in cameras intended for non-U.S./Canada sales so that the logos can be tailored for specific areas through firmware updates, rather than printed notices on the bottom of the cameras themselves.

Setting Reset

Options: Reset Default, Factory Reset

Default: Reset

My preference: N/A

If you've made a lot of changes to your camera's settings, you may want to return the features to their defaults so you can start over without manually going back through the menus and restoring everything. This menu item lets you do that. Your choices are as follows:

- Camera Settings Reset. Resets the main shooting settings to their default values.
- Initialize. Resets *all* camera settings to their default settings, including the time/date and downloaded applications, but *not* including any AF Micro Adjustments you may have dialed in.

Shooting Modes and Exposure Control

In the most basic sense, exposure is all about light. Exposure can make or break your photo. Correct exposure brings out the detail in the areas you want to picture, providing the range of tones and colors you need to create the desired image. Poor exposure can cloak important details in shadow, or wash them out in glare-filled featureless expanses of white.

However, getting the perfect exposure requires some intelligence—either that built into the camera or the smarts in your head—because digital sensors can't capture all the tones we are able to see. If the range of tones in an image is extensive, embracing both inky black shadows and bright highlights, we often must settle for an exposure that renders most of those tones—but not all—in a way that best suits the photo we want to produce. This chapter discusses using the full range of the camera's various shooting modes and exposure controls, so you'll be better equipped to override the default settings when you want to, or need to, and achieve spot-on exposures that produce the exact image you are looking for, every time.

Getting a Handle on Exposure

You're probably well aware of the traditional "exposure triangle" of aperture (quantity of light, light passed by the lens), shutter speed (the amount of time the shutter is open), and the ISO sensitivity of the sensor—all working *proportionately* and *reciprocally* to produce an exposure. The trio is itself affected by the amount of illumination that is available to work with. So, if you double the amount of light, increase the aperture by one stop, make the shutter speed twice as long, or boost the ISO setting 2X, with any one of those changes you'll get exactly twice as much exposure. Similarly, you

can *increase* any of these factors while *decreasing* one of the others by a similar amount to keep the same exposure.

Working with any of the three controls involves trade-offs. Larger f/stops provide less depth-of-field, while smaller f/stops increase depth-of-field (and potentially at the same time can *decrease* sharpness through a phenomenon called *diffraction*). Shorter shutter speeds do a better job of reducing the effects of any camera/subject motion, while longer shutter speeds make that motion blur more likely. Higher ISO settings increase the amount of visual noise and artifacts in your image, while lower ISO settings reduce the effects of noise. (See Figure 7.1.)

Exposure determines the look, feel, and tone of an image, in more ways than one. Incorrect exposure can impair even the best-composed image by cloaking important tones in darkness, or by washing them out so they become featureless to the eye. On the other hand, correct exposure brings out the detail in the areas you want to picture, and provides the range of tones and colors you need to create the desired image. However, getting the perfect exposure can be tricky, because digital sensors can't capture all the tones we are able to see. If the range of tones in an image is extensive, embracing both inky black shadows and bright highlights, the sensor may not be able to capture them all. Sometimes, we must settle for an exposure that renders most of those tones—but not all—in a way that best suits the photo we want to produce. You'll often need to make choices about which details are important, and which are not, so that you can grab the tones that truly matter in your image. That's part of the creativity you bring to bear in realizing your photographic vision.

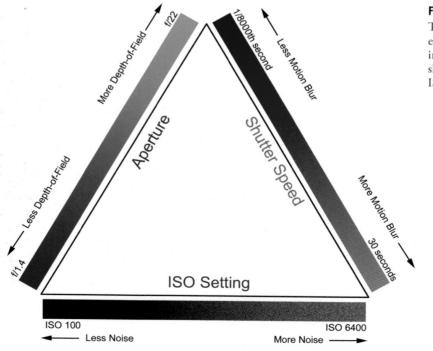

Figure 7.1
The traditional exposure triangle includes aperture, shutter speed, and ISO sensitivity.

For example, look at the two bracketed exposures presented in Figure 7.2. For the image at top left, the highlights (chiefly the clouds at upper left and the top-left edge of the skyscraper) are well exposed, but everything else in the shot is seriously underexposed. The version at the top right, taken an instant later with the tripod-mounted camera, shows detail in the shadow areas of the buildings, but the highlights are completely washed out. The camera's sensor simply can't capture detail in both dark areas and bright areas in a single shot. With digital camera sensors, it's tricky to capture detail in both highlights and shadows in a single image, because the number of tones, the dynamic range of the sensor, is limited.

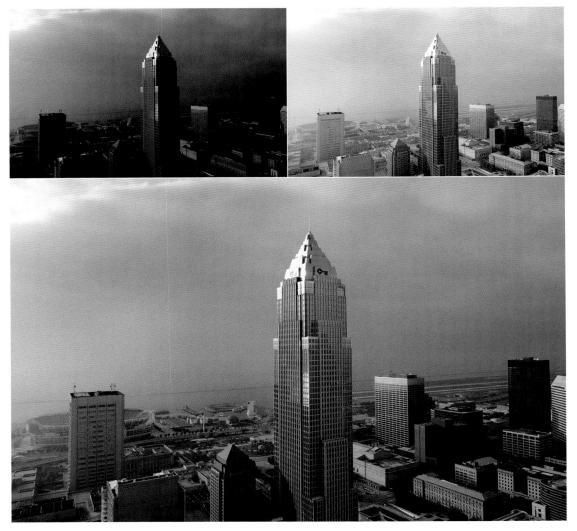

Figure 7.2 At top left, exposure for the highlights loses shadow detail. At top right, exposure for the highlights washes out the background. Bottom, combining the two exposures produces the best compromise.

The solution is to resort to a technique called High Dynamic Range (HDR) photography. It's included as a built-in feature of the camera (through the DRO/HDR Photography entry in the Camera Settings 5 menu). However, I elected to produce the image shown at the bottom of the figure by merging the two original shots using a Photoshop/Photoshop Elements feature called Merge to HDR. There are also specialized software tools like Photomatix (about \$100 from www.hdrsoft.com), Google's HDR Efex Pro 2 as part of the Nik Collection (\$149 at www.google.com/nikcollection), or, for Macs only, Aurora HDR (\$39.95 from www.aurorahdr.com).

I'll explain more about HDR photography, and how to explore it with your a7R II/a7 II later in this chapter. For now, though, I'm going to concentrate on showing you how to get the best exposures possible without resorting to such tools, using only the features of your camera.

To understand exposure, you need to appreciate the aspects of light that combine to produce an image. Start with a light source—the sun, a household lamp, or the glow from a campfire—and trace its path to your camera, through the lens, and finally to the sensor that captures the illumination. Here's a brief review of the things within our control that affect exposure, listed in "chronological" order (that is, as the light moves from the subject to the sensor):

- Light at its source. Our eyes and our cameras—film or digital—are most sensitive to that portion of the electromagnetic spectrum we call visible light. That light has several important aspects that are relevant to photography, such as color and harshness (which is determined primarily by the apparent size of the light source as it illuminates a subject). But, in terms of exposure, the important attribute of a light source is its intensity. We may have direct control over intensity, which might be the case with an interior light that can be brightened or dimmed. Or, we might have only indirect control over intensity, as with sunlight, which can be made to appear dimmer by introducing translucent light-absorbing or reflective materials in its path.
- **Light's duration.** We tend to think of most light sources as continuous. But, as you'll learn in Chapter 13, the duration of light can change quickly enough to modify the exposure, as when the main illumination in a photograph comes from an intermittent source, such as an electronic flash.
- Light reflected, transmitted, or emitted. Once light is produced by its source, either continuously or in a brief burst, we are able to see and photograph objects by the light that is reflected from our subjects toward the camera lens; transmitted (say, from translucent objects that are lit from behind); or emitted (by a candle or television screen). When more or less light reaches the lens from the subject, we need to adjust the exposure. This part of the equation is under our control to the extent we can increase the amount of light falling on or passing through the subject (by adding extra light sources or using reflectors), or by pumping up the light that's emitted (by increasing the brightness of the glowing object).
- Light passed by the lens. Not all the illumination that reaches the front of the lens makes it all the way through. Filters can remove some of the light before it enters the lens. Inside the lens barrel is a variable-sized diaphragm that dilates and contracts to produce an aperture that controls the amount of light that enters the lens. You, or the Alpha's autoexposure system, can vary

the size of the aperture to control the amount of light that will reach the sensor. The relative size of the aperture is called the f/stop. (See Figure 7.3, which is a graphic representation of the relative size of the lens opening, not an actual photo of the aperture of a lens.)

- Light passing through the shutter. Once light passes through the lens, the amount of time the sensor receives it is determined by the camera's shutter; this mechanism can remain open for as long as 30 seconds (or even longer if you use camera's Bulb setting) or as briefly as 1/8,000th second.
- Light captured by the sensor. Not all the light falling onto the sensor is captured. If the number of photons reaching a particular photosite doesn't pass a set threshold, no information is recorded. Similarly, if too much light illuminates a pixel in the sensor, then the excess isn't recorded or, worse, spills over to contaminate adjacent pixels. We can modify the minimum and maximum number of pixels that contribute to image detail by adjusting the ISO setting. At higher ISO levels, the incoming light is amplified to boost the effective sensitivity of the sensor.

These factors—quantity of light, light passed by the lens, the amount of time the shutter is open, and the sensitivity of the sensor—all work proportionately and reciprocally to produce an exposure. That is, if you double the amount of light, increase the aperture size by one stop, make the shutter speed twice as long, or double the ISO, you'll get twice as much exposure. Similarly, you can reduce any of these and reduce the exposure when that is preferable.

As we'll see however, changing any of those aspects in P, A, or S mode does not change the actual exposure; that's because the camera also makes changes when you do so, in order to maintain the same exposure. That's why Sony provides other methods for modifying the exposure in those modes.

Figure 7.3
Top row (left to right): f/3.5, f/5.6, f/8; bottom row: f/11, f/16, f22.

F/STOPS AND SHUTTER SPEEDS

Especially if you're new to advanced cameras, it's worth quickly reviewing some essential concepts. For example, the lens aperture, or f/stop, is a ratio, much like a fraction, which is why f/2 is larger than f/4, just as 1/2 is larger than 1/4. However, f/2 is actually four times as large as f/4. (Think back to high school geometry where we learned that to double the area of a circle, you multiply its diameter by the square root of two: 1.4.)

The full f/stops available with an f/2 lens are f/2, f/2.8, f/4, f/5.6, f/8, f/11, f/16, and f/22. Each higher number indicates an aperture that's half the size of the previous number. Hence, it admits half as much light as the one before. Figure 7.3 shows a simplified representation. (Of course, you can also set intermediate apertures with the a7R II/a7 II, such as f/6.3 and f/7.1, which are the 1/3 stop increments between f/5.6 and f/8.)

Shutter speeds are actual fractions (of a second), so that 1/60, 1/125, 1/250, 1/500, 1/1000, and so forth represent 1/60th, 1/125th, 1/250th, 1/500th, and 1/1000th second. Each higher number indicates a shutter speed that's half as long as the one before. (And yes, intermediate shutter speeds can also be used, such as 1/640th or 1/800th second.) To avoid confusion, Sony uses quotation marks to signify long exposures: 0.8", 2", 2.5", 4", and so forth; these examples represent 0.8-second, 2-second, 2.5-second and 4-second exposures, respectively.

Equivalent Exposure

One of the most important aspects in this discussion is the concept of *equivalent exposure*. This term means that exactly the same amount of light will reach the sensor at various combinations of aperture and shutter speed. Whether we use a small aperture (large f/number) with a long shutter speed or a wide aperture (small f/number) with a fast shutter speed, the amount of light reaching the sensor can be exactly the same. Table 7.1 shows equivalent exposure settings using various shutter speeds and f/stops; in other words, any of the combination of settings listed will produce exactly the same exposure.

When you set the camera to P mode, it sets both the aperture and the shutter speed that should provide a correct exposure, based on guidance from the light metering system. In P mode, you cannot change the aperture or the shutter speed individually, but you can shift among various aperture/

Table 7.1 Equivalent Exposures			
Shutter speed	f/stop	Shutter speed	f/stop
1/30th second	f/22	1/250th second	f/8
1/60th second	f/16	1/500th second	f/5.6
1/125th second	f/11	1/1,000th second	f/4

shutter speed combinations by rotating the rear dial, providing what is called *program shift*. (If you use program shift, an asterisk will appear next to the P on your display screens to let you know you've made an adjustment.) If you change the ISO, the camera will set a different combination automatically. As the concept of equivalent exposure indicates, the image brightness will be exactly the same in every photo you shoot with the various combinations because they all provide the same exposure.

In Aperture Priority (A) and Shutter Priority (S) modes, you can change the aperture or the shutter speed, respectively. The camera will then change the other factor to maintain the same exposure. I'll cover all of the operating modes and the important aspects of exposure with each mode in this chapter.

How the a7 II Series Calculates Exposure

Your camera calculates exposure by measuring the light that passes through the lens and reaches the sensor, based on the assumption that each area being measured reflects about the same amount of light as a neutral gray card that reflects a "middle" gray of about 12- to 18-percent reflectance. (The photographic "gray cards" you buy at a camera store have an 18-percent gray tone; your camera is calibrated to interpret a somewhat darker 12-percent gray. I'll explain more about this later.) That "average" 12- to 18-percent gray assumption is necessary, because different subjects reflect different amounts of light. In a photo containing, say, a white cat and a dark gray cat, the white cat might reflect five times as much light as the gray cat. An exposure based on the white cat will cause the gray cat to appear to be black, while an exposure based only on the gray cat will make the white cat washed out.

This is more easily understood if you look at some photos of subjects that are dark (they reflect little light), those that have predominantly middle tones, and subjects that are highly reflective. I'm not going to use actual cats but, rather, will include a more human figure in the frame (which is more common, unless you're a cat photographer), accompanied by a card with a trio of gray reference patches. The next few figures show what you would end up with if you exposed a set of photographs using a different gray patch for each.

Correctly Exposed

The image shown in Figure 7.4 represents how a photograph might appear if you inserted the patches shown at bottom left into the scene, and then calculated exposure by measuring the light reflecting from the middle gray patch, which, for the sake of illustration, we'll assume reflects approximately 12 to 18 percent of the light that strikes it. The exposure meter in the camera sees an object that it thinks is a middle gray (the middle patch), calculates an exposure based on that, and the patch in the center of the strip is rendered at its proper tonal value. Best of all, because the resulting exposure is correct, the black patch at left and white patch at right are rendered properly as well.

When you're shooting pictures with your a7 II—series camera, and the meter happens to base its exposure on a subject that averages that "ideal" middle gray, then you'll end up with similar (accurate) results. The camera's exposure algorithms are concocted to ensure this kind of result as often as possible, barring any unusual subjects (that is, those that are backlit, or have uneven illumination). The camera has three different metering modes (described next), each of which is equipped to handle certain types of unusual subjects, as I'll outline.

Overexposed

Figure 7.5 shows what would happen if the exposure were calculated based on metering the left-most, black patch, which is roughly the same tonal value of the darkest areas of the subject's hair. The light meter sees less light reflecting from the black square than it would see from a gray middle-tone subject, and so figures, "Aha! I need to add exposure to brighten this subject up to a middle gray!" That lightens the "black" patch, so it now appears to be gray.

But now the patch in the middle that was *originally* middle gray is overexposed and becomes light gray. And the white square at right is now seriously overexposed and loses detail in the highlights, which have become a featureless white. Our human subject is similarly overexposed. You should always be *aware* when overexposure occurs, but note that it's not *always* a bad thing. I happen to like the dreamy look that this particular overexposure produces: once you know how the rules are derived, you'll know how and when to break them.

Figure 7.4 When exposure is calculated based on the middle-gray tone in the center of the card, the black and white patches are rendered accurately, too, and our model is properly exposed.

Figure 7.5 When exposure is calculated based on the black square at lower left, the black patch looks gray, the gray patch appears to be a light gray, and the white square is seriously overexposed.

Figure 7.6 When exposure is calculated based on the white patch on the right, the other two patches, and the photo, are underexposed.

Underexposed

The third possibility in this simplified scenario is that the light meter might measure the illumination bouncing off the white patch, and try to render *that* tone as a middle gray. A lot of light is reflected by the white square, so the exposure is *reduced*, bringing that patch closer to a middle gray tone. The patches that were originally gray and black are now rendered too dark. Clearly, measuring the gray card—or a substitute that reflects about the same amount of light—is the only way to ensure that the exposure is precisely correct. (See Figure 7.6.)

As you can see, the ideal way to measure exposure is to meter from a subject that reflects 12 to 18 percent of the light that reaches it. If you want the most precise exposure calculations, the solution is to use a stand-in, such as the evenly illuminated gray card I mentioned earlier. But, because the standard Kodak gray card reflects 18 percent of the light that reaches it and, as I said, your camera is calibrated for a somewhat darker 12-percent tone, you would need to add about one-half stop *more* exposure than the value metered from the card.

In some very bright scenes (like a snowy landscape or a lava field), you won't have a mid-tone to meter. Another substitute for a gray card is the palm of a human hand (the backside of the hand is too variable). But a human palm, regardless of ethnic group, is even brighter than a standard gray card, so instead of one-half stop more exposure, you need to add one additional stop. That is, if your meter reading is 1/500th of a second at f/11, use 1/500th second at f/8 or 1/200th second at f/11 instead. (Both exposures are equivalent.)

Or, you might want to resort to using an evenly illuminated gray card mentioned earlier. Small versions are available that can be tucked in a camera bag. Place it in your frame near your main subject, facing the camera, and with the exact same even illumination falling on it that is falling on your subject. Then, use the Spot metering function (described in the next section) to calculate exposure.

But, the standard Kodak gray card reflects 18 percent of the light while, as I noted, your camera is calibrated for a somewhat darker 12-percent tone. If you insisted on getting a perfect exposure, you would need to add about one-half stop more exposure than the value provided by taking the light meter reading from the card. Of course, in most situations, it's not necessary to do this. Your camera's light meter will do a good job of calculating the right exposure, especially if you use the exposure tips in the next section. But, I felt that explaining exactly what is going on during exposure calculation would help you understand how your camera's metering system works.

EXTERNAL METERS CAN BE CALIBRATED

The light meters built into your camera are calibrated at the factory. But if you use a hand-held incident or reflective light meter, you *can* calibrate it, using the instructions supplied with your meter. Because a hand-held meter *can* be calibrated to the 18-percent gray standard (or any other value you choose), my rant about the myth of the 18-percent gray card doesn't apply.

ORIGIN OF THE 18-PERCENT "MYTH"

Why are so many photographers under the impression that camera light meters are calibrated to the 18-percent "standard," rather than the true value, which may be 12 to 14 percent, depending on the vendor? You'll find this misinformation in an alarming number of places. I've seen the 18-percent "myth" taught in camera classes; I've found it in books, and even been given this wrong information from the technical staff of camera vendors. (They should know better—the same vendors' engineers who design and calibrate the cameras have the right figure.)

The most common explanation is that during a revision of Kodak's instructions for its gray cards in the 1970s, the advice to open up an extra half stop was omitted, and a whole generation of shooters grew up thinking that a measurement off a gray card could be used as-is. The proviso returned to the instructions by 1987, it's said, but by then it was too late. Next to me is a (c)2006 version of the instructions for KODAK Gray Cards, Publication R-27Q (still available in authorized versions from non-Kodak sources). The current directions read (with a bit of paraphrasing from me in italics):

- For subjects of normal reflectance increase the indicated exposure by 1/2 stop.
- For light subjects, use the indicated exposure; for very light subjects, decrease the exposure by 1/2 stop. (*That is, you're measuring a subject that's lighter than middle gray.*)
- If the subject is dark to very dark, increase the indicated exposure by 1 to 1-1/2 stops. (*You're shooting a dark subject.*)

In serious photography, you'll want to choose the *metering mode* (the pattern that determines how brightness is evaluated) and the *exposure mode* (determines how the appropriate shutter speed and aperture is set). I'll describe both aspects in later sections.

The Importance of ISO

Another essential concept when discussing exposure, ISO control allows you to change the sensitivity of the camera's imaging sensor. Sometimes photographers forget about this option, because the common practice is to set the ISO once for a particular shooting session (say, at ISO 100 or 200 for bright sunlight outdoors, or ISO 800 or 1600 when shooting indoors) and then forget about ISO. Or some shooters simply leave the camera set to ISO Auto. That enables the camera to change the ISO it deems necessary, setting a low ISO in bright conditions or a higher ISO in a darker location. That's fine, but sometimes you'll want to set a specific ISO yourself. That will be essential sometimes, since ISO Auto cannot set the highest ISO levels that are available when you use manual ISO selection. Indeed, when shooting movies, only ISO settings from ISO 200 to ISO 25600 (with the a7 II) or ISO 100 to ISO 25600 (with the a7R II) can be set.

TIP

When shooting in the Program (P), Aperture Priority (A), and Shutter Priority (S) modes, all discussed soon, changing the ISO does not change the exposure. If you switch from using ISO 100 to ISO 1600 in A mode, for example, the camera will simply set a different shutter speed. If you change the ISO in S mode, the camera will set a different aperture, and in P mode, it will set a different aperture and/or shutter speed. In all of these examples, the camera will maintain the same exposure. If you want to make a brighter or a darker photo in P, A, or S mode, you would need to set + or – exposure compensation, as discussed later.

However, when you use the Manual (M) mode, changing the ISO also changes the exposure, as discussed shortly.

With either model, the camera provides the best possible image quality in the ISO 50 to 400 range. We use higher ISO levels such as ISO 1600 in low light and ISO 6400 in a very dark location because it allows us to shoot at a faster shutter speed. That's often useful for minimizing the risk of blurring caused by camera shake, which can occur even with 5-axis image stabilization in the camera body and optical image stabilization (OSS) built into many lenses. And, of course, you must also contend with movement of the subject, which no amount of image stabilization will fix.

Although you can set a desired ISO level yourself, the a7R II/a7 II also offers an ISO Auto option. When enabled, the camera will select an ISO that should be suitable for the conditions: a low ISO on a sunny day and a high ISO in a dark location. In Intelligent Auto, Superior Auto, Scene Selection, or Sweep Panorama modes, ISO Auto is the only available option. The camera will set an ISO no higher than 3200, except in the Anti Motion Blur Scene and Hand-held Twilight scene modes where it can set ISO 6400.

Over the past few years, there has been something of a competition among the manufacturers of digital cameras to achieve the highest ISO ratings. The highest announced ISO numbers have been rising annually, from 1600 to 3200 and 6400; a few cameras even allow you to set an ISO higher than 104200. Sony is a bit more conservative, but the a7 II series offers all of the ISO options you're ever likely to need, up to ISO 25600 with the a7 II and ISO 104200 with the a7R II.

Choosing a Metering Method

The Sony a7R II/a7 II has three different schemes for evaluating the light received by its exposure sensors. The quickest way to choose among them is to assign Metering Mode to a key using the Custom Key settings in the Custom Settings 6 menu, as described in Chapter 4. Then, you can press the defined key to produce the Metering Mode screen; then scroll up/down among the options. Without a custom key, the default method for choosing a metering mode is to use the Camera Settings 5 menu entry (see Figure 7.7), the Function menu, or Quick Navi menu.

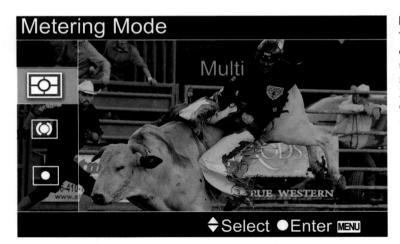

Figure 7.7
The a7 II—series cameras provide three options for metering mode:
Multi (the default),
Center, and Spot (left, top to bottom).

Your options are:

■ Multi. In this "intelligent" (multi-segment) metering mode, the Alpha slices up the frame into 1,200 different zones, as shown in Figure 7.8. The camera evaluates the measurements to make an educated guess about what kind of picture you're taking, based on examination of exposure data derived from thousands of different real-world photos. For example, if the top section of a picture is much lighter than the bottom portions, the algorithm can assume that the scene is a landscape photo with lots of sky. This mode is the best all-purpose metering method for most pictures. A typical scene suitable for Multi metering is shown in Figure 7.9.

The Multi system can recognize a very bright scene and it can automatically increase the exposure to reduce the risk of a dark photo. This will be useful when your subject is a snow-covered landscape or a close-up of a bride in white. Granted, you may occasionally need to use a bit of exposure compensation, but often, the exposure will be close to accurate even without it. (In my experience, the Multi system is most successful with light-toned scenes on bright days. When shooting in dark, overcast conditions, it's more likely to underexpose a scene of that type.)

■ Center. This (center-weighted) metering was the only available option with cameras some decades ago. In this mode you get conventional metering without any "intelligent" scene evaluation. The light meter considers brightness in the entire frame but places the greatest emphasis on a large area in the center of the frame, as shown in Figure 7.10, on the theory that, for most pictures, the main subject will not be located far off-center.

Of course, Center metering is most effective when the subject in the central area is a mid-tone. Even then, if your main subject is surrounded by large, extremely bright or very dark areas, the exposure might not be exactly right. (You might need to use exposure compensation, a feature discussed shortly.) However, this scheme works well in many situations if you don't want to use one of the other modes for scenes like the one shown in Figure 7.11.

■ **Spot.** This mode confines the reading to a very small area in the center of the image, as shown in Figure 7.12. (When you use the Flexible Spot autofocus options, however, the spot metering will be at the area where the camera sets focus.) The Spot meter does not apply any "intelligent" scene evaluation. Because the camera considers only a small target area, and completely ignores its surroundings, Spot metering is most useful when the subject is a small mid-tone area. For example, the "target" might be a tanned face, a medium red blossom, or a gray rock in a wideangle photo; each of these is a mid-tone. And that is important as you will recall from our example involving the cats.

The Spot metering technique is simple if you want to Spot meter a small area that's dead center in the frame. If the "target" is off-center, you would need to point the lens at it and use the AE Lock technique discussed later in this chapter. (Lock exposure on your target before re-framing for a better composition so the exposure does not change.) For Figure 7.13, Spot metering was used to base the exposure on a middle gray area in the upper-right quadrant of the sculpture.

If you Spot meter a light-toned area or a dark-toned area, you will get underexposure or over-exposure respectively; you would need to use an override for more accurate results. On the other hand, you can Spot meter a small mid-tone subject surrounded by a sky with big white clouds or by an indigo blue wall and get a good exposure. (The light meter ignores the subject's surroundings so they do not affect the exposure.) That would not be possible with Center-weighted metering, which considers brightness in a much larger area.

Figure 7.8 Multi metering uses 1.200 zones.

Figure 7.9 Multi metering is suitable for complex scenes like this one.

Figure 7.10 Center metering calculates exposure based on the full frame, but emphasizes the center area.

Figure 7.11 Scenes with the important tones in the center of the frame lend themselves to Center metering.

Figure 7.12 Spot metering calculates exposure based on a spot that's only a small percentage of the image area.

Figure 7.13 Meter from precise areas in an image using Spot metering.

Choosing an Exposure Mode

After you set a desired metering mode, you have several methods for choosing the appropriate shutter speed and aperture, semi-automatically or manually. Just press the center button and spin the mode dial to the exposure mode that you want to use. If the Mode Dial Guide is activated in the Setup 2 menu (as described in Chapter 6), you'll see a display that briefly explains what the selected mode does. Your choice of which is best for a given shooting situation will depend on aspects like your need for extensive or shallow depth-of-field (the range of acceptably sharp focus in a photo) or the desire to freeze action or to allow motion blur. The semi-automatic Aperture Priority and Shutter Priority modes discussed in the next section emphasize one aspect of image capture or another, but the following sections introduce you to all four of the modes that photographers often call "creative."

Aperture Priority (A) Mode

When using the A mode, you specify the lens opening (aperture or f/stop) with the front or rear dial. After you do so, the camera (guided by its light meter) will set a suitable shutter speed considering the aperture and the ISO in use. If you change the aperture, from f/5.6 to f/11 for example, the camera will automatically set a longer shutter speed to maintain the same exposure, using guidance from the built-in light meter. (I discussed the concept of equivalent exposure earlier and provided the equivalent exposure chart).

Aperture Priority is especially useful when you want to use a particular lens opening to achieve a desired effect. Perhaps you'd like to use the smallest aperture (such as f/22) to maximize depth-of-field (DOF), to keep the entire subject sharp in a close-up picture. Or, you might want to use a large aperture (small f/number like f/4) to throw everything except your main subject out of focus, as in Figure 7.14. Maybe you'd just like to "lock in" a particular f/stop, such as f/8, because it allows your lens to provide the best optical quality. Or, you might prefer to use f/2.8 with a lens that has a maximum aperture of f/1.4, because you want the best compromise between shutter speed and optical quality.

Aperture Priority can even be used to specify a *range* of shutter speeds you want to use under varying lighting conditions, which seems almost contradictory. But think about it. You're shooting a soccer game outdoors with a telephoto and want a relatively fast shutter speed, but you don't care if the speed changes a little should the sun duck behind a cloud. Set your camera's shooting mode to A, and adjust the aperture using the front or rear dial until a shutter speed of, say, 1/1,000th second is selected at the ISO level that you're using. (In bright sunlight at ISO 400, that aperture is likely to be around f/11.) Then, go ahead and shoot, knowing that your a7R II/a7 II will maintain that f/11 aperture (for sufficient DOF as the soccer players move about the field), but will drop down to 1/800th or 1/500th second if necessary should a light cloud cover part of the sun.

Figure 7.14
Use Aperture
Priority mode to
"lock in" a wide
aperture (denoted by
a large f/number)
when you want to
blur the
background.

When the camera cannot provide a good exposure at the aperture you have set, the +/- symbol and the shutter speed numeral will blink in the LCD display. The blinking warns that the camera is unable to find an appropriate shutter speed at the aperture you have set, considering the ISO level in use and over- or underexposure will occur. That's the major pitfall of using Aperture Priority: you might select an f/stop that is too small or too large to allow an optimal exposure with the available shutter speeds.

Here are a couple of examples where you might encounter a problem. Let's say you set an aperture of f/2.8 while using ISO 400 on an extremely bright day (perhaps at the beach or in snow); in this situation, even your camera's fastest shutter speed might not be able to cut down the amount of light reaching the sensor to provide the right exposure. (The solution here is to set a lower ISO or a smaller aperture, or both, until the blinking stops.) Or, let's say you have set f/16 in a dark arena while using ISO 100; the camera cannot find a shutter speed long enough to provide a correct exposure so your photo will be underexposed. (In low light, the solution is to set a higher ISO or a wider aperture, or both, until the blinking stops.) Aperture Priority is best used by those with a bit of experience in choosing settings. Many seasoned photographers leave their camera set on Aperture Priority all the time.

Shutter Priority (S) Mode

Shutter Priority is the inverse of Aperture Priority. You set the shutter speed you'd like, using the front or rear dial, and the camera sets an appropriate f/stop considering the ISO that's in use. When you change the shutter speed, the camera will change the aperture to maintain the same (equivalent) exposure using guidance from the built-in light meter. Shutter Priority mode gives you some control over how much action-freezing capability your digital camera brings to bear in a particular situation. In other cases, you might want to use a slow shutter speed to add some blur to a sports photo that would be mundane if the action were completely frozen (see Figure 7.15).

Take care when using a slow shutter speed such as 1/8th second, because you'll potentially get blurring from camera shake unless you're using a tripod or other firm support. Of course, this applies to any mode, but in most modes the camera displays a camera shake warning icon when the shutter speed is long. That does not appear in S mode however, perhaps because Sony assumes that users of Shutter Priority are aware of the potential problem caused by camera shake. The in-body 5-axis image stabilization and SteadyShot stabilizer in OSS-designated lenses are useful but they cannot work miracles.

As in Aperture Priority, you can encounter a problem in Shutter Priority mode; this happens when you select a shutter speed that's too long or too short for correct exposure under certain conditions. I've shot outdoor soccer games on sunny fall evenings and used Shutter Priority mode to lock in a 1/1,000th second shutter speed, only to find that my camera refused to produce the correct

Figure 7.15 Set a slow shutter speed when you want to introduce blur into an action shot, as with this panned image of a basketball player.

exposure when the sun dipped behind some trees and there was no longer enough light to shoot at that speed, even with the lens wide open.

In cases where you have set an inappropriate shutter speed, the aperture numeral and the +/- symbol will blink on the LCD. When might this happen? Let's say you set 1/15th second shutter speed while using ISO 400 on that extremely bright day; in this situation, even the smallest aperture available with your lens might not be able to cut down the amount of light reaching the sensor to provide a correct exposure. (The solution here is to set a lower ISO or a faster shutter speed, or both, until the blinking stops.) Or, let's say you have set 1/250th second in the arena while using ISO 100; your lens does not offer an aperture that's wide enough to enable the camera to provide a good exposure so you'll get the blinking and your photo will be underexposed. (In low light, the solution is to set a higher ISO or a longer shutter speed, or both, until the blinking stops.)

Program Auto (P) Mode

The Program mode uses the camera's built-in smarts to set an aperture/shutter speed combination, based on information provided by the light meter. If you're using Multi metering, the combination will often provide a good exposure. Rotate the front or rear dial and you can switch to other aperture/shutter speed combinations, all providing the same (equivalent) exposure. The P on the screen changes to P*. You can't use Program Shift when working with flash. To reverse Program Shift, change to another exposure mode (you can immediately switch back to P mode) or turn the camera off.

In the unlikely event that the correct exposure cannot be achieved with the wide range of shutter speeds and apertures available, the shutter speed and aperture will both blink. (The solution is to set a lower ISO in bright light and a higher ISO in dark locations until the blinking stops.) The P mode is the one to use when you want to rely on the camera to make reasonable basic settings of shutter speed and aperture, but you want to retain the ability to adjust many of the camera's settings yourself. All overrides and important functions are available, including ISO, white balance, metering mode, exposure compensation, and others.

Making Exposure Value Changes

Sometimes you'll want a brighter or darker photo (more or less exposure) than you got when relying on the camera's metering system. Perhaps you want to underexpose to create a silhouette effect, or overexpose to produce a high-key (very light) effect. It's easy to do so by using the a7R II/a7 II's exposure compensation features, available only in P, S, A, M, Panorama, and Movie modes. There are several ways to set exposure compensation:

■ Exposure compensation dial. This dial, located at the right end of the top surface of the camera, is the fastest method for adding/subtracting exposure. It can be rotated to provide plus or minus three stops of exposure in one-third stop increments. Only plus/minus 2 stops is available when using Movie mode.

In Manual exposure mode, exposure compensation can be dialed in only when ISO Auto is activated, as the camera will leave your shutter speed and aperture settings undisturbed and add or subtract exposure by changing ISO sensitivity instead. The dial is not "locked," so you can easily spin it with your thumb while shooting. It has click detents and is not likely to rotate accidentally.

- Exposure Compensation menu. If you want additional exposure compensation, venture to the Camera Settings 4 menu, where the Exposure Comp. entry will let you set plus or minus five stops of exposure using the front or rear dials or control wheel. This option is not available if you've made a setting with the exposure compensation dial; its menu entry will be grayed out.
- Function menu. Unless you've redefined your Function menu to remove it, exposure compensation can also be applied by pressing the Fn button. Its default position is at the far right of the top row of functions. The Function menu entry also lets you choose up to five stops of compensation.
- **Define a key.** If you like, you can define a key as your exposure compensation button, using the Custom Keys feature described in Chapter 4. When I feel I am going to be making many exposure compensation settings, I define the down directional button as the exposure compensation button. Then, I can press the down button and rotate the control wheel to make quick adjustments.

In my experience, adding exposure compensation is the option that's most often necessary. I'll often set +2/3 when using Multi metering if the camera underexposed my first photo of a light-toned scene. With Center-weighted or Spot metering, +1.3 or an even higher level of plus compensation is almost always necessary with a light-toned subject. Since the camera provides a live preview of the scene (when Setting Effect is turned on), it's easy to predict when the photo you'll take is likely to be obviously over or under exposed. When the histogram display is on, you can make a more accurate prediction about the exposure; I'll discuss this feature shortly. Of course, you can also use plus compensation when you want to intentionally overexpose a scene for a creative effect.

You won't often need to use minus compensation. This feature is most likely to be useful when metering a dark-toned subject, such as close-ups of black animals or dark blue buildings, for example. Since these dark-toned subjects lead the camera to overexpose, set -2/3 or -1 compensation (when using Multi metering) for a more accurate exposure. (The amount of minus compensation that you need to set may be quite different when using the other two metering modes.) Minus compensation can also be useful for intentionally underexposing a scene for a creative effect, such as a silhouette of a sailboat or a group of friends on a beach.

Any exposure compensation you set will remain active for all photos you take afterward. The camera provides a reminder as to what value is currently set in some display modes. Turning the a7R II/a7 II off and then back on does not set compensation back to zero; when you no longer need to use it, be sure to do so yourself. If you inadvertently leave it set for +1 or -1, for example, your photos taken under other circumstances will be over- or underexposed.

Manual Exposure (M) Mode

Part of being an experienced photographer comes from knowing when to rely on your a7R II/a7 II's automation (including Intelligent Auto, Superior Auto, P mode, and SCN mode settings), when to go semi-automatic (with Shutter Priority or Aperture Priority), and when to set exposure manually (using M). Some photographers actually prefer to set their exposure manually. This is quite convenient since the camera is happy to provide an indication of when your settings will produce over- or underexposure, based on its metering system's judgment. It can even indicate how far off the "correct" (recommended) exposure your photo will be at the settings you have made.

I often hear comments from novices first learning serious photography claiming that they must use Manual mode in order to take over control from the camera. While a back-to-basics approach does force you to learn photographic principles, it's not always necessary. For example, you can control all important aspects when using semi-automatic A or S mode as discussed in the previous sections. This allows you to control depth-of-field (the range of acceptable sharpness) or the rendition of motion (as blurred or as frozen). You can set a desired ISO level; that will not change the exposure. You would use exposure compensation when you want a brighter or a darker photo.

Manual mode provides an alternative that allows you to control the aperture and the shutter speed and the exposure simultaneously. For example, when I shot the windmill in Figure 7.16, I was not getting exactly the desired effect with A or S mode while experimenting with various levels of exposure compensation. So, I switched to M mode, set ISO 100, and then set an aperture/shutter speed that might provide the intended exposure. After taking a test shot, I changed the aperture slightly and the next photo provided the exposure for the interpretation of the scene that I wanted.

Manual mode is also useful when working in a studio environment using multiple flash units. The additional flash units are triggered by slave devices (gadgets that set off the flash when they sense the light from another flash, or, perhaps from a radio or infrared remote control). In some cases, M mode is the only suitable choice. Your camera's exposure meter doesn't compensate for the extra illumination, and can't interpret the flash exposure at all, so you need to set the aperture and shutter speed manually.

The Basic M Mode Technique

Depending on your proclivities, you might not need to use M mode very often, but it's still worth understanding how it works. Here are your considerations:

- Rotate the mode dial to M.
- Use the front dial to adjust aperture and the rear dial to adjust shutter speed (unless you've swapped their functions, as described in Chapter 6). The setting that is currently active will be highlighted in orange.
- If you have Exposure Set Guide in the Custom Settings 2 menu set to On, enlarged labels showing the changing shutter speed or aperture will be displayed near the bottom of the screen, unless you choose the Graphic display mode with the DISP button. In that case, scales will show the current shutter speed and aperture at the same time.

Figure 7.16 Manual mode allowed setting the exact exposure for this silhouette shot, by metering the subject and then underexposing.

- Any change you make to either factor affects the exposure, of course, so if you have Live View Display in the Custom Settings 2 menu set to Setting Effect ON, you'll see the display getting darker or brighter as you change settings.
- If the display you're viewing includes the histogram graph, that will provide an even better indication of the exposure you'll get as you set different apertures or shutter speeds. I'll explain histograms later in this chapter.
- A guide at the bottom of the Monitor or viewfinder indicates exposure. To use the suggested exposure, adjust the shutter speed or f/stop until the MM guide reads + 0.0.

Long Exposures

You can specify exposures as long as 30 seconds when using P, A, or S modes. In Manual exposure mode, you can select B (for bulb exposure), located *after* the 30-second option. Bulb cannot be selected when using Auto HDR, Continuous Shooting, Speed Priority Continuous, or Multi Frame Noise Reduction.

In Bulb mode, you can press and hold the shutter release button, and the shutter will remain open as long as the button is depressed. Standing there with your finger on the trigger, so to speak, can produce vibration, so I prefer to use a wired release with a locking button, such as the Sony RM-VPR1 (\$65).

Adjusting Exposure with ISO Control in M Mode

As mentioned in the previous section, changing the ISO level is another method of changing the exposure in M mode, whether you adjust it yourself manually, or activate Auto ISO and let the camera do it for you when you add or subtract exposure compensation.

Most photographers control the aperture and/or shutter speed exclusively to adjust exposure, sometimes forgetting about the option to adjust ISO. The common practice is to set the ISO once for a particular shooting session (say, at ISO 100 outdoors on a bright day or ISO 1600 when shooting indoors). There is also a tendency to use the lowest ISO level possible because of a concern that high ISO levels produce images with obvious digital noise (such as a grainy effect). However, changing the ISO is a valid way of adjusting exposure in M mode, particularly with the a7 II series, which produce good results at relatively high ISO levels that create grainy, unusable pictures with some other camera models.

Indeed, I find myself using ISO adjustment as a convenient alternate way of adding or subtracting EV (exposure values) when shooting in Manual mode, and as a quick way of choosing equivalent exposures when in automatic or semi-automatic modes. For example, I've selected a manual exposure with both f/stop and shutter speed suitable for my image using, say, ISO 400. I can change the exposure in full stop increments by pressing the ISO button (right directional button), and spinning the front/rear dials or control wheel one click at a time. The difference in image quality/noise is not much different at ISO 200 or ISO 800 than at ISO 400 and this exposure control method allows me to shoot at my preferred f/stop and shutter speed while retaining control of the exposure.

Or, perhaps, I am using Shutter Priority mode and the metered exposure at ISO 400 is 1/500th second at f/11. If I decide on the spur of the moment I'd rather use 1/500th second at f/8, I can press the ISO button and quickly switch to ISO 200. Of course, it's a good idea to monitor your ISO changes, so you don't end up at ISO 6400 or above accidentally; a setting like that will result in more digital noise (graininess) in your image than you would like. In M mode, you can use Auto ISO, as discussed in the section that follows. Higher ISO levels are necessary only when shooting in a very dark location where a fast shutter speed is important; this might happen during a sports event in a dark arena, for example.

Using ISO Auto

ISO Auto is a powerful feature, available in PSAM and Movie modes. In your camera's Fn and Camera Settings 5 ISO menus, it's designated as Auto; the setting labeled ISO Auto is actually Multi Frame Noise Reduction, and it's easy to get the two confused. ISO Auto provides two major benefits. First, if the shutter speed and aperture settings in use won't provide a proper exposure, ISO Auto can adjust the ISO setting to compensate. Second, you can use ISO Auto to "lock in" a particular shutter speed or aperture (or both, in Manual mode), and use ISO sensitivity to compensate for changing or low-light conditions.

In the first case, suppose you were shooting a moving subject in Aperture Priority mode and your selected f/stop would result in a shutter speed of 1/8th second at ISO 400. All the image stabilization in the world can't protect you from blur caused by *subject* movement. If you were using ISO Auto with the a7R II (only) and had specified a minimum shutter speed of 1/30th second in the Camera Settings 5 menu (as described in Chapter 3), the camera's exposure system would automatically increase ISO from 400 to 1600. Most of us would prefer a slight increase in noise from the ISO boost than a blurry photograph. **Note:** you can't specify a minimum shutter speed with the a7 II.

With the a7R II, the minimum (slowest) shutter speed allowed before ISO Auto kicks in can be specified in the Camera Settings 5 menu. The setting has no effect when you're using Shutter Priority, as the shutter speed you choose is locked in. But in Program and Aperture Priority modes, you can choose that minimum. If you were shooting action and wanted to ensure that P and A modes would try to use a shutter speed of 1/250th second or faster, you could select that speed as the minimum speed before ISO Auto would increase sensitivity. If you were shooting subjects with little movement, you might select 1/8th second and count on the camera and/or lens's image stabilization to give you sharp results. For most general applications, a minimum of 1/30th second should work well.

We're not done yet. ISO Auto also allows you to choose a *minimum* and *maximum* ISO speed to be used. If you want to avoid noise, you could set the Minimum ISO to 100 and the Maximum to 800, and still gain the benefits of using ISO Auto. If you wouldn't mind seeing a little noise, you could set the Maximum somewhat higher. Coupled with Minimum Shutter speed (with the a7R II), ISO Auto gives you quite a bit of flexibility in controlling the range of shutter speeds and apertures used.

Don't forget that in Manual Exposure mode you can use ISO Auto in a special way. As you might expect, in Manual Exposure mode, the shutter speed and aperture are selected by you and fixed at those settings until you change them. However, if ISO Auto is active, you can add or subtract exposure compensation, as described earlier, by rotating the exposure compensation dial on top of the camera, or by using the menu, Function menu, or a physical ISO control.

Exposure Bracketing

While exposure compensation lets you adjust exposure, sometimes you'll want to quickly shoot a series of photos at various exposures in a single burst. Doing so increases the odds of getting one photo that will be exactly right for your needs, and is particularly useful when assembling high dynamic range (HDR) composite images manually. This technique is called bracketing.

Years ago, before high-tech cameras became the norm, it was common to bracket exposures when shooting color slide film especially, by taking three (or more) photos at different exposures in Manual mode. Eventually, exposure compensation became a common feature as cameras gained semi-automatic modes; it was then possible to bracket exposures by setting a different compensation level for each shot in a series, such as 0, -1, and +1 or 0, -1/3 and +2/3.

Today, cameras like the a7R II/a7 II give you a lot of options for automatically bracketing exposures. When Bracket is active, you can take a series of consecutive photos: one at the metered ("correct") exposure, and others with more or less exposure. Figure 7.17 shows an image with the metered exposure (center), flanked by exposures of 2/3 stop more (left), and 2/3 stop less (right).

Bracketing cannot be performed when using Auto mode, any SCN mode, Sweep Panorama mode, or when using the Smile Shutter or Auto HDR features. If flash is used, you must take the photos one at a time, manually, rather than in a continuous burst. Exposure bracketing can be used with both RAW and JPG capture. When it's set, the camera will fire the shots in a sequence if you keep the shutter release button depressed; you can also decide to shoot the photos one at a time.

Bracketing is activated using the Drive settings, which can be found in the Camera Settings 2 menu, Function menu, and summoned by pressing the left directional button or some other button you've defined as the Drive button. Four different bracketing modes can be selected: continuous bracket, single bracket, white balance bracket, and DRO (dynamic range optimizer) bracket, plus Self-Timer During Bracketing for exposure bracketing.

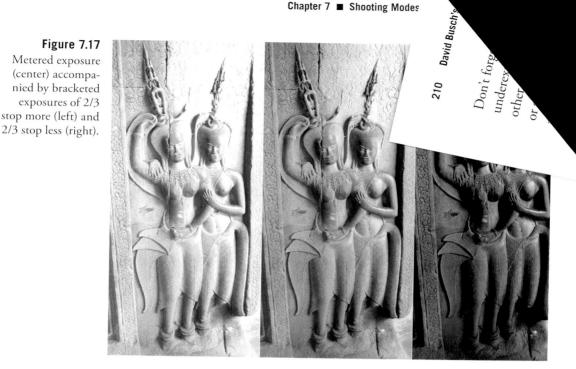

Continuous Bracketing

This mode captures three, five, or nine images in one burst when the shutter release is held down, bracketing them 0.3, 0.7, 1.0, 2.0, or 3.0 stops apart. When you highlight Cont. Bracket. in the Drive menu, the left/right buttons are used to select the increment between shots and the number of shots. In Manual Exposure (when ISO Auto is disabled), or in Aperture Priority, the shutter speed will change. If ISO Auto is set in Manual Exposure, the bracketed set will be created by changing the ISO setting. In Shutter Priority, the aperture will change. Use continuous mode when you want all the images in the set to be framed as similarly as possible, say, when you will be using them for manually assembled high dynamic range (HDR) photos.

You can use flash when continuous bracketing is active, but, because of the time required for the flash to recycle, you'll need to press the shutter button each time to take subsequent images (effectively switching the camera into Single Bracket mode, described next). Continuous Bracketing (and Single Bracketing) is disabled when using Superior Auto, SCN modes, or Sweep Panorama.

Only the last shot in the set is displayed when using Auto Review. With all types of bracketing, the exposure/bracket scale at the bottom of the EVF or LCD monitor (in Display All Info mode) will display indicators showing the number of images shot and the relative amount of under- or overexposure.

posure applied while bracketing, too. You can bracket your exposures based on something than the base (metered) exposure value. Set any desired exposure compensation, either a plus a minus value. Then set the Bracketing level you want to use. The camera will bracket exposures as over, under, and equal to the *compensated* value.

HDR ISN'T HARD

The 1.0 to 3.0 EV options are the ones you might try first when bracketing if you plan to perform High Dynamic Range magic later on in Photoshop (with Merge to HDR), Elements (with Photomerge), or with another image editor that provides an HDR feature. That will allow you to combine images with different exposures into one photo with an amazing amount of detail in both highlights and shadows. To get the best results, mount your camera on a tripod, shoot in RAW format, and use BRK C3.0EV to get three shots with 3 EV of difference in exposure. Of course, with this camera, you also have the option of using the Auto HDR feature as well; this can provide very good results in the camera without the need to use any special HDR software.

Single Bracketing

This mode captures one bracketed image in a set of three or five shots each time you press the shutter release, bracketing them 0.3, 0.7, 1.0, 2.0, or 3.0 stops apart. The left/right buttons are used to select the increment and number of shots. In this mode, you can separate each image by an interval of your choice. You might want to use this variation when you want the individual images to be captured at slightly different times, say, to produce a set of images that will be combined in some artistic way.

White Balance Bracketing

In this mode, the camera shoots three images, each with a different adjustment to the color temperature. While you can't specify which direction the color bias is tilted, you can select Lo (the default) for small changes, or Hi, for larger changes using the left/right buttons. Only the last shot taken is displayed during Auto Review.

DRO Bracketing

This mode takes three images, with Lo (the default) or High adjustments to the dynamic range optimization. Use the left/right buttons to specify the degree of adjustment. Again, only the last shot taken is displayed during Auto Review.

Dealing with Digital Noise

Visual noise is that random grainy look with colorful speckles that some like to use as a visual effect, but most consider to be objectionable. That's because it robs your image of detail even as it adds that "interesting" texture. Noise is caused by two different phenomena: high ISO levels and long exposures. The a7R II/a7 II offers a menu item to minimize high ISO noise. In Chapter 3, I discussed the Camera Settings 6 menu item that you can use to modify the noise reduction processing; you might want to review the sections about High ISO NR and Long Exposure NR as a refresher.

High ISO Noise

Digital noise commonly appears when you set an ISO above ISO 1600 with the a7 II series. High ISO noise appears as a result of the amplification needed to increase the effective sensitivity of the sensor. While higher ISOs do pull details out of dark areas, they also amplify non-signal information randomly, creating noise.

High ISO Noise Reduction is very useful, although at default, it also tends to make images slightly softer as blurring the noise pattern also blurs some intricate details. The higher the ISO, the more aggressive the processing will be, depending on whether you've specified Normal or Low. The Low level for NR provides images that are more grainy but with better resolution of fine detail. Even if you've chosen Off, the camera still applies some noise reduction.

High ISO NR is grayed out when the camera is set to shoot only RAW-format photos. The camera does not use this feature on RAW-format photos since noise reduction—at the optimum level for any photo—can be applied in the software you'll use to modify and convert the RAW file to JPEG or TIFF. (If you shoot in RAW & JPEG, the JPEG images, but not the RAW files, will be affected by this camera feature.) I'll discuss Noise Reduction with software in more detail in the next section.

Figure 7.18 shows two pictures that I shot at ISO 6400. For the first, I used the default (Normal) High ISO NR, and for the second shot, I set the NR to Off. (I've exaggerated the differences between the two slightly so the grainy/less grainy images are more evident on the printed page. The halftone screen applied to printed photos tends to mask these differences.)

Long Exposure Noise

A similar digital noise phenomenon occurs during long time exposures, which allow more photons to reach the sensor, increasing your ability to capture a picture under low-light conditions. However, the longer exposures also increase the likelihood that some pixels will register as random, "phantom," photons, often because the longer an imager collects photos during an exposure, the hotter it becomes, and that heat can be mistaken by the sensor as actual photons. The camera tries to minimize this type of noise automatically; there is no separate control you can adjust to add more or less noise reduction for long exposures.

Figure 7.18 The Normal level for High ISO NR (left) produces a smoother (less grainy) image than one made with High ISO NR turned off (right).

CMOS imagers like the one in the a7R II/a7 II, contain millions of individual amplifiers and A/D (analog to digital) converters, all working in unison though the BIONZ X digital image processor chip. Because these circuits don't necessarily all process in precisely the same way all the time, they can introduce something called fixed-pattern noise into the image data.

Long exposure noise reduction is used with JPEG exposures longer than one full second. (This feature is not used on RAW photos and in continuous shooting, bracketing, Panorama mode, Sports Action, and Hand-held Twilight scene modes.) When it's active, long exposure noise reduction processing removes random pixels from your photo, but some of the image-making pixels are unavoidably vanquished at the same time.

It's possible that you prefer the version made without NR, and you can achieve that simply by shooting RAW. Indeed, noise reduction can be applied with most image-editing programs. You might get even better results with an industrial-strength product like Nik Dfine, part of Google's Nik collection, or Topaz DNoise or Enhance (www.topazlabs.com). You can apply noise reduction to RAW photos with Sony's Image Data Converter or any other versatile converter software. Some products are optimized for NR with unusually sophisticated processing, such as Photo Ninja (www.picturecode.com) and DXO Optics Pro's version 9 or higher (www.dxo.com).

SPECIAL MODES FOR FINE HIGH ISO QUALITY

As I'll discuss in the section on scene modes, the a7R II/a7 II offers two modes for use in low light at high ISO for superior image quality. When you use Hand-held Twilight and Anti Motion Blur, the camera shoots a series of photos and composites them into one after discarding most of the digital noise. These are automatic modes so they're not ideal for all types of serious photography but they certainly provide the "cleanest" images possible at high ISO with your camera.

Using Dynamic Range Optimizer

Dynamic Range Optimizer (DRO) and Auto HDR (discussed next) are features you can select from the Camera Settings 5 menu or the Function menu, as explained in Chapter 3. When enabled, the camera will examine your images as they are exposed, and, if the shadows appear to have detail even though they are too dark, will attempt to process the image so the shadows are lighter, with additional detail, without overexposing detailed highlights. The processed image is always saved as a JPEG, so if you are shooting RAW you won't notice a difference.

Here is how the DRO and Auto HDR features work:

- DRO Off. No optimization. You're on your own; the camera will not apply extra processing even to your JPEG photos. Of course, if you are shooting RAW (or RAW & JPEG) photos, you can apply DRO effects to your photo when converting it with the downloadable Image Data Converter SR software. (Other programs have different tools for lightening shadow areas and/ or darkening highlight areas.) Use Off when shooting subjects of normal contrast, or when you want to capture an image just as you see it, without modification by the camera.
- DRO. Press the left/right buttons after scrolling to DRO Auto and you can then set a specific intensity level for the Dynamic Range Optimizer, from Level 1 through Level 5.

 If you do not want to set a specific level, simply scroll to DRO Auto and allow the camera to decide on the amount of increased dynamic range. With the Auto setting, the camera dives into your image, looking at various small areas to examine the contrast of highlights and shadows, making modifications to each section to produce the best combination of brightness and tones with detail. In my experience, Auto provides a mid level of DRO that's worth leaving on at all times.

■ HDR Auto. In this mode, the a7R II/a7 II creates a high dynamic range photo. It starts by taking three JPEG photos, each at a different exposure; the three are then composited into one by the processor using the best-exposed areas from each photo. The final image will have a high dynamic range effect, with great detail in shadow areas and increased detail in bright areas. You can specify how dramatic the effect should be.

After scrolling to HDR Auto, press the left/right buttons and set an HDR Level, from 1.0 EV to 6.0 EV. (One EV equals one stop of exposure.) The higher the level you set, the greater the exposure difference will be among the three photos the camera will shoot to produce one with High Dynamic Range. There's no "best" setting; it depends on your personal preference. At a very high EV level, the effect will be dramatic, but the photo may not appear to be "natural" looking. See the section that follows for more on HDR photography.

Tip

The primary method for DRO processing is lightening the dark tones and mid tones of an image. The higher the level of DRO you set, the more significantly the processor will lighten those areas; that causes digital noise to be more and more noticeable, especially in photos made at ISO 800 and at higher ISO levels. This is one reason why you would not always want to set Level 4 or 5 for DRO, particularly when using a high ISO setting. The other reason is that very high DRO produces a somewhat unnatural-looking effect with all shadow areas lighter than "normal." Auto and Levels 1 to 3 retain the most natural-looking effect.

When you activate DRO, you have your choice of specifying the aggressiveness of the processing (from Level 1 through Level 5), in which case it will *always* be applied at the level you specify. Or, you can set the feature to Auto and let the camera decide the ideal amount of optimization (or even when to apply it at all). Auto is usually your best choice, because the camera is pretty smart about choosing which images to process, and which to leave alone. Indeed, the camera's programming usually does a better job than a similar feature available in the Image Data Converter SR software you may have installed on your computer.

Figure 7.19 shows an image with DRO turned off, and using Level 1, Level 3, and Level 5 optimization. (The differences between, say Level 1 and 2, or 2 and 3 are subtle and wouldn't show up well on the printed page, so I skipped the even-numbered levels.) The printed page also doesn't show that DRO tends to increase the amount of noise in an image as it works more aggressively; it's usually a good idea to avoid using the feature at high ISO levels where noise tends to be a real problem under any conditions.

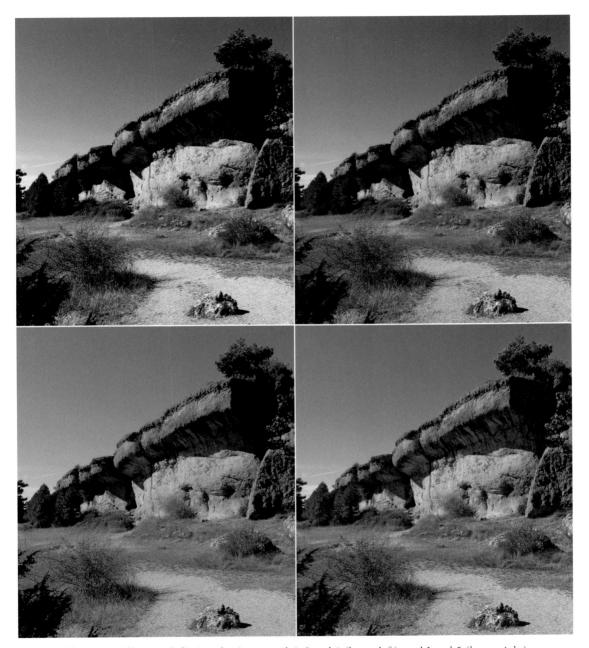

Figure 7.19 DRO Off (upper left); Level 1 (upper right); Level 3 (lower left); and Level 5 (lower right).

Working with HDR

High dynamic range (HDR) photography is quite the rage these days, and entire books have been written on the subject. It's not really a new technique—film photographers have been combining multiple exposures for ages to produce a single image of, say, an interior room while maintaining detail in the scene visible through the windows.

It's the same deal in the digital age. Suppose you wanted to photograph a dimly lit room that had a bright window showing an outdoors scene. Proper exposure for the room might be on the order of 1/60th second at f/2.8 at ISO 200, while the outdoors scene probably would require f/11 at 1/400th second. That's almost a 7 EV step difference (approximately 7 f/stops) and well beyond the dynamic range of any digital camera, including the Sony a7 II—series cameras. (An additional problem, of course, is the mixed illumination: daylight outdoors and probably tungsten or fluorescent lamps indoors. Pro photographers sometimes gel the windows with corrective film so that inside/outside illumination matches.)

Until camera sensors gain much higher dynamic ranges (which may not be as far into the distant future as we think), special tricks like DRO and HDR photography will remain basic tools. With the Sony cameras, you can create in-camera HDR exposures, or shoot HDR the old-fashioned way—with separate bracketed exposures that are later combined in a tool like Photomatix or Adobe's Merge to HDR image-editing feature. I'm going to show you how to use both.

Auto HDR

The camera's in-camera Auto HDR feature is simple and effective in creating high dynamic range images. It's also remarkably easy to use. It can be dialed in using the DRO/Auto HDR entries found in the menu, Function menu, and any key you might define with that function.

Although Auto HDR combines only three images to create a single HDR photograph, in some ways it's as good as the manual HDR method I'll describe in the section after this one. For example, it allows you to specify an exposure differential of six stops/EV between the three shots, whereas the camera shooting bracketed exposures is limited to no more than three EV between shots.

Figure 7.20 illustrates how the three shots that the camera's Auto HDR feature merges might look. There is a one-stop differential between each of the images, from the underexposed image at left, to the intermediate exposure in the middle, and then to the overexposed image at right. The incamera HDR processing is able to combine the three to derive an image similar to the one shown in Figure 7.21, which has a much fuller range of tones.

To use the camera's HDR feature, select it in the Camera Settings 5 menu's DRO/Auto HDR entry, or from the Fn menu. You can manually specify an increment from 1 EV to 6 EV, or choose Auto and allow the camera to select the appropriate differential. When you press the shutter release, the camera will take all three shots consecutively, align the images (because, if the camera is hand-held, there is likely to be a small amount of movement between shots), and then save one JPEG image to your memory card. The feature does not work if you have selected RAW or RAW+JPEG formats.

Figure 7.20 The three images can be automatically combined...

Figure 7.21 ...to produce this merged high dynamic range (HDR) image.

Bracketing and Merge to HDR

If your credo is "If you want something done right, do it yourself," you can also shoot HDR manually, without resorting to the camera's HDR mode. Instead, you can shoot individual images either by manually bracketing or using the camera's auto bracketing modes, described earlier in this chapter.

Although my goal in this book is to show you how to take great photos *in the camera* rather than how to fix your errors in Photoshop, the Merge to HDR Pro feature in Adobe's flagship image editor (and a variation also found in Photoshop Elements) is too cool to ignore. The ability to have a bracketed set of exposures that are identical except for exposure is key to getting good results with this Photoshop feature, which allows you to produce images with a full, rich dynamic range that includes a level of detail in the highlights and shadows that is almost impossible to achieve with digital cameras.

When you're using Merge to HDR Pro, you'd take several pictures, some exposed for the shadows, some for the middle tones, and some for the highlights. The exact number of images to combine is up to you. Four to seven is a good number. Then, you'd use the Merge to HDR Pro command to combine all of the images into one HDR image that integrates the well-exposed sections of each version. Here's how.

The images should be as identical as possible, except for exposure. So, it's a good idea to mount the camera on a tripod, use a remote release, and take all the exposures in one burst. Just follow these steps:

- 1. Set up the camera. Mount the camera on a tripod.
- 2. Set the camera to shoot a bracketed burst of five to nine images with an increment of at least 2 EV.

The description of how to do this will be found earlier in this chapter. As I noted there, you can set the camera to shoot up to nine exposures, each one increment apart, and use all five for your HDR merger.

TIP

If you want to use more than nine exposures, you can skip the camera's auto bracketing feature and switch to Manual exposure and take as many exposures as you want, at any increment you desire. In Manual mode, make sure Auto ISO is off, and you adjust exposures *only* by changing the shutter speed. You should be very careful when you make the adjustment to avoid jostling the camera.

- 3. **Choose an f/stop.** Set the camera for Aperture Priority and select an aperture that will provide a correct exposure at your initial settings for the series of manually bracketed shots. *And then leave this adjustment alone!* You don't want the aperture to change for your series, as that would change the depth-of-field and, potentially, the image size of some elements. You want the camera to adjust exposure *only* using the shutter speed.
- 4. **Choose manual focus.** You don't want the focus to change between shots, so set the camera to manual focus, and carefully focus your shot.
- 5. **Choose RAW exposures.** Set the camera to take RAW files, which will give you the widest range of tones in your images. (This is an advantage of manually creating HDR files; the camera's Auto HDR feature can't be used when RAW or RAW+JPEG is active.)
- 6. **Take your bracketed set.** Press the button on the remote (or carefully press the shutter release or use the self-timer) and take the set of bracketed exposures.
- 7. **Continue with the Merge to HDR Pro steps listed next.** You can also use a different program, such as Photomatix or Nik software, if you know how to use it.

DETERMINING THE BEST EXPOSURE DIFFERENTIAL

How do you choose the number of EV/stops to separate your exposures? You can use histograms, described at the end of this chapter, to determine the correct bracketing range. Take a test shot and examine the histogram. Reduce the exposure until dark tones are clipped off at the left of the resulting histogram. Then, increase the exposure until the lighter tones are clipped off at the right of the histogram. The number of stops between the two is the range that should be covered using your bracketed exposures.

The next steps show you how to combine the separate exposures into one merged high dynamic range image. Figure 7.22 shows the results you can get from a three-shot bracketed sequence.

- 1. Copy your images to your computer. If you use an application to transfer the files to your computer, make sure it does not make any adjustments to brightness, contrast, or exposure. You want the real raw information for Merge to HDR Pro to work with.
- Activate Merge to HDR Pro. Choose File > Automate > Merge to HDR Pro.
- 3. Select the photos to be merged. Use the Browse feature to locate and select your photos to be merged. You'll note a check box that can be used to automatically align the images if they were not taken with the camera mounted on a rock-steady support. This will adjust for any slight movement of the camera that might have occurred when you changed exposure settings.
- 4. Choose parameters (optional). The first time you use Merge to HDR Pro, you can let the program work with its default parameters. Once you've played with the feature a few times, you can read the Adobe Help files and learn more about the options than I can present in this non-software-oriented camera guide.

Figure 7.22 Three bracketed photos should look like this.

- 5. **Click OK.** The merger begins.
- 6. Save. Once HDR merge has done its thing, save the file to your computer.

Figure 7.23 You'll end up with an extended dynamic range photo like this one.

If you do everything correctly, you'll end up with a photo like the one shown in Figure 7.23.

What if you don't have the opportunity, inclination, or skills to create several images at different exposures, as described? If you shoot in RAW format, you can still use Merge to HDR, working with a *single* original image file. What you do is import the image into Photoshop several times, using Adobe Camera Raw to create multiple copies of the file at different exposure levels.

For example, you'd create one copy that's too dark, so the shadows lose detail, but the highlights are preserved. Create another copy with the shadows intact and allow the highlights to wash out. Then, you can use Merge to HDR to combine the two and end up with a finished image that has the extended dynamic range you're looking for. (This concludes the image-editing portion of the chapter. We now return you to our alternate sponsor: photography.)

Exposure Evaluation with Histograms

While you may be able to improve poorly exposed photos in your image-editing software or with DRO or HDR techniques, it's definitely preferable to get the exposure close to correct in the camera. This will minimize the modifications you'll need to make in post-processing, which can be very time-consuming and will degrade image quality, especially with JPEGs. A RAW photo can tolerate more significant changes with less adverse effects, but for optimum quality, it's still important to have an exposure that's close to correct.

Instead, you can use a histogram, which is a chart displayed on the camera's screen that shows the number of tones that have been captured at each brightness level. Two types of histograms are available, a "live" histogram that appears at the lower-right corner of the screen in Shooting mode, and a larger, more detailed version that appears in Histogram mode during playback. The live version can help you make exposure decisions as you shoot, whereas the playback version is useful in determining corrections to be made before you take your next shot. I'll explain both versions, but first it's useful to understand exactly what you're seeing when you view a histogram.

The Live Histogram

The camera's live histogram offers the most reliable method for judging the exposure as you shoot (although the Zebra feature described in Chapter 4 can be used to isolate specific problems involving blown highlights). A pair of live histograms are also available for display for both the viewfinder and monitor; activate both with the DISP Button (Monitor/Finder) item in the Custom Settings 4 menu, as discussed in Chapter 4. After activating, press the DISP button a few times to reach the display that includes the histogram, which will be shown at lower right in the viewfinder and LCD monitor screens.

In Shooting mode, you'll get a luminance (brightness) histogram that shows the distribution of tones and brightness levels across the image given the current camera settings, including exposure compensation, Dynamic Range Optimizer (DRO) level in use, or the aperture, shutter speed, and ISO that you have set if using Manual mode. This live histogram (displayed before taking a photo) is useful for judging whether the exposure is likely to be satisfactory or whether you should use a camera feature to modify the exposure. When the histogram looks better, take the photo. I'll show you how to evaluate histograms later in this chapter.

The Playback Histograms

You can view histograms in Playback mode, too; press the DISP button until the display shown in Figure 7.24 appears. The top graph, called the luminance or brightness histogram, is conventional, showing the distribution of tones across the image. Each of the other three histograms is in a specific color: red, green, and blue. That indicates the color channel you're viewing in that histogram: red, green, or blue. These additional graphs allow you to see the distribution of tones in the three individual channels. It takes a lot of expertise to interpret those extra histograms and, frankly, the conventional luminance histogram is the only one that many photographers use.

As a bonus in Playback mode, another feature is available when the histograms are visible: any areas of the displayed image that are excessively bright, or excessively dark, will blink. This feature, often called "blinkies," warns that you may need to change your settings to avoid loss of detail in highlight areas (such as a white wedding gown) or in shadow areas (such as a black animal's fur). The camera also includes the Zebra feature to indicate overexposure, as discussed in Chapter 4. You can use the histogram information along with the flashing blinkie and Zebra alerts to guide you in modifying the exposure, and/or setting the DRO feature (discussed earlier), before taking the photo again.

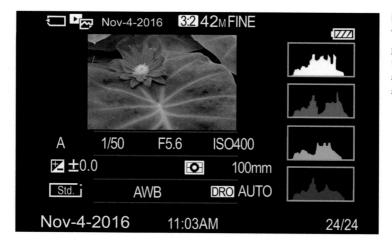

Figure 7.24
The Playback histograms show you the tonal distribution of a photo you've already taken.

Tonal Range

Histograms help you adjust the tonal range of an image, the span of dark to light tones, from a complete absence of brightness (black) to the brightest possible tone (white), and all the middle tones in between. Because all values for tones fall into a continuous spectrum between black and white, it's easiest to think of a photo's tonality in terms of a black-and-white or grayscale image, even though you're capturing tones in three separate color layers of red, green, and blue.

Because your images are digital, the tonal "spectrum" isn't really continuous: it's divided into discrete steps that represent the different tones that can be captured. Figure 7.25 may help you understand this concept. The gray steps shown range from 100-percent gray (black) at the left, to 0-percent gray (white) at the right, with 20 gray steps in all (plus white).

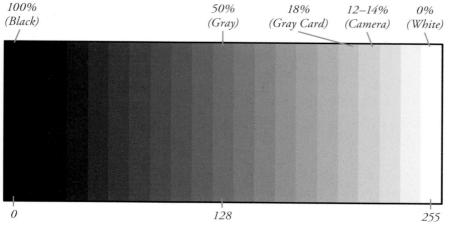

Figure 7.25
A tonal range from black (left) to white (right) and all the gray values in between.

Along the bottom of the chart are the digital values from 0 to 255 recorded by your sensor for an image with 8 bits per channel. (8 bits of red, 8 bits of green, and 8 bits of blue equal a 24-bit, full-color image.) Any black captured would be represented by a value of 0, the brightest white by 255, and the midtones would be clustered around the 128 marker.

Grayscale images (which we call black-and-white photos) are easy to understand. Or, at least, that's what we think. When we look at a black-and-white image, we think we're seeing a continuous range of tones from black to white, and all the grays in between. But, that's not exactly true. The blackest black in any photo isn't a true black, because *some* light is always reflected from the surface of the print, and if viewed on a screen, the deepest black is only as dark as the least-reflective area a computer monitor can produce. The whitest white isn't a true white, either, because even the lightest areas of a print absorb some light (only a mirror reflects close to all the light that strikes it), and, when viewing on a computer monitor, the whites are limited by the brightness of the display's LCD or LEDs picture elements. Lacking darker blacks and brighter, whiter whites, that continuous set of tones doesn't cover the full grayscale tonal range.

The full scale of tones becomes useful when you have an image that has large expanses of shades that change gradually from one level to the next, such as areas of sky, water, or walls. Think of a picture taken of a group of campers around a campfire. Since the light from the fire is striking them directly in the face, there aren't many shadows on the campers' faces. All the tones that make up the *features* of the people around the fire are compressed into one end of the brightness spectrum—the lighter end.

Yet, there's more to this scene than faces. Behind the campers are trees, rocks, and perhaps a few animals that have emerged from the shadows to see what is going on. These are illuminated by the softer light that bounces off the surrounding surfaces. If your eyes become accustomed to the reduced illumination, you'll find that there is a wealth of detail in these shadow images.

This campfire scene would be a nightmare to reproduce faithfully under any circumstances. If you are an experienced photographer, you are probably already wincing at what is called a *high-contrast* lighting situation. Some photos may be high in contrast when there are fewer tones and they are all bunched up at limited points in the scale. In a low-contrast image, there are more tones, but they are spread out so widely that the image looks flat. Your digital camera can show you the relationship between these tones using a histogram.

Histogram Basics

Your camera's histograms are a simplified display of the numbers of pixels at each of 256 brightness levels, producing an interesting mountain range effect. Although separate charts may be provided for brightness and the red, green, and blue channels, when you first start using histograms, you'll want to concentrate on the brightness histogram.

Each vertical line in the graph represents the relative number of pixels in the image for each brightness value, from 0 (black) on the left to 255 (white) on the right. The vertical axis measures that relative number of pixels at each level. Ideally, all the tones in an image will fall within one of those two values. If not, there may be a spike at the left edge of the histogram, meaning that some black tones were clipped off; or, there may be a spike at the right edge, where some of the highlight details were clipped.

Contrast, Too

Although histograms are most often used to fine-tune exposure, you can glean other information from them, such as the relative contrast of the image. Figure 7.26 shows a generic histogram captured from an image-editing program, accompanied by an image at left having normal contrast. In such an image, most of the pixels are spread across the image, with a healthy distribution of tones throughout the midtone section of the graph. That large peak at the right side of the graph represents all those light tones in the sky. A normal-contrast image you shoot may have less sky area, and less of a peak at the right side, but notice that very few pixels hug the right edge of the histogram, indicating that the lightest tones are not being clipped because they are off the chart.

With a lower-contrast image, like the one shown in Figure 7.27, the basic shape of the previous histogram will remain recognizable, but gradually will be compressed together to cover a smaller area of the gray spectrum. The squished shape of the histogram is caused by all the grays in the original image being represented by a limited number of gray tones in a smaller range of the scale.

Instead of the darkest tones of the image reaching into the black end of the spectrum and the whitest tones extending to the lightest end, the blackest areas of the scene are now represented by a light gray, and the whites by a somewhat lighter gray. The overall contrast of the image is reduced. Because all the darker tones are actually a middle gray or lighter, the scene in this version of the photo appears lighter as well.

Going in the other direction, increasing the contrast of an image produces a histogram like the one shown in Figure 7.28. In this case, the tonal range is now spread over the entire width of the chart, but, except for the bright sky, there is not much variation in the middle tones; the mountain "peaks" are not very high. When you stretch the grayscale in both directions like this, the darkest tones become darker (that may not be possible) and the lightest tones become lighter (ditto). In fact, shades that might have been gray before can change to black or white as they are moved toward either end of the scale.

The effect of increasing contrast may be to move some tones off either end of the scale altogether, while spreading the remaining grays over a smaller number of locations on the spectrum. That's exactly the case in the example shown. The number of possible tones is smaller and the image appears harsher.

Figure 7.26
This image has fairly normal contrast, even though there is a peak of light tones at the right side representing the sky.

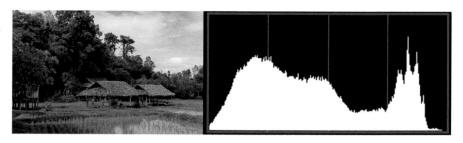

Figure 7.27
This low-contrast image has all the tones squished into one section of the grayscale.

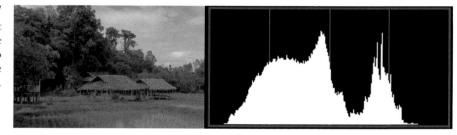

Figure 7.28
A high-contrast image produces a histogram in which the tones are spread out.

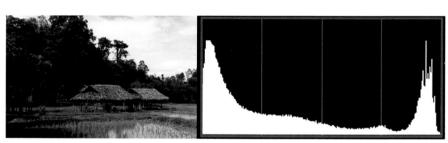

Understanding Histograms

Although the histograms I just showed you display how these charts change depending on the contrast of an image, an important thing to remember when working with the histogram display in your camera is that changing the exposure does *not* change the contrast of an image. The curves illustrated in the previous three examples retain exactly the same basic shape when you increase or decrease exposure. I repeat: The proportional distribution of grays shown in the histogram doesn't change when exposure changes; it is neither stretched nor compressed. However, the tones as *a whole* are moved toward one end of the scale or the other, depending on whether you're increasing or decreasing exposure. You'll be able to see that in some illustrations that follow.

So, as you reduce exposure, tones gradually move to the black end (and off the scale), while the reverse is true when you increase exposure. The contrast within the image is changed only to the extent that some of the tones can no longer be represented when they are moved off the scale.

To change the contrast of an image, you must do one of four things:

- Change the camera's contrast setting using one of the Creative Styles, which each has a contrast adjustment. I explain Creative Styles in Chapter 9, which covers some advanced options.
- Use your camera's shadow-tone "boosters." As previously discussed, both DRO and Auto HDR processing can adjust the contrast of your final image.
- Alter the contrast of the scene itself, for example, by using a fill light or reflectors (if available) to add illumination to shadows that are too dark.
- Attempt to adjust contrast in post-processing using your image editor or RAW file converter. You may use features such as Levels or Curves (in Photoshop, Photoshop Elements, and many other image editors), or work with HDR software to cherry-pick the best values in shadows and highlights from multiple images.

Of the four of these, the third—changing the contrast of the scene—is the most desirable, because attempting to fix contrast by fiddling with the tonal values is unlikely to be a perfect remedy. However, adding a little contrast can be successful because you can discard some tones to make the image more contrasty. However, the opposite is much more difficult. An overly contrasty image rarely can be fixed, because you can't add information that isn't there in the first place.

What you can do is adjust the exposure so that the tones that are already present in the scene are captured correctly, even if the contrast itself remains the same. Figure 7.29 shows the histogram for an image that is badly underexposed. You can guess from the shape of the histogram that many of the dark tones to the left of the graph have been clipped off. There's plenty of room on the right side for additional pixels to reside without having them become overexposed. So, you can increase the exposure (either by changing the f/stop or shutter speed, or by adding an EV value) to produce the corrected histogram shown in Figure 7.30.

Conversely, if your histogram looks like the one shown in Figure 7.31, with bright tones pushed off the right edge of the chart, you have an overexposed image, and you can correct it by reducing exposure. In addition to the histogram, the camera has its Highlights and Zebra options, which, when activated, shows areas that are overexposed with flashing tones (often called "blinkies") in the picture review screen, or, with Zebra, by stripes in the overexposed areas in your live view image. Depending on the importance of this "clipped" detail, you can adjust exposure or leave it alone. For example, if all the dark-coded areas in the review are in a background that you care little about, you can forget about them and not change the exposure, but if such areas appear in facial details of your subject, you may want to make some adjustments.

In working with histograms, your goal should be to have all the tones in an image spread out between the edges, with none clipped off at the left and right sides. Underexposing (to preserve highlights) should be done only as a last resort, because retrieving the underexposed shadows in your image editor will frequently increase the noise, even if you're working with RAW files. A better course of action is to expose for the highlights ("exposing to the right"), but, when the subject

Figure 7.29 A histogram of an underexposed image may look like this.

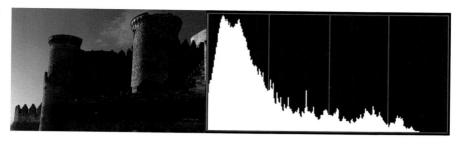

Figure 7.30 Adding exposure will produce a histogram like this one.

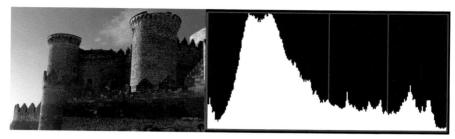

Figure 7.31
A histogram of an overexposed image will show clipping at the right side.

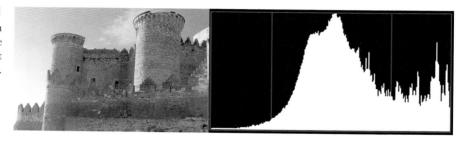

matter makes it practical, fill in the shadows with additional light, using reflectors, fill flash, or other techniques rather than allowing them to be seriously underexposed.

A histogram graph includes a *representation* of up to 256 vertical lines on a horizontal axis (but not 256 actual lines; only the general shape of the resulting curve is shown). The graph shows the number of pixels in the image at each brightness level, from 0 (black) on the left side to 255 (white) on the right. The 3-inch LCD doesn't have enough pixels to show each and every one of the 256 lines; instead, it provides a representation of the shape of the curve, often resembling a mountain range. The more pixels at a given level, the higher the "peak" will be at that position. If no bar appears at a particular position along the scale in the graph, there are no pixels at that particular brightness level.

A typical histogram produces a mountain-like shape, with most of the pixels bunched in the middle tones, with fewer pixels at the dark and light ends of the scale. Ideally, though, there will be at least some pixels at either extreme, so that your image has both a true black and a true white representing some details. Learn to spot histograms that represent over- and underexposure, and add or subtract

228

exposure using exposure compensation as described earlier. (The D-Range Optimizer is also a useful feature when you want to get more detail in shadow areas; it can also slightly increase the amount of detail in highlight areas.)

The key is to make settings that will produce a histogram with a more even distribution of tones. A corrected histogram exhibits a mountain-like shape with a tall wide peak in the center of the scale (denoting the many mid-tone areas), and a good distribution of tones overall. This histogram indicates that the image exhibits detail in both the dark and the light tones since there's no spike at either end of the graph. Typically, this is the type of histogram you want for an accurate exposure. Of course, you'll sometimes want to create a special effect like a silhouette or a high-key look (mostly light tones); then your histogram will look entirely different.

As noted earlier, the histogram can also warn you of very high or very low contrast in an image. If all the tones are bunched up in one area of the graph (usually around the center), the photo will be low in contrast. You can increase the contrast level with the Creative Style item or do so later with software.

The more you work with histograms, the more useful they become. One of the first things that histogram veterans notice is that it's possible to overexpose one channel even if the overall exposure appears to be correct. The camera's playback histogram screen shows separate histograms for both brightness (luminance) at top right, and for red, green, and blue channels underneath.

For example, flower photographers soon discover that it's really, really difficult to get a good picture of a red rose, say. The luminance histogram may imply that the exposure looks okay—but there's no detail in the rose's petals. Looking at the histogram will show you why: you should be able to see that the red channel is blown out. If you look at the red histogram, there is probably a peak at the right edge that indicates that highlight information has been lost.

Any of the primary channels—red, green, or blue—can blow out all by themselves, although bright reds seem to be the most common problem area. More difficult to diagnose are overexposed tones in one of the "in-between" hues on the color wheel. Overexposed yellows (which are very common) will be shown by blowouts in *both* the red and green channels. Too-bright cyans will manifest as excessive blue and green highlights, while overexposure in the red and blue channels reduces detail in magenta colors. As you gain experience, you'll be able to see exactly how anomalies in the RGB channels translate into poor highlights and murky shadows.

The only way to correct for color channel blowouts is to reduce exposure. As I mentioned earlier, you might want to consider filling in the shadows with additional light to keep them from becoming too dark when you decrease exposure. In practice, you'll want to monitor the red channel most closely, followed by the blue channel, and slightly decrease exposure to see if that helps. Because of the way our eyes perceive color, we are more sensitive to variations in green, so green channel blowouts are less of a problem, unless your main subject is heavily colored in that hue. If you plan on photographing a frog hopping around on your front lawn, you'll want to be extra careful to preserve detail in the green channel, using bracketing or other exposure techniques outlined in this chapter.

Automatic and Specialized Shooting Modes

After the long discussion of exposure control and other issues, let's get back to the remaining shooting modes. When you set the Intelligent Auto or the Superior Auto mode, the camera will use its programmed intelligence to try to identify the type of scene and set itself accordingly. These "autopilot" modes are useful when you suddenly encounter a picture-taking opportunity and don't have time to decide exactly what settings you might want to make in a semi-automatic or manual mode. Instead, you can spin the mode dial to one of the Auto modes, or, if you have a little more time, to the most appropriate scene mode, and fire away, knowing that you have a fighting chance of getting a usable or very good photo.

The a7 II series also offers more specialized modes, for use in particular situations: Sweep Panorama and two special scene modes that provide surprisingly fine quality at high ISO levels—Hand-held Twilight and Anti Motion Blur.

Auto and Scene Modes

The two Auto modes and the scene modes are especially helpful when you're just learning to use your a7R II/a7 II, because they let you get used to composing and shooting, and obtaining excellent results, without having to struggle with unfamiliar controls to adjust things like shutter speed, aperture, ISO, and white balance. Once you've learned how to make those settings, you'll probably prefer to use P, A, S, and M modes since they provide more control over shooting options.

The fully automatic modes may give you few options for overrides, or none at all. For example, the AF mode, AF area, ISO, white balance, Dynamic Range Optimizer, and metering mode are all set for you. In most modes, you can select the drive setting and the flash mode, though not all settings for those options are available. You cannot adjust exposure compensation or Creative Styles in any of these modes. Here are some essential points to note about the Intelligent Auto, Superior Auto, and SCN modes:

- Intelligent Auto. This is the setting to use when you hand your camera to a total stranger and ask him or her to take your picture posing in front of the Eiffel Tower. All the photographer has to do is press the shutter release button. Every other crucial decision is made by the camera's electronics, and many settings, such as ISO, white balance, metering mode, exposure compensation, and focus settings are not available to you for adjustment. However, you still are able to set the drive mode to Continuous shooting, add self-timer (but not to Bracketing), and you can set the flash mode for any attached flash to Auto Flash Fill Flash or Flash Off. If the camera detects a subject suitable for a scene mode, it will switch to that mode and display its choice in the upper-left corner of the screen.
- Superior Auto. This mode is exactly like Intelligent Auto, but provides an extra benefit. In scenes that include extremely bright areas as well as shadow areas, the camera can activate its Auto HDR (high dynamic range) feature to provide more shadow detail. And in dark locations,

when an extremely high ISO will be used, the camera can activate a special mode that fires several shots and composites them into one after discarding the digital noise data.

- Portrait. The first of the scene modes that you'll encounter, this mode tends to use wide apertures (large f/numbers) and faster shutter speeds. This is intended to provide shallow depth-of-field to blur the background while minimizing the risk of blurry photos caused by camera shake or subject movement. It's also optimized to provide "soft" skin tones. The drive mode cannot be set to Continuous shooting, but you can do the following: set the self-timer to take three shots; use the Remote Commander; set AF, MF, or DMF in the Function submenu; and set the flash mode for an attached flash to Auto Flash, Fill Flash, or forced off.
- Landscape. The Alpha tries to use smaller apertures for more depth-of-field to try to render the entire scene sharply; it also boosts saturation slightly for richer colors. You have some control over flash and can use the self-timer; most other settings are not available in this mode.
- Macro. This mode is similar to the Portrait setting, favoring wider apertures to isolate your close-up subjects, and fast shutter speeds to eliminate the camera shake that's accentuated at close focusing distances. However, if your camera is mounted on a tripod or if you're using a lens with SteadyShot, you might want to use Aperture Priority mode instead. That will allow you to specify a smaller aperture (larger f/number) for additional depth-of-field to keep an entire three-dimensional subject within the range of acceptably sharp focus.
- Sports action. In this mode, the Alpha favors fast shutter speeds to freeze action and it switches to Continuous drive mode to let you take a quick sequence of pictures with one press of the shutter release button. Continuous Autofocus is activated to continually refocus as a subject approaches the camera or moves away from your shooting position. You can find more information on autofocus options in Chapter 8.
- Sunset. Increases saturation to emphasize the red tones of a sunrise or sunset. You can use the Fill Flash or Flash Off settings, but most other adjustments are unavailable to you.
- Night Portrait. This mode is intended for taking people pictures in dark locations with flash using a long shutter speed. The Flash mode is set to Slow Sync. A nearby subject will be illuminated by flash while a distant background (such as a city skyline) will be exposed by the available light during the long exposure. Because the shutter speed will be long, it's necessary to use a tripod or set the camera on something solid like the roof of a car. If using an OSS-designated lens with a SteadyShot stabilizer, make sure it's on, unless the camera is mounted on a tripod; in that case, turn the stabilizer off using the SteadyShot item in the Setup menu. You can use the Self-timer or the Remote Commander in Night Portrait mode.
- **Night Scene.** This is another mode for low-light photography. Similar to Night Portrait, but the flash is forced off. Use a tripod if at all possible or set the camera on a solid object, because the shutter speed will be long in low light. Most settings are not available, other than the Selftimer and Remote Commander.

- Hand-held Twilight. This is one of the two special modes designed for use in low light when hand-holding the a7 II—series camera. The camera will set a high ISO (sensitivity) level to enable it to use a fast shutter speed to minimize the risk of blurring caused by camera shake. (In extremely dark conditions however, the shutter speed may still be quite long.) When you press the shutter release button, the camera takes six shots in a quick series. The processor then composites them into one after discarding most of the digital noise data for a "cleaner" image than you'd get in a conventional high ISO photo. You'll get one image that's of surprisingly fine quality. Flash is never fired in this mode and you have access to virtually no camera options.
- Anti Motion Blur. Similar to Hand-held Twilight, this mode is also designed for use in dark locations, but it's more effective at reducing blurring that might be caused by a subject's motion or by a shaky camera. That's because the camera will set an even faster shutter speed; that may require it to set a higher ISO level. (Of course, in an extremely dark location, the shutter speed may still be a bit long.) Again, the camera fires a series of six shots and composites them into one with minimal digital noise.

Sweep Panorama Mode

I showed you some panorama techniques in Chapter 3, but here's a recap. A conventional panorama mode has been available for several years with many other cameras, especially those with a built-in lens. That allows you to shoot a series of photos, with framing guided by an on-screen display; make sure they overlap correctly and you can then "stitch" them together in special software to make a single, very wide, panoramic image. Some cameras can even do this for you with in-camera processing but most (though not all) require you to use a tripod. Your Sony camera offers the most convenient type of panorama mode; it's automatic (but allows you to use some overrides) and it can produce very good results without a tripod. Of course, it's easier to keep the camera perfectly level while shooting the series when using a tripod but that's not always practical. Here are a few tips to consider:

- Choose a direction. You can select one of four directions for your panorama: right, left, up, or down. Select any of these options in the Camera Settings 1 menu, using the Panorama Direction item. It's only available when the camera is set to Sweep Panorama mode. The default setting, right, is probably the most natural for many people; it requires you to pan the camera from the left to the right across a wide vista. Occasionally, you might want to use one of the other options. The up or down motion is the one you'll need to make a panoramic photo of very tall subjects, such as skyscrapers and nearby mountains.
- Change settings while in Panorama mode. When you select this Shooting mode, the camera presents you with a large arrow and urgent-sounding instructions to press the shutter button and move the camera in the direction of the arrow. Don't let the camera intimidate you with this demand; what it is neglecting to tell you is that you can take all the time you want, and that you are free to change certain settings before you shoot.

Press the MENU button and you can set the focus mode, white balance, and metering mode. Other useful functions include exposure compensation; Image Size in the Image Size menu, which lets you set either the Standard or the Wide panorama option; and the Creative Style modes in the Brightness/Color menu. Once you have those settings fine-tuned to your satisfaction, *then* go ahead and press the shutter release button.

- Smooth and steady does it. While keeping the shutter release button depressed, immediately start moving the camera smoothly and steadily in an arc; pivot your feet or the camera on a tripod head and keep going until the shutter stops clicking. The on-screen guide that appears during the exposure will help you keep the speed and direction of movement right. If you moved the camera at a speed that was too fast or too slow, you'll get an error message and the camera will prompt you to start over.
- Beware of moving objects. The Sweep Panorama mode is intended for stationary subjects, such as mountain ranges, city skylines, or expansive gardens. There's nothing to stop you from shooting a scene that contains moving cars, people, or other objects, but be aware of problems that can arise in that situation. Because you're taking multiple overlapping shots that are then stitched into a single image, the camera may capture the same car or person two or more times in slightly different positions; this can result in a truncated or otherwise distorted picture of that particular subject. Press the Playback button to view your just completed panorama; press the center button to view a moving playback of the image.

Mastering Autofocus Options

The mirrors found in traditional SLRs had two distinct advantages: they allowed previewing an image through an optical viewfinder, and made it possible to direct some of the incoming illumination to a separate electronic autofocus system. At the moment of exposure, focus was locked, and the mirror flipped up out of the way, allowing the light to pass through the camera body to the film or digital sensor. Autofocus was fast, and reasonably accurate.

But the mirror system had its drawbacks, which were generally eliminated when mirrorless systems like the current Sony a7 II series were introduced. Moving mirrors are noisy and bulky, and increase the distance between the lens mounting flange and the film or sensor, resulting in larger cameras. Mirror-based viewing systems also mean that autofocus can't take place during exposure, which is particularly problematic when capturing video. Mirrorless cameras eliminated those limitations, but at a steep cost. The first few generations of mirrorless cameras from Sony and other vendors had to use a slower AF method, based on what the sensor sees. The original a7R camera that preceded the current a7R Mark II model, was notorious for its painfully slow autofocus.

But that was then, and this is now. Sony has combined the slow, but inherently very accurate method of autofocus, called *contrast detection*, with a much speedier *phase detection* system to produce a single *hybrid* AF system that combines speed with accuracy.

However, there is one logistical problem to overcome: the camera doesn't really know, for certain, what subject you want to be in sharp focus. It may select an object and lock in focus with lightning speed—even though it's not the center of interest in your photograph. Or, the camera may lock focus too soon, or too late. This chapter will help you understand the options available with your Sony a7R II/a7 II in order to help the camera understand what you want to focus on, when, and maybe even why.

cting into Focus

cearning to use the a7 II—series autofocus system is easy, but you do need to fully understand how the system works to get the most benefit from it. Once you're comfortable with autofocus, you'll know when it's appropriate to use the manual focus option, too. The important thing to remember is that focus isn't absolute. For example, some things that appear to be in sharp focus at a given viewing size and distance might not be in focus at a larger size and/or closer distance. That family portrait hanging over the mantle may look fine when you're seated on the sofa, but it appears less sharp when examined from two feet away.

In addition, the goal of optimum focus isn't always to make things look sharp. For some types of subjects, not all of an image needs be sharp. Controlling exactly what is sharp and what is not is part of your creative palette. Use of depth-of-field characteristics to throw part of an image out of focus while other parts are sharply focused is one of the most valuable tools available to a photographer. But selective focus works only when the desired areas of an image are in focus properly. For the digital camera photographer, correct focus can be one of the trickiest parts of the technical and creative process.

As I said in the introduction to this chapter, there are two major focusing methods used by modern digital cameras: *phase detection*, used by all digital cameras with mirrors, including the fixed-mirror Sony models like the a77 II; and *contrast detection*, which was the primary focusing method employed by all mirrorless models until very recently.

Contrast Detection

Contrast detection relies on examining the image formed on the sensor, and how it works is illustrated, if over-simplified, in Figure 8.1. At top in the figure, the transitions between the edges of the vertical wood grain grooves are soft and blurred because of the low contrast between them. The traditional contrast detection autofocus system looks only for contrast between edges, and those edges can run in any direction. At the bottom of the figure, the image has been brought into sharp focus, and the edges have much more contrast; the transitions are sharp and clear. Although this

Figure 8.1
Using the contrast detection method of autofocus, a camera can evaluate the increase in contrast in the edges of subjects, starting with a blurry image (top) and producing a sharp, contrasty image (bottom).

example is a bit exaggerated so you can see the results on the printed page, it's easy to understand that when maximum contrast in a subject is achieved using contrast detection, it can be deemed to be in sharp focus.

Contrast detection works best with static subjects, because it is inherently slower and not well-suited for tracking moving objects. Contrast detection works less well in dim light, because its accuracy depends on its ability to detect variations in brightness and contrast. You'll find that contrast detection works better with faster lenses, too, because larger lens openings admit more light that can be used by the sensor to measure contrast.

Phase Detection

Phase detection is an alternative focusing method used in many advanced cameras including digital SLRs and current Sony Alpha SLT models, like the a77 II. It is also used with the a7 II series when you attach the optional LA-EA2 or LA-EA4 A-mount lens adapters, which each have their own built-in phase detection autofocus systems. But, most importantly, phase detection is part of the a7R II/a7 II's advanced sensor-based hybrid AF system, which combines contrast detection with phase detection to give us, potentially, the best of both worlds.

With phase detection, each autofocus sampling area (either a separate sensor with dSLRs and SLT models or pixels embedded in the sensor in the case of cameras like the a7R II/a7 II) is divided into two halves. The two halves are compared, much like (actually, exactly like) a two-window range-finder used in surveying, weaponry, and non-SLR cameras such as the venerable Leica M film models. The contrast between the two images changes as focus is moved in or out, until sharp focus is achieved when the images are "in phase," or lined up. Figure 8.2 can help you visualize how this works.

Phase detection
"lines up" portions
of your image using
rangefinder-like
comparison to
achieve focus.

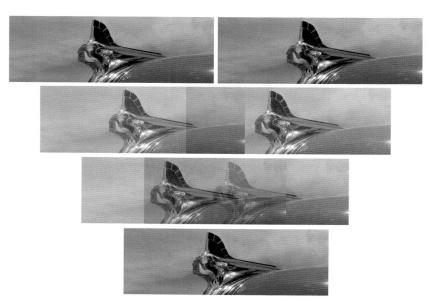

Figure 8.3 is another way of visualizing phase detection. (This is a greatly simplified view just for illustration purposes.) In Figure 8.3 (left), a typical horizontally oriented focus sensor is looking at a series of parallel vertical lines in a weathered piece of wood. The lines are broken into two halves by the sensor's rangefinder prism, and you can see that they don't line up exactly; the image is slightly out of focus. The rangefinder approach of phase detection tells the camera exactly how much out of focus the image is, and in which direction (focus is too near, or too far), thanks to the amount and direction of the displacement of the split image.

The camera can snap the image into sharp focus and line up the vertical lines, as shown in Figure 8.3, right, in much the same way that rangefinder cameras align two parts of an image to achieve sharp focus. Even better, because it knows the amount of focus travel needed, the camera is able to adjust the speed of the lens's AF motor to move the lens elements slowly or quickly, depending on how much focus adjustment is needed.

As with any rangefinder-like function, accuracy is better when the "base length" between the two images is larger, so the two split images have greater separation. (Think back to your high school trigonometry; you could calculate a distance more accurately when the separation between the two points where the angles were measured was greater.) For that reason, phase detection autofocus is more accurate with larger (wider) lens openings than with smaller lens openings, and, with the Sony a7 II series, may not work at all when the f/stop is smaller than f/8 (Sony says f/9 or smaller). Obviously, the "opposite" edges of the lens opening are farther apart with a lens having an f/2.8 maximum aperture than with one that has a smaller, f/5.6 maximum f/stop, and the base line is much longer. The camera is able to perform these comparisons and then move the lens elements directly to the point of correct focus very quickly, in milliseconds.

Figure 8.3
When an image is out of focus, the split lines don't align precisely (left); using phase detection, a camera can align the features of the image and achieve sharp focus quickly (right).

Because of the speed advantages of phase detection, makers of mirrorless cameras have been adding on-chip phase detect points to their sensors. Sony, because it designs and makes its own sensors, has been able to do a stellar job with this. The a7R II has a whopping 399 phase detect pixels embedded in its sensor, and the a7 II includes 117 phase detect pixels. (The a7S II, not covered in this book, has no phase detect pixels in its 12MP sensor, but does use 169 different contrast detect zones.)

Comparing the Two Hybrid Components

Sony a7 II–series autofocus uses both phase detection autofocus (PDAF) and contrast detection autofocus (CDAF) to provide a combination of fast and accurate AF. Figure 8.4 shows the layout of the autofocus points and zones used by the a7 II (left) and a7R II (right).

- Contrast detection zones. The blue boxes in both versions represent the areas of the sensor used by the a7 II and a7R II when using contrast detection in full-frame mode. Notice that a large area of the frame, roughly 60 percent, is covered by the contrast-sensitive areas of the sensor.
- Phase detection points. The 117 phase detect points of the a7 II (Figure 8.4, left) are concentrated in the center of the screen, roughly at the location of the nine center contrast detect zones. That represents about 18 percent of the total frame area. The a7R II's 399 phase detection points are spread over a wider area (Figure 8.4, right), with at least some pixels located in each of the camera's 25 contrast detection zones. The a7R II's PDAF covers roughly 40 percent of the full frame, providing extra coverage.
- Crop mode coverage. One often-overlooked advantage of using the a7 II—series APS-C crop mode is that both the CDAF and PDAF areas are larger, because the outside area of the sensor is cropped out. Figure 8.5 shows the effective area of each. In both cases, contrast detect zones fill the entire cropped frame. The a7 II's phase detect points are spread over a larger percentage, and the a7R II's 399 points reach almost every corner of the cropped frame. That can be important for sports photographers, who may have subjects in all parts of the image.

Figure 8.4 Autofocus zones for contrast detection (blue boxes) and phase detection (green boxes) with the a7 II (left) and a7R II (right).

Figure 8.5 The same AF areas in APS-C crop mode for the a7 II (left) and a7R II (right).

The hybrid autofocus systems of both cameras use both types of AF. Each begins by rapidly focusing using PDAF, because the rangefinder approach always tells the camera whether to move focus closer or farther, and by approximately how much. No hunting is required, which is often the case with contrast detection, which needs to tweak the focus point until it settles on the sharpest position.

Once the PDAF has done its stuff, contrast detection kicks in, using its finicky but more accurate focusing capabilities to fine-tune focus. So, you end up with speedy initial focus (PDAF) and slightly slower final adjustments (CDAF), providing a perfect hybrid compromise. That's why Sony didn't switch to phase detection completely. Here's a quick rundown of the advantages of a hybrid system:

- Contrast detection works with more image types. Contrast detection doesn't require subject matter to have lines that are at angles to the PDAF points to work optimally, as phase detection does. Any subject that has edges running in any direction can be used to achieve sharp focus.
- Contrast detection can focus on larger areas of the scene. Whereas phase detection focus can be achieved *only* at the points that fall on one of the special autofocus sensor pixels, with contrast detection much larger portions of the image can be used as focus zones. Focus is achieved with the actual sensor image, so focus point selection is simply a matter of choosing which part of the sensor image to use. (This point is highlighted by the fact, discussed below, that in Flexible Spot mode, you can move the Autofocus Area to many parts of the sensor, whereas with a phase detection system, you can move the Autofocus Area only to a small number of specific locations where the special autofocus sensors used for phase detection are located.)
- Contrast detection can be more accurate with some types of scenes. Phase detection can fall prey to the vagaries of uncooperative subject matter: if suitable lines aren't available, the system may achieve less than optimal focus. In addition, accuracy decreases as the maximum aperture baseline used for calculations becomes smaller. Although AF is always conducted with the lens wide open, a lens with a maximum aperture of f/5.6 will focus with less accuracy than one with an f/1.4 maximum aperture. Contrast detection focus is more clear-cut. In most cases, the camera is able to determine clearly when sharp focus has been achieved.

- Phase detection "knows" which direction to focus. The split image seen by phase detection sensors reveal instantly whether focus is too close or too far. As I mentioned earlier, there is no need to "hunt" for the focus point, as the AF system can immediately adjust in the proper direction. That boosts focus speed considerably.
- Phase detection "knows" how far out of focus a subject is. The separation between the two halves of the image let the AF system know whether the subject is grossly out of focus, or whether only a slight adjustment is needed. That means faster autofocus, too.
- Phase detection isn't as dependent on scene brightness. As long as the split images are illuminated well enough for the AF system to make an evaluation, greater or lesser amounts of light don't have as much of an effect on speed and accuracy. Remember, the reason phase detect systems operate less well at smaller f/stops is because the baseline diameter of the aperture is smaller.

TRICKY BITS

There are a few restrictions you need to keep in mind when using the a7 II-series' hybrid AF system.

- **f/8 or larger.** Sony advises that focal plane phase detection AF is disabled whenever an aperture of f/9 or smaller is used; the a7R II/a7 II will rely *only* on contrast detection in that case.
- Compatible lenses. Not all lenses are compatible with the phase detection component. Older lenses, and lenses that need to be updated using firmware, don't support phase detection, which in turn blocks use of the Automatic AF, AF Track Duration, and AF Drive Speed features explained in Chapter 3. A-Mount lenses used with the LA-EA2 or LA-EA4 adapters do not support focal plane phase detection, although most can be used with their own phase detection. Visit www.sony.co.jp/dSLR/support for information on compatible lenses.

Focus Modes and Options

Now that you understand the fundamental principles of how the a7R II/a7 II achieves focus, let's discuss the practical application of these principles to your everyday picture-taking activities, by setting the various modes and options available for the autofocus system. We'll also discuss the use of manual focus, and when that method might be preferable to autofocus.

As you've come to appreciate by now, the a7R II/a7 II offers many options for your photography. Focus is no exception. Of course, as with other aspects of this camera, you can set the shooting mode to either Auto option or a scene mode such as Sports Action, and the camera will do just fine in most situations, using its default settings for autofocus. But, if you want more creative control, the choices are there for you to make.

FOCUS MODES/FOCUS AREA MODES

Your camera has a lot of modes! To keep the various focus options straight, remember that *focus modes* determine *when* the camera focuses: either once or continuously using autofocus, or manually. *Focus area modes* determine *where* in the frame the a7R II/a7 II collects the information used to achieve autofocus.

So, no matter what shooting mode you're using, your first choice is whether to use autofocus or manual focus. Yes, there's also a Direct Manual Focus (DMF) option, discussed in Chapter 3, but that still provides autofocus, with the option of *fine-tuning* focus manually before taking the shot. Manual focus presents you with great flexibility along with the challenge of keeping the image in focus under what may be difficult conditions, such as rapid motion of the subject, darkness of the scene, and the like. Later in this chapter, I'll cover manual focus as well as DMF. For now, I'll assume you're going to rely on the camera's conventional AF mode.

The Sony a7 II series has three basic AF modes: AF-S (Single-shot autofocus) and AF-C (Continuous autofocus), as well as Automatic AF (AF-A), which switches between the two other modes as required. Once you have decided on which of these to use, you also need to tell the camera how to select the area used to measure AF. In other words, after you tell the camera *how* to autofocus, you also have to tell it *where* to direct its focusing attention. I'll explain both *AF modes* and *AF area modes* in more detail later in this section.

MANUAL FOCUS

When you select manual focus (MF) in the Focus Mode entry in the Camera Settings 3 menu, using the Function menu, or by switching using a defined button, the a7R II/a7 II lets you set the focus yourself by turning the focus ring on the lens. There are some advantages and disadvantages to this approach. While your batteries will last slightly longer in manual focus mode, it will take you longer to focus the camera for each photo. And unlike older 35mm film SLRs, digital cameras' electronic viewfinders and LCDs are not designed for optimum manual focus. Pick up any advanced film camera and you'll see a big, bright viewfinder with a focusing screen that's a joy to focus on manually. So, although manual focus is still an option for you to consider in certain circumstances, it's not as easy to use as it once was. I recommend trying the various AF options first, and switching to manual focus only if AF is not working for you. And then be sure to take advantage of the focus peaking feature and the automatic frame enlargement (MF Assist), which can make it easier to determine when the focus is precisely on the most important subject element. And remember, if you use the DMF mode, you can fine-tune the focus after the AF system has finished its work.

Focus Pocus

Back in the pre-AF days, manual focusing was problematic because our eyes and brains have poor memory for correct focus, which is why your eye doctor must shift back and forth between sets of lenses and ask "Does that look sharper or was it sharper before?" in determining your correct prescription. Similarly, manual focusing involves jogging the focus ring back and forth as you go from almost in focus, to sharp focus, to almost focused again. The little clockwise and counterclockwise arcs decrease in size until you've zeroed in on the point of correct focus. What you're looking for is the image with the most contrast between the edges of elements in the image.

The Sony a7 II series can assess sharpness quickly, and it's also able to remember the progression perfectly, making the entire process fast and precise. Unfortunately, even this high-tech system doesn't really know with any certainty *which* object should be in sharpest focus. Is it the closest object? The subject in the center of the frame? Something lurking *behind* the closest subject? A person standing over at the side of the picture? Many of the techniques for using autofocus effectively involve telling the camera exactly what it should be focusing on.

Adding Circles of Confusion

But there are other factors in play, as well. You know that increased depth-of-field brings more of your subject into focus. But more depth-of-field also makes autofocusing (or manual focusing) more difficult because the contrast is lower between objects at different distances. So, autofocus with a 300mm lens (or zoom setting) may be easier than at a 16mm focal length (or zoom setting) because the longer lens has less apparent depth-of-field. By the same token, a lens with a maximum aperture of f/1.8 will be easier to autofocus (or manually focus) than one of the same focal length with an f/4 maximum aperture, because the f/4 lens has more depth-of-field and a dimmer view. It's also important to note that lenses with a maximum aperture smaller than f/5.6 would give your Sony Alpha's autofocus system fits, because the smaller opening (aperture) would allow less light to enter or to reach the autofocus sensor.

To make things even more complicated, many subjects aren't polite enough to remain still. They move around in the frame, so that even if the camera's lens is sharply focused on your main subject, the subject may change position and require refocusing. An intervening subject may pop into the frame and pass between you and the subject you meant to photograph. You (or the camera) have to decide whether to focus on this new subject, or to remain focused on the original subject. Finally, there are some kinds of subjects that are difficult to bring into sharp focus because they lack enough contrast to allow the camera's AF system (or our eyes) to lock in. Blank walls, a clear blue sky, or other low-contrast subject matter may make focusing difficult even with the hybrid AF system.

If you find all these focus factors confusing, you're on the right track. Focus is, in fact, measured using something called a *circle of confusion*. An ideal image consists of zillions of tiny little points, which, like all points, theoretically have no height or width. There is perfect contrast between the point and its surroundings. You can think of each point as a pinpoint of light in a darkened room.

Figure 8.6
When a pinpoint of light (left) goes out of focus, its blurry edges form a circle of confusion (center and right).

When a given point is out of focus, its edges decrease in contrast and it changes from a perfect point to a tiny disc with blurry edges (remember, blur is the lack of contrast between boundaries in an image). (See Figure 8.6.)

If this blurry disc—the circle of confusion—is small enough, our eye still perceives it as a point. It's only when the disc grows large enough that we can see it as a blur rather than as a sharp point that a given point is viewed as being out of focus. You can see, then, that enlarging an image, either by displaying it larger on your computer monitor or by making a large print, also magnifies the size of each circle of confusion. Moving closer to the image does the same thing. So, parts of an image that may look perfectly sharp in a 5×7 —inch print viewed at arm's length, might appear blurry when blown up to 11×14 inches and examined at the same distance. Take a few steps back, however, and the image may look sharp again.

To a lesser extent, the viewer also affects the apparent size of these circles of confusion. Some people see details better at a given distance and may perceive smaller circles of confusion than someone standing next to them. For the most part, however, such differences are small. Truly blurry images will look blurry to just about everyone under the same conditions.

Technically, there is just one plane within your picture area, parallel to the back of the camera (actually the sensor) that is in sharp focus. That's the plane in which the points of the image are rendered as precise points. At every other plane in front of or behind the focus plane, the points show up as discs that range from slightly blurry to extremely blurry. In practice, the discs in many of these planes will still be so small that we see them as points, and that's where we get depth-of-field: the range of planes that includes discs that we perceive as points rather than blurred splotches. The size of this range increases as the aperture is reduced in size and is allocated roughly one-third in front of the plane of sharpest focus, and two-thirds behind it. (See Figure 8.7.)

Figure 8.7
The focused plane (the nose of the train) is sharp, but the area in front of (the track) and behind it (the background) are blurred because the depthof-field (the range of acceptably sharp focus) is shallow in this image.

Your Autofocus Mode Options

Manual focus can come in handy, as I'll explain later in this chapter, but autofocus is likely to be your choice in the great majority of shooting situations. Choosing the right AF mode and the way in which focus points are selected is your key to success. Using the wrong mode for a particular type of photography can lead to a series of pictures that are all sharply focused—on the wrong subject.

But autofocus isn't some mindless beast out there snapping your pictures in and out of focus with no feedback from you. There are several settings you can modify to regain a fair amount of control. Your first decision should be which of the autofocus modes to select: Single-shot (AF-S), Continuous AF (AF-C), or Automatic AF (AF-A). DMF first uses autofocus, and then allows you to fine-tune focus manually. Press the MENU button, go to the Camera Settings 3 menu, and navigate to the line for Focus Mode. Press the center button, then highlight your autofocus mode choice from the submenu, and press the center button again. You can also set autofocus mode by pressing the Fn button and using the Function menu.

FOCUS INDICATOR

At the lower-left corner of your screen, you'll find a green focus confirmation indicator that's active while focusing is underway. It consists of a round green disk which may have rounded brackets at either side. If the *disk glows steadily*, the image is in focus. Only the disk appears when using AF-S; in AF-C mode, the disk is surrounded by the brackets and indicates that the focus plane may change if the subject moves. If the *brackets are flashing and no disk appears*, focusing is in progress; if the *disk is flashing*, focusing has failed. (See Figure 8.8.)

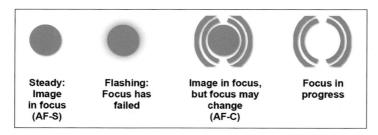

Figure 8.8
The focus indicator icon shows focus status.

Single-Shot AF (AF-S) Mode

With Single-Shot AF (AF-S), the camera will lock in focus when you press the shutter release (or defined AF start button) and will not adjust focus if your subject moves or you change the distance between you and your subject, as long as you hold down the button.

In AF-S mode, focus is locked. By keeping the button depressed halfway, you'll find you can reframe the image by moving the camera to aim at another angle; the focus (and exposure) will not change. Maintain pressure on the shutter release button and focus remains locked even if you recompose, or if the subject begins running toward the camera, for example.

Note

In this chapter, I'm assuming that you're using P, A, S, or M mode where you have full control over the camera features. This is important because the camera will use *only* AF-S in either Intelligent Auto or Superior Auto modes, in any scene mode *except* Sports Action, in Sweep Panorama, and whenever the Smile Shutter feature is active. And it will set Continuous AF (AF-C) only in Movie mode, regardless of what focus mode you've selected for still images.

When sharp focus is achieved in AF-S mode, the solid green focus indicator appears in the lower-left corner of the screen and you'll hear a little beep. One or more green focus confirmation frames will also appear to indicate the area(s) of the scene that will be in sharpest focus.

For non-action photography, AF-S is usually your best choice, as it minimizes out-of-focus pictures (at the expense of spontaneity). Because of the small delay while the camera zeroes in on correct focus, you might experience slightly more shutter lag. This mode uses less battery power than Continuous AF.

If you have set the a7R II/a7 II for Pre-AF in the Custom Settings 3 menu, you may notice something that seems strange: the camera's autofocus mechanism will begin seeking focus even before you touch the shutter release button. In this mode, no matter which AF method is selected, the camera will continually alter its focus as it is aimed at various subjects, *until* you press the shutter release button halfway. At that point, the camera locks focus, in Single-shot AF mode.

Continuous AF (AF-C) Mode

When Continuous AF is active, focus is constantly readjusted as your subject (or you) move. The difference between Single-shot AF and Continuous AF comes at the point the shutter release button (or defined focus start button) is pressed halfway. (See the discussion of *back button focus* later in this chapter.)

Switch to this mode when photographing sports, young kids at play, and other fast-moving subjects. In this mode, the camera can lock focus on a subject if it is not moving toward the camera or away from your shooting position; when it does, you'll see a green circle surrounded by brackets. (There will be no beep.) But if the camera-to-subject distance begins changing, the camera instantly begins to adjust focus to keep it in sharp focus, making this the more suitable AF mode with moving subjects.

Automatic AF (AF-A) Mode

The camera begins using AF-S, and switches to AF-C if the subject begins moving. Use this mode when you're not certain that your subject will begin moving, and you'd like to take advantage of AF-S, as described earlier, until the subject does move. You might use AF-A to photograph a sleeping pet, which, if awakened by the activity, might respond with sudden movement.

Setting the AF Area

So far, you have allowed the camera to choose which part of the scene will be in the sharpest focus using its focus detection points called *AF areas* by Sony. However, you can also specify a single focus detection point that will be active. Use the Function menu, or press the MENU button, navigate to the Focus Area item in the Camera Settings 3 menu, press the center button, and select one of the options. Press the center button again to confirm. Here is how the AF Area options work:

- Wide. The camera chooses the appropriate focus area(s) in order to set focus on a certain subject in the scene. There are no focus brackets visible on the screen until you press the shutter release button halfway to lock focus. At that point, the camera displays one or more pairs of green focus indicators to show what area(s) of the image it has used to set focus on. If Face Detection is active, the AF system will prioritize faces when making its decision as to where it should set focus. You'll see several pairs of brackets when several parts of the scene are at the same distance from the camera. When most of the elements of a scene are at roughly the same distance, the camera displays a single, large green focus bracket around the entire edge of the screen. Even if you set one of the other options, Wide is automatically selected in certain shooting modes, including both Auto and all SCN modes. Use this mode to give the camera complete control over where to focus. (See Figure 8.9.)
- **Zone.** A 3 × 3 array of up to nine focus areas is shown on the screen (see Figure 8.10). You can move the focus zone by holding down the defined Focus Settings button (the default is C2) and then rotating the front or rear dial or pressing the directional buttons to shift the array to one of nine overlapping areas—three at the top of the frame, three at the bottom of the frame, and

Figure 8.9 With Wide AF Area, the camera either displays one large green bracket indicating that most of the scene is at the same distance to the camera or it displays one or more smaller brackets to indicate the specific area(s) of the scene that will be in sharpest focus.

Figure 8.10 In Zone mode, an array of nine areas appears, and you can move the zone to nine different locations on the screen. The camera selects one or more focus zones within that array.

three in the middle. Select one of those nine focus areas, and the camera chooses which sections within that zone to use to calculate sharp focus. Those individual areas will be highlighted in green. Use this mode when you know your subject is going to reside in a largish area of the frame, and want to allow the a7R II/a7 II to select the exact focus zone.

- Center. Activate this AF area and the camera will use only a single focus detection point in the center of the frame to set focus. Initially a pair of black focus brackets appears on the screen. Touch the shutter release button and the camera sets and locks focus on the subject in the center of the image area; the brackets then turn green to confirm the area that will be in the sharpest focus in your image. (See Figure 8.11.) Choose this option if you want the camera to always focus on the subject in the center of the frame. Center the primary subject (like a friend's face in a wide-angle landscape composition), allow the camera to focus on it, maintain slight pressure on the shutter release button to keep focus locked, and re-frame the scene for a more effective, off-center, composition. Take the photo at any time and your friend (who is now off-center) will be in the sharpest focus.
- Flexible Spot. This mode enables you to move the camera's focus detection point (focus area) around the scene to any one of multiple locations, using the directional buttons. When opting for Flexible Spot, you can use the left/right buttons to choose Small, Medium, or Large spots. This mode can be useful when the camera is mounted on a tripod and you'll be taking photos of the same scene for a long time, while the light is changing, for example. Move the focus area to cover the most important subject, and it will always focus on that point when you later take a photo.

Figure 8.11 In the Center AF Area mode, the camera displays the focus brackets in the center of the screen; the brackets turn green after focus has been set.

Figure 8.12 When the Flexible Spot AF Area mode is initially selected, the active focus detection point is delineated with brackets that turn green when focus is confirmed and locked; the arrows at each side of the screen indicate that you can move the brackets in any of the four directions.

When you initially select this AF Area mode, a small pair of focus brackets appears in the center of the screen along with four triangles pointing toward the four sides of the screen. (See Figure 8.12.) The triangles merely indicate that the AF area can be moved in any direction.

Use the directional controls to move the orange brackets around the screen, which allows great versatility in the placement of the active focus detection point. Move the orange brackets until they cover the most important subject area and touch the shutter release button. The brackets will turn green and the camera will beep to confirm that focus has been set on the intended area.

- **Expand Flexible Spot.** If the camera is unable to lock in focus using the selected focus point, it will also use the eight adjacent points to try to achieve focus.
- Lock-On AF. In this mode, the camera locks focus onto the subject area that is under the selected focus spot when the shutter button is depressed halfway. Then, if the subject moves (or you change the framing in the camera), the camera will continue to refocus *on that subject*. You can select this mode only when the focus mode is set to Continuous AF (AF-C).

This option is especially powerful, because you can activate it for any of the five focus area options described above. That is, once you've highlighted Lock-On AF on the selection screen, you can then press the left-right directional button and choose Wide, Zone, Center, Flexible Spot, or Expand Flexible Spot. The camera will lock on a subject, using one of those five area modes to follow it. (See Figure 8.13.)

Just as you're limited in the use of the AF mode in certain operating modes, there's a limitation with AF Area as well. For example, Flexible Spot is not available for selection in automatic modes: in either Auto mode or any SCN mode, the camera will always use Multi as the AF Area mode.

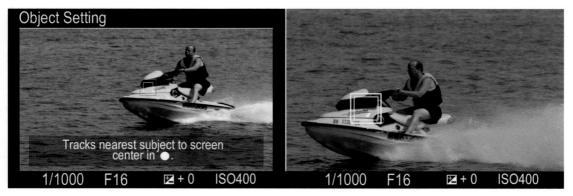

Figure 8.13 Left: Decide on the object the camera should track, center it, and press OK to instruct the a7R II/a7 II as to your preferred target. Right: When Lock-On AF is active, the camera maintains focus on your preferred target, tracking it as it moves around the scene.

MOVING THE FOCUS FRAME

As described in Chapter 4, you can define a custom key of your choice in the Custom Settings 7 menu to activate focus setting mode to move the focus frame and select a focus area. Once you've done that, in autofocus or direct manual focus modes you can move the focus area using the front dial/up/down buttons to move the frame up or down; the rear dial/left/right buttons to move the frame from side to side; and the control wheel to select a specific focus area. In manual focus mode, the same controls move the magnified focus area.

Face Detection and Eye AF

As hinted already, the a7R II/a7 II has a couple more tricks up its sleeve for setting the AF area. By default, Smile/Face Detection in the Camera Settings menu is on, enabling the camera to attempt to identify any human faces in the scene. If it finds one or more faces, the camera will surround each one (up to eight in all) with a white frame on the screen. (Later, I'll discuss a feature that allows you to specify favorite faces that the camera should prioritize.) If it judges that autofocus is possible for one or more faces, it will turn the frames around those faces orange. When you press the shutter button halfway down to lock autofocus, the frames will turn green, confirming that they are in focus. The camera will also attempt to adjust exposure (including flash, if activated) as appropriate for the scene.

Face Detection is available only when you're using AF and when the Focus Area and the Metering mode are both set to Multi, the defaults. So, if the Face Detection option is grayed out on the Camera Settings menu, check those other settings to make sure they are in effect. Personally, I often prefer to exercise my own control as to exactly where the camera should focus, but when shooting

THE EYES HAVE IT

I like to use Face Detection in tandem with Eye AF. By default, the control wheel's center button activates Eye AF while you hold the button down. When active, simply point the camera at a face and press the defined key. The camera will magically identify the face and focus on the eye that's closest to the camera. If no eye is detected, the a7R II/a7 II reverts to face detection. If it cannot find a face, Eye AF will fail to lock in. But if you'd like to be amazed, set your camera as follows:

- Continuous AF
- Lock-On AF: Flexible Spot
- Eye AF

The camera will almost unerringly locate faces and focus on the eye of your subject. It's great for candid portraits, weddings, or child photography.

quick snaps during a party, Face Detection can be a useful feature. It's also an ideal choice if you need to hand the camera to someone to photograph you and your family or friends at an outing in the park. However, it really comes in useful when you couple it with Eye AF.

Center Lock-On AF

The next trick the camera can perform is called Center Lock-On AF, which is a separate feature from the Lock-On AF that you can activate with a half-press of the shutter release. Center Lock-On AF must be accessed from a defined key, like Eye AF, or from its Camera Settings 7 menu entry. It's designed to maintain focus on a specific subject as it moves around the scene that you're shooting. Don't confuse this feature with Continuous AF (AF-C), the mode you would use in action photography with a subject running toward you, for example. AF-C's *predictive focus* feature is often called "AF tracking" by other cameras and by many photographers. The a7R II/a7 II offers that feature too, with AF-C mode autofocus, but it's not the same as Center Lock-On or Lock-On AF.

The Center Lock-On AF function *can* change focus as a person approaches the camera, but it's not intended for that purpose with a fast-action subject. And this feature is far more versatile than Continuous AF mode. Once the camera knows what your preferred subject is, it can maintain focus as it moves around the image area, as a person might do while mingling with a large group of friends at a party.

Turn on Center Lock-On AF in the Camera Settings 7 menu. (You cannot do so when the camera is set for Hand-held Twilight or Sweep Panorama or manual focus.) When it's been activated by a defined key or its menu entry, a small white square initially appears in the center of the screen, as in Figure 8.13, left. Move the position of the square with the directional controls until it covers your intended subject and press the center button. The small square now changes to a larger double square (as shown in Figure 8.13, right) that's called the *target frame*. You have instructed the camera as to your preferred subject. If the camera is set to AF-C mode, the camera tracks a focus subject when the shutter button is pressed halfway.

To use Center Lock-On AF, just follow these steps:

- 1. **Deactivate Lock-On AF.** You won't be able to activate Center Lock-On AF if its Lock-On AF cousin is enabled. Visit the Function menu and choose Wide, Zone, Center, Flexible Spot, or Expand Flexible Spot.
- 2. Activate Center Lock-On AF. Next, stop by the Camera Settings 7 menu and enable Center Lock-On AF.
- 3. Activate. Press the center button to activate.
- 4. **Choose subject.** Align the camera so the subject you want to track is within the selection box. Press the center button again to select that subject.
- 5. **Start tracking.** Once the camera figures out which areas of the image under the selection box include your subject, it will outline the subject with a double white border. The camera will now use the live view image to track the subject and its phase detection AF system to keep that subject in focus.
 - Move the camera around to change your composition or wait until your targeted subject begins moving around. Note that the target frame will remain on your subject, confirming that it will be in the sharpest focus when you take a photo. Changes in lighting, lack of contrast with the background, extra-small or extra-large subjects, and anything moving very rapidly can confuse Center Lock-On AF, but it's generally quite effective. Note that once you take a picture, you must go through the menu/custom key rigmarole again; this mode is not "sticky."
- 6. **Don't panic.** If your subject moves out of the frame, the a7R II/a7 II will remember what it was tracking for several seconds, and relock on it if it appears in the frame again within that time. If tracking is totally lost, the camera resumes its normal AF behavior until you select another subject to track.
- 7. Stop tracking. You can press the center button again to stop tracking your subject.

There are a few other benefits with Center Lock-On AF when using the camera when Face Detection is also active. Let's say you have designated the intended target as your friend Jack's face. If Jack leaves the room while being tracked and then returns to the scene, Center Lock-On AF will remember it and focus on Jack again. Whenever a face is your target, the camera can continue tracking that person even if the face is not visible; it will then make the body the target for tracking. If you also activate the camera's Smile Shutter feature (in the Camera Settings menu) in addition to Face Detection, the camera will not only track the targeted face, but it will take a photo if your subject smiles.

Center Lock-On AF allows you to choose the subject to track, rather than rely on the camera to track whatever object focus is originally locked on, as with Lock-On AF, described next. In addition, it can also be used in Movie mode, which can be very handy when you want to track a moving subject as you capture video. It cannot be used when Lock-On AF is active.

There are some special considerations when using this feature if the target subject is a human face. The camera "remembers" the face selected, so if the subject disappears from the frame and then returns, the camera locks in on that face again. If you're using the Smile Shutter function, then the a7R II/a7 II will not only track the individual's face, but release the shutter and take a picture if your subject smiles!

Center Lock-On may not work if the subject is moving too quickly, is too small or too large to be isolated effectively, has only reduced contrast against its background, or if the ambient light is too dark or changes dramatically while you're tracking.

Lock-On AF

Lock-On AF is the other tool for tracking a moving subject. Lock-On AF is easier than Center Lock-On AF, because you can turn it on and forget it. It does, however, only work in still photography mode; you can't use it when shooting movies. To use Lock-On AF, just follow these steps:

- 1. **Choose AF-C.** This feature works only when you are using continuous autofocus because, well, it refocuses continually.
- 2. Deactivate Center Lock-On. You can't use Lock-On and Center Lock-On at the same time.
- 3. **Activate Lock-On AF.** Use the Function menu and choose Focus Area. Scroll down past the Expand Flexible Spot entry and highlight Lock-On AF.
- 4. **Choose Focus Area.** Surprise! Using Lock-On AF does *not* mean you lose access to the four AF area modes. With Lock-On AF highlighted, use the left/right controls to select Wide, Zone, Center, Flexible Spot, or Expand Flexible Spot. That will give you both Lock-On AF *and* the area mode you prefer. If you switch from AF-C to AF-S, you lose the lock on capabilities, and the camera just reverts to whatever focus area mode you select here.
- 5. **Start tracking.** When you activate focus by pressing the shutter release halfway, the camera will use your selected focus area option to lock in focus, as always. However, now, once focus has been locked, the camera will *track* your subject as it roams around the screen. You'll see the green focus area rectangles moving as your subject moves (or you reframe the image with the camera). If a face is detected, a tracking rectangle around the face will be shown. (You'll learn more about face detection in an upcoming section.)

Using Manual Focus

As I noted earlier, manual focus is not as straightforward as with an older manual focus 35mm SLR equipped with a focusing screen optimized for this purpose and a readily visible focusing aid. But Sony's designers have done a good job of letting you exercise your initiative in the focusing realm, with features that make it easy to determine whether you have achieved precise focus. It's worth becoming familiar with the techniques for those occasions when it makes sense to take control in this area.

Here are the basic steps for quick and convenient setting of focus:

- Select Manual Focus. After you do so (in the Focus Mode entry in the Camera Settings 3 menu), the letters MF will appear in the LCD display when you're viewing the default display that includes a lot of data. (You can change display modes by pressing the DISP button.)
- Aim at your subject and turn the focusing ring on the lens. As soon as you start turning the focusing ring, the image on the LCD is enlarged (magnified) to help you assess whether the center of interest of your composition is in focus. (That is, unless you turned off this feature, called MF Assist, through the Custom Settings 1 menu.) Use the up/down/left/right direction controls to move around the magnified image area until you're viewing the most important subject element, such as a person's eyes. Turn the focusing ring until that appears to be in the sharpest possible focus.

The enlargement lasts two seconds before the display returns to normal; you can increase that with the MF Assist Time menu item. In situations where you want to use manual focus without enlargement of the preview image, you can turn this feature off in the Custom Settings menu, using the MF Assist item.

- If you have difficulty focusing, zoom in if possible and focus at the longest available focal length. If you're using a zoom lens, you may find it easier to see the exact effect of slight changes in focus while zoomed in. Even if you plan to take a wide-angle photo, zoom to telephoto and rotate the ring to set precise focus on the most important subject element. When you zoom back out to take the picture, the center of interest will still be in sharp focus.
- Use Peaking of a suitable color. On by default in Shooting mode, focus peaking provides a colored overlay around edges that are sharply focused; this makes it easier to determine when your subject is precisely focused. The overlay is white, but you can change that to another color when necessary. The alternate hue may be needed to provide a strong contrast between the peaking highlights and the color of your subject. Access the Peaking Color item of the Setup menu to adjust the color. To make the overlay even more visible, select High in the Peaking Level item; you can also turn peaking Off with this item, if desired.
- Consider using the DMF option. Your third option is DMF, or Direct Manual Focus. Activate it and the camera will autofocus with Single-shot AF and lock focus when you press the shutter release button halfway. As soon as focus is confirmed, you can turn the focusing ring to make fine-tuning adjustments, as long as you maintain slight pressure on the shutter release button. The MF Assist magnification will be activated immediately.

This method gives you the benefit of autofocus but gives you the chance to change the exact point of focus, to a person's eyes instead of the tip of the nose, for example. This option is useful in particularly critical focusing situations, when the precise focus is essential, as in extremely close focusing on a three-dimensional subject. Because depth-of-field is very shallow in such work, you'll definitely want to focus on the most important subject element, such as the pistil or stamen inside a large blossom. This will ensure that it will be the sharpest part of the image.

Back-Button Focus

Once you've been using your camera for a while, you'll invariably encounter the terms *back focus* and *back-button focus*, and wonder if they are good things or bad things. Actually, they are *two different things*, and are often confused with each other. *Back focus* is a bad thing, and occurs when a particular lens consistently autofocuses on a plane that's *behind* your desired subject. Fortunately, that's a malady only cameras with outboard AF sensors have, so you won't experience back or front focus unless you're using an EA-LA2 or EA-LA4 A-mount adapter.

Back-button focus, on the other hand, is a tool you can use to separate two functions that are commonly locked together—exposure and autofocus—so that you can lock in exposure while allowing focus to be attained at a later point, or vice versa. It's a *good* thing, although using back-button focus effectively may require you to unlearn some habits and acquire new ways of coordinating the action of your fingers.

As you have learned, the default behavior of your camera is to set both exposure and focus (when AF is active) when you press the shutter release down halfway. When using AF-S mode, that's that: both exposure and focus are locked and will not change until you release the shutter button, or press it all the way down to take a picture and then release it for the next shot. In AF-C mode, exposure is locked and focus is set when you press the shutter release halfway, but the a7R II/a7 II will continue to refocus if your subject moves for as long as you hold down the shutter button halfway. Focus isn't locked until you press the button down all the way to take the picture. In AF-A mode, the camera will start out in AF-S mode, but switch to AF-C if your subject begins moving.

What back-button focus does is *decouple* or separate the two actions. You can retain the exposure lock feature when the shutter is pressed halfway, but assign autofocus *start* and/or autofocus *lock* to a different button. So, in practice, you can press the shutter button halfway, locking exposure, and reframe the image if you like (perhaps you're photographing a backlit subject and want to lock in exposure on the foreground, and then reframe to include a very bright background as well).

But, in this same scenario, you *don't* want autofocus locked at the same time. Indeed, you may not want to start AF until you're good and ready, say, at a sports venue as you wait for a ballplayer to streak into view in your viewfinder. With back-button focus, you can lock exposure on the spot where you expect the athlete to be, and activate AF at the moment your subject appears. The a7R II/a7 II gives you a great deal of flexibility, both in the choice of which button to use for AF, and the behavior of that button. You can *start* autofocus, *lock* autofocus at a button press, or *lock it while holding the button*. That's where the learning of new habits and mind-finger coordination comes in. You need to learn which back-button focus techniques work for you, and when to use them.

Back-button focus lets you avoid the need to switch from AF-S to AF-C when your subject begins moving unexpectedly. Nor do you need to use AF-A and *hope* the camera switches when appropriate. You retain complete control. It's great for sports photography when you want to activate autofocus precisely based on the action in front of you. It also works for static shots. You can press and release your designated focus button, and then take a series of shots using the same focus point. Focus will not change until you once again press your defined back button.

Want to focus on a spot that doesn't reside under one of the a7R II/a7 II's focus areas? Use back-button focus to zero in focus on that location, then reframe. Focus will not change. Don't want to miss an important shot at a wedding or a photojournalism assignment? If you're set to *focus priority*, your camera may delay taking a picture until the focus is optimum; in *release priority* there may still be a slight delay. With back-button focus you can focus first, and wait until the decisive moment to press the shutter release and take your picture. The a7R II/a7 II will respond immediately and not bother with focusing at all.

Activating Back-Button Focus

To enable back-button focus, just follow these steps:

- 1. Select an AF-ON button. In the Custom Settings 7 menu, select Custom Key Settings.
- 2. **Redefine a button of your choice.** I recommend jumping to the second page of the Custom Key Settings submenu, and defining the AEL button as AF On (that option is located between Eye AF and Focus Hold). You can use a different button, even one that's not on the back panel, but activation may not be as intuitive. And, who's ever heard of Top-Button Focus, anyway?
- 3. **Redefine AF/MF button.** In the entry immediately below the AEL Button choice on the second page of the Custom Key Settings submenu, select AF/MF Button, and set it to AF/MF Toggle.
- 4. **Turn off shutter button AF activation.** In the Custom Settings 5 menu, set AF/w Shutter to Off. When you want to disable back-button focus (temporarily or permanently), change it back to On. The other two settings can be left as-is.

That's all there is to it. Henceforth, pressing the shutter release will *not* activate autofocus. Autoexposure metering will still be initiated by pressing the button halfway, as long as the AEL/w Shutter is set to Auto or On (and not Off), and pressing it all the way takes a picture. You can start AF by pressing the AEL button (the switch has to be in the AEL position, rather than AF/MF; with the switch in the AF/MF position, the button will instead toggle between autofocus and manual focus).

Useful Menu Items for AF

I discussed how to set all the autofocus options, which are scattered among the Camera Settings and Custom Settings menus, plus how to define Custom Keys to activate certain features in Chapters 3 and 4. If you need a recap, here is a list of the a7R II/a7 II autofocus features that you should keep in mind.

■ **AF Illuminator.** This Setup menu item is set at Auto by default, indicating that the illuminator on the front of the camera will provide a burst of light in a dark location when using in AF-S mode. That provides a bright target for the autofocus system. Turn this feature off when you feel the red burst might be intrusive.

■ Face Registration. Mentioned briefly earlier in this chapter, this Custom Settings 4 menu item is quite versatile, and was described in Chapter 3. You can register up to eight faces that should get priority in terms of autofocus and then specify the order of priority from the most important faces to the least important.

To register a face, point the camera at the person's face, make sure it's within the large square on the screen, and press the shutter release button. Do so for several faces. When you're taking a photo of a scene that contains more than one registered face, the camera will prioritize faces based on which were the first to be registered in the process you used.

Take advantage of the Order Exchanging option of this menu item so the faces you consider the most important are prioritized. When you access it, the camera displays the registered faces with a number on each; the lower the number the higher the priority. You can now change the priority in which the faces will be recognized, from 1 (say your youngest child) to 8 (perhaps your cousin twice removed). You can also use the Delete or the Delete All options to delete one or more faces from the registry, such as your ex and former in-laws.

■ Smile Shutter. If you activate this feature in the Camera Settings menu, the face detection system will try to find smiling faces. In fact, it will not take a photo until it finds at least one. Press the Option button (the down directional key) and you get three options: Normal Smile, Big Smile, Small Smile. Set the one you want and the camera will watch for a smile of that magnitude; it will cover the relevant face(s) with an orange frame which will turn green after focus is set. And as mentioned earlier, when the camera will be tracking a face using the Lock-On AF feature while Smile Shutter is on, it will prioritize this face while doing so.

Autofocus Summary

Here's a summary of autofocus considerations that were discussed elsewhere in this book, primarily here and in Chapters 3 and 4 under the explanations of the various autofocus settings. I'll recap the most important aspects here, as a quick guide to help you locate the longer discussions. Table 8.1 provides some guidelines for particular types of subjects. Remember that some of these are also available in the Function menu. (Tab numbers for a7R II; the a7 II may use slightly different tab numbers.)

- Focus Mode (Camera Settings 3). Choose focus modes from AF-S, AF-C, DMF, and MF.
- Focus Area (Camera Settings 3). Select the number and location of autofocus points used, from Wide, Zone, Center, Flexible Spot, and Expanded Flexible Spot.
- Focus Settings (Camera Settings 4). Adjust specific focus area with the front dial, and focus type of focus area with the control wheel.
- AF Illuminator (Stills) (Camera Settings 4). Enables/disables use of the AF illuminator as an autofocus aid.
- AF Drive Speed (Movies) (Camera Settings 4) (a7R II only). Choose between slow and accurate AF, or fast and slightly less accurate in video mode.

- AF Track Sensitivity (Movie) (Camera Settings 4) (a7R II only). Adjust how long the a7R II waits to refocus on intervening objects when shooting movies.
- Focus Magnifier (Camera Settings 6). Enlarges image during manual focus.
- Center Lock-On AF (Camera Settings 7). When activated, automatically tracks focused subject when shooting stills and movies. Mutually exclusive with Lock-On AF.
- Smile/Face Detection (Camera Settings 7). Sets focus, exposure, and white balance for detected faces, both registered and unregistered.
- MF Assist (Custom Settings 1). Turns manual focus magnifier on or off.
- Focus Magnifier Time (Custom Settings 1). Length of time focus magnifier remains active.
- Peaking Level/Color (Custom Settings 2). These two settings specify the color outline of manually focused sharp areas.
- **Display Continuous AF area (Custom Settings 3).** Enables/disables display of AF areas during continuous autofocus.
- Phase Detect Area (Custom Settings 3). Shows bounding box representing area where phase detect pixels on the sensor reside.
- Pre-AF (Stills) (Custom Settings 3). Enables/disables AF start when camera is brought up to the eye.
- Eye-Start AF (Custom Settings 4). AF begins when the a7R II/a7 II viewfinder window is brought up to your eye.
- Priority Set AF-S/AF-C (Custom Settings 4). Select whether focus is *release priority* (take picture immediately, even if sharp focus not achieved) or *focus priority* (don't take picture until sharp focus locked in). You can also choose *balanced emphasis* as a compromise between the two. Separate entries for AF-S and AF-C.
- **AF w/Shutter (Custom Settings 5).** Choose On to start AF when the shutter is pressed halfway, or Off to decouple AF start from shutter release.
- Face Registration (Custom Settings 6). Allows you to register up to eight faces.
- **AF Micro Adjustment (Custom Settings 6).** Fine-tune autofocus for specific A-mount lenses when used with EA-LA2 or EA-LA4 adapters.
- AF System (Stills) (a7R II only). Choose between phase detect and contrast detect autofocus when using an A-Mount lens with the LA-EA1 or LA-EA3 adapters.

Table 8.1	Focus	Guideline	S					
Subject	Focus Mode	Focus Area	Priority Setup	Lock-On AF	Tracking Drive Speed	Tracking Duration	Smile/ Face Detection	Eye AF
Portraits	AF-S	Flex. Spot	AF	Off	Fast	3	On	Yes
Street photography	AF-C	Wide	Balanced Emphasis	On	Fast	3	On	As needed
General sports action	AF-C	Expanded Flex. Spot	Release	On	Fast	1	Off	No
Birds in flight	AF-C	Expanded Flex. Spot	Balanced Emphasis	On	Fast	5	Off	No
Football, soccer, basketball	AF-C	Expanded Flex. Spot	Release	On	Fast	1	Off	Off
Kids, pets	AF-C	Zone	Balanced Emphasis	On	Fast	2	On	Yes
Track events, auto racing	AF-C	Wide	Release	On	Fast	3	Off	No
Landscapes	AF-S	Wide	AF	Off	Slow	3	Off	No
Concerts, performance	AF-S	Flex. Spot	AF	Off	Fast	3	On	Yes

Advanced Techniques

Of the primary foundations of great photography, only one of them—the ability to capture a compelling image with a pleasing composition—takes a lifetime (or longer) to master. The art of *making* a photograph, rather than just *taking* a photograph, requires an aesthetic eye that sees the right angle for the shot, as well as a sense of what should be included or excluded in the frame; a knowledge of what has been done in the medium before (and where photography can be taken in the future); and a willingness to explore new areas. The more you pursue photography, the more you will learn about visualization and composition. When all is said and done, this is what photography is all about.

The other basics of photography—equally essential—involve more technical aspects: the ability to use your camera's features to produce an image with good tonal and color values; to achieve sharpness (where required) or unsharpness (when you're using selective focus); and to master appropriate white/color balance. It's practical to learn these technical skills in a time frame that's much less than a lifetime, although most of us find there is always room for improvement. You'll find the basic information you need to become proficient in each of these technical areas in this book.

Now it's time to begin exploring advanced techniques that enable you to get stunning shots that will have your family, friends, and colleagues asking you, "How did you *do* that?" These more advanced techniques deserve an entire book of their own, but there is plenty of room in this chapter to introduce you to some clever things you can do with your a7R II/a7 II.

Exploring Ultra-Fast Exposures

Fast shutter speeds (such as 1/1,000th second) can stop action because they capture only a tiny slice of time: a high-jumper frozen in mid-air, perhaps. The Sony a7R II/a7 II has a top shutter speed of 1/8,000th second for ambient light exposures. Electronic flash can also freeze motion by virtue of its extremely short duration—as brief as 1/50,000th second or less. When you're using flash, the

short duration of the actual burst of light can freeze a moving subject; that can also give you an ultra-quick glimpse of a moving subject when the scene is illuminated only by flash.

The a7R II/a7 II is fully capable of immobilizing all but the very fastest movement if you use a shutter speed of 1/8,000th second (without flash). The top speeds are generally overkill when it comes to stopping action; I can rarely find a situation where even 1/4,000th second is required to freeze high-speed motion. For example, the image shown in Figure 9.1 required a shutter speed of just 1/2,000th second to freeze the high jumper as she cleared the bar.

Virtually all sports action can be frozen at 1/2,000th second or a slower shutter speed, and for many sports a slower shutter speed is actually preferable—for example, to allow the wheels of a racing automobile or motorcycle, or the propeller on a classic aircraft, to blur realistically.

There may be a few situations where a shutter speed faster than 1/4,000th second is required. If you wanted to use an aperture of f/1.8 at ISO 100 outdoors in bright sunlight, say to throw a background out of focus with the shallow depth-of-field available at f/1.8, a shutter speed of 1/4,000th second would more than do the job. You'd need a faster shutter speed only if you set a higher ISO,

Figure 9.1 A shutter speed of 1/2,000th second will freeze most action.

and you probably wouldn't do that if your goal were to use the widest aperture possible. Under *less* than full sunlight, I doubt you'd even need to use a shutter speed of 1/4,000th second in any situations you're likely to encounter.

Electronic flash works well for freezing the motion of a nearby subject when flash is the only source of illumination. Since the subject is illuminated for only a split second, you get the effect that would be provided by a very fast shutter speed and also the high level of light needed for an exposure. This feature can be useful for stopping the motion of a nearby subject.

Of course, as you'll see in Chapter 13, the tiny slices of time extracted by the millisecond duration of an electronic flash exact a penalty. To use flash, the a7R II/a7 II employs a shutter speed no faster than 1/250th second, which is the fastest shutter speed—called sync speed—in conventional flash photography with your a7 II—series camera.

You can have a lot of fun exploring the kinds of pictures you can take using very brief exposure times, whether you decide to take advantage of the action-stopping shutter speeds (between 1/1,000th and 1/8,000th second) or the brief burst of light from flash that can freeze the motion of a nearby subject. Here are a few ideas to get you started:

- Take revealing images. Fast shutter speeds can help you reveal the real subject behind the façade, by freezing constant motion to capture an enlightening moment in time. Legendary fashion/portrait photographer Philippe Halsman used leaping photos of famous people, such as the Duke and Duchess of Windsor, Richard Nixon, and Salvador Dali, to illuminate their real selves. Halsman said, "When you ask a person to jump, his attention is mostly directed toward the act of jumping and the mask falls so that the real person appears." Try some high-speed portraits of people you know in motion to see how they appear when concentrating on something other than the portrait. (See Figure 9.2.)
- Create unreal images. High-speed photography can also produce photographs that show your subjects in ways that are quite unreal. A helicopter in mid-air with its rotors frozen or a motocross cyclist leaping over a ramp, but with all motion stopped so that the rider and machine look as if they were frozen in mid-air, makes for an unusual picture. (See the frozen rotors at top in Figure 9.3.) When we're accustomed to seeing subjects in motion, seeing them stopped in time can verge on the surreal.
- Capture unseen perspectives. Some things are *never* seen in real life, except when viewed in a stop-action photograph. M.I.T. professor Dr. Harold Edgerton's famous balloon burst photographs were only a starting point for the inventor of the electronic flash unit. Freeze a hummingbird in flight for a view of wings that never seem to stop. Or, capture the splashes as liquid falls into a bowl, as shown in Figure 9.4. No electronic flash was required for this image (and wouldn't have illuminated the water in the bowl as evenly). Instead, a clutch of high-intensity lamps bounced off a green card and an ISO setting of 1600 allowed the camera to capture this image at 1/2,000th second.

Figure 9.2 Fast shutter speeds can freeze your subject at the top of a jump.

Figure 9.3
Freezing a helicopter's rotors with a fast shutter speed makes for an image that doesn't look natural (top); a little blur helps convey a feeling of motion (bottom).

Figure 9.4
A large amount of artificial illumination and an ISO 1600 setting made it possible to capture this shot at 1/2,000th second without use of electronic flash.

Long Exposures

Longer exposures are a doorway into another world, showing us how even familiar scenes can look much different when photographed over periods measured in seconds. At night, long exposures produce streaks of light from moving, illuminated subjects like automobiles or amusement park rides, as you can see in Figure 9.5. Or, you can move the camera or zoom the lens to get interesting streaks from non-moving light sources, such as holiday lights. Extra-long exposures of seemingly pitch-dark subjects can reveal interesting views using light levels barely bright enough to see by. At any time of day, including daytime (in which case you'll often need the help of neutral-density filters to make the long exposure practical), long exposures can cause moving objects to vanish entirely, because they don't remain stationary long enough to register in a photograph.

Because the a7R II/a7 II produces such good images at longer timed exposures (and at even longer bulb exposures), and there are so many creative things you can do with long-exposure techniques, you'll want to do some experimenting. Get yourself a tripod or another firm support and take some test shots with long exposure noise reduction both enabled and disabled in the Setup menu (to see whether you prefer low noise or high detail) and get started.

Figure 9.5 Long exposures can produce interesting streaks of light.

As I noted in Chapter 7, you can make exposures as long as 30 seconds when using P, A, or S modes. In Manual exposure mode, bulb exposures can be even longer (but not available if you're using any mode that produces multiple exposures within the same frame, such as Auto HDR, Continuous/ Speed Priority Continuous, or Multi Frame Noise Reduction). In bulb mode, hold down the shutter release for the duration of the exposure, or use a wired release with a locking button, such as the Sony RM-VPR1 (\$53).

If you want to experiment with long exposures, here are some things to try:

- Make people invisible. One very cool thing about long exposures is that objects that move rapidly enough won't register at all in a photograph, whereas the subjects that remain stationary are portrayed in the normal way. That makes it easy to produce people-free landscape photos and architectural photos at night, or even in full daylight if you use one or more dark neutral-density filters to allow an exposure of at least a few seconds. At ISO 100 and f/16, for example, a pair of 8X (three-stop) neutral-density filters will allow you to make an exposure of nearly two seconds on a sunny day. Overcast days and/or even more neutral-density filtration would work even better if daylight people-vanishing is your goal. They'll have to be walking *very* briskly and across the field of view (rather than directly toward the camera) for this to work. At night, it's much easier to achieve this effect with the 20- to 30-second exposures that are possible in low light without any filter.
- Create streaks. If you aren't shooting for total invisibility, long exposures with the camera on a tripod can produce some interesting streaky effects. Even a single 8X ND filter will let you shoot at f/22 and 1/6th second in daylight. Indoors, you can achieve interesting streaks with slow shutter speeds, which is a technique I often use when photographing ballet dancers.

Tip

Neutral-density filters are gray (non-colored) filters that reduce the amount of light passing through the lens, without adding any color or effect of their own.

- Produce light trails. At night, car headlights, taillights, and other moving sources of illumination can generate interesting light trails. Your camera doesn't even need to be mounted on a tripod; hand-holding the camera for longer exposures adds movement and patterns to your trails. If you're shooting fireworks, a longer exposure—with the camera on a tripod—may allow you to combine several bursts into one picture.
- Blur waterfalls, etc. You'll find that waterfalls and other sources of moving liquid produce a special type of long-exposure blur, because the water merges into a fantasy-like veil that looks different at different exposure times, and with different waterfalls. Cascades with turbulent flow produce a rougher look at a given longer exposure than falls that flow smoothly. Although blurred waterfalls and rapids have become almost a cliché, there are still plenty of variations for a creative photographer to explore.

Figure 9.6 A long exposure transformed this night scene into a picture apparently taken at dusk.

■ Show total darkness in new ways. Even on the darkest, moonless nights, there is enough starlight or glow from distant illumination sources to see by, and, if you use a long exposure, there is enough light to take a picture, too. I was visiting a Great Lakes park hours after sunset, but found that a several-second exposure revealed the skyline scene shown in Figure 9.6, even though in real life, there was barely enough light to make out the boats in the distance. Although the photo appears as if it were taken at twilight or sunset, in fact the shot was made at 10 p.m.

Continuous Shooting

The a7R II/a7 II's continuous shooting modes are indispensable for the sports photographer, and useful for anyone photographing an event in which, even if you have lightning-fast reflexes, a decisive moment may occur a fraction of a second after you've completed an exposure. The a7R II and a7 II both are capable of capturing images continuously at *up to* (and note that qualification) 5 frames per second, so you can shoot consecutive images non-stop until the camera's buffer fills. At an air show I covered earlier this year, I took more than 1,000 images in a couple hours. I was able to cram hundreds of Large/Fine JPEGs on a single memory card. That's a lot of shooting. Given an average burst of about eight frames per sequence at the camera's highest frame (nobody really takes 15 to 20 shots or more of one pass, even with a slow-moving biplane as shown in Figure 9.7), I was able to capture more than 100 different sequences like the one shown before I needed to swap cards. For some types of action (such as football), even longer bursts come in handy, because running and

passing plays often last 5 to 10 seconds; there's also a change in character as the action switches from the quarterback dropping back to pass or hand off the ball, then to the receiver or running back trying to gain as much yardage as possible. (See Figure 9.8.)

Figure 9.7
Air shows make a perfect subject for continuous bursts.

Figure 9.8 Continuous shooting allows you to capture an entire sequence of exciting moments as they unfold.

To use the a7R II/a7 II's continuous advance mode, press the drive button (left direction button), access the Function menu, or go to the Drive Mode entry in the Camera Settings 2 menu. Then navigate to the Cont. Shooting option. Press the left/right buttons to select Hi or Lo, which yields (up to) 5 and 2.5 frames per second, respectively.

If you set the AF mode (in the Function submenu) to AF-C, Continuous autofocus (with phase detection AF) will be available in all continuous drive modes, but only as long as the subject is covered by the active focus detection point(s). This feature is useful when a moving subject is approaching the camera or moving away from it; the a7R II/a7 II will continuously adjust to focus on the subject as the distance changes, so the entire set of photos should be sharply focused.

Continuous shooting is not available if you're using Sweep Panorama; if you select a scene mode other than Sports Action; when DRO/Auto HDR is set to Auto HDR; when Smile Shutter is enabled; or Picture Effect is set to Soft Focus, HDR Painting, Rich-tone Mono, Miniature, Watercolor, or Illustration. Continuous shooting may also be disabled if your battery level is low.

The Buffer and Frame Rates

Once you have decided on a continuous shooting mode and speed, press the center button to confirm your choice. Then, while you hold down the shutter button, the a7R II/a7 II will fire continuously until it reaches the limit of its capacity to store images, given the image size and quality you have selected and other factors, such as the speed of your memory card and the environment you are shooting in.

For example, if the lighting is so dim as to require an exposure of about one second, the camera clearly cannot fire the shutter at a rate of even 2.5 frames per second. (Sony suggests turning the Lens Comp.: Distortion feature Off in the Custom Settings 7 menu to ensure the full framing speed.) And to be able to shoot at 5 fps, you definitely need to be using a fast shutter speed. Another factor that will affect your continuous shooting is the use of flash, which needs time to recycle after each exposure before it can fire again.

Sony doesn't publish exact figures for how many images you can shoot continuously, partly because there are so many variables that affect that number. So, I've conducted my own tests, using a Lexar 128GB 1000x memory card. When shooting JPEGs, both cameras can keep on firing continuously for quite a while (I've shot more than 150 JPEG Fine images continuously with the a7R II at 42 MP), but will slow down dramatically when the buffer fills. Additional shots are captured at a much slower speed, perhaps a few frames per second. The results of my own tests are shown in Table 9.1. For the RAW images, I used the Compressed format, as Uncompressed was not available until this book had already commenced production. Your results may vary, depending on your exact shooting settings.

The reason the cameras cannot let you shoot hundreds of photos in a single burst is that continuous images are first shuttled into the a7R II/a7 II's internal memory buffer, then doled out to the memory card as quickly as the card can write the data. Technically, the a7R II/a7 II takes the data

Table 9.1 Tested Buffer Capacity			
File Format	a7R II at 42.4 MP/5 fps	a 7 II at 24 MP/5 fps	
JPEG Extra Fine	25	32	
Fine	37	46	
Standard	45	56	
RAW	23	28	
RAW & JPEG	22	29	

received from the digital image processor and converts it to the output format you've selected—either JPEG or RAW—and deposits it in the buffer ready to store on the card.

The internal "smart" buffer can suck up photos much more quickly than the memory card and, indeed, some memory cards are significantly faster or slower than others. When the buffer begins to fill, the framing speed slows significantly; eventually the buffer fills and then you can't take any more continuous shots until the a7R II/a7 II has dumped some of them to the card, making more room in the buffer. (If you often need to shoot long bursts, be sure to use a fast memory card, rated at least as Class 10 with 30 to 95MB/s or faster writing speeds, since it can write images more quickly than a slower card, freeing up buffer space faster; this allows for shooting a longer series of photos.)

So, if you're in a situation in which continuous shooting is an issue, you may need to make some quick judgments. If you're taking photos at a breaking news event where it's crucial to keep the camera firing no matter what and quality of the images is not a huge issue, your best bet may be to set the image size to Small and the quality to Standard. On the other hand, if you're taking candid shots at a family gathering and want to capture a variety of fleeting expressions on people's faces, you may opt for taking Large-size shots at the Fine quality setting, knowing that the drive speed may slow occasionally; if using a fast card however, I doubt you'll find that to be a problem unless you want to shoot several dozen photos in a burst (unlikely). A good point to bear in mind at all times is that the speeds given for the three Continuous shooting options are maximums that can be reached; you may find the speed slower when the camera has difficulty maintaining focus on an erratically moving subject (in AF-C mode) and it will definitely be slower when you're not using a fast shutter speed.

The biggest problem with shooting at the top frame rate is that the camera doesn't show you a live view of what you're capturing; the image on the LCD or viewfinder seems to lag a frame or two behind (although it's difficult to tell the difference when shooting at such a high speed), and may black out between frames. Nor can you review any of your images until the camera has finished writing all the images in its buffer to your memory card. This is a significant drawback for sports shooters, or anyone who is accustomed to being able to view their images almost continually through an optical viewfinder like those found on conventional dSLRs.

Autofocus and Continuous Shooting

The reliability of autofocus when shooting continuously is bound to be a concern of sports photographers or anyone firing off many shots consecutively. When capturing action in Single shot mode, using Continuous Autofocus (AF-C) is the norm, with tools like Center Lock-On helpful for tracking subjects as they move. You might want to let the camera select an AF point or zone using the Wide or Zone focus area options or select your own with Flexible Spot area selection.

It's a whole different ballgame when you're shooting continuously, especially at (up to) 5 frames per second. Specifying your focus point on the fly is tricky, thanks to the blackouts between frames, and the fact that the camera shows the last frame shot rather than a live view when shooting at the top speed. If you slow down to a meager 2.5 fps, you do get the live view between blackouts, but you still have to contend with your view of the action blanked for a fraction of a second between shots.

In this shooting environment, AF-C works well, but both Wide and Zone focus areas are easily confused by a frame filled with moving subjects, which will be the case in football games, soccer matches, and many other sports. The a7 II—series cameras handle sports like baseball well with Wide or Zone focus. You will probably be better off using Flexible Spot AF, using the Small or Medium spots. You'll still have difficulty manipulating the focus spot because of the blackouts between frames, but you can usually place the AF point in the right place just as a play begins. If you're shooting a player that you don't expect to be surrounded by many other players, Lock-On AF and Center Lock-On AF can also be used if you're able to select the subject you want to track at the start of each sequence.

Sports photographers who want to make up for the lack of a variety of long lenses for their a7 II–series camera will be disappointed to discover that, at the time I write this, if you mount a non–E-mount lens using an adapter, Continuous AF will not function at 5 fps; you must drop down to 2.5 fps to use it. In addition, neither Expand Flexible Spot nor Zone AF area modes will work with an adapted lens, nor Eye AF and Lock-On AF modes.

Customizing White Balance

Back in the film days, both color transparency and color negative ("print") films were standardized, or balanced, for a particular "color" of light. Most were balanced for daylight but you could also buy "tungsten" balanced color negative and transparency film for shooting under incandescent lamps that produced light of an amber color. This type of film had a bluish color balance, intended to moderate the effect produced by light that was amber. Digital cameras like the Sony a7R II/a7 II can be adjusted for specific white balance options suitable for particular types of illumination.

This is important because various light sources produce illumination of different "colors," although sometimes we are not aware of the difference. Indoor illumination tends to be somewhat amber when using lightbulbs that are not daylight balanced, while noonday light outdoors is close to white, and the light early and late in the day is somewhat red/yellow.

White balance is measured using a scale called color temperature. Color temperatures were assigned by heating a theoretical "black body radiator" (which doesn't reflect any light; all illumination comes from its radiance alone) and recording the spectrum of light it emitted at a given temperature in degrees Kelvin. So, daylight at noon has a color temperature in the 5,500- to 6,000-degree range. Indoor illumination is around 3,400 degrees. Hotter temperatures produce bluer images (think blue-white hot) while cooler temperatures produce redder images (think of a dull-red glowing ember). Because of human nature, though, bluer images are actually called "cool" (think wintry day) and redder images are called "warm" (think ruddy sunset), even though their color temperatures are reversed.

Take a photo indoors under warm illumination with a digital camera sensor balanced for cooler daylight and the image will appear much too red/yellow. An image exposed outdoors with the white balance set for incandescent (tungsten) illumination will seem much too blue. These color casts may be too strong to remove in an image editor from JPEG files. Of course, if you shoot RAW photos, you can later change the WB setting to the desired value in RAW converter software; this is a completely "non-destructive" process so full image quality will be maintained.

Mismatched white balance settings are easier to achieve accidentally than you might think, even for experienced photographers. I'd just arrived at a Charlie Musselwhite concert after shooting some photos indoors with electronic flash and had manually set WB for Flash. Then, as the concert began, I resumed shooting using the incandescent stage lighting—which looked white to the eye—and ended up with a few shots like Figure 9.9, left. Eventually, I caught the error during picture review and changed my white balance. Another time, I was shooting outdoors, but had the camera white balance still set for incandescent illumination. The excessively blue image is shown in Figure 9.9, right.

The Auto White Balance (AWB) setting, available from the White Balance entry in the Camera Settings 5 menu, Function menu, or a key defined with that function, examines your scene and chooses an appropriate value based on its perception of the color of the illumination and even the colors in the scene. However, the process is not foolproof (with any camera). Under bright lighting conditions, it may evaluate the colors in the image and still assume the light source is daylight and balance the picture accordingly, even though, in fact, you may be shooting under extremely bright incandescent illumination. In dimmer light, the camera's electronics may assume that the illumination is tungsten, and if there are lots of reddish colors present, set color balance for that type of lighting. With mercury vapor or sodium lamps, correct white balance may be virtually impossible to achieve with any of the so-called presets. In those cases, you should use flash instead, or Custom WB with JPEGs, or shoot in RAW format and make your corrections after importing the file into your image editor with a RAW converter.

The a7R II/a7 II provides many WB presets, each intended for use in specific lighting conditions. You can choose from Daylight, Shade, Cloudy, Incandescent (often called Tungsten by photographers), four types of Fluorescent (Warm White, Cool White, Day White, and Daylight) and Flash.

Figure 9.9 An image exposed indoors with the WB set for electronic flash will appear too reddish (left); using the incandescent setting outdoors makes an image too blue (right).

However, the a7R II/a7 II also offers a method for setting a desired color temperature/filter as well as a custom WB feature.

The Daylight preset provides WB at 5,200K, while the Shade preset uses 7,000K to give you a warming effect that's useful in the bluish light of a deeply shaded area. The chief difference between direct sun and an area in shade, or even incandescent light sources, is nothing more than the proportions of red and blue light. The spectrum of colors used by the a7R II/a7 II is continuous, but it is biased toward one end or the other, depending on the white balance setting you make.

However, some types of fluorescent lights produce illumination that has a severe deficit in certain colors, such as only particular shades of red. If you looked at the spectrum or rainbow of colors encompassed by such a light source, it would have black bands in it, representing particular wavelengths of light that are absent. You can't compensate for this deficiency by adding all tones of red. That's why the fluorescent setting of your Sony may provide less than satisfactory results with some kinds of fluorescent bulbs. If you take many photographs under a particular kind of non-compatible fluorescent light, you might want to investigate specialized filters intended for use under various types of fluorescent light, available from camera stores, or develop skills in white balance adjustment using an image editor or RAW converter software program. However, you do get four presets for fluorescent WB with the a7R II/a7 II and one of these should provide close to accurate white balance with the common types of lights.

It's when you find that AWB and the various presets simply cannot produce pleasing white balance in certain lighting conditions that you'll need the other options (discussed shortly): use the white balance adjustment feature, set a specific color temperature, or calibrate the WB system to set a custom white balance.

Fine-Tuning Preset White Balance

After you scroll to any of the WB options (AWB, Daylight, Shade, etc.), pressing the right directional button reveals the White Balance Adjustment screen, with a grid, shown in Figure 9.10. This feature allows you to fine-tune the white balance by biasing it toward certain colors. Use any of the four directional keys to move the orange dot (cursor) from the center of the grid: upward to bias the WB toward green (G), downward toward magenta (M), right toward amber (A), or left toward blue (B). You can move the cursor seven increments (although Sony doesn't reveal exactly what those increments are) in any of the four directions.

Naturally, you can also move the orange dot to any point within the grid: toward amber/magenta for example. While biasing the WB, examine the scene in the LCD or viewfinder preview display; stop making adjustments when the white balance looks fine. Tap the shutter release to escape from the WB settings adjustments. Let's look at the options in more detail:

■ Cooler or warmer. Pressing the left/right directional buttons changes the white balance to cooler (left) or warmer (right) along the blue/amber scale. There are seven increments, and the value you "dial in" will be shown in the upper-left corner of the screen as an A-B value (yes, the labels are *reversed* from the actual scale at the right side of the screen). The red dot will move along the scale to show the value you've selected. Typically, blue/amber adjustments are what we think of as "color temperature" changes, or, "cooler" and "warmer." These correspond to the way in which daylight illumination changes: warm at sunrise and sunset, very cool in the shade (because most of the illumination comes from reflections of the blue sky), and at high noon. Indoor light sources can also be cooler or warmer, depending on the kind of light they emit.

Figure 9.10
Use this feature when you want to fine-tune white balance when using AWB or any of the presets.

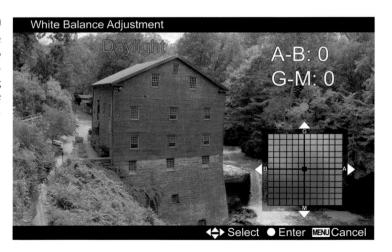

- Green/magenta bias. Press the up/down buttons to change the color balance along the green (upward) or magenta (downward) directions. Seven increments are provided here, too, and shown as vertical movement in the color balance matrix at the right of the screen. Color changes of this type tend to reflect special characteristics of the light source; certain fluorescent lights have a "green" cast, for example.
- Either or both. Because the blue/amber and green/magenta adjustments can be made independently, you're free to choose just one of them, or both if your fine-tuning requires it.
- **Never mind.** If you want to cancel all fine-tuning and shift back to neutral, just press the down directional button. The red dot in the color chart will be restored to the center position.

Setting White Balance by Color Temperature

If you want to set a specific white balance based on color temperature, choose C. Temp/Filter in the White Balance menu and press the right button. You'll next see a display of color temperatures arrayed along the bottom of the screen. Press the right button a second time to view an adjustment screen similar to the one shown in Figure 9.10, but with a scrolling list of color temperatures displayed along the right edge of the screen. Here's how to use this feature.

- Change color temperature. Rotate the control wheel on the camera back to select a specific color temperature in 100K increments, from 2,500K (a level that makes your image much bluer, to compensate for amber illumination) to 9,900K (a level that makes images much redder to correct for light that is extremely blue in color). The live preview changes as you scroll to give you an indication as to the white balance you can expect at any K level. If you have a color temperature meter accessory, or reliable tips that guide you in making the optimal setting, this WB feature will be particularly useful. Even if you don't have that accessory or useful information, you may want to experiment with this setting using the live preview, especially if you are trying to achieve creative effects with color casts along the spectrum from blue to red.
- Fine-tune the color temperature. In addition to color temperature, you can change the blue/amber or green/magenta bias, exactly as described earlier; move the cursor in any direction with the directional keys. If you change your mind, press the MENU button to cancel the bias adjustments you've made.

This feature corresponds to the use of CC (Color Compensation) filters that were used to compensate for various types of lighting when shooting film. When you use C. Temp/Filter, the color filter value you set takes effect in conjunction with the color temperature you set. In other words, both of these settings work together to give you very precise control over the degree of color correction you are using.

Setting a Custom White Balance

If you often shoot in locations that are illuminated by artificial light of unusual colors, the best bet is to set a custom white balance. This calls for teaching (calibrating) the WB system to render white as white under a specific type of illumination. When white is accurately rendered, other colors will look accurate as well. You can use this feature under more common types of lighting too; it's very useful under tungsten lamps, for example, when the Incandescent WB option does not adequately correct for the amber color of the light. Custom WB is the most accurate way of getting the right color balance, short of having a special meter that gives you a precise reading of color temperature. It's easy to do with the a7R II/a7 II. Just follow these steps:

- 1. Navigate to White Balance in the Camera Settings 5 or Function menus.
- 2. Use the direction buttons or the control wheel to scroll up/down through the list of white balance options until the Set icon is highlighted. Don't select the Custom 1, Custom 2, or Custom 3 entries, located just above it. These are white balance memory register "slots" you can use to store customized white balance settings.
- 3. Press the center button. The LCD will display a message telling you to press the shutter button to capture the white balance data. (Custom 1, 2, and 3 are used later to *choose* a custom WB setting you have saved; Custom Set *creates* that setting.)
- 4. Point the camera at a white object (such as a sheet of white paper) large enough to fill the small circle that's displayed in the center of the frame. Your target must be in the same light as the subject you plan to photograph, not in some entirely different part of the scene where the illumination is different.
- 5. Press the shutter release button. The target (such as the sheet of white paper) that you had aimed at, as well as the custom white balance data, appears on the LCD or EVF screen. (The image is not recorded to the memory card.)
- 6. The white balance of the target you photographed will appear at the bottom of the screen, along with an invitation to choose one of the three registers to store that setting. Rotate the control wheel to specify the register and press the center button to enter it and return to live view.
- 7. Press the center button to return to the live view on the LCD. Henceforth, you can select that Custom register to load a particular set of white balance parameters.

Using Creative Styles

This option, the last entry on the Camera Settings 5 menu, gives you six basic Creative Styles with fixed combinations of contrast, saturation, and sharpness. They each have a number prefix on the screen: 1: Standard, 2: Vivid, 3: Neutral, 4: Portrait, 5: Landscape, 6: B&W. Each *also* appears a second time (without the number prefix) and with the addition of Clear, Deep, Light, Night, Autumn, Sepia, and Sunset. You can adjust the contrast, saturation, and sharpness of the non-numbered versions using the left/right buttons to choose an attribute, and the up/down buttons to

adjust that attribute. You can apply Creative Styles when you are using any Shooting mode except Superior Auto, Intelligent Auto, or any of the scene modes. When working with Creative Styles, you can *adjust* the parameters within each preset option to fine-tune the rendition. First, look at the "stock" creative styles, each labeled with the number prefix:

- 1: Standard. This is, as you might expect, your default setting, with a good compromise of sharpness, color saturation, and contrast. Choose this, and your photos will have excellent colors, a broad range of tonal values, and standard sharpness that avoids the "oversharpened" look that some digital pictures acquire.
- 2: Vivid. If you want more punch in your images, with richer colors, heightened contrast that makes those colors stand out, and standard sharpness, this setting is for you. It's good for flowers, seaside photos, any picture with expanses of blue sky, and on overcast days where a punchier image can relieve the dullness.
- 3: Neutral. Reduces saturation and sharpness to produce images with more subdued tones. Use this if you plan on tweaking your photos in an image editor and you want a basic image without any of the enhancements of the other styles.
- 4: Portrait. You'll get reduced saturation, contrast, and sharpness for a more "gentle" rendition that often works well for people pictures, especially skin tones. This style is a good choice if you're planning on fine-tuning those aspects of your JPEG photos in your computer and don't want the camera to overdo any of them.
- 5: Landscape. As with the Vivid setting, this option boosts saturation (especially in blues and greens) and contrast to give you rich scenery and purple mountain majesties, even when your subject matter is located far enough from your camera that distant haze might otherwise be a problem. There's extra sharpness, too, to give you added crispness when you're shooting Fall colors, for example.
- 6: B/W. This is useful if you want to shoot monochrome photos in the camera, so you won't need to modify color photos in software. This style will allow you to change the contrast and sharpness, but not the saturation (because there are no colors to saturate).

As mentioned earlier, those six are repeated without the number prefix, and augmented with seven additional Creative Styles:

- Clear. Sony recommends this style for "clear tones" and "limpid colors" in the highlights, especially when you're capturing "radiant light." The description is a bit artsy, but I've found this style useful for foggy mornings and other low-contrast scenes.
- Deep. Darker and more somber images result from this style.
- **Light.** Recommended for bright, uncomplicated color expressions. I like it for high-key images with lots of illumination and few shadows.
- Sunset. Accentuates the red tones found in sunrise and sunset pictures.

- Night Scene. Contrast is adjusted to provide a more realistic night-time effect.
- Autumn Leaves. Boosts the saturation of reds and yellows for vivid Fall colors.
- **Sepia.** Provides a warm brownish, old-timey tone to images.

To adjust the level of Contrast, Saturation, and/or Sharpness for any Creative Style, scroll to a style you want to use (in the Camera Settings 5 menu) and use the left/right keys to display a line at the bottom of the screen showing the available adjustments of the three parameters. Use the left/right direction buttons to scroll among Contrast, Saturation, and Sharpness. With the parameter you want to modify highlighted, press the up/down direction buttons to change the values in a range of –3 to +3. Press the center button to confirm. Here is a summary of how changing the parameters in a Creative Style will affect your images:

- **Sharpness.** Increases or decreases the contrast of the edge outlines in your image, making the photo appear more or less sharp, depending on whether you've selected 0 (no sharpening), +3 (extra sharpening), to −3 (softening). Remember that boosting sharpness also increases the overall contrast of an image, so you'll want to use this parameter in conjunction with the contrast parameter with caution.
- Contrast. Compresses the range of tones in an image (increase contrast from 0 to +3) or expands the range of tones (from 0 to -3) to decrease contrast. Higher-contrast images tend to lose detail in both shadows and highlights, whereas lower-contrast images retain the detail but appear more flat and dull, without any snap.
- Color Saturation. You can adjust the richness of the color from low saturation (0 to -3) to high saturation (0 to +3). Lower saturation produces a muted look that can be more realistic for certain kinds of subjects, such as humans. Higher saturation produces a more vibrant appearance, but can be garish and unrealistic if carried too far. Boost your saturation if you want a vivid image, or to brighten up pictures taken on overcast days. (Remember, however, Vivid and Landscape provide high saturation even at the zero level.) As I noted earlier, saturation cannot be changed for the Black & White Creative Style.

To modify Creative Styles, just follow these steps:

- 1. **Access Creative Style menu.** Use the Camera Settings 5 menu entry, or press the Fn button and navigate to the Creative Style entry.
- 2. **Choose a style to apply.** In the Creative Style screen, the styles are shown in the left-hand column. (You must scroll down to see all of them.) If you want to modify one of the styles shown, press up/down to highlight that style, and press the center button to activate it.
- 3. **Select a parameter to modify.** You can adjust the contrast, saturation, and sharpness of any of the styles in the left column. Highlight the style you want to adjust/replace, and press the right directional button.

- 4. **Select an attribute to change.** The icons at the bottom of the image area represent (left to right): Image Style, Contrast, Saturation, and Sharpness. Press left/right to highlight the attribute you'd like to modify.
- 5. **Enter your adjustments.** To change the style that appears in the box you selected at left, highlight the Image Style icon and press up/down to choose one of the 13 styles.
- 6. **Make other adjustments.** To modify the currently selected style, press left/right to highlight Contrast, Saturation, or Sharpness, described earlier, then press up/down to add/subtract from the default zero values.
- 7. **Confirm and exit.** Press the center button to confirm your changes. If you redefined one of the six slots, that style will appear in the listing in the left column henceforth and can be selected quickly by following Steps 1 and 2 above.

Don't confuse the Picture Effects feature with the Creative Styles. The Picture Effects are intended to provide special effects in-camera, such as Pop Color, Posterization, and Soft Focus. Since I have discussed them in detail in Chapter 3, I won't do so here. And you may remember that the a7R II/a7 II can use apps, including some that can modify the look of your photos.

Movie-Making Basics

As we've seen during our exploration of its features so far, the a7R II/a7 II is superbly equipped for taking still photographs of very high quality in a wide variety of shooting environments. But this camera's superior level of performance is not limited to stills. It's highly capable in the moviemaking arena as well. It can shoot Full HD (high-definition) clips. Sony has also provided overrides for controlling all important aspects of a video clip.

So, even though you may have bought your camera primarily for shooting stationary scenes, you acquired a device that's also great for recording high-quality video clips. Whether you're looking to record informal clips of the family on vacation, the latest viral video for YouTube, or a set of scenes that will be painstakingly crafted into a cinematic masterpiece using editing software, the a7R II/a7 II will perform admirably.

Both cameras can shoot HD video at 1920×1080 resolution using Sony's AVCHD encoding, plus MP4 video, which allows both 1920×1080 full HD and 1280×7210 standard HD. They also can capture HD video in the newer XAVC S format. The a7R II adds the ability to capture superior 4K video *internally* using XAVC S 4K.

The cameras also use something called *Picture Profiles*, to tailor color, saturation, sharpness, and some video-centric attributes. You can visualize Picture Profiles as Creative Styles for video. This chapter will show you the fundamentals of shooting video; in the next chapter, you'll learn about some of your camera's more advanced features, including the XAVC S format in HD with both cameras, and, with the a7R II, 4K options.

Some Fundamentals

Recording a video with the a7R II/a7 II is extraordinarily easy to accomplish—just press the black button with the red dot at the upper right of the camera's back to start. Sony has tucked it off to the side to minimize the chance that you'll start recording a movie accidentally. That's because video can be captured in *any* exposure mode; there's no need to activate a special Movie mode. (If you start recording in Sweep Panorama mode, however, the camera will actually use P mode and the video won't be a panorama.) After you press the button, the camera will confirm that it's recording with a red REC and numerals showing the elapsed time in the EVF and LCD monitor. Press the button again when you want to stop recording.

Before you start, though, there are some settings to prepare the camera to record the scene the way you want it to. Setting up the camera for recording video can be a bit tricky, because it's not immediately obvious, either from the camera's menus or from Sony's manuals, which settings apply to video recording and which do not. I will unravel that mystery for you, and throw in a few other tips to help improve your movies.

I'll show you how to optimize your settings before you start shooting video, but here are some considerations to be aware of as you get started. Many of these points will be covered in more detail later in this chapter:

- Use the right card. Because movie capture, is, basically, full-time "continuous" shooting, you'll need to use a memory card with sufficient capacity and a fast enough write speed to handle the streams of video you'll be shooting.
 - For AVCH or MP4 format. Sony recommends using an SD, SDHC, or SDXC memory card with Class 4 or UHS Speed Class U1, or faster. You can also use Sony Memory Sticks of the Pro Duo II, PRO-HG, or Micro II variety. With slow cards, your recording may stop after a minute or two until the card is able to offload the captured video from your camera.
 - For XAVC S format. Sony recommends SDXC memory cards 64GB or larger, and Speed Class 10 or UHS U1 or faster write speeds. Such cards are mandatory for shooting 4K video.

The camera can shoot a continuous movie of just under 30 minutes when shooting HD video (a limitation on cameras not classified as camcorders), or 20 minutes for MP4/MPEG4 (a limitation imposed by the maximum 4GB file size allowed by that format). If you reach either limit, you can stop recording and start shooting the next clip right away; this assumes there's enough space on the memory card and adequate battery power. Of course, you will miss about 30 seconds of the action. (Also see the later item about keeping the camera cool.)

- Avoid extraneous noise. Try not to make too much noise when changing camera controls or when using a conventional zoom lens's mechanical zooming ring (power zooms are typically relatively quiet). And don't make comments that you will not want to hear on the audio track.
- Minimize zooming. While it's great to be able to use the zoom for filling the frame with a distant subject (especially the power zoom on lenses equipped with that feature), think twice before zooming. The sound made by a mechanical zoom ring rotating will be picked up and it will be audible when you play a movie. (Lenses with power zoom are virtually silent, however.) As well, remember that any more than the occasional minor zoom will be very distracting to friends who watch your videos. And digital zoom will definitely degrade video quality. Don't use the digital zoom if quality is more important than recording a specific subject such as a famous movie star far from a distance.
- Use a fully charged battery. A fresh battery will allow about one hour of filming at normal (non-Winter) temperatures, but that can be shorter if there are many focus adjustments. Individual clips can be no longer than 29 minutes, however.
- **Keep it cool.** Video quality can suffer terribly when the imaging sensor gets hot so keep the camera in a cool place. When shooting on hot days especially, the sensor can get hot more quickly than usual; when there's a risk of overheating, the camera will stop recording and it will shut down about five seconds later. Give it time to cool down before using it again. And remember that when you record a couple of very long clips in a series, the sensor will start to get warm; it's better to wait a few minutes to let it cool before starting to record another clip. This limitation generally won't affect serious movie-makers, who tend to shoot a series of short scenes that are assembled into a finished movie with an editor. But if you plan to set up your camera and shoot your kid's school pageant non-stop for an hour, you're out of luck.
- Press the Movie button. You don't have to hold it down. Press it again when you're done to stop recording. It's recessed so you will not press it inadvertently.

Preparing to Shoot Video

First, here's what I recommend you do to prepare for a *basic* recording session. More advanced detail settings will be addressed later:

■ Choose your file format. Go to the File Format entry in the Camera Settings menu (as discussed in Chapter 3) and select the file format for your movies. You can set it to MP4, an abbreviation for MPEG-4, AVCHD, XAVC S HD, or, with the a7R II, XAVC S 4K. You'll learn more about these formats later.

■ Choose record setting. Also in the Camera Settings menu, you'll find the Record Setting item, which allows you to choose the size, frame rate, and image quality for your movies. Tables 10.1 to 10.4 later in this chapter spell out your choices.

Which of the many options should you choose? It depends in part on your needs. When you have very little remaining space on your memory cards, or if your video clip is intended strictly for upload to a website, you might choose MP4, which provides either full HD or standard HD clips. The MP4 format is also more "upload friendly"; in other words, it's the format you'll want to use if you plan to post video clips on a website, including video sharing sites.

If your plan is to primarily shoot videos that you'll show to friends and family on an HDTV set, choose AVCHD. That format gives you better quality, but can be harder to manipulate and edit on a computer than MP4 videos. For more professional productions, you'll want to select XAVC S HD or (with the a7R II) XAVC S 4K. I'll explain the differences later.

- Activate dual recording (optional). If you are shooting an XAVC S or AVCHD movie, you can elect to record an MP4 simultaneously, giving you a standard MPEG video that can be viewed immediately without needing to process with a video-editing program. Use the Dual Video REC option in the Camera Settings menu to activate this capability. You'll definitely want to use a larger memory card when working with this option.
- Preview the movie's aspect ratio for stills. There's an item in the Image Size menu for Aspect Ratio and it's at 3:2 by default, but you can change that to 16:9. *The setting in this item won't affect your video recording*. Setting the 16:9 option will merely cause the camera to display the preview of the scene when you are shooting stills, before you start movie recording, in the format that will be used for the video clip. This gives you a better feel for what will be included in the frame after you press the record button.
- Turn on autofocus. Make sure autofocus is turned on through the Focus Mode entry of the Camera Settings menu. You also have the option of using manual focus, or even Direct Manual Focus, with focus peaking. I find that manual focus is fine for situations such as a stage play where the actors will usually be at roughly the same distance to your position during the entire performance, and for more professional productions where precise focus is a must, or when changing focus during a shot (*focus pulling*) is used creatively. In other cases, however, you'll probably want to rely on the camera's effective full-time continuous autofocus ability while recording a video clip.
- Try Flexible Spot AF Area. As in still image making, you can use the Flexible Spot AF Area (discussed in Chapter 8) while recording a video clip. This feature is most suitable for a static scene you'll record with the camera on a tripod, where an important small subject is off-center and will remain in the same location. By placing the AF Area exactly on that part of the scene, you'll be sure that the focus will remain on the most important part of the scene during the entire recording. (In truth, you could use manual focus for the same purpose.)

If you decide to try this, compose the scene as desired before pressing the record button. Set the AF Area to Flexible Spot in the Camera Settings menu. An orange bracket will appear on the screen, indicating the current location of the active focus detection point. Move the brackets with the direction buttons so they cover the primary subject and press OK (the center button) to confirm. You can now begin recording the video, confident that the focus will always be on your primary subject (assuming it does not move while you're recording).

- Set useful functions. Before you start recording, you can set a desired ISO, white balance, Creative Style, Picture Profiles (explained in the next chapter), a Picture Effect (for special effects), any of the three metering modes, and the level of exposure compensation. You can also set an override in the Creative Style for a specific level of sharpness, contrast, and saturation, if desired, or use a Picture Profile for other parameters. The DRO and Auto HDR features will not be available, however. You'll recall that these functions are not available in fully automatic modes; if you set them while using another mode and then switch to a fully automatic mode for recording the video, the camera will revert back to the defaults.
- Decide on a shooting mode. There's no need for a Movie mode item on the mode dial since you can use any exposure mode for movie recording. The P mode works well, allowing the camera to set the aperture/shutter speed and giving you access to the other features discussed above. Program shift (to other aperture/shutter speed combinations) can be used before you start recording, but it will not be available during actual recording.

You might prefer to use Aperture Priority (A) mode for full control over the specific aperture; in that case, you can preset a desired aperture and you can also change it anytime while recording. Be careful however, especially if you have set a specific ISO level. If you switch to a very small aperture while recording in low light, your movie clip may darken; this is particularly likely if you're using a low ISO level. And if you switch to a very wide aperture on a sunny day, especially if using a high ISO, your video will become too bright. Of course, you can see the change in brightness in the live view display before recording a movie and while you're recording.

Switch to S mode if you want control over the shutter speed; this is a more advanced technique in Movie mode. You can preset a shutter speed and you can change it while recording. Again, be careful as to your settings to avoid a very dark or overly bright video, especially if you have set a specific ISO level. The live view display before and during recording will help to guide you. I don't recommend using the Manual (M) mode initially but you might want to experiment with it later.

■ Press the record button. You don't have to hold it down. Press it to start recording and press it again when you're done. Shoot a short test clip and view it to make sure that the settings you made are producing the overall effect you want. If not, change some settings (White Balance or Creative Style or Exposure Compensation, for example) and try again.

Steps During Movie Making

Once you have set up the camera for your video session and pressed the Movie button, you have done most of the technical work that's required of you for basic movie clips. Now your task is to use your skills at composition, lighting, scene selection, and, perhaps, directing actors, to make a compelling video production.

■ Zoom, autofocus, and autoexposure all work. If you're new to the world of high-quality still cameras that also take video, you may just take it for granted that functions such as autofocus continue to work normally when you switch from stills to video. But until recently, most such cameras performed weakly in their video modes; they would lock their exposure and focus at the beginning of the scene, and you could not zoom while shooting the video. The a7 II series has no such handicaps, and, in fact, it is especially capable in these areas.

Indeed, the camera allows you to choose any exposure mode, including Manual exposure, Auto ISO, shutter speed, and aperture. You can change settings while shooting, and lock exposure with the AEL button.

Autoexposure works very well, modifying the exposure as the scene brightness changes; the method used depends on the metering mode that you're using. You can zoom to your heart's content (though I recommend that you zoom sparingly). Best of all, AF-C autofocus works like a charm; the camera can track moving subjects and quickly snap them back into sharp focus with speedy continuous AF. Manual focus is also available, with focus peaking to help you zero in on a focus plane. Don't limit yourself based on the weaknesses of past cameras; the a7 II series opens up new horizons of video freedom.

■ Exposure compensation works while filming. I found this feature to be quite remarkable. Although the autoexposure system works very well (especially with Multi metering) to vary the aperture when the ambient lighting changes, you can certainly dial in exposure compensation when you need to do so or want to do so for a certain effect. You could even use this function as a limited kind of "fade to black" in the camera, though you probably won't be able to fade quite all the way to black.

If the preview display (when Live View Display is set to Setting Effect On in the Setup menu) suggests that your movie will be dark (underexposed) and if it does not get brighter after you set plus compensation, there's another problem: the camera cannot provide a good exposure for the movie at the ISO that you have set (as discussed earlier). Switch to a higher ISO level until the brightness is as desired or switch to ISO Auto to enable the camera to set a higher ISO level to prevent the "underexposure."

- Use AE Lock instead. Occasionally, you may find that you start having an exposure problem during recording; this might happen when pointing the lens toward a light-tone area that causes the camera to begin underexposing. While plus compensation will allow you to increase brightness, it's preferable to use the defined AE Lock button (either the physical AEL button or one you specify using Custom Keys in the Setup menu) to maintain a pleasing exposure during the entire video clip.
 - Why would you need this feature? Let's say you're filming entertainers against grass and foliage, but you're moving the camera and will soon be filming a second group against a white sky. As soon as you do so, the backlighting will cause the video to get darker. Don't let that happen. Before pointing the lens toward the backlit area, press AEL and keep it depressed. This will prevent the exposure from changing as you point the lens toward the backlit part of the scene. This is preferable to waiting until an underexposure problem starts and then setting plus exposure compensation that suddenly makes the video brighter.
- Don't be a Flash in the pan. With HD video, there is a possibility of introducing artifacts or distortion if you pan too quickly. (This effect is called rolling shutter distortion or the "Jello effect.") That is, because of the way the lines of video are displayed in sequence, if the camera moves too quickly in a sideways motion, some of the lines may not show up on the screen quickly enough to catch up to the rest of the picture. As a result, objects in your video can become somewhat distorted or you may experience a jiggling effect and/or loss of detail. So, if at all possible, make your pans smooth and steady, and slow them down to a comfortable pace.

More About Frame Rates and Bit Rates

If your ambitions include more advanced video endeavors, you'll want to learn a little more about frame rates, bit rates, and how they relate to file formats. This section will provide a quick summary.

Frame Rates

Even intermediate movie shooters can be confused by the choice between 24/25 frames per second and 50/60 fields per second. The difference lies in the two "worlds" of motion images, film and video. The standard frame rate for motion picture film is 24 fps, while the video rate, at least in the United States, Japan, and other places using the NTSC standard is 30/60 fps. That's actually 60 interlaced *fields* per second; that's where we get the 60i (60 fps *interlaced* specification). With interlaced video, the capture device grabs odd-numbered lines in one scan, even-numbered video lines in another scan, and they are combined to produce the final image we view. *Progressive* scan images (as in 60p) grab all the video lines of an image in order. In countries where NTSC is not used, instead of 30/60 fps, you'll find 25/50 fps instead.

Line-by-line scanning during capture and playback can be done in one of two ways. With *interlaced scanning*, odd-numbered lines (lines 1, 3, 5, 7, ... and so forth) are captured with one pass, and then the even-numbered lines (2, 4, 6, 8, ...and so forth) are grabbed. With the 1080/60i format, roughly 60 pairs of odd/even line scans, or 60 *fields* are captured each second. (The actual number is 59.94 fields per second.) Interlaced scanning was developed for and works best with analog display systems such as older television sets. It was originally created as a way to reduce the amount of bandwidth required to transmit television pictures over the air. Modern LCD, LED, and plasmabased HDTV displays must de-interlace a 1080i image to display it. (See Figure 10.1.)

Newer displays work better with a second method, called *progressive scanning* or *sequential scanning*. Instead of two interlaced fields, the entire image is scanned as consecutive lines (lines 1, 2, 3, 4, and so forth). This happens at a rate of 30 frames per second (not fields), or, more precisely, 29.97 frames per second. (All these numbers apply to the NTSC television system used in the United States, Canada, Japan, and some other countries; other places use systems like PAL, where the nominal scanning figures are 50/25 rather than 60/30.)

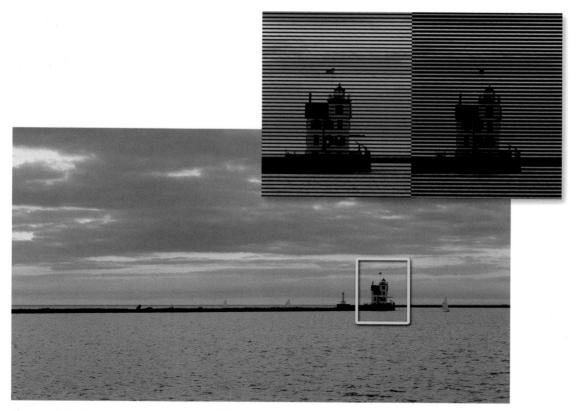

Figure 10.1 The inset shows how lines of the image alternate between odd and even in an interlaced video capture.

One problem with interlaced scanning appears when capturing video of moving subjects. Half of the image (one set of interlaced lines) will change to keep up with the movement of the subject while the other interlaced half retains the "old" image as it waits to be refreshed. Flicker or *interline twitter* results. That makes your progressive scan (p) options a better choice for action photography. Interlaced video frame rates are indicated with an (i) designation; for example, within the AVCHD choices, 60i 24M (FX) indicates interlaced video, while 60p 28M (PS) represents progressive scan video. (I'll explain the 24M/28M part in the next section.)

Computer-editing software can handle either type (although AVCHD, XAVC S 4K, and XAVC S HD may not be compatible with the programs you own), and convert between them. The choice between 24 fps and 60 fps (or 25 fps and 50 fps) is determined by what you plan to do with your video. The short explanation is that, for technical reasons I won't go into here, shooting at 24 fps (or 25 fps) gives your movie more of the so-called "cinematic" look that film would produce, excellent for showing fine detail. However, if your clip has moving subjects, or you pan the camera, 24 fps (or 25 fps) can produce a jerky effect called "judder." The 60 fps (or 50 fps) option produces a home-video look that some feel is less desirable, but which is smoother and less jittery when displayed on an electronic monitor. I suggest you try both and use the frame rate that best suits your tastes and video-editing software.

Movies captured with MP4 format can't be burned to disk with Sony's PMB (Picture Motion Browser) software. However, if you capture using AVCHD, you can create Blu-Ray discs, AVCHD disks, or DVD-Video discs using the PMB software.

Bit Rates

Bit rates represent the speed of transfer from your camera to your memory card or external video recorder. The higher the bit rate, the more demands made on your media in storing that data quick enough to keep pace with the video capture. Higher average bit rates range from 6 Mbps (megabits per second) for 1280×720 (720p) MP4 movies, to as much as 28 Mbps maximum for AVCHD, 60p full-HD clips. When using XAVC formats, the demands are even higher: 50 Mbps with XAVC S HD and 60 to 100 Mbps with XAVC S 4K (with the a7R II only). Tables 10.1 to 10.4 show the frame rates, bit rates, and resolution of the various recording settings for video. Note that frame rates of 30/25, 60/50, and 120/100 represent NTSC/PAL systems, respectively.

Table 10.1 XAVC S 4K			
Record Setting	Resolution	Bit Rate	
30p/25p 100M	3840 × 2160	Approx. 100 Mbps	
30p/25p 60M	3840×2160	Approx. 60 Mbps	
24p 100M (NTSC only)	3840×2160	Approx. 100 Mbps	
24p 60 M (NTSC only)	3840×2160	Approx. 60 Mbps	

Table 10.2 XAVC S HD			
Record Setting	Resolution	Bit Rate	
60p/50p 50M	1920 × 1080	Approx. 50 Mbps	
30p/25p 50M	1920×1080	Approx. 50 Mbps	
24p 50M (NTSC only)	1920×1080	Approx. 50 Mbps	
24p 50 M (NTSC only)	1280×720	Approx. 50 Mbps	
120p/100p 50M	1280×720	Approx. 50 Mbps	

Table 10.3 AVCHD		
Record Setting	Resolution	Bit Rate
60i/50i 24M (FX)	1920 × 1080	Approx. 24 Mbps
60i/50i 17M (FH)	1920×1080	Approx. 17 Mbps
60p/50p 28M (PS)	1920×1080	Approx. 28 Mbps
24p/25p 24M (FX)	1920×1080	Approx. 24 Mbps
24p/25p 17M (FH)	1920 × 1080	Approx. 17 Mbps

Table 10.4 MP4			
Record Setting	Resolution	Bit Rate	
1920 × 1080 60p/50p 28M	1920 × 1080	Approx. 28 Mbps	
1920 × 1080 30p/25p 16M	1920×1080	Approx. 16 Mbps	
1280 × 720 30p/25p 6M	1280×720	Approx. 6 Mbps	

Stop That!

You might think that setting your camera to a faster shutter speed will help give you sharper video frames. But the choice of a shutter speed for movie making is a bit more complicated than that. As you might guess, it's almost always best to leave the shutter speed at 1/30th or 1/60th second, and allow the overall exposure to be adjusted by varying the aperture and/or ISO sensitivity. We don't normally stare at a video frame for longer than 1/30th or 1/24th second, so while the shakiness of the *camera* can be disruptive (and often corrected by your camera's in-lens and in-body image stabilization), if there is a bit of blur in our *subjects* from movement, we tend not to notice. Each frame flashes by in the blink of an eye, so to speak, so a shutter speed of 1/30th or 1/60th second works a lot better in video than it does when shooting stills. Even shots with lots of movement, such as the frame shown in Figure 10.2, are often sufficiently sharp at 1/60th second.

Higher shutter speeds actually introduce problems of their own. If you shoot a video frame using a shutter speed of 1/250th second, the actual moment in time that's captured represents only about 12 percent of the 1/30th second of elapsed time in that frame. Yet, when played back, that frame occupies the full 1/30th of a second, with 88 percent of that time filled by stretching the original image to fill it. The result is often a choppy/jumpy image, and one that may appear to be *too* sharp.

Figure 10.2 Movement adds interest to a video clip.

The reason for that is more social imprinting than scientific: we've all grown up accustomed to seeing the look of Hollywood productions that, by convention, were shot using a shutter speed that's half the reciprocal of the frame rate (that is, 1/48th second for a 24 fps movie). Movie cameras use a rotary shutter (achieving that 1/48th second exposure by using a 180-degree shutter "angle"), but the effect on our visual expectations is the same. For the most "film-like" appearance, use 24 fps and 1/60th second shutter speed.

Faster shutter speeds do have some specialized uses for motion analysis, especially where individual frames are studied. The rest of the time, 1/30th or 1/60th of a second will suffice. If the reason you needed a higher shutter speed was to obtain the correct exposure, use a slower ISO setting, or a neutral-density filter to cut down on the amount of light passing through the lens. A good rule of thumb is to use 1/60th second or slower when shooting at 24 fps; 1/60th second or slower at 30 fps; and 1/125th second or slower at 60 fps.

Tips for Movie Making

I'm going to close out this introductory movie chapter with a general discussion of movie-making concepts that you need to understand as you move toward more polished video production. In the chapter that follows, I'll explain some of the a7R II/a7 II's features that allow you to produce more sophisticated movies.

Here are some basic tips:

- Keep things stable and on the level. Camera shake's enough of a problem with still photography, but it becomes even more of a nuisance when you're shooting video. While the a7 II—series' in-body five-axis stabilization and stabilizer found in lenses with the OSS designation can help minimize this, neither can work miracles. Placing your camera on a tripod will work much better than trying to hand-hold it while shooting. One bit of really good news is that compared to pro dSLRs, the a7 II series can work very effectively on a lighter tripod, due to the camera's light weight. On windy days however, the extra mass of a heavy tripod is still valuable.
- Use a shooting script. A shooting script is nothing more than a coordinated plan that covers both audio and video and provides order and structure for your video. A detailed script will cover what types of shots you're going after, what dialogue you're going to use, audio effects, transitions, and graphics.
- Plan with storyboards. A storyboard is a series of panels providing visuals of what each scene should look like. While the ones produced by Hollywood are generally of very high quality, there's nothing that says drawing skills are important for this step. Stick figures work just fine if that's the best you can do. The storyboard just helps you visualize locations, placement of actors/actresses, props, and furniture, and also helps everyone involved get an idea of what you're trying to show. It also helps show how you want to frame or compose a shot. You can

even shoot a series of still photos and transform them into a "storyboard" if you want, such as in Figure 10.3.

Today's audience is used to fast-paced, short-scene storytelling. In order to produce interesting video for such viewers, it's important to view video storytelling as a kind of shorthand code for the more leisurely efforts print media offers. Audio and video should always be advancing the story. While it's okay to let the camera linger from time to time, it should only be for a compelling reason and only briefly.

It only takes a second or two for an establishing shot to impart the necessary information. For example, many of the scenes for a video documenting a model being photographed in a rock 'n' roll music setting might be close-ups and talking heads, but an establishing shot showing the studio where the video was captured helps set the scene.

- **Provide variety.** Provide variety too. Change camera angles and perspectives often and never leave a static scene on the screen for a long period of time. (You can record a static scene for a reasonably long period and then edit in other shots that cut away and back to the longer scene with close-ups that show each person talking.)
- When editing, keep transitions basic! I can't stress this one enough. Watch a television program or movie. The action "jumps" from one scene or person to the next. Fancy transitions that involve exotic "wipes," dissolves, or cross fades take too long for the average viewer and make your video ponderous.

Figure 10.3 A storyboard is a series of simple sketches or photos to help visualize a segment of video.

Composition

In movie shooting, several factors restrict your composition, and impose requirements you just don't always have in still photography (although other rules of good composition do apply). Here are some of the key differences to keep in mind when composing movie frames:

- Horizontal compositions only. Some subjects, such as basketball players and tall buildings, just lend themselves to vertical compositions. But movies are generally shot and shown in horizontal format only. (Unless you're capturing a clip with your smartphone; I see many vertically oriented YouTube videos.) So if you're shooting a conventional video and interviewing a local basketball star, you can end up with a worst-case situation like the one shown in Figure 10.4. If you want to show how tall your subject is, it's often impractical to move back far enough to show him full-length. You really can't capture a vertical composition. Tricks like getting down on the floor and shooting up at your subject can exaggerate the perspective, but aren't a perfect solution.
- Wasted space at the sides. Moving in to frame the basketball player as outlined by the yellow box in Figure 10.4 means that you're still forced to leave a lot of empty space on either side. (Of course, you can fill that space with other people and/or interesting stuff, but that defeats your intent of concentrating on your main subject.) So when faced with some types of subjects in a horizontal frame, you can be creative, or move in *really* tight. For example, if I was willing to give up the "height" aspect of my composition, I could have framed the shot as shown by the green box in the figure, and wasted less of the image area at either side.
- Seamless (or seamed) transitions. Unless you're telling a picture story with a photo essay, still pictures often stand alone. But with movies, each of your compositions must relate to the shot that preceded it, and the one that follows. It can be jarring to jump from a long shot to a tight close-up unless the director—you—is very creative. Another common error is the "jump cut" in which successive shots vary only slightly in camera angle, making it appear that the main subject has "jumped" from one place to another. (Although everyone from French New Wave director Jean-Luc Goddard to Guy Ritchie—Madonna's ex—have used jump cuts effectively in their films.) The rule of thumb is to vary the camera angle by at least 30 degrees between shots to make it appear to be seamless. Unless you prefer that your images flaunt convention and appear to be "seamy."
- The time dimension. Unlike still photography, with motion pictures there's a lot more emphasis on using a series of images to build on each other to tell a story. Static shots where the camera is mounted on a tripod and everything is shot from the same distance are a recipe for dull videos. Watch a television program sometime and notice how often camera shots change distances and directions. Viewers are used to this variety and have come to expect it. Professional video productions are often done with multiple cameras shooting from different angles and positions. But many professional productions are shot with just one camera and careful planning, and you can do just fine with your a7 II—series camera.

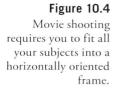

Here's a look at the different types of commonly used compositional tools:

- Establishing shot. Much like it sounds, this type of composition, as shown at top left in Figure 10.5, establishes the scene and tells the viewer where the action is taking place. Let's say you're shooting a video of your offspring's move to college; the establishing shot could be a wide shot of the campus with a sign welcoming you to the school in the foreground. Another example would be for a child's birthday party; the establishing shot could be the front of the house decorated with birthday signs and streamers or a shot of the dining room table decked out with party favors and a candle-covered birthday cake. In this case, I wanted to show the studio where the video was shot.
- **Medium shot.** This shot is composed from about waist to head room (some space above the subject's head). It's useful for providing variety from a series of close-ups and also makes for a useful first look at a speaker. (See Figure 10.5, top right.)

■ Close-up. The close-up, usually described as "from shirt pocket to head room," provides a good composition for someone talking directly to the camera. Although it's common to have your talking head centered in the shot, that's not a requirement. In the middle left image in Figure 10.5 the subject was offset to the right. This would allow other images, especially graphics or titles, to be superimposed in the frame in a "real" (professional) production. But the compositional technique can be used with a7R II/a7 II videos, too, even if special effects are not going to be added.

Figure 10.5 Establishing shot (upper left); Medium shot (upper right); Close-up (middle left); Extreme close-up (middle right); Two shot (lower left); Over-the-shoulder shot (lower right).

- **Extreme close-up.** When I went through broadcast training, this shot was described as the "big talking face" shot and we were actively discouraged from employing it. Styles and tastes change over the years and now the big talking face is much more commonly used (maybe people are better looking these days?) and so this view may be appropriate. Just remember, the a7R II/a7 II is capable of shooting in high-definition video and you may be playing the video on a high-def TV; be careful that you use this composition on a face that can stand up to high definition. (See middle right, Figure 10.5.)
- "Two" shot. A two shot shows a pair of subjects in one frame. They can be side by side or one subject in the foreground and one in the background. This does not have to be a head-to-ground composition. Subjects can be standing or seated. A "three shot" is the same principle except that three people are in the frame. (See Figure 10.5, lower left.)
- Over-the-shoulder shot. Long a composition of interview programs, the "over-the-shoulder shot" uses the rear of one person's head and shoulder to serve as a frame for the other person. This puts the viewer's perspective as that of the person facing away from the camera. (See Figure 10.5, lower right.)

Lighting for Video

Much like in still photography, how you handle light pretty much can make or break your videography. Lighting for video can be more complicated than lighting for still photography, since both subject and camera movement are often part of the process.

Lighting for video presents several concerns. First off, you want enough illumination to create a useable video. Beyond that, you want to use light to help tell your story or increase drama. Let's take a better look at both.

Illumination

You can significantly improve the quality of your video by increasing the light falling in the scene. This is true indoors or out, by the way. While it may seem like sunlight is more than enough, it depends on how much contrast you're dealing with. If your subject is in shadow (which can help him from squinting) or wearing a ball cap, a video light can help make him look a lot better.

Lighting choices for amateur videographers are a lot better these days than they were a decade or two ago. An inexpensive incandescent video light, which will easily fit in a camera bag, can be found for \$15 or \$20. You can even get a good-quality LED video light for less than \$100. Work lights sold at many home improvement stores can also serve as video lights since you can set the camera's white balance to correct for any color casts. You'll need to mount these lights on a tripod or other support, or, perhaps, to a bracket that fastens to the tripod socket on the bottom of the camera.

Much of the challenge depends upon whether you're just trying to add some fill light on your subject versus trying to boost the light on an entire scene. A small video light will do just fine for the former. It won't handle the latter. Fortunately, the versatility of the a7R II/a7 II comes in quite handy here. Since the camera shoots video in Auto ISO mode, it can compensate for lower lighting levels and still produce a decent image. For best results though, better lighting is necessary.

Creative Lighting

While ramping up the light intensity will produce better technical quality in your video, it won't necessarily improve the artistic quality of it. Whether we're outdoors or indoors, we're used to seeing light come from above. Videographers need to consider how they position their lights to provide even illumination while up high enough to angle shadows down low and out of sight of the camera.

When considering lighting for video, there are several factors. One is the quality of the light. It can either be hard (direct) light or soft (diffused) light. Hard light is good for showing detail, but it can also be very harsh and unforgiving. "Softening" the light, but diffusing it somehow, can reduce the intensity of the light but make for a kinder, gentler light as well.

While mixing light sources isn't always a good idea, one approach is to combine window light with supplemental lighting. Position your subject with the window to one side and bring in either a supplemental light or a reflector to the other side for reasonably even lighting.

Lighting Styles

Some lighting styles are more heavily used than others. Some forms are used for special effects, while others are designed to be invisible. At its most basic, lighting just illuminates the scene, but when used properly it can also create drama. Let's look at some types of lighting styles:

- Three-point lighting. This is a basic lighting setup for one person. A main light illuminates the strong side of a person's face, while a fill light lights up the other side. A third light is then positioned above and behind the subject to light the back of the head and shoulders. (See Figure 10.6.)
- **Flat lighting.** Use this type of lighting to provide illumination and nothing more. It calls for a variety of lights and diffusers set to raise the light level in a space enough for good video reproduction, but not to create a particular mood or emphasize a particular scene or individual. With flat lighting, you're trying to create even lighting levels throughout the video space and minimize any shadows. Generally, the lights are placed up high and angled downward (or possibly pointed straight up to bounce off of a white ceiling). (See Figure 10.7.)

- "Ghoul lighting." This is the style of lighting used for old horror movies. The idea is to position the light down low, pointed upward. It's such an unnatural style of lighting that it makes its targets seem weird and ghoulish.
- Outdoor lighting. While shooting outdoors may seem easier because the sun provides more light, it also presents its own problems. As a general rule of thumb, keep the sun behind you when you're shooting video outdoors, except when shooting faces (anything from a medium shot and closer) since the viewer won't want to see a squinting subject. When shooting another human this way, put the sun behind her and use a video light to balance light levels between the foreground and background. If the sun is simply too bright, position the subject in the shade and use the video light for your main illumination. Using reflectors (white board panels or aluminum foil—covered cardboard panels are cheap options) can also help balance light effectively.

Figure 10.6 With three-point lighting, two lights are placed in front and to the side of the subject (45-degree angles are ideal) and positioned about a foot higher than the subject's head. Another light is directed on the background in order to separate the subject and the background. There's also a supplementary hair light above, behind, and to the left of the model.

Figure 10.7 Flat lighting is another approach for creating even illumination. Here the lights can be bounced off of a white ceiling and walls to fill in shadows as much as possible. It is a flexible lighting approach since the subject can change positions without needing a change in light direction.

Audio

When it comes to making a successful video, audio quality is one of those things that separates the professionals from the amateurs. We're used to watching top-quality productions on television and in the movies, yet the average person has no idea how much effort goes in to producing what seems to be "natural" sound. Much of the sound you hear in such productions is actually recorded on carefully controlled sound stages and "sweetened" with a variety of sound effects and other recordings of "natural" sound.

Your a7R II/a7 II has a pair of stereo microphones on its front surface, able to capture Dolby Digital Audio. You can plug an external microphone into the jack on the left side of the camera. You can also use an adapter plugged into the Multi Interface shoe, or a microphone designed specifically for Sony cameras, such as the (roughly \$160) Sony ECM-XYSTM1 mic. If you stick with the built-in microphones, you must be extra careful to optimize the sound captured by those fixed sound-grabbers. You will find an Audio Recording entry in the Camera Settings menu (it just turns sound on or off), as well as a Wind Noise Reduction on/off switch. But that's as far as your camera adjustments go.

Tips for Better Audio

Since recording high-quality audio is such a challenge, it's a good idea to do everything possible to maximize recording quality:

- Turn off any sound makers you can. Little things like fans and air handling units aren't obvious to the human ear, but will be picked up by the microphone. Turn off any machinery or devices that you can plus make sure cell phones are set to silent mode. Also, do what you can to minimize sounds such as wind, radio, television, or people talking in the background.
- Make sure to record some "natural" sound. If you're shooting video at an event of some kind, make sure you get some background sound that you can add to your audio as desired in postproduction.
- Consider recording audio separately. Lip-syncing is probably beyond most of the people you're going to be shooting, but there's nothing that says you can't record narration separately and add it later. It's relatively easy if you learn how to use simple software video-editing programs like iMovie (for the Macintosh) or Windows Movie Maker (for Windows PCs). Any time the speaker is off-camera, you can work with separately recorded narration rather than recording the speaker on-camera. This can produce much cleaner sound.

WIND NOISE REDUCTION

The a7R II/a7 II does offer a low-cut filter feature that can further reduce wind noise; it's accessed with the Wind Noise Reduction item of the Camera Settings menu, discussed in Chapter 3. However, this processing feature also affects other sounds, making the wind screen far more useful.

Lens Craft

I'll cover the use of lenses with the a7R II/a7 II in more detail in Chapter 12, but a discussion of lens selection when shooting movies may be useful at this point. In the video world, not all lenses are created equal. The two most important considerations are depth-of-field, or the beneficial lack thereof, and zooming. I'll address each of these separately.

Depth-of-Field and Video

Have you wondered why professional videographers have gone nuts over still cameras that can also shoot video? The producers of *Saturday Night Live* could afford to have Alex Buono, their director of photography, use the niftiest, most-expensive high-resolution video cameras to shoot the opening sequences of the program. Instead, Buono opted for a pair of digital SLR cameras. One thing that makes digital still cameras so attractive for video is that they have relatively large sensors. That provides two benefits compared to cameras with a smaller sensor. In addition to improved low-light performance, the large chip allows for unusually shallow depth-of-field (a limited range of acceptable sharpness) for blurring the background; this effect is difficult or impossible to match with most professional video cameras since they use smaller sensors.

As you'll learn in Chapter 12, a larger sensor calls for the use of longer focal lengths to produce the same field of view, so, in effect, a larger sensor allows for making images with reduced depth-of-field. And *that's* what makes cameras like the a7R II/a7 II attractive from a creative standpoint. Shallow depth-of-field makes it easier to blur a cluttered background to keep the viewers' eyes riveted on the primary subject. Your camera, with its larger sensor, has a distinct advantage over consumer camcorders in this regard, and even does a much better job than professional video cameras.

Zooming and Video

When shooting still photos, a zoom is a zoom. The key considerations for a zoom lens used only for still photography are the maximum aperture available at each focal length ("How *fast* is this lens?), the zoom range ("How far can I zoom in or out?"), and its sharpness at any given f/stop ("Do I lose sharpness when I shoot wide open?").

When recording video, the priorities may change, and there are two additional parameters to consider. The first two I listed, lens speed and zoom range, have roughly the same importance in both still and video photography. Zoom range gains a bit of importance in videography, because you can always/usually move closer to shoot a still photograph, but when you're zooming during a shot most of us don't have that option (or the funds to buy/rent a dolly to smoothly move the camera during capture). But, oddly enough, overall sharpness may have slightly less importance under certain conditions when shooting video. That's because the image changes in some way many times per second (30/60 times per second), so any given frame doesn't hang around long enough for our eyes to pick out every single detail. You want a sharp image, of course, but your standards don't need to be quite as high when shooting video.

Here are the remaining considerations, and the two new ones:

- Zoom lens maximum aperture. The "speed" of the lens matters in several ways. A zoom with a relatively wide maximum aperture (small f/number) lets you shoot in lower light levels with fewer exposure problems. A wide aperture like f/1.8 also enables you to minimize depth-of-field for selective focus. Keep in mind that with most zooms, the maximum aperture gets smaller as you zoom to longer focal lengths. A variable-aperture f/3.5 to 5.6 lens like the power zoom kit lens, offers a fairly wide f/3.5 maximum aperture at its shortest focal length but only f/5.6 worth of light capturing ability at the long end. Zooms with a wide and constant (not variable) maximum aperture such as f/2.8 are available, but they are larger, heavier, and more expensive.
- **Power zoom.** An ideal movie zoom should have a power zoom feature, and that's available with Sony lenses with the PZ designation. PZ lenses offer smooth, silent zooming that's ideal for video shooting. Mechanical zooming with other lenses during capture can produce jerky images, even with vibration reduction turned on.
- **Zoom range.** Use of zoom during actual capture should not be an everyday thing, unless you're shooting a kung-fu movie. However, there are effective uses for a zoom shot, particularly if it's a "long" one from wide angle to telephoto. The Sony 18-200mm zoom, which has a relatively quiet autofocus motor and built-in stabilizer, can be used in this way, with mechanical zooming, of course. Most of the time, you'll use the zoom range to adjust the perspective of the camera *between* shots, and a longer zoom range can mean less trotting back and forth to adjust the field of view. Zoom range also comes into play when you're working with selective focus (longer focal lengths produce shallower depth-of-field), or want to expand or compress the apparent distance between foreground and background subjects. A longer range gives you more flexibility.
- Linearity. Interchangeable lenses may have some drawbacks, as many photographers who have been using the video features of their digital SLRs have discovered. That's because lenses with mechanical zooming are rarely linear unless they were specifically designed for shooting movies. Rotating the zoom ring manually at a constant speed doesn't always produce a smooth zoom. There may be "jumps" as the elements of the lens shift around during the zoom. Keep that in mind if you plan to zoom during a shot, and are using a non-linear lens. In practice, those include virtually all the lenses at your disposal, aside from power zoom lenses, a special E-mount cine lens, or a cine lens in an entirely different mount that you can use with your a7R II/a7 II with an optional third-party adapter.

Advanced Video Features

As I've noted several times in this book, the a7R II and a7 II boast professional-level video features not found in most consumer- or even pro-oriented digital cameras. Many of those looking for the best Sony mirrorless camera for video will probably choose the a7S II (which is not covered in detail in this book). Others may prefer a dedicated camcorder, like the Sony VG30 Handycam (about \$2,700), which uses E-mount lenses, or the 4K-capable Sony AX1 Professional Handycam (\$4,500), which has a fixed 20X zoom lens. Even so, neither of the other two a7 II—series cameras are slackers when it comes to capturing clips that can be assembled into polished video productions.

This chapter will introduce you to some of the most important concepts you'll need to learn as you continue your educational journey toward professional cinematography. Some of this will seem a little technical to those who are just learning about video, so if you're not going to be venturing into serious movie making soon, you might want to skim through this chapter simply to gain some background. As I mentioned when I talked about the a7R II's backside illuminated sensor, I don't normally venture this deeply into tech territory in my books, but the a7R II and a7 II aren't ordinary cameras!

More on Sensors and Crop Factors

In Chapter 10, I described some of the reasons why the large sensor size of a full-frame still camera provides video shooters with some selective focus advantages when compared to the much smaller sensor found on many professional video cameras in the past. I'll be explaining the concept of the *crop factor* in detail in Chapter 12. Both aspects are important in the video world, but with a few variations caused by the differences in how video is captured and used.

Sensor Size

Sensor size is important because smaller sensors use lenses with shorter focal lengths to fill their frames, and the shorter the focal length, the larger the depth-of-field. That's why point-and-shoot cameras (or smartphones), with their minuscule sensors can produce acceptably sharp images for subjects located a few inches from the lens out to infinity. Conversely, because a normal lens on an APS-C camera is in the 38mm range, and on a full-frame camera is roughly 55mm, a full-frame camera like the a7 II series has less depth-of-field for the same field of view.

Selective focus is a definite creative plus for videographers. We've all seen shots in which focus initially emphasizes some foreground object that's sharply rendered, and then the camera operator pulls focus out to a more distant subject, which suddenly appears in great detail. Larger sensors make such techniques easier, which is why current video cameras are often segregated into *small sensor* and *large sensor* categories. The Sony VG30 Handycam I mentioned earlier has a large APS-C sensor, measuring 23.5mm \times 15.6mm, while the Sony AX1 Professional Handycam has a smaller $^{1}/_{2.3}$ -inch sensor. (Video cameras dating back to the dawn of television have used the diameter of the video tube as a measurement.)

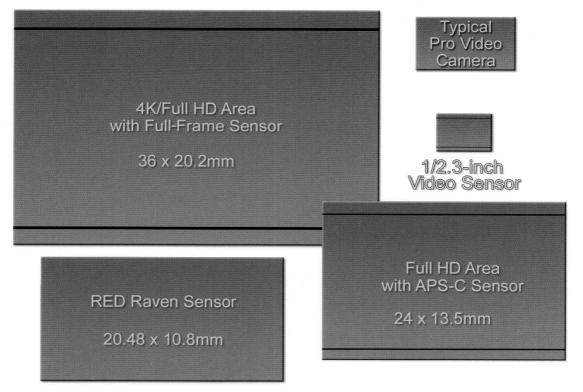

Figure 11.1 Relative video capture areas for example sensor sizes.

Figure 11.1 shows the relative size of the 4K and/or full HD capture area of some typical sensor sizes, starting with the a7 II–series' full-frame sensors at upper left, the "small" sensor of typical pro cameras and the $^{1}/_{2.3}$ -inch sensor of Sony's least expensive pro camera at right, and an APS-C sensor and the RED Raven "large" sensor shown at the bottom.

Crop Factor

The *crop factor* is important because with any given lens, the field of view will vary depending on how much of that lens's coverage area is used to capture video. (If you're unfamiliar with crop factors, skip ahead to Chapter 12 and read about them.) Still photos can be shot in both vertical or horizontal orientations, and most often using the 3:2 aspect ratio used outside the Micro Four Thirds (4:3) world. So the crop factor for stills is calculated by comparing the diagonal measurement of the frame with the diagonal of the traditional 35mm frame.

For video, clips are normally captured with the camera in a horizontal orientation (at least, outside the realm of the smartphone), and the proportions or aspect ratio of the video frame can vary, with 16:9 being the standard for standard HD, full HD, and 4K (Ultra HD) video (and beyond).

The 16:9 proportions work out to roughly 1.78:1, which is close enough to the 1.85:1 widescreen cinema aspect ratio that it's easy to show movies captured in either aspect ratio on displays compatible with either. Given the 16:9 standard, it's common to represent the resolution of a video image by its horizontal measurement and scanning method: that is, 720p, 1080p, and 4K (actually 3840 pixels with your Sony a7R II camera; 4096 pixels with some other 4K devices) for progressive scan (p) video.

A full-frame sensor provides a 1X crop factor for video, while sensors with smaller areas produce various crop factors, based, not on the sensor's diagonal measurement, but the relative *width* of the sensor area, compared to the full frame. Super 35 is a popular format for video and is available with your a7R II (but not with the a7 II, which has only an APS-C crop option). By comparing the widths of the sensor area, we can arrive at a crop factor of roughly 1.5X when shooting in APS-C/ Super 35mm mode with the a7R II. (See Figure 11.2.)

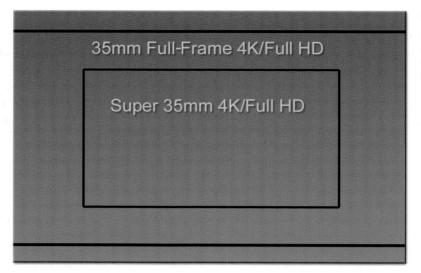

Figure 11.2 Full-frame and Super 35/APS-C crops of the Sony sensor.

How Can $1440 \times 1080p$ Be Widescreen?

Modern technology will throw you an occasional curveball, which ends up being a needless complication unless you understand what is going on. There are actually *three* different ways of expressing aspect ratios, or the proportions between an object's width and its height.

- **Display Aspect Ratio (DAR).** This is what we normally think of as an aspect ratio and is used to represent the proportions of a still photo or video frame's width compared to its height, as it is viewed in its final form. Your a7 II—series camera normally shoots still photos at a 3:2 DAR, and high-definition video at a 16:9 DAR (by convention, these whole numbers are used instead of the actual proportions of roughly 1.78:1). Standard-resolution (non-high-def) video, and Micro Four Thirds still cameras use a 4:3 DAR or, simply, aspect ratio. However, two other aspect ratios are used to calculate the final display aspect ratio, and are described next.
- Pixel Aspect Ratio (PAR). This figure describes the aspect ratio of individual pixels themselves. Today, most devices use pixels that are square, with a PAR of 1:1. (I'm using the term pixel loosely to describe the image components of both capture and display devices.) However, pixels can also be rectangular, with a pixel aspect ratio of 4:3. The proportions of the pixels are used with the frame aspect ratio to determine the display aspect ratio we end up with. The PAR is especially important when using anamorphic lenses, which squeeze the image horizontally to fit a wider area onto a narrower frame width. (It's reasonable to expect you will not be using a pro tool like an anamorphic lens with your a7R II/a7 II camera. They can cost \$40,000 or more, although far less expensive converters are available.)

■ Frame Aspect Ratio (FAR). This describes the ratio between the width of the pixels and the height of the pixels in each frame. This calculation needs to be done because pixels can be square (as they are with most modern cameras and display devices) or rectangular. For example, square pixels captured at 1920 × 1080 resolution yield the familiar 16:9 aspect ratio; square pixels captured at 1440 × 1080 (which is possible with some devices) would yield a 4:3 aspect ratio. However, your a7 II—series camera *does* capture widescreen movies at 1440 × 1080 in MP4 mode, but they are stretched so they are wider than they are tall. As a result, the 1440 × 1080 p MP4 video you capture, which might *seem* to have only a 4:3 aspect ratio, actually ends up using the same 16:9 aspect ratio as with AVCHD clips.

Frame Guides

Frame guides are a useful way of visualizing the area that will be captured within a larger visible display. In ancient times, interchangeable lens rangefinder film cameras that used an optical view-finder would have bright frame outlines appear, often automatically when a particular lens was mounted on the camera, and sometimes through the use of an attachment that fit over the built-in viewfinder. In the digital age, frame guides have been popular with digital cameras that use an optical viewfinder, providing a masked off display to preview the actual image area that will be captured in crop or video modes. Cameras with electronic displays, like the a7 II series, don't necessarily need frame guides, because the capture area can be enlarged and masked off electronically to show only the actual image area.

Even so, frame guides are a popular tool for videographers, because they allow viewing the area outside the actual frame that will be captured (the "look-around area") so you can monitor moving subjects before they enter the frame. In professional productions, it's useful to look at the region outside the captured frame to detect when boom microphones, careless crew members, or other objects threaten to intrude on the frame.

The a7 II—series cameras offer a variety of frame guides that can be turned on or off in the Custom Settings menu, including grid lines, aspect ratios, frame center markings, and "safety" areas. These markers appear *only* on the EVF or LCD monitor, and not in the captured video itself (see Figure 11.3 for example placement).

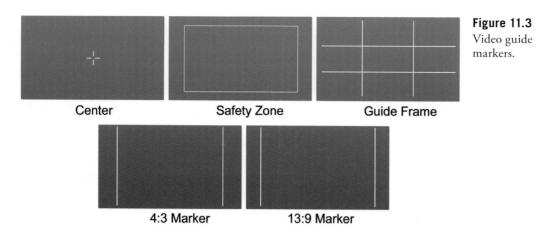

- Marker Display. This Custom Settings menu entry works in conjunction with the Marker Settings option (described next), and simply turns settings on or off.
- Marker Settings. This menu entry allows you to specify Center, Aspect Ratio, Safety Zone, or Guide Frame. Each can be specified individually, and turned on or off independently, so you can display any, all, or none.
 - Center. This crosshair can be used to determine whether your subject is placed in the exact center of the screen.
 - Aspect. Use these guides to frame your image so the important subject matter is contained within a desired aspect ratio, or to frame the image for later cropping to that aspect ratio. You can select from 4:3, 13:9, 14:9, 15:9, 1.66:1, 1.85:1, or 2.35:1. These conform to various movie formats in common use. (Star Wars, for example, was filmed in CinemaScope, with a 2.35:1 aspect ratio.)
 - Safety Zone. It's common to shoot movies knowing in advance that they will be cropped down eventually for display in a slightly different format. The director simply makes sure that the important parts of the frame are included in the "safety zone" that will never be cropped out. For example, you wouldn't want to put two characters who are talking to each other at opposite ends of the entire frame, but would instead locate them in the safety zone so both would be visible. Your camera's safety zone display can be set for 80 percent or 90 percent of the frame to represent the area that will always be shown when the movie is viewed on a standard HDTV.
 - Guide Frame. This grid is used to help you determine whether horizontal and vertical lines are skewed, and can also be used as a Rule of Thirds guide for composition.

HD or UHD (a7R II Only)?

If you own an a7R II, should you be shooting full high-definition movies, or ultra-high-definition (4K) video? (You a7 II owners don't have a choice: you have XAVC S HD, but no XAVC S 4K option.) If your memory card (which must be a 64GB or larger SDXC card) or external recorder like the Atomos Shogun, can handle the data rates, 4K is alluring, even if your movies will never be viewed in anything other than 1080p format. All that extra detail is hard to resist.

Video gurus who have studied the Sony cameras have concluded that the a7R II's Super 35 4K video provides the most detailed movies with the best dynamic range and noise characteristics. Each pixel in the Super 35 image area is captured, producing more information than is required for even a 4K video frame, and then downscaled. Paradoxically, this oversampling means that Super 35 4K has better detail than 4K video produced from the a7R II's full-frame 42 MP sensor.

Conversely, when using 1080p instead of 4K, the full-frame video typically has more detail than 1080p shot using the Super 35/APS-C setting. If full HD shooting is your intent, you're better off reserving Super 35/APS-C format for those times when you want to take advantage of the 1.5X crop factor to increase the reach/magnification of your lenses, say, for wildlife photography or sports.

In all cases, though, 4K video in either full-frame or Super 35/APS-C mode is superior to what you get using 1080p alone. Your video will still be better if shot in 4K and then downscaled to 1080p. The choice is yours.

Time Codes and User Bits

The Time Code (TC) and User Bit (UB) settings are information that can be embedded and used to sync clips and sound when editing movies. Advanced video shooters find SMPTE (Society of Motion Picture and Television Engineers)-compatible time codes embedded in the video files to be an invaluable reference during editing. To oversimplify a bit, the time system provides precise hour:minute:second:frame markers that allow identifying and synchronizing frames and audio. The time code system includes a provision for "dropping" frames to ensure that the fractional frame rate of captured video (remember that a 24 fps setting actually yields 23.976 frames per second while 30 fps capture gives you 29.97 actual "frames" per second) can be matched up with actual time spans.

Using time codes and user bits is a college-level film school class on its own, but I'm going to provide a quick overview to get your started. If you're at the stage where you're using time codes, you don't need this primer, anyway. However, the a7R II/a7 II's TC/UB Settings entry in the Setup menu includes the following options:

- TC Preset. Sets the time code. If you'll be shooting 60i/50i, you can choose time codes from 00:00:00:00 (hours, minutes, seconds, frame) to 23:59:59:29 or 23:59:59:24, respectively. With 24p, you can set multiples of four from 0 to 23 frames. If you own the RMT-VP1K remote commander, the time code can be reset to zero using a button on the controller.
- **UB Preset.** Sets the user bit, which is a marker you can insert in your video, say to designate a scene or take. There are four digits in each user bit (for example, 01:02:03:04), and the digits are each hexadecimal in nature, so you could create a code like C0 FF EE if you were feeling facetious.
- TC Format. Sets the recording method for the time code. You can choose from DF (drop frame) or NDF (non-drop-frame) formats. Drop frames are a way of compensating for the discrepancy between the nominal number of frames per second and the actual number (for example, 30 fps yields 29.97 actual frames per second, and 60 fps gives you 59.95 frames per second). In drop-frame format, the camera will skip some time code numbers at intervals to eliminate the discrepancy. The first two frame numbers are removed every minute except for every tenth minute (think of it as a leap year). You may notice a difference of several seconds per hour when using the non-drop-frame option.
- TC Run. Sets the count up format for the time code. You can choose Rec Run, in which the time code counts up only when you are actually capturing video; or Free Run (also known as Time of Day), which allows the time code to run up even between shooting clips. The latter is useful when you want to synchronize clips between multiple cameras that are shooting the same event. When using Free Run, even if the cameras record at different times, you'll be able to match the video that was captured at the exact same moment during editing.
- TC Make. Sets the recording format for the time code on the recording medium. Choose Preset to record a new time code, or Regenerate to read the previous time code setting and record the new time code consecutively. When Regenerate is selected, the time code advances no matter what TC Run setting has been selected.
- **UB Time Rec.** Sets whether or not to record the time as a user bit.

Picture Profiles

If you've been taking photos for a while, you're probably familiar with all the fixes and tweaks you can do with your still images within image editors like Photoshop. It's relatively easy to adjust color tones, contrast, sharpness, and other parameters prior to displaying or printing your photo. Movies are a little trickier, because any given video typically consists of *thousands* of individual photos, captured at 24 frames per second (or faster), with the possibility that each and every frame within a particular sequence might need fixes or creative adjustments.

Shooting video does not preclude doing post-processing during editing. Indeed, many videographers deliberately shoot relatively low-contrast video in order to capture the largest dynamic range possible, and then fine-tune the rendition later using their editing software. Picture Profiles let you do that—and also allow you to adjust your camera so that the video you capture is *pre-fine-tuned* in order to reduce or eliminate the amount of post-processing you do later.

The a7 II—series cameras are furnished with seven "canned" picture profiles, which you can think of as Creative Styles for movies. The 13 parameters included in these profiles can be further adjusted by you to better suit the "look" you are striving for in your videos. You can connect your camera to a TV or monitor using the HDMI Out connector and an HDMI cable, view the image produced by the camera on the larger screen, and then make adjustments to the picture profile. I described the process in how-to form briefly in Chapter 3.

Needless to say, creating and using Picture Profiles is a highly technical aspect of video making, at least in terms of the amount of knowledge you need to have to correctly judge what changing one of the 13 parameters will do to your video. I hope to get you started with a quick description of what those parameters do, so you'll have a starting point when you start to explore them.

Gamma, Gamma Ding Dong

The seven Picture Profile presets in the Camera Settings menu already have their own default values, each adjusted for a particular type of shooting, using various gamma and color tone settings. Thanks to our evolutionary heritage, humans don't see differences in tones in a linear manner. An absolutely smooth progression of pixels from absolute black to pure white (with 0 representing black and 256 representing white) would not look like a continuous gradient to our eyes. We'd be unable to detect differences in shadows and highlights that have the same change in tonal values as midtones. So, everything from computer monitors to printers use a correction factor (gamma) to cancel out the differences in the way we see tones.

This correction takes the form of a curve, called a *gamma curve*. If you remember your geometry, the x and y axes on a graph are used to define the shape of a curve, and in the case of gamma curves, the values use logarithmic units (ack!) to define the slope. That's where the terms S-log2 and other mind-numbing jargon comes from. The whole shebang is needed to reconcile the ability of sensors to capture, video systems to display, and printers to output a range of tones in a linear way with the actual tones we perceive non-linearly. Gamma correction and gamma compression are used to help make sure that what we get is what we see. While gamma correction between computer platforms (that is, between Macs and PCs) may be different, the actual gamma values defined by video standards like NTSC and PAL are fixed and well-known. Picture Profiles allow you to configure your camera to capture video using a desired amount of gamma and color tone correction.

The seven predefined Picture Profiles in the a7 II series are as follows:

- **PP1:** Example setting using [Movie] gamma.
- **PP2:** Example setting using [Still] gamma.
- **PP3:** Example setting of natural color tone using the ITU709 gamma, a broadcast television standard.
- **PP4:** Example setting of a color tone faithful to the [ITU709] standard.
- **PP5:** Example setting using [Cine1] gamma. Gives you what Sony calls a "relaxed" color movie with soft contrast in dark areas, and emphasis on gradation in the highlights.
- **PP6:** Example setting using [Cine2] gamma. Similar to Cine1, but optimized for editing the full video signal.
- **PP7:** Example setting using [S-Log2] gamma.

And here are the parameters you can adjust:

- **Black Level.** Sets the black level (–15 to +15). Black level is the level of brightness at which no light is emitted from a screen, resulting in a pure black screen. Adjustment of this parameter ensures that blacks are seen as black, and not a dark shade of gray.
- **Gamma.** Selects a gamma curve to adjust the relationship between the brightness (*luminance*) captured by a sensor and the brightness of the image as it's displayed on a monitor. As I've noted, this correction is needed to make what you see on a screen more closely resemble what the camera captured in real life. You can choose from nine different gamma curves.
- Black Gamma. Provides special correction for gamma in low-intensity areas, using Range and Level controls. This adjustment will make the video look more/less contrasty. Negative values make the darker parts of the image darker, but can lead to clipped blacks.

- Knee. Sets "knee point," which is the brightness level (*luma* in tech-talk) at which knee compression starts. It also allows adjusting the knee slope, or the *amount* of knee compression used. That prevents overexposure by limiting signals in high-intensity areas of the subject to the dynamic range of your camera. In short, a higher knee level produces more detail in the highlights; a lower knee level produces fewer details in the highlights. Too much compression may prevent exposure from reaching 100 percent.
- Mode. In Auto mode, the knee point and slope are set automatically; in Manual mode, they are set manually.
- **Auto Set.** When Auto is selected, values are automatically chosen by the camera for the maximum knee point, sensitivity, manual settings, and knee slope.
- Color Mode. Sets type and level of colors, from among Movie, Still, Cinema, Pro, ITU-709 Matrix, Black & White, and S-Gamut.
- **Saturation.** Sets the color saturation, from -32 to +32 values. This can be useful for reducing color in dark scenes that you want to appear low key, and help reduce noise levels in dark scenes.
- Color Phase. Sets the color phase (-7 to +7).
- Color Depth. Sets the color depth for each color phase.
- **Detail.** Sets parameters including Level, and Detail adjustments including Mode, Vertical/ Horizontal Balance, B/W Balance, Limit, Crispning (sic), and Hi-Light Detail.
- Copy. Copies the settings of the picture profile to another picture profile number.
- **Reset.** Resets the picture profile to the default setting. You cannot reset all picture profile settings at once.

S-Log2

S-Log2 is a log gamma curve that is used when the video will be processed after shooting, and captures a much larger range of tones (as many as 14 stops!) than standard gamma curves. Indeed, the tones captured using S-Log2 can't be displayed in all their glory on a standard TV or monitor, which are generally adjusted for the broadcast television BT-709 standard. Instead, the unprocessed video will look darker and lower in contrast because all those tonal values have been squeezed into the BT-709 (also called REC-709) range.

Video signals normally encompass brightness levels from 0 percent to 109 percent (you read that right: modern video cameras can record detail in highlights that are actually brighter than was possible when the video age began; the old scale was retained, reminiscent of Nigel Tufnel's 11 setting on his amp). However, even the 109 percent provides too much of a limitation; cameras can capture detail in highlights that are even brighter than *that*. So, a log gamma curve (in this case one called S-Log2) is used to *compress* all that image detail to fit into the space allowed for conventional

video signals. Post-processing in a video editor allows working with all that information and produces a finished video that contains the filmmaker's selection of tonal values in a form that can be displayed comfortably. The full dynamic range can be used to produce the finished movie. You might find that useful when exposing for highlights while avoiding blowing out the sky, or for capturing detail in shadows without losing mid tones and highlights.

The Picture Profile 7 (PP7) is already set up for S-Log2, and should be your choice if you want to work with that curve. I've oversimplified things a bit, because there are many other great things you can do with S-Log2, such as overexposing or "pushing" your video to reduce noise (but at the risk of losing some detail in brighter skin tones), and then output (called "grading") to produce an optimized final image.

I know this chapter doesn't tell you everything you need to know to take the next step in movie-making with your a7 II—series camera, but my intent was to introduce you to enough of your Sony's capabilities to spur additional exploration of this exciting creative arena.

Choosing and Using Lenses

In a paradox that continues to astonish me, the Sony a7 II full-frame lineup, which includes the a7R II and a7 II, simultaneously has the *fewest* native lenses available of any full-fledged system camera, but yet boasts the *largest* range of compatible lenses of any competing line-up. Although the number of Sony and Zeiss FE-mount lenses is still relatively small (fewer than two dozen as I write this), there is a much larger number of APS-C format (non-full-frame) E-mount lenses available, most of which will operate with all full autofocus and autoexposure functions intact. That's a particularly good match with the a7R II, which gives you 18-megapixel images even in APS-C crop mode.

Figure 12.1 A full range of FE-mount lenses, including this Sony FE 70-200mm F4 G OSS, work well on the a7 II series.

If you're willing to use an adapter, there are at least 100 or more different full-frame lenses in Sony/ Minolta A-mount or Canon EF-mount—often available at bargain prices—that can be used on your a7R II or a7 II, again, with autofocus and autoexposure. And the number of lenses that can be used with *manual* focus and Aperture Priority autoexposure using adapters for Nikon, Yashica, Contex, Contarex, Alpha, and other types of lenses is mind-boggling. Indeed, Pulitzer Prize—winning photographer (and Sony guru) Brian Smith has called the Sony a7 product line the "universal mount" cameras.

This chapter will help you wend your way through the confusing world of lenses for the a7R II/a7 II. Before we get into the actual lenses themselves, it may be useful to explore some aspects that affect how you choose and use optics.

Don't Forget the Crop Factor

If the a7 II series is your introduction to full-frame photography, you may be wondering about the term *crop factor*, or, perhaps, alternate nomenclature such as *lens multiplier* or *focal length multiplication factor*. They're used to describe the same phenomenon: the fact that cameras that do not have a full-frame sensor provide a field of view (or scene coverage) that's smaller than what you get with a camera employing the larger sensor. The a7 II—series cameras (as well as numerous other cameras of several brands) use a sensor that's approximately 24mm × 36mm in size. Many other digital cameras use a smaller so-called *APS-C sensor* that measures roughly 16mm × 24mm. In comparison, the APS-C sensor's field of view is *cropped*. While some interchangeable-lens (ILC) cameras from other vendors, including Olympus, Panasonic, and Fujifilm, may use even smaller sensors (with even greater cropping effect), the Sony ILC product line consists entirely of full-frame and APS-C models if you count both A-mount and E-mount variations.

In practical terms, let's say you're using a 200mm lens on a full-frame Sony a7R II/a7 II; you get a field of view (measured diagonally) of a little more than 12 degrees. But if you use a 100mm focal length lens on an APS-C camera, like the Sony a6000, the field of view is roughly 8 degrees because the smaller sensor records only a part of the image that the lens projects. Knowledgeable photographers often discuss this effect as the *crop factor* and you'll often find a reference in lens reviews to a *focal length equivalent*, such as 1.5X. In other words, a 200mm lens used on an APS-C camera (or the a7R II/a7 II when in APS-C/Super 35mm mode) is equivalent to a 300mm focal length on a full-frame camera. The most accurate expression to describe this concept might be something like *field of view equivalency factor*.

Figure 12.2 quite clearly shows the phenomenon at work. The outer rectangle, marked 1X, shows the field of view you might expect with a 200mm lens mounted on a full-frame digital model like the a7R II/a7 II. The rectangle marked 1.5X shows the field of view you'd get with that 200mm lens installed on a camera using the APS-C format (or an a7 II–series camera in APS-C/Super 35

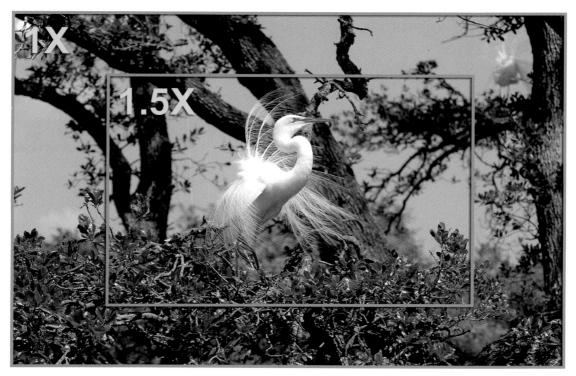

Figure 12.2 This image illustrates the field of view provided by a full-frame camera like the Sony a7 II–series (1X) with a 200mm lens, as well as the field of view you'd get when using a camera with the smaller sensor (1.5X crop) like the Sony a77 II.

mode). It's easy to see from the illustration that the 1X rendition provides a wider, more expansive view, while the other view is, in comparison, *cropped*.

In any event, I strongly prefer *crop factor* to *focal length multiplier*, because nothing is being multiplied (as I said above). A 200mm lens doesn't "become" a 300mm lens; the depth-of-field and lens aperture remain the same. (I'll explain more about these later in this chapter.) Only the field of view is cropped. Of course, the term *crop factor* has a drawback: it implies that a 24mm × 36mm frame is "full" and anything else is "less than full."

I get e-mails all the time from Hasselblad and Mamiya medium-format photographers who point out that they, too, own "full-frame" cameras that employ oversized $36 \, \text{mm} \times 48 \, \text{mm}$ and larger sensors. By their logical reckoning, the $24 \, \text{mm} \times 36 \, \text{mm}$ sensors found in full-frame cameras like the Sony a7 II series are "cropped."

The Crop Factor and the a7 II Series

So, what should the crop factor mean to you? Here's a checklist of things you should consider:

- Lens compatibility. Lenses designed for APS-C cameras may not cover the entire 24mm × 36mm full frame of the a7 II—series cameras, although some zoom lenses may have a large enough image circle at some focal lengths. With most APS-C lenses you will experience vignetting (darkening) in the corners and reduced sharpness along the edges of the image. For full-frame photography, these lenses will usually be less than satisfactory.
- **Crop mode.** As described in Chapter 4, you'll find the APS-C/Super 35mm crop mode in the Custom Settings menu. It has three settings:
 - On. The a7R II/a7 II *always* shoots in cropped mode, regardless of which lens is mounted on the camera. Both full-frame and APS-C lenses will produce images with a cropped field of view. You might use this setting to give your lenses some extra "reach" for sports or wildlife photography.
 - Auto. If the camera detects that an APS-C lens is mounted, it will switch to crop mode. Not all lenses will be automatically detected, so you may have to use the On setting instead to manually select crop mode.
 - **Off.** The camera *never* switches to crop mode. Even APS-C lenses will be used in full-frame mode. If you have a lens that *almost* covers the full frame at certain zoom settings, you can use this option and crop out the offending dark corners in your image editor.
- Reduced resolution. In crop mode, your images will have reduced resolution, producing 10MP images with the a7 II and 18MP shots with the a7R II. You'll find that, unless you're shooting photos for snapshots or to post on web pages, 10MP is not particularly useful, but the a7R II's 18MP images are more than enough.
- Shoot now, crop later? Some point out that you can always shoot everything in full-frame mode and crop your images, perhaps with greater flexibility, in an image editor. While that's true, it's not necessarily the best route. In crop mode, the a7R II and a7 II enlarge the cropped image to fill the EVF and LCD monitor, and it's more intuitive to frame and compose your images already cropped. Sports photographers and photojournalists who fire off 1,000 shots at an event won't be eager to go through their digital files and manually crop images. It's easier to crop as you shoot.

SteadyShot and You

Even the highest resolution lenses and sensors can do nothing to correct image sharpness lost due to movement. And while higher shutter speeds can counter most subject movement, when it's the *camera* that's causing blur due to vibration, other approaches have to be taken. Your a7 II—series camera has improved technology that can help avoid blur caused by shutter movement and bounce, but when the entire camera and lens are vibrating, that's where *image stabilization* (IS) comes into play.

Image stabilization/vibration reduction can take many forms, and Sony has expertise in all of them. Electronic IS is used in video cameras, and involves shifting pixels around from frame to frame so that pixels that are not moving remain in the same position, and portions of the image that *are* moving don't stray from their proper path. Optical image stabilization, which Sony calls Optical SteadyShot (OSS), is built into many FE-mount lenses, and involves lens elements that shift in response to camera movement, as detected by motion sensors included in the optics. Then, when the a7 II series was unveiled, Sony introduced a new (at least for its mirrorless lineup) wrinkle: inbody, anti-shake technology called SteadyShot Inside (SSI), which adjusts the position of the sensor carriage itself along five different axes to counteract movement. If you're using an OSS lens with your a7R II/a7 II camera, you actually have access to two different, complementary image stabilization systems.

The results can be spectacular. Sony claims a 4.5 stop improvement from its in-body SteadyShot technology. That is, a photograph taken at 1/30th second should have the same sharpness (at least in terms of resistance to camera shake) as one shot at 1/750th second. I've found this to be true. Figure 12.3 shows two shots of pelicans taken a few minutes apart with a 100–400mm Minolta A-mount zoom lens (using the Sony EA-LA4 adapter) at 400mm and 1/125th second hand-held. This older lens has no image stabilization built-in, so the shot at top was taken using only the camera's in-body IS. For the bottom photo, SteadyShot was turned off.

No amount of SteadyShot can eliminate blur from moving subjects, but you should find yourself less tied to a tripod when using longer lenses, or when working with wide-angle lenses under dim lighting conditions than in the past. If you're taking photos in venues where flash or tripods are forbidden, you'll find the a7 II—series' IS tandem invaluable. Because lens-based and in-body image stabilization work together, it's appropriate to discuss their use in this lens-oriented chapter.

Figure 12.3 When hand-holding a lens at 400mm (top) and panning slightly to follow the pelican's movement, I was able to get a blur-free photo at 1/125th second. With SteadyShot deactivated, camera movement produced noticeable blurring (bottom).

How It Works

As I mentioned, stabilization uses gyroscope-like motion sensors to detect camera motion, which can occur along one of five different axes, as shown in Figure 12.4. Shifts in the *x* and *y* directions are likely to occur when shooting macro images hand-held, but can take place any time. *Roll* happens when you rotate the camera along the axis passing through the center of the front of the lens, say, to align the horizon while shooting a landscape. There may be a tendency to continue to "correct" for the horizon as you shoot, producing vibration along the roll axis. Roll is especially noticeable in video clips, because it's easy to see straight lines changing their orientation during a shot.

Pitch movements happen when the camera shake is such that the lens moves up or down, often because the lens itself is a front-heavy telephoto lens. The magnification of the tele only serves to exaggerate the changes in pitch. Telephotos are also a major contributor to *yaw* vibrations, in which the camera pivots slightly as if you were shooting a panorama—even when you're *not*. All five of these types of movement can be countered through image stabilization.

OSS does best in nullifying changes in pitch and yaw. SSI in the body can correct for all five types of movement. If both OSS and SSI are active at the same time, the a7R II and a7 II use the two in tandem, allowing the lens to correct for pitch and yaw, while the in-body IS compensates for x, y, and roll movements. That makes a lot of sense, because in correcting for x, y, and roll the camera is able to keep the sensor in the exact same plane to preserve precise focus, and simply move the sensor carriage up, down, or slightly rotated to nullify the movement. If your lens does *not* have OSS, the SSI technology handles all the image stabilization tasks, in effect bringing IS to *every* lens you mount on the camera. That includes all E-mount lenses, as well as A-mount lenses attached with an EA-LA3 or EA-LA4 adapter (more on those later), and even "foreign" lenses like Canon EF optics using an appropriate adapter.

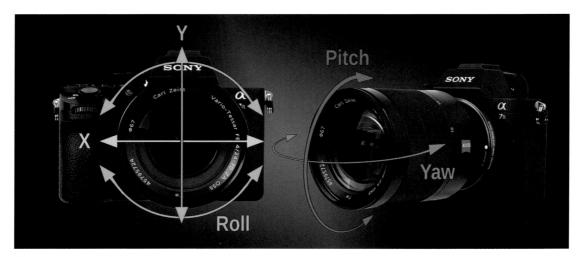

Figure 12.4 The five axes of in-body SteadyShot stabilization.

However, not all non-stabilized lenses benefit in identical ways from Sony's stabilization technology. For best results, the SSI system needs to know both focal length and focus distance to provide optimum stabilization. That's an advantage of OSS: stabilization built into the lens always knows exactly what focal length setting and focus distance is being used. For SSI, the same information has to be supplied to the smarts inside the camera body, using the SteadyShot Settings entry on the Camera Settings menu.

The lens may be one that can communicate this information to the camera. Focal length and distance data is also used with Sony's advanced distance integration (ADI) technology for flash exposure, as described in Chapter 13. Focal length information is needed to correct for pitch and yaw, while x and y compensation need to know the focal distance. (Roll correction needs neither type of data, and can do its thing just from what SteadyShot sees happening on the sensor.)

However, when all the data is available, the full array of the a7R II/a7 II's IS capabilities can be used to correct on all five axes. If the lens *cannot* communicate this information, the focal length can still be specified using the SteadyShot Settings entry in the Camera Settings menu, as described in Chapter 3. Simply change the SteadyShot Adjustment option to Manual, then use the SteadyShot Focal Length sub-entry to specify the focal length of the lens or the zoom position you're going to use from the range 8mm to 1000mm.

Unless you're working with a non-zoom lens, going this route can be clumsy, but at least it works. When I am shooting sports with my 100–400mm Minolta lens, I set the focal length to 400mm, and get appropriate IS the majority of the time. Manually entering the focal length doesn't provide the second half of the required data—the focus distance. But with only the focal length data to work with, the IS can calculate the amount of compensation to provide to correct for pitch and yaw, and it doesn't *need* that data to fix roll. When using your non-compatible and foreign lenses, and lenses from third-party vendors like Rokinon/Samyan, you must forgo corrections along the x and y axes, but that deficit can be lived with, I've found.

One interesting variation comes when using a Metabones adapter (described later) with a Canon EF lens that *does* have image stabilization. Sony recommends turning off the Canon lens's IS using the switch on the lens, because, even with the Metabones adapter, the lens has no way of working with the in-body stabilization (and vice versa). The result would be having *both* the lens and the a7R II/a7 II trying to correct for pitch and yaw simultaneously, and possibly overcompensating.

Here's a quick summary of some things you should keep in mind:

■ Compatible lenses. All FE lenses and most Sony E-mount lenses should be compatible, and you can leave SteadyShot turned on. The a7R II/a7 II will identify the lens and choose how to apply the in-lens and in-body stabilization. For best results, turn off SteadyShot when the camera is mounted on a tripod.

- SteadyShot doesn't stop action. Unfortunately, no stabilization is a panacea to replace the action-stopping capabilities of a faster shutter speed. If you need to use 1/1,000th second to freeze a high jumper in mid-air, neither type of image stabilization achieves the desired effect at a longer shutter speed.
- Stabilization might slow you down. The process of adjusting the lens and/or sensor to counter camera shake takes time, just as autofocus does, so you might find that SteadyShot adds to the lag between when you press the shutter and when the picture is actually taken. In a situation where you want to capture a fleeting instant that can happen suddenly, image stabilization might not be your best choice.
- Give SteadyShot a helping hand. When you simply do not want to carry a tripod all day and you'll be relying on the OSS system, brace the camera or your elbows on something solid, like the roof of a car or a piece of furniture. Remember that an inexpensive monopod can be quite compact when not extended; many camera bags include straps that allow you to attach this accessory. Use a monopod for extra camera-shake compensation. Brace the accessory against a rock, a bridge abutment, or a fence and you might be able to get blur-free photos at surprisingly long shutter speeds. When you're heading out into the field to photograph wild animals or flowers and want to use longer exposures and think a tripod isn't practical, at least consider packing a monopod.

Choosing a Lens

Since the introduction of the original a7R and a7 in October 2013, Sony has been introducing new full-frame FE lenses for the system at an admirable pace, although many eager users have expressed impatience over the arrival of their personal most-anticipated optics. So, while I'm going to provide a quick listing of some of the lenses currently available for the a7R II/a7 II series, it will necessarily be somewhat incomplete. After all, I expect additional lenses to be introduced as this book goes into production and, with luck, during the life of the book itself.

I'm going to cover only full-frame lenses in this chapter. If you read through my explanation of the crop factor, you know that APS-C lenses can also be used with a7 II–series cameras, particularly with the a7R II, which still gives you an 18MP image in crop mode. But, as I noted, there are pros and cons to that approach, and the number of APS-C lenses available is vast, so I'm not going to list those options here.

In addition, most of my books rarely discuss third-party offerings, whether it's lenses, flash units, or accessories. There are so many of them, and the product churn can quickly make any recommendation obsolete. And, besides, for the most part the original vendor, such as Sony, provides the superior product. The situation is slightly different in the case of Sony's full-frame mirrorless

cameras. In addition to Sony's own product line, produced internally from the company's own designs or with the cooperation of Zeiss, there are some excellent third-party optics you really should consider.

Some of these are from Zeiss and some are from third parties looking to fill the vacuum caused by the relative dearth of full-fledged FE lenses. Still more possibilities derive from the a7 II series' capability of using "foreign" lenses with tolerable—or better—autofocus and autoexposure features. As I noted in the introduction to this chapter, you can use a zillion A-mount lenses with the EA-LA3 and EA-LA4 adapters, Canon EF lenses with an appropriate auto adapter from Metabones or other vendors, and adapters for virtually every other possible lens mount if you're willing to forgo autofocus and some other features.

I'll break down my overviews by vendor, and provide you with my own recommendations where appropriate.

Sony FE Lenses

While the Sony-designated E-mount FE lenses should meet the needs of most photographers, you'll also find several premium-grade (and expensive) products with the Carl Zeiss ZA designation. The Carl Zeiss models all boast rugged metal construction for great durability, the very effective T* multi-layer anti-reflective coating for flare control, and one or more large high-tech optical elements for effective correction of optical aberrations. I'm going to list my favorite E-mount options for a7 II—series owners who want the very best.

First up, the trinity of must-have lenses. These three lenses all have built-in optical image stabilization that can work in tandem with the a7R II/a7 II's in-body SteadyShot. All have a constant f/4 maximum aperture that doesn't change as you zoom and are reasonably affordable (as far as premium optics go) at \$1,200–\$1,500 each. Sony is rumored to be prepping faster f/2.8 versions, but you can bet that they will be larger, heavier, and much more expensive. (See Figure 12.5.)

■ Sony FE 16-35mm f/4 ZA OSS lens. This is the lens you need for your architectural, land-scape, and indoor photography in tight quarters. It covers an almost perfect range of focal lengths, from an ultra-wide 16mm to the street/urban photographer's favorite 35mm field of view. Some might prefer a 14-24mm zoom range (which wouldn't overlap with the 24-70mm lens described next), but I find the extra 11mm useful. I don't have to swap lenses when I need to zoom in a little tighter. One wonderful thing about this optic is that it has *curved* aperture blades, producing smooth circular defocused highlights for great *bokeh*. At around \$1,350, you can afford this lens, and if you shoot a lot of wide-angle images, you can't afford *not* to have it.

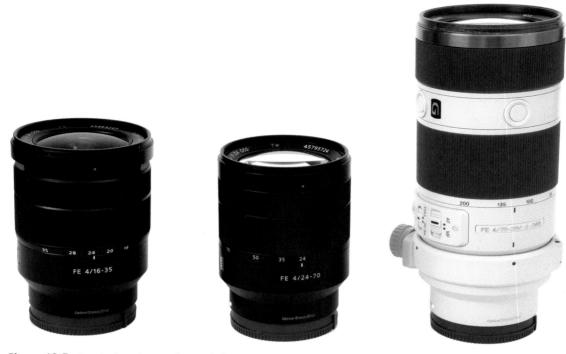

Figure 12.5 Sony's three key FE lenses, left to right: 16-35mm f/4, 24-70mm f/4, and 70-200mm f/4.

- Sony Vario-Tessar T* FE 24-70mm f/4 ZA OSS lens. This lens includes my personal least-used focal length range. I tend to see my subjects either with a wide-angle view, often with an apparent perspective distortion aspect, or with a telephoto/selective focus approach. Another Zeiss-branded product, it has excellent balance with the a7 II series, making it useful as a walk-around lens for travel photography, full-length and three-quarters portraits, and indoor sports like basketball and volleyball. Unfortunately, it won't be the sharpest optical knife in your toolkit, despite the Zeiss label. I find it perfectly acceptable when stopped down two or three stops from maximum aperture, but for \$1,200, I expected more. You might explore the \$500 Sony FE 28-70mm f/3.5-5.6 OSS kit lens. It's abominably slow (f/5.6) at the 70mm zoom position, but you might find that saving \$700 while filling out your trinity alleviates the pain.
- Sony FE 70-200mm f/4 G OSS lens. Compared to 70-200mm f/4 lenses designed for other full-frame cameras, this \$1,500, 3-pound, 10.4 × 5.4 × 5.3-inch lens is almost petite, but it's quite a beast mounted on the tiny a7 II—series cameras. It's well balanced and these cameras do have the new beefed-up mounting bayonet, but you really should consider using the swiveling tripod collar, either when mounting on a tripod/monopod or as a support when hand-holding. It's a Sony premium G lens (the G stands for "Gold") and its optical performance won't disappoint.

These are my choices among the other Sony FE lenses. They include walk-around lenses, some fast primes for photojournalism and other available light applications, and even a stellar macro.

- Sony FE 55mm/1.8 ZA lens. So, why get excited about a "normal" lens with an f/1.8 maximum aperture and a \$1,000 price tag? After all, both Nikon and Canon offer full-frame 50mm f/1.8 prime lenses for \$200 or less. In this case, your ten Benjamins buys you one of the sharpest lenses ever made, with exquisite resolution at every f/stop—including wide open. Given that perspective, this lens is actually a bargain. You'll love using it for head-and-shoulders or 3/4 length portraits using selective focus at f/1.8. It's said to rival super-costly lenses, like the 55mm f/1.4 Zeiss Otus, which has a \$4,000 price tag. You owe it to yourself to get this lens.
- Sony FE 24-240mm f/3.5-6.3 OSS lens. On first glance, a 10X zoom lens stretching from a true wide-angle 24mm field of view to the edge of super telephoto range at 240mm sounds very tempting. With a second look, this optic's \$1,000 price adds to the appeal. The reality check comes only when you realize that mating this hefty (1.72 pound), somewhat slow lens (f/6.3 at maximum zoom) to the compact a7R II/a7 II counters the best reason for toting around a tiny full-frame mirrorless camera. If you truly want to walk around with only a single lens and can justify the bulk, this optic does fill the bill. It would also be an efficient choice for photography that might call for extreme wide-angle views and telephoto reach in rapid succession. Given its modest price tag, you can expect this lens will be a jack-of-all-trades and master of none. I'd rather carry a medium-sized camera bag and fill it with the trio of lenses described in the previous section, even at a cost premium of \$3,000.
- Sony FE 28-135mm f/4 G PZ OSS lens. The specs alone might lead you to believe this is a faster, heavier (5 pounds) walk-around lens with a more restricted zoom range. You'd be wrong. This \$2,500 monster is especially designed for pro-level 4K video productions, and if heavy-duty movie making isn't on your agenda, you probably don't want or need this lens. Video shooters, though, will delight in its near-silent precision variable 8-speed power zoom, and responsive manual control rings for zoom (with direction reversal for smooth zooms), focus pulling, and aperture.
- Sony FE 28mm f/2.0 lens. Here's a lens that comes with its own bag of tricks. It's a compact prime lens with a fast f/2.0 aperture, so you can shoot in low light and even gain a modicum of selective focus with its (relatively) shallow depth-of-field wide open. Despite its \$450 price, it boasts an advanced optical design with ED (extra-low dispersion) glass elements that improve contrast and reduce troublesome chromatic and spherical aberrations. (You'll find descriptions of lens aberrations later in this chapter.) If that's not enough, you can attach either of two adapter optics to the front. There is a wide-angle version (\$250), which converts it to a 21mm f/2.8 wide angle that focuses down to eight inches, and a 16mm fisheye attachment (\$300) that I personally find more interesting and fun. But then, I own eight different fisheye lenses, so I'm susceptible.

- Sony Distagon T* FE 35mm f/1.4 ZA lens. This Zeiss lens is a photojournalist's dream, with a wide-angle focal length that lets you get up close and personal with your subject, and a fast f/1.4 aperture suitable for low light and selective focus. The Zeiss T* (T-star) coating suppresses contrast loss from internal reflections among the lens elements. It's great for video, too, as the aperture ring can be de-clicked with a switch. The only drawback is the price: \$1,600, which is a lot to pay for a lens that doesn't give you a range of different focal lengths to work with. However, the shooters this lens is designed for will confirm that it's worth it.
- Sony Sonnar T* FE 35mm f/2.8 ZA lens. This tiny lens is a perfect match for the compact a7R II/a7 II. At a mere eight ounces and measuring 2.42 × 1.44 inches, it makes a great walk-around lens for stealthy photographers. The image quality is great, but you'd expect that from a Zeiss lens that, at \$800, is not bargain-basement cheap.
- Sony FE 90mm f/2.8 Macro G OSS. I expect that Sony will make additional macro lenses available for the a7 II—series cameras, but until then this \$1,100 lens is an excellent choice. Its 90mm focal length gives you a decent amount of distance between the camera and your close-up subject, even at its minimum focusing distance of 11 inches. With internal focusing such that only the internal elements move, the lens doesn't get longer as you focus, avoiding a common problem. You can add a set of auto extension tubes to get even closer. I use Fotodiox Pro 10mm and 16mm tubes. Those tubes are primarily plastic and not especially rugged, but are serviceable for light-duty use.

A-Mount Lenses

If you're coming to the Sony mirrorless world from the SLT/A-mount arena, you may already own some Sony or Minolta lenses that can work very well with your a7R II/a7 II. And even if you *don't* have any A-mount lenses now, you may want to investigate purchasing some. In some cases, they are as good as—or better—than the current roster of FE lenses. I know one professional photographer who skipped both FE mid-range zooms (the 24-70mm Zeiss and 28-70mm Sony kit lens) entirely, because he already owned the superb Sony Zeiss 24-70mm f/2.8 ZA SSM I Vario Sonar T* lens, which he used with his Sony a99. Of course at \$2,100, you'd only want to buy one if you were *very* serious about working with those particular focal lengths. You'd also need to sink another \$200–\$350 into a Sony A-Mount to E-Mount adapter, which I'll describe later in this chapter.

However, a viable option for everyone is to buy gently *used* A-mount lenses from reliable sources, such as KEH Camera (www.keh.com). I've purchased more than a dozen lenses from them over the last few years, including the ever-popular "beercan," the Minolta AF Zoom 70-210mm f/4, an ancient optic prized for its tank-like solid build, commendable sharpness, constant maximum aperture, and smooth bokeh. Of course, my favorite is my Minolta AF 100-400mm f/4.5-6.7 APO Tele-Zoom lens. (See Figure 12.6.) It's not my sharpest lens, but I would never have been able to afford a 400mm autofocus lens otherwise.

Figure 12.6 A Minolta 100-400mm lens mounted using the Sony EA-LA4 adapter.

I'm not sure where KEH gets 30-year-old lenses that are like new, but their selection is huge and the prices are a fraction of what you'd pay for new A-mount optics. Keep in mind that when it took over Konica Minolta's camera/lens technology, Sony simply rebranded quite a few of the most popular lenses, so you may find a 50mm f/1.4 Minolta lens that's identical to the Sony 50mm f/1.4 lens at a much lower price.

The only drawback to the most affordably priced A-mount lenses is that they probably use Minolta's original screw-drive autofocus technology. To use them on your a7R II/a7 II, you'll need the Sony LA-EA4 adapter, which has its own SLT (single-lens translucent) phase-detect autofocus system, similar to that used in the Sony a99.

It's highly preferable to use A-mount lenses with built-in autofocus motors of the SSM or SAM variety. These lenses work with the less expensive Sony LA-EA3 adapter and let you use the a7R II and a7 II's own hybrid phase detect/contrast detect AF system, which is typically both faster and more accurate. (Such lenses are easy to spot: they incorporate the SSM, SSM II, SAM, or SAM II designations in their official names.) SSM stands for SuperSonic motor, which uses a ring-type ultrasonic driver that is fast and virtually silent, and is found on upper-end lenses. SAM stands for Smooth Autofocus Motor, an alternate system built into some lower-end Sony optics introduced since 2009.

I won't recommend specific additional A-mount lenses here, as the selection is so vast and varied. Just keep these provisos in mind:

- Both full-frame and APS-C. The older Minolta lenses you'll find were designed for full-frame film cameras, but Sony has introduced both full-frame and APS-C lenses for A-mount. You can usually identify Sony APS-C A-mount lenses by the designation DT in the lens name; if DT is not included, it is a full-frame lens. Third-party lens manufacturers such as Tokina, Sigma, Vivitar, and Tamron also offer a mixture of both types. Research your lenses before you buy.
- Motor/No Motor. It's easy to discern Sony A-mount lenses with internal motors, as the specification is included in their name. However, specs of the offerings of third-party vendors are not always obvious. Somewhere in their catalog descriptions they will usually specify whether a particular lens includes an internal motor, and they'll also reveal whether a lens is intended for full-frame or APS-C models.

Zeiss Loxia Lenses

While the Zeiss FE lenses produced and sold by Sony all feature autofocus, Zeiss also independently sells its own optics, including the Loxia lineup designed specifically for Sony full-frame E-mount cameras.

Zeiss lenses are all premium optics, and, as I write this, the super-premium Zeiss Otus lineup (priced at \$4,000 and up) is not available in Sony E-mount. Nor can you buy the new Milvus full-frame lenses to fit your A7r II/a7 II, and, just in case you're wondering, the Zeiss Touit lenses in E-mount are designed for APS-C sensors only.

However, these Loxia lenses are among the best we can get, with, initially, three lenses available, all manual focus. Not including autofocus helps keep the price down on these otherwise premiumquality super-sharp lenses. Keep in mind that your a7R II/a7 II has a wealth of manual-focus-friendly features, including focus peaking and focus magnification, all described elsewhere in this book.

- Zeiss Loxia 50mm f/2 Planar T* lens. If you've been involved with photography for any length of time, you'll recognize the Zeiss Planar name, first applied to a symmetrical lens design as far back as 1896. This fast manual focus lens does a good job of correcting for chromatic aberration and distortion, and is one of the best lenses you can buy for roughly \$1,000. Like all the Loxia lenses, the manual aperture ring can be de-clicked, using a supplied tool, for use when constantly varying apertures are desired when shooting video.
- Zeiss Loxia 35mm f/2 Biogon T* lens. Another name out of the past, Biogon lenses have historically been some of the best wide-angle optics you can buy, and this fast 35mm f/2 lens has been optimized for use with digital cameras (that is, illumination emerges from the back of the lens at a less steep angle, as explained in Chapter 2). Your \$1,300 buys you a well-corrected lens suitable for street photography, architecture, landscapes, and other subjects.

■ Zeiss Loxia 21mm f/2.8 T* lens. This final lens in the trio was the last introduced, in December 2015 for \$1,500. It's an extra-compact lens using the famed Distagon design, which overcomes some of the drawbacks of many wide angles to provide consistent sharpness from edge to edge, with little light falloff and excellent correction for chromatic aberrations.

Zeiss Batis Lenses

Here we have two reasonably priced autofocus lenses from Zeiss, one of which fills a gaping hole in Sony's full-frame E-mount lineup. If you're looking for a futuristic touch, they each feature an illuminated OLED (organic LED) display that dynamically shows focus distance and depth-of-field. In the good old days, prime (non-zoom) lenses had etched or painted color-coded depth-of-field markers on the lens barrel, but those largely disappeared when zoom lenses became dominant. Now depth-of-field can be displayed on your lens in a more useful form. As I write this, the two available Batis lenses are as follows:

- Zeiss Batis 85mm f/1.8 lens. This is a \$1,200 medium telephoto autofocus lens that's ideal for portraits, and a primo choice for low-light photography and selective focus. It's the first Zeiss lens that has optical image stabilization (the equivalent of Sony's trademarked OSS), giving you hybrid IS when used with the a7 II—series cameras' in-body SteadyShot Inside.
- Zeiss Batis 25mm f/2.0 lens. There's a bit of overlap in potential use between this autofocus lens and Sony's own 28mm f/2.0 optic. This one is more expensive at \$1,300, sharper, and isn't compatible with Sony's wide-angle/fisheye adapters.

Other Third-Party Lenses

Because the a7R II/a7 II have relatively short back-focus distances (the gap between the lens mount bayonet and sensor), it's fairly easy for third parties to adapt their existing full-frame lenses to fit your camera. There are some interesting lenses available. Among them:

- Mitakon. This company makes an ultra-fast 85mm f/1.2 manual focus lens (\$800), and a hyperfast 50mm f/0.95 lens (\$850) in Sony E-mount, with the latter having the distinction of being the world's fastest full-frame E-mount lens.
- Voigtlander. Probably the oldest name in camera gear, dating back to its founding in Vienna in 1756 (well before the invention of photography itself). It produces some interesting lenses, including 10mm and 12mm f/5.6 Heliar and a 15mm f/4.5 Heliar.
- Samyang/Rokinon. This company's manual focus 12mm f/2.8 fisheye resides in my fisheye collection, and I often alternate its use with my 15mm f/2.8 Sigma fisheye. I use them in manual focus mode with adapters, but Samyang/Rokinon also sells lenses in E-mount (sometimes under the Bower brand name). They include a 14mm f/2.8, 24mm f/1.4, 35mm f/1.4, 50mm f/1.4, 85mm f/1.4, 135mm f/2, and a 100mm f/2.8 macro lens that produce 1:1 (lifesize) magnification at a minimum focusing distance of 12 inches.

Using the LA-EA Series Adapters

Sony makes four A-mount to E-mount adapters, which allow using Sony/Minolta A-mount lenses on an Alpha E-mount camera such as the a7R II/a7 II. Why four different adapters? All four, the LA-EA1, LA-EA2, LA-EA3, and LAEA4, allow connecting an A-mount lens to an NEX/Alphaseries camera. The two odd-numbered adapters use *only* contrast detect autofocus with lenses that have built-in AF motors and are compatible with them. The two even-numbered adapters have built-in SLT-like phase detection AF systems for fast focusing with lenses that use the original screw-drive AF system. The LA-EA1 and LA-EA2 are designed for APS-C cameras, while the LA-EA3 and LA-EA4 shown in Figure 12.7 are intended for full-frame models like the a7 II series. Table 12.1 should clear things up a bit.

Figure 12.7
The LA-EA3 (left)
and LA-EA4 (right)
adapters allow using
A-mount lenses on
the a7R II/a7 II.

Table 12.1 LA-EA Series Adapters		
Adapter	Autofocus	Format
LA-EA1	Contrast detect with lenses that have built-in SSR or SAM AF motors. Lenses using a screw-drive motor in the camera body will not autofocus.	APS-C
LA-EA2	Phase detect using Translucent Mirror technology.	APS-C
LA-EA3	Contrast detect with lenses that have built-in SSM or SAM AF motors. Lenses using a screw-drive motor in the camera body will not autofocus.	Full Frame and APS-C
LA-EA4	Phase detect using Translucent Mirror technology.	Full Frame and APS-C

The LA-EA3 adapter or LA-EA4 adapter are both satisfactory, depending on the type of autofocus used in your A-mount lenses. I own both, because I have a mixture of SSM, SAM, and screw-drive lenses

The LA-EA2 and LA-EA4 are clever because both involve, basically, building a version of Sony's Translucent Mirror Technology, found in the SLT cameras, into an adapter, as you can see in the exploded diagram shown in Figure 12.8. (In actual use, the lens must be physically mounted to the adapter.)

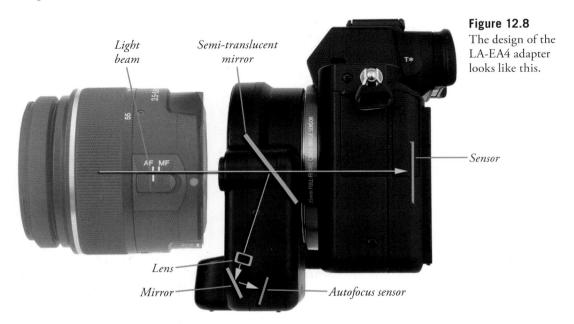

Other Lens Options

Because of the popularity of the camera line, third-party vendors have rushed to produce lenses for these models. As I mentioned earlier, because the a7 II–series' "flange to sensor" distance is relatively short, there's room to use various types of adapters between camera and lens and still allow focusing all the way to infinity. There are already a huge number of adapters that allow mounting just about any lens you can think of on the a7 II cameras, if you're willing to accept manual focus and, usually, a ring on the adapter that's used to stop down the "adopted" lens to the aperture used to take the photo. You can find these from Novoflex (www.novoflex.com), Metabones (www.metabones.com), Fotodiox (www.fotodiox.com), Rainbow Imaging (www.rainbowimaging.biz), Cowboy Studio (www.cowboystudio.com), and others.

Some adapters of certain types and brands sell for as little as \$20–\$30. With many of them you should not expect autofocus even if you're using an AF lens from some other system; as well, many of the cameras' high-tech features do not operate. However, you can usually retain automatic exposure by setting the a7R II/a7 II to Aperture Priority, stopping down to the f/stop you prefer, and firing away. Figure 12.9 shows a Nikon-to-E-Mount adapter I bought from Fotodiox.

It's possible to mount lenses of entirely different brands on your a7R II/a7 II with an adapter, but many camera functions are then disengaged.

The ultra-high grade Novoflex and Metabones adapters for using lenses of other brands sell for much higher prices. I found only two that are said to maintain autofocus with a lens of an entirely different brand. The Metabones Canon EF-to-Sony Smart Adapter (Mark IV) and their similar Speed Booster model (\$400 and \$600, respectively) maintain autofocus, autoexposure, and the Canon lens's image stabilizer feature when used with a camera. The "Speed Booster" part of the name comes from the adapter's ability to magically add one f/stop to the maximum aperture of the lens (thanks to the adapter's internal optics), transforming an f/4 lens into an f/2.8 speed demon.

The Metabones Smart Adapter IV has been taking the a7 II arena by storm, thanks to the ability to use AF-C with Canon's EF or EF-S lenses and your camera's hybrid phase detect/contrast detect autofocus system. Reports are that autofocus with these lenses is equal to or superior to that of the same lenses when mounted on their native Canon camera bodies. The Canon lenses' in-lens IS also works, but you may want to disable it and rely solely on the a7R II/a7 II's own SteadyShot capabilities. The Metabones Smart Adapter IV is well made, with brass components, and costs a hefty \$399, but if you are switching over from a Canon system, the ability to use your existing lenses is priceless.

My absolute favorite lens bargain is the 35mm f/1.7 Fujian (no relation to Fuji) optic, which I purchased brand new for a total of \$38, with the E-mount adapter included in the price. It's actually a tiny CCTV (closed-circuit television) lens in C-mount (a type of lens mount used for cine cameras). It's manual focus and manual f/stop, of course (and it works in Aperture Priority mode); it's a toy lens, or something like a super-cheap Lensbaby, or a great experimental lens for fooling around. It covers the full APS-C frame (more or less; expect a bit of vignetting in the corners at some f/stops), so you'll have to use it in APS-C crop mode. It is not incredibly sharp wide open, and exhibits a

weird kind of "bokeh" (out-of-focus rendition of highlights) that produces fantasy-like images. The only drawback (or additional drawback, if you will), is that you may have to hunt some to find one; the manufacturer doesn't sell directly in the USA. I located mine on Amazon.com.

Once you own the C-mount to E-mount adapter, you can use any of the host of other similar CCTV lenses on your a7R II/a7 II. Also relatively cheap, but not necessarily of equal quality, are a 25mm f/1.4, 35mm f/1.7, and 50mm f/1.4 lens (shown in Figure 12.10), as well as a Tamron 8mm f/1.4, and other lenses that I haven't tried and probably won't cover even the APS-C image area, but are worth borrowing to try out if you have a friend who does CCTV.

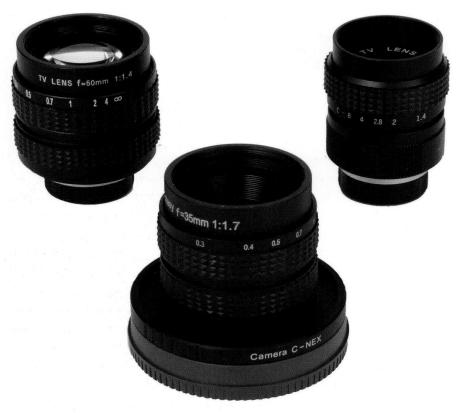

Figure 12.10 These CCTV lenses make great "toys" for your a7 II—series camera.

Fine-Tuning the Focus of Your A-Mount Lenses

In Chapter 4, I introduced you to the a7R II/a7 II's AF Micro Adjustment feature in the Custom Settings menu, which can be manipulated *only* when you're using a Sony or a Minolta Maxxum/ Dynax A-mount lens with the EA-LA2 or EA-LA4 adapters. It is not available when using the LA-EA1 or LA-EA3 adapters. (The micro adjustment may work with an A-mount lens of another brand, but Sony warns that the results may be inaccurate.) Millions of A-mount lenses have been sold over the years, and the adapter is not terribly expensive, so I will assume that many readers will eventually want to consider the fine-tuning feature.

If you do not currently have such lenses or the adapter, you cannot use AF Micro Adjustment (you can turn the feature on or off, but you cannot enter any adjustment factor). But if you do own the relevant equipment, you might find that a particular lens is not focusing properly. If the lens happens to focus a bit ahead or a bit behind the desired area (like the eyes in a portrait), and if it does that consistently, you can use the adjustment feature.

Why is the focus "off" for some lenses in the first place? There are lots of factors, including the age of the lens (an older lens may focus slightly differently), temperature effects on certain types of glass, humidity, and tolerances built into a lens's design that all add up to a slight misadjustment, even though the components themselves are, strictly speaking, within specs. A very slight variation in your lens's mount can cause focus to vary slightly. With any luck (if you can call it that) a lens that doesn't focus exactly right will at least be consistent. If a lens always focuses a bit behind the subject, the symptom is *back focus*. If it focuses in front of the subject, it's called *front focus*.

You're almost always better off sending such a lens in to Sony to have them make it right. But that's not always possible. Perhaps you need your lens recalibrated right now, or you purchased a used lens that is long out of warranty. If you want to do it yourself, the first thing to do is determine whether or not your lens has a back focus or front focus problem.

For a quick-and-dirty diagnosis (*not* a calibration; you'll use a different target for that), lay down a piece of graph paper on a flat surface, and place an object on the line at the middle, which will represent the point of focus (we hope). Then, shoot the target at an angle using your lens's widest aperture (smallest available f/number) and the autofocus mode you want to test. Mount the camera on a tripod so you can get accurate, repeatable results.

If your camera/lens combination doesn't suffer from front or back focus, the point of sharpest focus will be the center line of the chart, as you can see in Figure 12.11. If you do have a problem, one of the other lines will be sharply focused instead. Should you discover that your lens consistently front focuses or back focuses, it needs to be recalibrated. Unfortunately, it's only possible to calibrate a lens for a single focusing distance. So, if you use a particular lens (such as a macro lens) for close-focusing, calibrate for that. If you use a lens primarily for middle distances, calibrate for that. Close-to-middle distances are most likely to cause focus problems, anyway, because as you get closer to infinity, small changes in focus are less likely to have an effect.

Figure 12.11 Correct focus (top), front focus (middle), and back focus (bottom).

Lens Tune-Up

The AF Micro Adj setting in the Custom Settings menu is the key tool you can use to fine-tune your A-mount lens used with the LA-EA2 or LA-EA4 adapter. Of course, this assumes you are using an A-mount lens and the adapter. You'll find the process easier to understand if you first run through this quick overview of the menu options:

- AF Adjustment Setting. Set: This option enables AF fine-tuning for all the lenses you've registered using this menu entry. If you discover you don't care for the calibrations you make in certain situations (say, it works better for the lens you have mounted at middle distances, but is less successful at correcting close-up focus errors), you can deactivate the feature as you require. You should set this to On when you're doing the actual fine-tuning. Adjustment values range from −20 to +20. Off: Disables autofocus micro adjustment.
- **Amount.** You can specify values of plus or minus 20 for each of the lenses you've registered. When you mount a registered lens, the degree of adjustment is shown here. If the lens has not been registered, then +/-0 is shown. If "—" is displayed, you've already registered the maximum number of lenses—up to 30 different lenses can be registered with each camera.
- **Clear.** Erases *all* user-entered adjustment values for the lenses you've registered. When you select the entry, a message will appear. Select OK and then press the center button of the control wheel to confirm.

Evaluate Current Focus

The first step is to capture a baseline image that represents how the lens you want to fine-tune autofocuses at a particular distance. You'll often see advice for photographing a test chart with millimeter markings from an angle, and the suggestion that you autofocus on a particular point on the chart. Supposedly, the markings that actually *are* in focus will help you recalibrate your lens. The problem with this approach is that the information you get from photographing a test chart at an angle doesn't actually tell you what to do to make a precise correction. So, your lens back focuses three millimeters behind the target area on the chart. So what? Does that mean you change the Saved Value by -3 clicks? Or -15 clicks? Angled targets are a "shortcut" that don't save you time.

Instead, you'll want to photograph a target that represents what you're actually trying to achieve: a plane of focus locked in by your lens that represents the actual plane of focus of your subject. For that, you'll need a flat target, mounted precisely perpendicular to the sensor plane of the camera. Then, you can take a photo, see if the plane of focus is correct, and if not, dial in a bit of fine-tuning in the AF Fine Tuning menu, and shoot again. Lather, rinse, and repeat until the target is sharply focused.

You can use the focus target shown in Figure 12.12, or you can use a chart of your own, as long as it has contrasty areas that will be easily seen by the autofocus system, and without very small details that are likely to confuse the AF. Download your own copy of my chart from

Figure 12.12 Use this focus test chart, or create one of your own.

www.dslrguides.com/FocusChart.pdf. (The URL is *case sensitive*.) Then print out a copy on the largest paper your printer can handle. (I don't recommend just displaying the file on your monitor and focusing on that; it's unlikely you'll have the monitor screen lined up perfectly perpendicular to the camera sensor.) Then, follow these steps:

- 1. **Position the camera.** Place your camera on a sturdy tripod with a remote release attached, positioned at roughly eye-level at a distance from a wall that represents the distance you want to test for. Keep in mind that autofocus problems can be different at varying distances and lens focal lengths, and that you can enter only *one* correction value for a particular lens. So, choose a distance (close-up or mid range) and zoom setting with your shooting habits in mind.
- 2. **Set the autofocus mode.** Choose the autofocus mode you want to test.
- 3. Level the camera (in an ideal world). If the wall happens to be perfectly perpendicular, you can use a bubble level, plumb bob, or other device of your choice to ensure that the camera is level to match. Many tripods and tripod heads have bubble levels built in. Avoid using the center column, if you can. When the camera is properly oriented, lock the legs and tripod head tightly.
- 4. Level the camera (in the real world). If your wall is not perfectly perpendicular, use this old trick. Tape a mirror to the wall, and then adjust the camera on the tripod so that when you look through the viewfinder at the mirror, you see directly into the reflection of the lens. Then, lock the tripod and remove the mirror.
- 5. **Mount the test chart.** Tape the test chart on the wall so it is centered in your camera's viewfinder.
- 6. **Photograph the test chart using AF.** Allow the camera to autofocus, and take a test photo using the remote release to avoid shaking or moving the camera.
- 7. **Make an adjustment and re-photograph.** Navigate to the Custom Settings menu and choose AF Micro Adj. Make sure the feature has been turned on, then press down to Amount and make a fine-tuning adjustment, plus or minus, and photograph the target again.
- 8. **Lather, rinse, repeat.** Repeat steps 6 and 7 several times to create several different adjustments to check.
- 9. **Evaluate the image(s).** If you have the camera connected to your computer with a USB cable or through a Wi-Fi connection, so much the better. You can view the image(s) after transfer to your computer. Otherwise, *carefully* open the camera card door and slip the memory card out and copy the images to your computer.
- 10. **Evaluate focus.** Which image is sharpest? That's the setting you need to use for this lens. If your initial range doesn't provide the correction you need, repeat the steps between -20 and +20 until you find the best fine-tuning. Once you've made an adjustment, the -7 will automatically apply the AF fine-tuning each time that lens is mounted on the camera, as long as the function is turned on.

MAXED OUT

If you've reached the maximum number of lenses (which is unlikely—who owns 30 lenses?), mount a lens you no longer want to compensate for, and reset its adjustment value to ± -0 . Or you can reset the values of all your lenses using the Clear function and start over.

What Lenses Can Do for You

A sane approach to expanding your lens collection is to consider what each of your options can do for you and then choose the type of lens that will really boost your creative opportunities. Here's a guide to the sort of capabilities you can gain by adding a lens (using an adapter, if necessary) to your repertoire.

- Wider perspective. A 24-70mm or 28-70mm lens can serve you well for moderate wide-angle to medium telephoto shots. Now you find your back is up against a wall and you *can't* take a step backward to take in more subject matter. Perhaps you're standing on the boulevard adjacent to the impressive domed walls of the Mirogoj Cemetery in Zagreb, Croatia, and you want to show the expanse of the walls, as I did for the photo in Figure 12.13, made with the Sony/Zeiss 16-35mm f/4 zoom lens. Or, you might find yourself just behind the baseline at a high school basketball game and want an interesting shot with a little perspective distortion tossed in the mix. If you often want to make images with a super wide field of view, a wider lens is in your future.
- Bring objects closer. A long focal length brings distant subjects closer to you, allows you to produce images with very shallow depth-of-field, and avoids the perspective distortion that wide-angle lenses provide. If you find the traffic on the street intrusive, as I did in Zagreb, you can zoom in to eliminate the distraction, as in Figure 12.14. A lens like the Sony/Zeiss 24-70mm f/4 can be your best friend.
 - Or, perhaps you want to zoom in on one of the domes. As I write this, the longest focal length in an FE lens zooms from 70 to only 200mm, but even that can provide an obvious telephoto effect. If you own such a lens, it's easy to blur the background because the maximum remains f/4 at long focal lengths. With the right adapter, you can also use a much longer super telephoto lens on your a7 II, as I did for Figure 12.15, using my Minolta 100-400mm lens.
- Bring your camera closer. Sony's 90mm FE macro lens is great, but you can also use an adapter and work with other close-up lenses if you don't want to purchase the E-mount 30mm f/3.5 macro lens. Sony has two excellent A-mount macro lenses that would be fine for use with an adapter; you might own one of these or may be able to borrow one: the 50mm f/2.8 and the 100mm f/2.8 macro lens.

Figure 12.13
A 16mm view shows
a broad expanse of
wall outside the
Mirogoj Cemetery
in Zagreb, Croatia.

Figure 12.14
This photo, taken from roughly the same distance, shows the view using a 70-200mm telephoto lens at 100mm.

Figure 12.15
A long telephoto lens at 300mm captured this view from approximately the same shooting position.

Even if the autofocus speed you get isn't fast enough for you, the need to manually focus an A-mount macro lens is not a tremendous hardship. Most serious photographers use manual focus in extreme close-up photography for the most convenient method of controlling the exact subject element that will be in sharpest focus. The A-mount 100mm f/2.8 macro lens (\$800) is preferable to the shorter macro lenses in nature photography because you do not need to move extremely close to a skittish subject for high magnification. And you can get a frame-filling photo of a tiny blossom without trampling all the other plants in its vicinity.

- Look sharp. Many lenses, particularly the higher-priced Sony and Zeiss optics, are prized for their sharpness and overall image quality. Your run-of-the-mill lens is likely to be plenty sharp for most applications at the optimum aperture (usually f/8 or f/11), but the very best optics, such as the Zeiss 55mm f/1.8, are definitely superior. You can expect to get excellent sharpness in much of the image area at the maximum aperture, high sharpness even in the corners by one stop down, more consistent sharpness at various focal lengths with a zoom, and better correction for various types of distortions (discussed shortly).
- More speed. Your basic lens might have the perfect focal length and sharpness for sports photography, but the maximum aperture may be small at telephoto focal lengths, such as f/5.6 or f/6.3 at the far end. That won't cut it for night baseball or football games, since you'll need to use an extremely high ISO (where image quality suffers) to be able to shoot at a fast shutter speed to freeze the action. Even outdoor sports shooting on overcast days can call for a high ISO if you're using a slow zoom lens (with small maximum apertures).

That makes the FE-mount lenses with a very wide aperture (small f/number) such as the 24mm f/2 optic a prime choice (so to speak) for low-light photography when you can get close to the action; that's often possible at an amateur basketball or volleyball game. But, you might be happier with an adapter and an A-mount lens, such as the Carl Zeiss Sonnar T* 135mm f/1.8 lens (if money is no object; it costs \$1,700). But there are lower-cost fast lens options, such as the 50mm f/1.4 lens (\$450), which might be suitable for indoor sports in a gym and whenever you must shoot in dark locations, in a castle or cathedral or theater, for example.

Categories of Lenses

Lenses can be categorized by their intended purpose—general photography, macro photography, and so forth—or by their focal length. The range of available focal lengths is usually divided into three main groups: wide-angle, normal, and telephoto. Prime lenses fall neatly into one of these classifications. Zooms can overlap designations, with a significant number falling into the catchall wide-to-telephoto zoom range. This section provides more information about focal length ranges, and how they are used.

Any lens with a focal length of 10mm to 20mm is said to be an *ultra-wide-angle lens*; from about 20mm to 40mm is said to be a *wide-angle lens*. *Normal lenses* have a focal length roughly equivalent to the diagonal of the film or sensor, in millimeters, and so fall into the range of about 45mm to 60mm on a full-frame camera like your a7 II—series model. *Telephoto lenses* usually fall into the 75mm and longer focal lengths, while those with a focal length much beyond 300mm are referred to as *super telephotos*.

Using Wide-Angle Lenses

To use wide-angle prime lenses and wide zooms, you need to understand how they affect your photography. Here's a quick summary of the things you need to know.

- More depth-of-field (apparently). Practically speaking, wide-angle lenses seem to produce more extensive depth-of-field at a particular subject distance and aperture. However, the range of acceptable sharpness actually depends on magnification: the size of the subject in the frame. With a wide-angle lens, you usually include a full scene in an image; any single subject is not magnified very much, so the depth-of-field will be quite extensive. When using a telephoto lens however, you tend to fill the frame with a single subject (using high magnification), so the background is more likely to be blurred. (I'll discuss this in more detail in the sidebar below.) You'll find a wide-angle lens helpful when you want to maximize the range of acceptable sharpness in a landscape, for example. On the other hand, it's very difficult to isolate your subject (against a blurred background) using selective focus unless you move extremely close. Telephoto lenses are better for this purpose and as a bonus, they also include fewer extraneous elements of the scene because of their narrower field of view.
- Stepping back. Wide-angle lenses have the effect of making it seem that you are standing farther from your subject than you really are. They're helpful when you don't want to back up—or can't because of impediments—to include an entire group of people in your photo, for example.
- Wider field of view. While making your subject seem farther away, as implied above, a wideangle lens also provides a more expansive field of view, including more of the scene in your photos.
- More foreground. As background objects appear further back than they do to the naked eye, more of the foreground is brought into view by a wide-angle lens. That gives you extra emphasis on the area that's closest to the camera. Photograph your home with a 50mm focal length, for example, and the front yard probably looks fairly conventional in your photo. Switch to a wider lens, such as the 16mm setting of the 16-35mm f/4 zoom, and you'll discover that your lawn now makes up much more of the photo. So, wide-angle lenses are great when you want to emphasize that lake in the foreground, but problematic when your intended subject is located farther in the distance.

- Super-sized subjects. The tendency of a wide-angle lens to emphasize objects in the foreground while de-emphasizing objects in the background can lead to a kind of size distortion that may be more objectionable for some types of subjects than others. Shoot a bed of flowers up close with a 16mm or shorter focal length, and you might like the distorted effect of the nearby blossoms looming in the photo. Take a shot of a family member with the same lens from the same distance, and you're likely to get some complaints about that gigantic nose in the foreground.
- Perspective distortion. This type of distortion occurs when you tilt the camera so the plane of the sensor is no longer perpendicular to the vertical plane of your subject. As a result, some parts of the subject are now closer to the sensor than they were before, while other parts are farther away. This is what makes buildings, flagpoles, or NBA players appear to be leaning over backward (like the building shown in Figure 12.16). While this kind of apparent distortion is actually caused by tilting the camera/lens upward (not by a defect in the lens), it can happen with any lens, but it's most apparent when a wide angle is used.
- Steady cam. You'll find that it is easier to get photos without blur from camera shake when you hand-hold a wide-angle lens at slower shutter speeds than it is with a telephoto lens. And, thanks to SteadyShot stabilization, you can take sharp photos at surprisingly long shutter speeds at a long focal length without using a tripod. That's because the reduced magnification of the wide-angle lens or wide-zoom setting doesn't emphasize camera shake like a telephoto lens does.
- Interesting angles. Many of the factors already listed combine to produce more interesting angles when shooting with wide-angle lenses. Raising or lowering a telephoto lens a few feet probably will have little effect on the appearance of a distant subject that fills the frame. The same change in elevation can produce a dramatic effect if you're using a short focal length and are close to your subject.

DOF IN DEPTH

The depth-of-field advantage of wide-angle lenses disappears when you enlarge your picture. Believe it or not, a wide-angle image enlarged and cropped to provide the same subject size as a telephoto shot will have the same depth-of-field. Try it: take a wide-angle photo of a friend from a fair distance. Then, use a longer (telephoto) zoom setting from the same shooting position to take the same picture; naturally, your friend will appear to be larger in the second because of the greater telephoto magnification.

Download the two photos to your computer. While viewing the wide-angle shot, magnify it with the zoom or magnify tool so your friend is as large as in the telephoto image. You'll find that the wide-angle photo will have the same depth-of-field as the telephoto image; for example, the background will be equally blurred.

Figure 12.16 Tilting the camera produces this "falling back" look in architectural photos.

Avoiding Potential Wide-Angle Problems

Wide-angle lenses have a few quirks that you'll want to keep in mind when shooting so you can avoid falling into some common traps. Here's a checklist of tips for avoiding common problems:

- Symptom: converging lines. Unless you want to use wildly diverging lines as a creative effect, it's a good idea to keep horizontal and vertical lines in landscapes, architecture, and other subjects carefully aligned with the sides, top, and bottom of the frame. To prevent undesired perspective distortion, you must take care not to tilt the camera. If your subject is very tall, like a building, you may need to shoot from an elevated position (like a high level in a parking garage) so you won't need to tilt the lens upward. And if your subject is short, like a small child, get down to a lower level so you can get the shot without tilting the lens downward.
- **Symptom: color fringes around objects.** Lenses often produce photos that are plagued with fringes of color around backlit objects, produced by *chromatic aberration*. This common lens flaw comes in two forms: *longitudinal/axial*, in which all the colors of light don't focus in the same plane, and *lateral/transverse*, in which the colors are shifted to one side. Axial chromatic aberration can be reduced by stopping down the lens (to f/8 or f/11, for example), but transverse chromatic aberration cannot.
 - Better-quality lenses reduce both types of imaging defect; it's common for reviews to point out these failings, so you can choose the best performing lenses that your budget allows. The Lens Compensation feature in the Custom Settings menu can help reduce this problem. Leave it set for Auto to get the chromatic aberration reduction processing that the camera can provide.
- Symptom: lines that bow outward. Some wide-angle lenses cause straight lines to bow outward, an effect called barrel distortion; you'll see the strongest effect at the edges. Most fisheye (or *curvilinear*) lenses produce this effect as a feature of the lens; it's much more obvious than with any other type of lens. (See Figure 12.17.) The mild barrel distortion you get with a conventional lens is rarely obvious except in some types of architectural photography. If you find it objectionable, you'll need to use a well-corrected lens.
 - Manufacturers like Sony do their best to minimize or eliminate it (producing a *rectilinear* lens), often using *aspherical* lens elements (which are not cross-sections of a sphere). You can also minimize barrel distortion simply by framing your photo with some extra space all around, so the edges where the bowing outward is most obvious can be cropped out of the picture. The Lens Correction feature can help reduce this problem, too. Leave it set to Auto to allow the processor to minimize the slight barrel distortion that can occur with the more affordable lenses.

■ Symptom: light and dark areas when using a polarizing filter. You should be aware that polarizers work best when the camera is pointed 90 degrees away from the sun and have the least effect when the camera is oriented 180 degrees from the sun. This is only half the story, however. With lenses like the 16-35mm f/4 zoom, the range is extensive enough to cause problems.

Think about it: if you use the widest setting of such a zoom, and point it at a part of a scene that's at the proper 90-degree angle from the sun, the areas of the scene that are at the edges of the frame will be oriented at much wider angles from the sun. Only the center of the image area will be at exactly 90 degrees. When the filter is used to darken a blue sky, the sky will be very dark near the center of your photo. Naturally, the polarizing effect will be much milder at the edges so the sky in those areas will be much lighter in tone (less polarized). The solution is to avoid using a polarizing filter in situations where you'll be including the sky with lenses that have an actual focal length of less than about 28mm.

Figure 12.17 Many wide-angle lenses cause lines to bow outward toward the edges of the image. That's often not noticeable unless you use a fisheye lens; the effect is considered to be interesting and desirable.

Using Telephoto and Tele-Zoom Lenses

Telephoto lenses also can have a dramatic effect on your photography. Here are the most important things you need to know. In the next section, I'll concentrate on telephoto considerations that can be problematic—and how to avoid those problems.

- Selective focus. Long lenses have reduced depth-of-field, a shallow range of acceptably sharp focus, especially at wide apertures (small f/numbers); this is useful for selective focus to isolate your subject. You can set the widest aperture to create shallow depth-of-field, or close it down (to a small f/number) to allow more of the scene to appear to be in acceptably sharp focus. The flip side of the coin is that even at f/16, a 300mm and longer lens will not provide much depth-of-field, especially when the subject is large in the frame (magnified). Like fire, the depth-of-field aspects of a telephoto lens can be friend or foe.
- **Getting closer.** Telephoto lenses allow you to fill the frame with wildlife, sports action, and candid subjects. No one wants to get a reputation as a surreptitious or "sneaky" photographer (except for paparazzi), but when applied to candids in an open and honest way, a long lens can help you capture memorable moments while retaining enough distance to stay out of the way of events as they transpire.
- Reduced foreground/increased compression. Telephoto lenses have the opposite effect of wide angles: they reduce the importance of things in the foreground by squeezing everything together. This so-called *compressed perspective* makes objects in the scene appear to be closer than they are to the naked eye. You can use this effect as a creative tool. You've seen the effect hundreds of times in movies and on television, where the protagonist is shown running in and out of traffic that appears to be much closer to the hero (or heroine) than it really is.
- Accentuates camera shakiness. Telephoto focal lengths hit you with a double whammy in terms of camera/photographer shake. The lenses themselves are bulkier, more difficult to hold steady, and may even produce a barely perceptible seesaw rocking effect when you support them with one hand halfway down the lens barrel. As they magnify the subject, they amplify the effect of any camera shake. It's no wonder that image stabilization like Optical SteadyShot (OSS) is especially popular among those using longer lenses, and why Sony includes this feature in the 18-200mm zooms (and many of the long A-mount lenses).
- Interesting angles require creativity. Telephoto lenses require more imagination in selecting interesting angles, because the "angle" you do get on your subjects is so narrow. Moving from side to side or a bit higher or lower can make a dramatic difference in a wide-angle shot, but raising or lowering a telephoto lens a few feet probably will have little effect on the appearance of the distant subjects you're shooting.

Avoiding Telephoto Lens Problems

Many of the "problems" that telephoto lenses pose are really just challenges and not that difficult to overcome. Here is a list of the seven most common picture maladies and suggested solutions.

- Symptom: flat faces in portraits. Head-and-shoulders portraits of humans tend to be more flattering when a focal length of 50mm to 85mm is used with a full-frame camera. Longer focal lengths compress the distance between features like the nose and ears, making the face look wider and flat. (Conversely, a wide-angle lens will make the nose look huge and ears tiny if you move close enough for a head-and-shoulders portrait.) So avoid using a focal length much longer than about 60mm with your a7R II/a7 II unless you're forced to shoot from a greater distance. (Use a wide-angle lens only when shooting three-quarters/full-length portraits, or group shots.)
- Symptom: blur due to camera shake. Because a long focal length amplifies the effects of camera shake, make sure the SteadyShot stabilization is not turned off (with a menu item). Then, if possible, use a faster shutter speed; that may mean that you'll need to set a higher ISO to be able to do so. Of course, a firm support like a solid tripod is the most effective tool for eliminating camera shake, especially if you trip the shutter with a remote commander accessory or the self-timer to avoid the risk of jarring the camera. Of course, only the fast shutter speed option will be useful to prevent blur caused by *subject* motion; SteadyShot or a tripod won't help you freeze a race car in mid-lap.
- Symptom: color fringes. Chromatic aberration is the most pernicious optical problem found in telephoto lenses. There are others, including spherical aberration, astigmatism, coma, curvature of field, and similarly scary-sounding phenomena. The best solution for any of these is to use a better lens that offers the proper degree of correction for aberrations, or stop down the lens (to f/8 or f/11) to minimize the problem. But that's not always possible. Your second-best choice may be to correct the fringing in your favorite RAW conversion tool or image editor. Photoshop's Lens Correction filter offers sliders that minimize both red/cyan and blue/yellow fringing. A feature such as this (also available with some other software) can be useful in situations where the a7R II/a7 II's Lens Compensation feature doesn't fully correct for chromatic aberration.
- Symptom: lines that curve inward. Pincushion distortion is common in photos taken with many telephoto lenses; lines, especially those near the edges of the frame, bow inward like the pincushion your grandma might have used. You can take photos of a brick wall at various focal lengths with your zoom lens to find out where the pincushion distortion is the most obvious; that will probably be at or near the longest focal length. Like chromatic aberration, it can be partially corrected using tools like Photoshop's Lens Correction filter (or a similar utility in some other software).

- Symptom: low contrast from haze or fog. When you're photographing distant objects, a long lens shoots through a lot more atmosphere, which generally is muddied up with extra haze and fog. The dust or moisture droplets in the atmosphere can reduce contrast and mute colors. Some feel that a skylight or UV filter can help, but this practice is mostly a holdover from the film days. Digital sensors are not sensitive enough to UV light for a UV filter to have much effect. A polarizer might help a bit, but only in certain circumstances. I don't consider this to be a huge problem because it's easy to boost contrast and color saturation in Picture Styles (a menu item) or later in image-editing software.
- Symptom: low contrast from flare. Lenses are often furnished with lens hoods for a good reason: to minimize the amount of stray light that will strike the front element causing flare or a ghost image of the diaphragm containing the aperture. A hood is effective when the light is at your side, but it has no value when you're shooting toward the sun. On the other hand, you'll often be shooting with the light striking the lens from an angle. In this situation, the lens hood is only partially effective, so minimize flare by using your hand or cap to cast a shadow over the front element of the lens. (Just be careful not to let your hand or cap intrude into the image area.)
- Symptom: dark flash photos. Edge-to-edge flash coverage isn't as problematic with telephoto lenses as it is with wide angles. (An electronic flash simply cannot provide light that covers the entire field of view that's recorded by a lens shorter than 16mm.) The shooting distance is the problem with longer lenses. A 210mm focal length might allow you to make a distant subject appear close to the camera, but the flash isn't fooled. You'll need extra power for distant flash shots, making a large accessory flash unit a valuable accessory.
 - If you do not have a powerful flash unit and cannot get closer to the subject (like Lady Gaga strutting her stuff on a dark stage), try setting the camera's ISO level to 3200. This increases the sensitivity of the sensor so less light is required to make a bright photo; of course, the photo is likely to be grainy because of digital noise. If that does not solve the problem, you will need to set an even higher ISO, but then you'll get even more obvious digital noise in your photo.

Working with Flash

Photography is a form of visual art that uses light to shape the finished product. The photographer may have little or no control over the subject (other than posing human subjects) but can often adjust both viewing angle *and* the nature of the light source to create a particular compelling image. The direction and intensity of the light sources create the shapes and textures that we see. The distribution and proportions determine the contrast and tonal values: whether the image is stark or high key, or muted and low in contrast. The colors of the light (because even "white" light has a color balance that the sensor can detect), and how much of those colors the subject reflects or absorbs, paint the hues visible in the image.

As a Sony photographer, you must learn to be a painter and sculptor of light if you want to move from *taking* a picture to *making* a photograph. Most of the time, you'll be working with available or ambient light, perhaps with reflectors or other modifiers, or even some additional continuous light sources, such as incandescent or fluorescent lamps. But at times you'll want to turn to one of the most versatile sources of illumination you have available, the brief, but brilliant snippets of light we call *electronic flash*. This chapter will show you the differences between working with continuous illumination and working with flash, and explain how to use the flash capabilities of the Sony a7R II/a7 II.

Why Flash?

Flash sometimes gets a bad rap, but that's usually prompted by photographers who make poor use of the capabilities electronic flash offers. In some respects, working with continuous lighting instead is easier and more predictable. Conventional lighting is exactly what you might think: uninterrupted illumination that is available all the time during a shooting session. Daylight, moonlight, and the artificial lighting encountered both indoors and outdoors count as continuous light sources (although all of them can be "interrupted" by passing clouds, solar eclipses, a blown fuse, or simply by switching off a lamp). Indoor continuous illumination includes both the lights that are there already (such as incandescent lamps or overhead fluorescent lights indoors) and fixtures you supply yourself, including photoflood lamps or reflectors used to bounce existing light onto your subject.

On the face of things, electronic flash may be uncomfortably *different* from what we are used to, and sometimes considered difficult to use. In practice, you can use flash in all the same ways you use continuous lighting to shape your images, and, in some cases, take advantage of its special properties, such as its action-freezing short duration. Electronic flash is notable because it can be much more intense than continuous lighting, lasts only a brief moment, and can be much more portable than supplementary incandescent sources. It's a light source you can carry with you and use anywhere.

Of course, your Sony a7R II/a7 II does not have a built-in flash of any sort. There are several reasons for that. The company wanted to make the a7 II—series cameras exceptionally compact, and a built-in flash would have added bulk. In addition, as you are undoubtedly painfully aware, the cameras are equipped with undersized 1020 mAh batteries, with less capacity even than those found in some point-and-shoot cameras. I estimate that with heavy flash usage drawing power from an NP-FW50 battery, you would scarcely get 50 shots from a single charge. So, any electronic flash used with these cameras is necessarily an external flash with its own power supply, which happily solves the power drain situation while reducing red-eye and other effects of on-camera flash.

Before moving on to discussing flash in detail, here's a quick comparison of the pros and cons of continuous illumination versus flash:

■ Lighting preview—Pro: continuous lighting. With continuous lighting, such as incandescent lamps or daylight, you always know exactly what kind of lighting effect you're going to get. If you're using multiple lights, you can visualize how they will interact with each other. With electronic flash, the general effect you're going to see may be a mystery until you've built some experience.

- Lighting preview—Con: electronic flash. Compact portable flash units often do not provide a "modeling light" function, although studio flash typically do.
- Exposure calculation—Pro: continuous lighting. Your camera has no problem calculating accurate exposure for continuous lighting, because the lighting remains constant and can be measured through built-in light meters that interpret the light reaching the sensor. The amount of light available just before the exposure will, in almost all cases, be the same amount of light present when the shutter mechanism is opened to take the shot. The Spot metering mode can be used to measure brightness in the bright areas of the scene and the dark areas; if you have a bit of expertise in this technique, you'll know whether it would be useful to bounce some light into the shadow areas using a reflector panel accessory.
- Exposure calculation—Con: electronic flash. A flash unit provides no illumination until it actually fires so the exact exposure can't be measured by the a7R II/a7 II's exposure sensor before you take a photo. Instead, the light must be measured by metering the intensity of a pre-flash triggered an instant before the main flash, as it is reflected back to the camera and through the lens.
- Evenness of illumination—Pro/con: continuous lighting. Of continuous light sources, day-light, in particular, provides illumination that tends to fill an image completely, lighting up the foreground, background, and your subject almost equally. A sunlit scene may have shadow areas too, of course, so you might need to use reflectors or fill-in light sources to even out the illumination. Barring objects that block large sections of your image from daylight, the light is spread fairly evenly. Indoors, however, continuous lighting is much less likely to be evenly distributed. The average living room, for example, has hot spots and dark corners. But on the plus side, you can *see* this uneven illumination and compensate with additional lamps.
- Evenness of illumination—Con: electronic flash. Electronic flash units, like the continuous light provided by lamps, don't have the advantage of being located 93 million miles from the subject as the sun is. Because of this factor, they suffer from the effects of their proximity.
 - The *inverse square law*, first applied to both gravity and light by Sir Isaac Newton, dictates that as a light source's distance increases from the subject, the amount of light reaching the subject falls off proportionately to the square of the distance. In plain English, that means that a flash or lamp that's 12 feet away from a subject provides only one-quarter as much illumination as a source that's 6 feet away (rather than half as much). (See Figure 13.1.) This translates into relatively shallow "depth-of-light."

■ Action stopping—Pro: electronic flash. When it comes to the ability to freeze moving objects in their tracks, the advantage goes to electronic flash. The brief duration of the emitted light serves as a very fast "shutter speed" when the flash is the main or only source of illumination for the photo. In other words, this effect is possible when shooting in a dark area without much, if any, lighting provided by ambient sources but assumes that the subject is not beyond the range of the flash.

In flash photography, your camera's shutter speed (called *sync speed* in flash photography) is set to 1/250th second, but when flash is the primary light source, the *effective* exposure time will be the 1/1,000th to 1/50,000th second or less; this is the actual duration of the flash illumination. As you can see in Figure 13.2, it's possible to freeze motion with flash of very short duration. The only fly in the ointment is that, if the ambient light is strong enough, it may produce a secondary "ghost" exposure, as I'll explain later in this chapter.

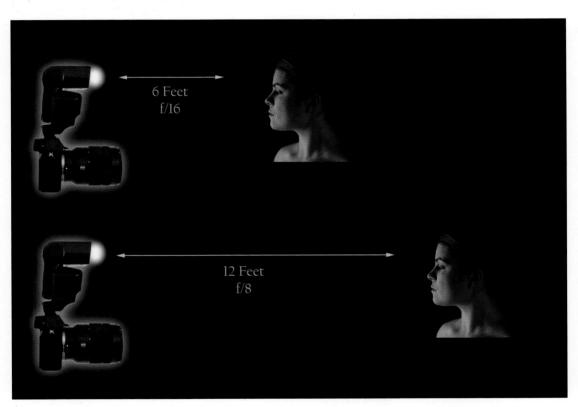

Figure 13.1 A light source that is twice as far away provides only one-quarter as much illumination.

Figure 13.2 Electronic flash can freeze almost any motion because of its extremely short duration.

- Action stopping—Con: continuous lighting. Action stopping with continuous light sources is completely dependent on the shutter speed you've dialed in on the camera. And the speeds available are dependent on the amount of light available and your camera's ISO sensitivity setting. Outdoors in daylight, there will probably be enough sunlight to let you shoot at 1/2,000th second and f/6.3 with a non-grainy ISO of 400. That's a fairly useful combination of settings if you're not using a super-telephoto with a small maximum aperture.
 - But indoors, the reduced illumination quickly has you pushing your a7R II/a7 II to its limits. For example, if you're shooting indoor sports in a dark arena, there probably won't be enough available light to allow you to use a 1/2,000th second shutter speed unless you use a lens with an extremely wide aperture, such as f/1.8, with, say, the Sony Sonnar T* FE 55mm f/1.8 ZA. You can also specify a very high ISO setting, and accept that image quality may suffer. (In truth, the gym where I shoot indoor basketball allows me to do so at 1/500th second at f/4 using ISO 1600.) In many indoor sports situations, you may find yourself limited to a shutter speed of 1/500th second or slower.
- Flexibility—Pro: electronic flash. The action-freezing power of electronic flash, at least for nearby subjects in a dark location, allows you to work without a tripod; that provides extra flexibility and speed when choosing angles and positions.
- Flexibility—Con: continuous lighting. Because incandescent and fluorescent lamps are not as bright as electronic flash, the slower shutter speeds required (see "Action stopping," above) mean that you may have to use a tripod more often, especially when shooting portraits. The incandescent variety of continuous lighting gets hot, especially in the studio, and the side effects range from discomfort (for your human models) to disintegration (if you happen to be shooting perishable foods like ice cream).

Electronic Flash Basics

Until you delve into the situation deeply enough, it might appear that serious photographers have a love/hate relationship with electronic flash. You'll often hear that flash photos are less natural looking, and that on-camera flash in most cameras should never be used as the primary source of illumination because it provides a harsh, garish look. Some photographers strongly praise available ("continuous") lighting while denouncing electronic flash.

As I noted at the beginning of this chapter, that bias is against *bad* flash photography. Indeed, flash—often with light-modifier accessories—has become the studio light source of choice for many pro photographers. That's understandable, because the light is more intense (and its intensity can be dialed up or down by the photographer), freezes action, frees you from using a tripod (unless you want to use one to lock down a composition), and has a snappy, consistent light quality that

matches daylight. (While color balance changes as the flash duration shortens, some Sony flash units can communicate to the camera the exact white balance provided for that shot.) And even conservative photographers will concede that electronic flash has some important uses as an adjunct to existing light, particularly to fill in dark shadows.

How Electronic Flash Works

The electronic flash you use will be connected to the camera by slipping it onto the hot shoe, or linked by a cable connected to an adapter mounted on the shoe. In all cases, the flash is triggered at the instant of exposure, during a period when the sensor is fully exposed by the shutter.

The a7R II and a7 II have electronic shutter options, which I'll describe later, and a conventional vertically traveling physical shutter that consists of two curtains. The front curtain opens and moves to the opposite side of the frame, at which point the shutter is completely open. The flash can be triggered at this point (so-called *front-curtain sync*, which is the default mode), making the flash exposure. Then, after a delay that can vary from 30 seconds to 1/250th second, a second, *rear curtain* begins moving across the sensor plane, covering up the sensor again. If the flash is triggered just before the rear curtain starts to close, then the optional *rear-curtain sync* is used. In both cases, though, a shutter speed of 1/250th second is (ordinarily) the *maximum* that can be used to take a photo, because that's the speed at which both the front and rear curtains are tucked out of the way, leaving the entire full frame exposed to capture the flash burst.

Figure 13.3 illustrates how this works, with a fanciful illustration of a generic shutter (your a7R II/a7 II's shutter does *not* look like this).

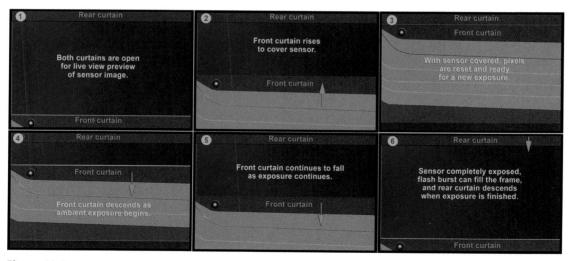

Figure 13.3 A focal plane shutter has two curtains, the lower, or front curtain, and an upper, or rear curtain.

358

As an exposure is made using the conventional (non-electronic) shutter, the curtains move as follows:

- 1. Both curtains open. With a mirrorless camera like the a7R II/a7 II, the sensor remains completely exposed, so that the image that's being captured can be viewed on the electronic viewfinder and LCD monitor.
- 2. Front curtain closes. As the exposure begins, the front curtain rises to cover the sensor.
- 3. Prior image is dumped. When the sensor is completely covered, the preview image is dumped, resetting the pixels so that the exposure can begin.
- 4. Front curtain begins to descend. As the front curtain drops, the sensor is gradually exposed to light, and the *ambient* exposure (using the available light in the scene) begins.
- 5. Front curtain continues to descend. More of the sensor is uncovered, and the ambient exposure continues.
- 6. Both curtains open. With the sensor fully exposed, the electronic flash's brief burst can fill the frame.
 - If this burst takes place as soon as the curtains are fully open, then *front-curtain sync*, which is the default, has been used. Following the flash, the sensor continues to be exposed for the length of the exposure, which can range from 1/250th second to 30 seconds (or longer, with a Bulb exposure).
 - The burst can also take place *at the very end* of the exposure, just before the rear curtain starts to descend. This is called *rear-curtain sync*.
 - When the exposure is finished, the rear curtain descends and the captured image is conveyed off the sensor to the camera's internal buffer, and thence to your memory card. The rear curtain then ascends to the top of the frame, exposing the sensor again and a preview image for the next picture appears in the EVF and LCD monitor.

Keep in mind that the a7R II/a7 II *always* defaults to front-curtain sync unless you explicitly select another sync mode using the Fn button or Flash Mode entry in the Camera Settings menu.

And Now for Something Completely Different...

If you've absorbed that, things are about to get *really* interesting. The a7R II/a7 II have special modes available from the Custom Settings menu, in which either the physical front curtain or both the physical front curtain *and* the rear curtain are simulated electronically. Only one of the two modes can be used with flash.

Here's the difference:

■ e-Front Curtain Shutter. Recall that the sensor of a mirrorless camera is always exposed and feeding its image to the EVF and LCD monitor; in order to capture an image within a specified period of time, the sensor needs to *stop* collecting the image so the exposure can begin. In normal operation, as described above, when you press the shutter release down all the way, the shutter closes and the camera dumps the image you were previewing, resetting the pixels and leaving the sensor blank and ready to capture an exposure. When the e-Front Curtain Shutter, available on both the a7R II and a7R, is enabled, the physical front shutter doesn't close: the image is dumped *electronically*, and then the sensor immediately begins capturing an image. The physical rear curtain shutter then closes at the end of the exposure.

The advantages of the electronic front curtain are that the camera can respond more quickly with less shutter lag, there is no possibility of vibration caused by the physical shutter bouncing at the end of its travel (this was a significant problem with the original a7 series), and an electronic front curtain shutter is quieter. As the a7 II—series is mirrorless, these cameras are already quieter than dSLR models, which have a mirror flapping about before and after the exposure.

However, an electronic front curtain shutter can exhibit problems with certain lenses and very fast shutter speeds. In such cases, when you are using an unusually wide aperture, such as f/1.8, some areas of the photo may exhibit a secondary (ghost) image. The aperture of an affected lens requires the "leaves" to travel a greater distance, and there may simply not be enough time. An overexposure may result. If you encounter that problem, turn the e-curtain option off; otherwise, you can do as I do and leave it on all the time.

■ Electronic shutter. The a7R II has an all-electronic shutter that can be activated by selecting Silent Shooting in the Custom Settings menu. In that case, both the physical front and rear curtains are replaced by electronic equivalents. Exposure is started and stopped electronically, with no curtains at all. Silent Shooting is indeed silent; I've had other photographers watching me snap away in that mode ask me whether I was really taking pictures at all. It is an excellent mode for religious ceremonies and other events where even the quiet click of the e-Front Curtain might be intrusive.

Silent shooting's rolling shutter captures the image line by line (as opposed to a global shutter that grabs the image in one fell swoop), and is subject to the same unwanted side effects found in video cameras, including wobble/jello effect in hand-held shots, diagonal skewing, smear, and other defects. But the most important complication, in terms of the subject of this chapter, is that the electronic shutter cannot be used with flash at all. If you have a flash mounted and powered up and press the shutter release, it won't go off when the electronic shutter is active. Indeed, the Flash Mode options in the Camera Settings menu are grayed out and unavailable.

Avoiding Sync-Speed Problems

Using a shutter speed faster than the maximum sync speed can cause problems. Triggering the electronic flash *only* when the shutter is completely open makes a lot of sense if you think about what's going on. To obtain shutter speeds faster than 1/250th second, the a7R II/a7 II exposes only part of the sensor at one time, by starting the rear curtain on its journey before the front curtain has completely opened. That effectively provides a briefer exposure as the slit of the shutter passes over the surface of the sensor. If the flash were to fire during the time when the front and rear curtains partially obscured the sensor, only the slit that was actually open would be exposed.

You'd end up with only a narrow band, representing the portion of the sensor that was exposed when the picture was taken. For shutter speeds *faster* than the top sync speed, the rear curtain begins moving *before* the front curtain reaches the bottom of the frame. As a result, a moving slit, the distance between the front and rear curtains, exposes one portion of the sensor at a time as it moves from the top to the bottom. Figure 13.4 shows three views of our typical (but imaginary) physical focal plane shutter. At left is pictured the closed shutter; in the middle version you can see the front curtain has moved about 1/4 of the distance down from the top; and in the right-hand version, the rear curtain has started to "chase" the front curtain across the frame toward the bottom.

If the flash is triggered while this slit is moving, only the exposed portion of the sensor will receive any illumination. You end up with a photo like the one shown in Figure 13.5. Note that a band across the bottom of the image is black. That's a shadow of the rear shutter curtain, which had started to move when the flash was triggered. Sharp-eyed readers will wonder why the black band is at the *bottom* of the frame rather than at the top, where the rear curtain begins its journey. The answer is simple: your lens flips the image upside down and forms it on the sensor in a reversed position. You never notice that, because the camera is smart enough to show you the pixels that make up your photo in their proper orientation during picture review. But this image flip is why, if your sensor gets dirty and you detect a spot of dust in the upper half of a test photo, if cleaning manually, you need to look for the speck in the *bottom* half of the sensor.

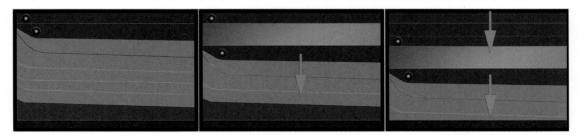

Figure 13.4 A typical exposure using the conventional physical shutter.

Figure 13.5
If a shutter speed faster than 1/250th second is used with flash, you can end up photographing only a portion of the image.

I generally end up with sync speed problems only when shooting in the studio, using studio flash units rather than my Sony dedicated unit. That's because if you're using either type of "smart" flash, the camera knows that a strobe is attached, and remedies any unintentional goof in shutter speed settings. If you happen to set the a7R II/a7 II's shutter to a faster speed in S or M mode, the camera will automatically adjust the shutter speed down to the maximum sync speed as soon as you attach and turn on an external flash (or prevent you from choosing a faster speed if the flash is powered up). In A, or P, where the a7R II/a7 II selects the shutter speed, it will never choose a shutter speed higher than 1/250th second when using flash.

But when using a non-dedicated flash, such as a studio unit plugged into an adapter attached to the accessory shoe, the camera has no way of knowing that a flash is connected, so shutter speeds faster than 1/250th second can be set inadvertently.

Note that the a7R II/a7 II can use a feature called *high-speed sync* that allows shutter speeds faster than the maximum sync speed with certain external dedicated Sony flash units. When using high-speed sync, the flash fires a continuous series of bursts at reduced power for the entire duration of the exposure, so that the illumination is able to expose the sensor as the slit moves.

HS sync is set using the controls that adjust the compatible external flash units, which include the HVL-F58AM, HVL-F56AM, HVL-F43AM/HVL-F43M, HVL-F32M, and HVL-F36AM. It cannot be used when working with multiple flash units. When active, the message H appears on the LCD panel on the back of the flash. You'll find complete instructions accompanying those flash units.

Ghost Images

The difference might not seem like much, but whether you use front-curtain sync (the default setting) or rear-curtain sync (an optional setting) can make a significant difference to your photograph if the ambient light in your scene also contributes to the image. At faster shutter speeds, particularly 1/250th second, there isn't much time for the ambient light to register, unless it is very bright. It's likely that the electronic flash will provide almost all the illumination, so front-curtain sync or rear-curtain sync isn't very important.

However, at slower shutter speeds, or with very bright ambient light levels, there is a significant difference, particularly if your subject is moving, or the camera isn't steady. In any of those situations, the ambient light will register as a second image accompanying the flash exposure, and if there is movement (camera or subject), that additional image will not be in the same place as the flash exposure. It will show as a ghost image and, if the movement is significant enough, as a blurred ghost image trailing in front of or behind your subject in the direction of the movement.

As I mentioned earlier, when you're using front-curtain sync, the flash goes off the instant the shutter opens, producing an image of the subject on the sensor. That happens whether you're using the mechanical shutter or the optional electronic Front Curtain option from the Custom Settings menu. Then, the shutter remains open for an additional period (which, as I've noted, can be from 30 seconds to 1/250th second). If your subject is moving, say, toward the right side of the frame, the ghost image produced by the ambient light will produce a blur on the right side of the original subject image, making it look as if your sharp (flash-produced) image is chasing the ghost. For those of us who grew up with lightning-fast superheroes who always left a ghost trail *behind them*, that looks unnatural (see Figure 13.6).

So, Sony provides rear (second) -curtain sync to remedy the situation. In that mode, the shutter opens, as before. The shutter remains open for its designated duration, and the ghost image forms. If your subject moves from the left side of the frame to the right side, the ghost will move from left to right, too. *Then*, about 1.5 milliseconds before the rear shutter curtain closes, the flash is triggered, producing a nice, sharp flash image *ahead* of the ghost image. Voilà! We have monsieur *le Flash* outrunning his own trailing image.

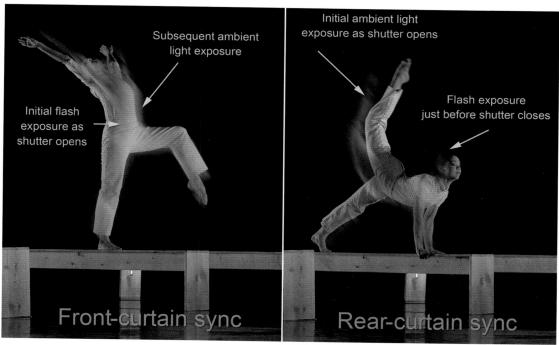

Figure 13.6 Front-curtain sync produces an image that trails in front of the flash exposure (left), whereas rearcurtain sync creates a more "natural looking" trail behind the flash image (right).

EVERY WHICH WAY, INCLUDING UP

Note that although I describe the ghost effect in terms of subject matter that is moving left to right in a horizontally oriented composition, it can occur in any orientation, and with the subject moving in *any* direction. (Try photographing a falling rock, if you can, and you'll see the same effect.) Nor are the ghost images affected by the fact that modern shutters travel vertically rather than horizontally. Secondary images are caused between the time the front curtain fully opens, and the rear curtain begins to close. The direction of travel of the shutter curtains, or the direction of your subject, does not matter.

Slow Sync

Another flash synchronization option is *slow sync*, which is actually an exposure option that tells the a7R II/a7 II to use slower shutter speeds when possible, to allow you to capture a scene by both flash and ambient illumination. To activate Slow Sync, press the Fn button, navigate to the flash options, and choose Slow Sync. Or, make the same selection from the Flash Mode entry in the Camera Settings menu.

Then, the exposure system will try to use longer shutter speeds with the flash, so that an initial exposure is made with the flash unit, and a secondary exposure of subjects in the background will be produced by the slower shutter speed. This will let you shoot a portrait of a person at night and, much of the time, avoid a dark background. Your portrait subject will be illuminated by the flash, and the background by the ambient light. It's a good idea to have the camera mounted on a tripod or some other support, or have SteadyShot switched on to avoid having this secondary exposure produce ghost images due to camera movement during the exposure. (See Figure 13.7.)

Figure 13.7 Without slow sync, ambient light may not be sufficient to balance with the flash exposure (left). When slow sync is activated, longer shutter speeds are selected, allowing the ambient light to register, too (right).

Because Slow Sync is a type of exposure control, it does not work in Manual mode or Shutter Priority mode (because the a7R II/a7 II doesn't choose the shutter speed in those modes). It is not disabled in those modes: you can still select it using the Camera Settings menu or Function menu, but your shutter speed will not be changed.

Determining Exposure

Calculating the proper exposure for an electronic flash photograph is a bit more complicated than determining the settings by continuous light. The right exposure isn't simply a function of how far away your subject is, even though the inverse square law I mentioned does have an effect: the farther away the subject is, the less light is available for the exposure. The a7R II/a7 II can calculate distance if you're using lenses with a *distance encoder chip*, which detects the position of the focusing mechanism as focus is locked in just prior to exposure. The component transmits this information to the camera, which can use it to determine the distance to the subject, and, therefore, much flash output is required to illuminate the scene. This Advanced Distance Integration (ADI) delivers high-precision flash metering that is unaffected by the reflectance of subjects or backgrounds.

But, of course, flash exposure isn't based on distance alone. Various objects reflect more or less light at the same distance so, obviously, the camera needs to measure the amount of light reflected back and through the lens. Yet, as the flash itself isn't available for measuring until it's triggered, the a7R II/a7 II has nothing to measure.

The solution is to fire the flash twice. The initial shot is a pre-flash that can be analyzed, then followed by a main flash that's given exactly the calculated intensity needed to provide a correct exposure. As a result, the primary flash may be longer for distant objects and shorter for closer subjects, depending on the required intensity for exposure. This through-the-lens evaluative flash exposure system uses distance information, and it operates whenever you have attached a Sony dedicated flash unit to the a7R II/a7 II, and a lens that provides the necessary distance integration information.

Flash Modes

There are several flash modes available in the Camera Settings menu:

- Flash Off. The flash never fires; this may be useful in museums, concerts, or religious ceremonies where electronic flash would prove disruptive. This option is not available in P, A, S, or M mode; if you do not want flash to fire, turn it off.
- **Auto Flash.** The flash fires as required, depending on lighting conditions. Not available in P, A, S, or M mode because flash *always* fires in these modes if it's attached and powered up, in the up position.
- Fill-Flash. When this option is set, the flash will always fire when set to P, A, S, or M modes, using one of the two Auto modes or in SCN modes where flash is not disabled. The camera balances the available illumination with flash to provide a balanced lighting effect. (See Figure 13.8.)

Figure 13.8 The owl (top) was in shadow. Fill flash (bottom) brightened up the bird, while adding a little catch light to its eye.

- **Slow Sync.** The camera combines flash with slow shutter speeds; the nearby subject can be illuminated by flash, but during the longer shutter speed, there's enough time for the darker surroundings (lit by ambient light) to record on the sensor.
- **Rear Sync.** Fires the flash at the *end* of the exposure time, after the ambient light exposure has been made, producing more satisfying photos of moving subjects when using a long exposure; light trails will be behind the "ghost" image, as illustrated earlier in Figure 13.6.
- Wireless. Allows an optional external flash mounted on the camera's multi-interface shoe to trigger one or more external flash units that support wireless off-camera flash; there's no need for any cable connection between the camera and the remote flash unit.

Flash Exposure Compensation

This is a feature discussed previously in Chapter 3. It's important to keep in mind how the camera's exposure compensation system works when you're using electronic flash. To activate exposure compensation for flash, visit the Flash Comp. item in the Camera Settings menu or use the Function menu, and set the amount of plus or minus compensation you want. This function is not available when using Auto or SCN modes or Panorama mode. When you find that your flash photos are too dark even after you have set +3, then the flash simply cannot provide more power; you must move closer to the subject, or use a wider aperture, or set a higher ISO, or take all of these steps. Note too that when a subject is extremely close to the camera, even a -3 setting may not prevent an excessively bright image. You'll probably have to *reduce* your ISO setting in that case.

Figure 13.9 Set flash exposure compensation.

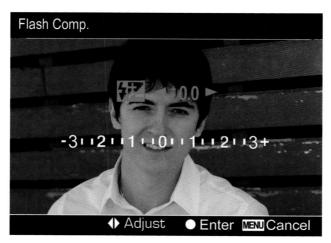

Flash exposure compensation affects only the amount of light emitted by the flash. If you want to adjust the brightness of the ambient light exposure, you would also need to use the conventional exposure compensation feature. In fact, you can use both features at the same time, to get a brighter subject and a darker background, or vice versa. Let's say you're taking a photo of a friend posing against a light-toned background such as a white cabana on a beach. A plus exposure compensation setting (perhaps +1 when using multi-segment metering) will ensure that the cabana won't be underexposed while a -1/3 or -2/3 flash exposure compensation will ensure that shadows on your friend's face will be lightened by a very gentle burst of flash. This is an advanced technique that requires some experimentation but can be valuable when used with some expertise.

Red Eye Reduction

When using semi-automatic or manual exposure modes (or any SCN mode in which flash is used), red-eye reduction is available if Red Eye Reduction is On in the Camera Settings menu (as described in Chapter 4). The flash will fire a burst before the photo is actually taken as you depress the shutter release button. That will theoretically cause your subjects' irises to contract (if they are looking toward the camera), thereby reducing the red-eye effect in your photograph.

Using an External Electronic Flash

As I write this, Sony offers four accessory electronic flash units that are compatible with the a7R II/a7 II's new-style multi-interface shoe: the HVL-F60M, HVL-F43M, HVL-F32M, and HVL-F20M. These external units can be mounted on the camera, connected to the camera's multi-interface shoe with a cable (I'll detail how later) or (except for the HVL-F20M) used off-camera with wireless connectivity when triggered by another external flash used as a controller/master. Each can also function as the controller/master mounted on the a7 II—series camera to trigger other flash units wirelessly.

In addition, there are earlier Sony flash units designed for the older Minolta/Sony proprietary hot shoe. They can be used with the a7 II—series cameras if you purchase an inexpensive adapter, such as the Sony ADP-MAA (about \$25). Or, you can skip the adapter and use these legacy flash units off-camera in wireless mode, triggered by an on-camera master/controller. Although they are discontinued, I'll describe some of these earlier flash units because you may already own one or can find one used at a price that's hard to resist. I don't recommend the legacy flash/adapter approach, because older units operate using a more limited communication protocol, which I'll describe later. But because some of you may have an older flash, or can pick one up used at a decent price, it doesn't make sense to pretend that these discontinued models don't exist, because they still can work with your a7R II/a7 II, especially as remote/slave units.

Guide Numbers, Hot Shoes, and More

Before I describe the flash units themselves, there are a few aspects you need to understand in order to compare electronic flash. If you're a veteran Sony (or Minolta) shooter, you can skim over this section, or skip it entirely. Those new to photography or the Sony realm should find this information useful.

Guide Numbers

The first thing you need to learn when comparing flash units is that Sony incorporates the Guide Number (GN) of each flash in the product name. So, what's a Guide Number? The GN designation derives from the good old days prior to automatic flash units and through-the-lens flash metering, when flash exposures had to be calculated mathematically. Those days are very long ago, indeed, as Honeywell introduced Auto/Strobonar flash units way back in the 1960s.

Guide numbers are a standard way of specifying the power of a flash when used in manual, non-autoexposure mode. Divide the guide number by the distance to determine the correct f/stop to use at full power. With a GN of 197 at ISO 100, you would use an aperture of around f/19.7 for a subject that's 10 feet from the camera (197 divided by 10), or around f/9.5 for a subject at a distance of 20 feet. Because most countries in the world use metric measurements, guide numbers are given using values for both meters and feet. Thus, Sony's HVL-F60M unit has a guide number of 60/197 in meters/feet, and the 60 GN is incorporated into the unit's product name.

The Guide Number data is most useful for comparing the relative power of several flash units that you're considering. According to the inverse square law, a flash unit with a GN of 200 (in feet) puts out four times the amount of light as one with a GN of about 100. If your accessory flash has a zoom head, which can change coverage to match the focal length setting of your lens, the GN will vary according to the zoom setting, as wider zoom settings spread the same light over a broader area than a telephoto zoom setting.

Hot Shoes

Starting in 1988, Minolta phased in a proprietary hot shoe, the so-called *iISO* shoe, which was supposedly more rugged and secure than the original ISO 518 shoe, based on a design that dates back to 1913, when it was used to attach viewfinders to a camera (electronic flash hadn't been invented yet). No other vendors, including Canon and Nikon, embraced Minolta's design and continued to use the industry standard shoe. The ISO 518 standard doesn't specify any electronic connections between camera and flash, other than the "dumb" triggering circuit, so when sophisticated electronic flash units with TTL metering and other capabilities were developed, each vendor created their own hot shoe version with the necessary electrical contacts for their cameras and flash units. The chief consequence for non-Minolta/Sony shooters was that you could mount dedicated flash units from one brand onto the ISO 518 shoe of another vendor's camera, and trigger that flash in manual, non-TTL mode.

When Sony purchased Konica Minolta's camera technology it began redesigning legacy features, and the old iISO hot shoe came under scrutiny. In 2012, Sony introduced a 21+3–pin hot shoe which it dubbed the *multi-interface shoe*, which resembles a standard ISO 518 hot shoe with its "dumb" contacts. However, tucked away at the front of the shoe are additional electrical contacts that allow intelligent TTL flash metering communication between the camera and flash, and much more. For example, a whole series of stereo microphones from Sony and others, designed to plug into the multi-interface shoe, are available. As I noted earlier, you can purchase adapters that allow you to connect older iISO flash to the a7R II/a7 II, or to attach new model flash units to a camera that has the original iISO hot shoe.

Cable Connections

In some cases, you can get your external flash off the camera without using a wireless connection by linking an HVL-F60M and a7R II/a7 II with a physical cable. The gear needed for the hook-up can be costly, so I don't recommend it, but if you want to go that route, here's the way to go. Purchase the Sony FA-CS1M multi-interface shoe adapter (about \$40). It slides to the a7 II—series camera's multi-interface shoe, and has a four-pin TTL socket on the front. Connect that socket to a matching four-pin outlet located on the underside of the HVL-F60M, beneath a protective terminal cap, using a 4.9-foot FA-MC1AM cable (\$60). If you need more length, the FA-EC1AM extension cable (\$50) adds another 4.9 feet to your connection. The HVL-F43M does not have the four-pin socket, and connecting it to a cable requires some additional adapters, so you're better off not going that way.

HVL-F60M Flash Unit

This \$550 flagship of the Sony accessory flash line (shown in Figure 13.10) is the most powerful unit the company offers, with an ISO 100 guide number (GN) of 60 in meters or 197 in feet at ISO 100. As I noted earlier, the GN does not indicate actual flash range but it's useful when comparing several flash units in terms of their general power output.

Like all Sony multi-interface shoe flash units except the HVL-F20M, the F60M automatically adjusts the zoom head to vary the angle of coverage to suit the lens focal length in use. You can zoom the head manually instead, if you prefer. A built-in slide-out diffuser panel boosts wide-angle coverage so it's suitable for photos taken at short focal lengths with the 10-18mm zoom. There's also a slide-out "bounce card" that can reflect some light forward even when bouncing the flash off the ceiling, to fill in shadows or add a catch light in the eyes of your portrait subjects. This dust- and moisture-resistant 21-ounce unit uses four AA batteries but can also be connected to the FA-EB1AM external battery adapter (you just blew another \$200), which has room for 6 AA batteries for increased capacity and faster recycling.

Figure 13.10
The Sony HVLF60M is the top-ofthe-line external
flash unit and
includes a bonus
LED light for video.

The F60M automatically communicates white balance information to your camera, allowing the Alpha to adjust WB to match the flash output. It also offers a dedicated video light that can be useful for a bit of extra illumination if the subject is close to the camera. When you point the flash head upward, the trio of LED video illuminator lamps are revealed.

You can use this large unit as a main flash, or allow it to be triggered wirelessly by another compatible flash unit. A pre-flash burst of light from the triggering master/controller unit causes a remote flash unit to fire. When using flash wirelessly, Sony recommends rotating the unit so that the flashtube is pointed to the location where light should be directed, while the front (light sensor) of the flash is pointed toward the camera. In wireless mode, you can control up to three groups of flashes, and specify the output levels for each group, giving you an easy way to control the lighting ratios of multiple flash units.

This flash unit can provide a simulated modeling light effect at two flashes per second or at a more useful (but more power-consuming) 40 flashes per second for 4 seconds for 160 continuous minibursts. In wireless off-camera flash, the HVL-60M can function as the main (on-camera) flash in wireless mode or it can be the remote flash, triggered wirelessly by another compatible flash unit, as discussed earlier.

HIGH-SPEED SYNC

Those who are frustrated by an inability to use a shutter speed faster than 1/250th second will love the High-Speed Sync (HSS) mode that allows for flash at 1/500th to 1/4,000th second! (HSS is also available with the HVL-F43M, HVL-F32M, and the discontinued HVL-58AM and HVL-F36AM.) This is ideal when you want to use a very wide aperture for selective focus with a nearby subject with flash; HSS at a fast shutter speed such as 1/1,000th second is one way to avoid overexposure. The Mode button on the back of the flash is used to choose either TTL or Manual flash exposure. You can then use the Menu button and plus/minus keys to activate HSS mode; HSS appears in the unit's data panel as confirmation of the mode.

Keep in mind that flash output is much lower in High-Speed Sync than in conventional flash photography. That's because less than the full duration of the flash is used to expose each portion of the image as it is exposed by the slit passing in front of the sensor. As a result, the effective flash (distance) range is much shorter.

In addition, HSS will not work when using multiple flash units or when the flash unit is set for left/right/up bounce flash or when the wide-angle diffuser is being used. (If you're pointing the flash downward, say, at a close-up subject, HSS can be used.)

HVL-F43M Flash Unit

This less pricey (\$400) electronic flash (shown in Figure 13.11) shares many of the advanced features of the HVL-F60M, but has a lower guide number of 43/138 (meters/feet). Features shared with the high-end unit include HSS, automatic white balance adjustment, and automatic zoom with the same coverage of focal lengths and the slide-out diffuser, as well as a built-in bounce card. Its quick-shift function allows you to direct the flash upward or to the side by rotating the head. This unit also can be used in wireless mode as a master/controller or remote/slave, and it also offers the quick-shift bounce feature. The HVL-F43M is a tad lighter (at 12 ounces) than its bigger sibling and runs on four AAs. This flash replaces the similar HVL-F43AM unit, which uses the older iISO hot shoe.

Figure 13.11
The Sony HVL-F43M is a more affordable external flash unit.

HVL-F36AM Flash Unit

Although discontinued, you can easily find this versatile flash available online or in used condition. It uses the old iISO hot shoe, so you'll need an adapter. The guide number for this lower-cost Sony flash unit is (surprise!) 36/118 (meters/feet). Although (relatively) compact at 9 ounces, you still get some big-flash features, such as wireless operation, auto zoom, and high-speed sync capabilities. Bounce flash flexibility is reduced a little, with no swiveling from side to side and only a vertical adjustment of up to 90 degrees.

HVL-F32M Flash Unit

The \$299 HVL-F32M is Sony's newest electronic flash unit. (See Figure 13.12.) It features a high-speed synchronization mode, wireless control, and automatic white balance compensation. In wireless mode, it can be used only on Channel 1 (as I'll describe shortly), but can function as both a master/controller and remote/slave. The flash is powered by a pair of AA batteries and it is resistant to both dust and moisture. Those who love to use bounce flash will like the built-in bounce sheet and retractable wide-angle panel that spreads the light to cover the equivalent of a 16mm lens.

Figure 13.12 The Sony HVL-F32M is an affordable external flash unit.

HVL-F20M Flash Unit

The least-expensive Sony flash (see Figure 13.13) is the HVL-F20M (\$150), designed to appeal to the budget conscious, especially those who need just a bit of a boost for fill flash, or want a small unit (just 3.2 ounces) on their camera. It has a guide number of 20 at ISO 100, and features simplified operation. For example, there's a switch on the side of the unit providing Indoor and Outdoor settings (the indoor setting tilts the flash upward to provide bounce light; with the outdoor setting,

Figure 13.13
The HVL-F20M
flash unit is compact
and inexpensive.

the flash fires directly at your subject). This flash can serve as a master/controller on the a7R II/a7 II to trigger off-camera flash units wirelessly, but cannot be used as a remote/slave flash. There are special modes for wide-angle shooting (use the built-in diffuser to spread the flash's coverage to that of a lens with a very wide field of view or choose the Tele position to narrow the flash coverage to that of a 50mm or longer lens for illuminating more distant subjects). While it's handy for fill flash, owners of an a7 II—series camera will probably want a more powerful unit as their main electronic flash.

BATTERY TIP

You may not use your flash very often, but when you do, you want it to operate properly. The problem with infrequent flash use is that conventional nickel-metal hydride batteries lose their charge over time, so if your flash unit is sitting in your bag for a long time between uses, you may not even be aware that your rechargeable batteries are pooped out. Non-rechargeable alkaline cells are not a solution: they generally provide less power for your flash, and replacing them can be costly. The Energizer Lithium Ultimate AA batteries last up to three times longer, but they sell for about \$10 for four.

I've had excellent luck with a new kind of battery developed by Panasonic called *eneloop* cells. They retain their charge for long periods of time—as much as 75 percent of a full charge over a three-year period (let's hope you don't go that long between uses of your flash). They're not much more expensive than ordinary rechargeables, and can be revitalized up to 1,500 times. They're available in capacities of 1500 mAh to 2500 mAh. I use the economical models with 1900 mAh capacity.

Wireless Flash

Because the Sony a7R II/a7 II lacks a built-in flash, in order to trigger flash wirelessly, you'll need to own at least two compatible flash units, such as the HVL-F60M, HVL-F43M, HVL-F32M, or HVL-F20M. One flash will be connected to the camera through the multi-interface shoe and serves as the master flash or controller. A second (and additional) flash unit can be triggered wirelessly, with full exposure control. If you want, your primary illumination can come from the off-camera flash, and you can use a less powerful on-camera flash as the master unit. In that mode the HVL-F20M makes a good controller/master, especially since it is the least-expensive Sony flash unit. But keep in mind that it cannot be used as a remote/slave flash unit.

To use wireless flash just follow these steps:

- 1. Connect the controller flash unit to the a7R II/a7 II. Slide it all the way into the multi-interface shoe so the connection is solid.
- 2. **Position additional flash(es).** Sony flash units come with a mini-stand that lets you set the flash on a table or other surface. You can also purchase third-party adapters so the off-camera flash can be mounted on a light stand or a tripod. In a pinch, you can press a helper into service to hold your supplementary flash units. The remote units must be able to "see" the master/controller's pre-flash signal, either directly or by bouncing off another surface in the room.
- 3. **Power up flash and camera.** Note that when you turn off the camera, the flash turns off as well; you don't need to manually turn both on or off simultaneously if you want to save power during a shooting session.
- 4. Switch camera and attached master/controller flash to wireless mode. Use the Camera Settings menu's Flash Mode option, or select Flash mode from the Function menu. Select Wireless (WL). Once the camera is set to wireless mode, press the shutter release halfway, and the attached powered-up flash automatically shifts into wireless mode as well.
- 5. Set one or more remote/slave flash unit(s) to wireless mode and choose options. Turn on the unit and follow the instructions supplied with your flash unit to switch to wireless mode, then select either controller (master) mode or remote (slave) mode. Then, choose a group and channel, which I'll explain in the next section. An alternate way of setting your off-camera flash to remote mode is to mount them on the camera, power up, choose Wireless (WL) from the Camera Settings menu's Flash Mode entry, and press the shutter release halfway to transfer the setting to the flash. You can then remove the flash and a red LED on the flash will start blinking to let you know the flash is ready to use in wireless mode.
- 6. **Test your connection.** Press your defined AEL button, and the controller will emit a burst, which the remotes will respond to with a flash of their own about half a second later.

Key Wireless Concepts

Here are some key concepts you must understand before jumping into wireless flash photography:

■ **Controllers.** The flash that communicates with and triggers all wireless flash units is called the *controller* in Sony nomenclature. It's more common within the photographic industry to use the term *master*, however, so I tend to use both terms together to avoid confusion. Because the a7R II/a7 II does not have a built-in flash, wireless communication requires one controller/master to be connected to the camera's multi-interface shoe.

- **Remotes.** The flash units that are controlled wirelessly are called the *remotes* by Sony, or *slaves*. There can only be one controller/master flash, but you can have multiple remote/slave units. All the remotes triggered by a controller/master must use the same *channel*, but flashes using a particular channel can be divided into one of two *remote groups*, and their power levels specified by group.
- Channels. Sony's wireless flash system offers users the ability to determine on which of up to four possible channels (depending on the flash's capabilities) the units can communicate. (The pilots, ham radio operators, or scanner listeners among you can think of the channels as individual communications frequencies.) The channels are numbered 1, 2, 3, and 4, and each flash must be assigned to one of them. Moreover, in general, each of the flash units you are working with should be assigned to the *same* channel, because the remote/slave flash units will respond *only* to a controller/master flash that is on the same channel. Note that the HVL-F20M cannot be used as a remote/slave flash, and when used as a controller/master flash, you *must* use its sole channel, Channel 1.

The channel ability is important when you're working around other photographers who are also using the same system. Photojournalists, including sports photographers, will encounter this situation frequently as Sony cameras make in-roads in these pro arenas. Each Sony photographer sets flash units to a different channel so as to not accidentally trigger other users' strobes. (At big events with more than four photographers using Sony flash, you may need to negotiate.) I use this capability at workshops I conduct where we have two different setups. Photographers working with one setup use a different channel than those using the other setup, and can work independently even though we're at opposite ends of the same large room.

■ **Groups.** Sony's wireless flash system lets you designate multiple flash units in two separate groups, dubbed RMT (which is selected for all flashes by default) and RMT2 (which must be specified explicitly to change individual flashes from the default RMT group). All the flashes in all the groups use the exact same *channel* and all respond to the same master controller, but you can set the output levels of each remote/slave group separately. So, flash in RMT might serve as the main light, while those in RMT2 might be adjusted to produce less illumination and serve as a fill light. It's convenient to be able to adjust the output of all the units within a given group simultaneously. This lets you create different styles of lighting for portraits and other shots.

Note that these two groups consist *only* of remote flashes. Your on-camera controller/master flash is effectively a third group. If the controller is a low-powered unit like the HVL-F20M, it may not contribute much to the exposure at all (or, perhaps just add a little fill if pointed directly at your subject); a more powerful unit can become a potential third group. You could, for example, point the on-camera flash at a ceiling or wall to provide additional diffuse illumination.

If you're using only one group, all the flashes in the RMT group are automatically adjusted based on the settings you specify for the controller/master, such as flash exposure bracketing and/or flash exposure compensation.

- Flash ratios. This ability to control the output of one flash (or set of flashes) compared to another flash or set in groups allows you to produce lighting *ratios*. You can control the power of multiple off-camera flash to adjust each unit's relative contribution to the image, for more dramatic portraits and other effects. Ratios are available with flash units that use the new CTRL+ protocol (described next).
- Flash Protocols. Older Sony flash units, including the HVL-F20M, used a particular protocol to communicate. More recent units, such as the HVL-F60M, HVL-F43M (with multi-interface shoe), and HVL-F58AM, HVL-F32M, and HVL-F32AM/HVL-F43AM (both with the old-style shoe) have an enhanced protocol for communicating with compatible flash, called CTRL+, but can also revert to the older protocol (CTRL) to be compatible with older flash as well. Because the HVL-F20M uses the original Sony protocol, it cannot be used to adjust flash ratios, as described above.
- Metering. In wireless flash mode, advanced distance integration (ADI) is not used (the distance between the flash and subject can't be determined by the off-camera flash), and Sony's P-TTL flash metering is used instead.

Setting Channels and Remote Groups

To specify the channels and remote groups used by each flash, you must use the flash unit's controls and menu system to do so. Here are the procedures for the HVL-F60M and HVL-F43M.

Setting the HVL-F60M

To choose the group on the HVL-F60M, just follow these steps:

- 1. Press the Mode button to display the Mode screen.
- 2. Rotate the control wheel or use its directional buttons to highlight WL RMT.
- 3. Press the Fn button and use the control wheel to select the group, either TTL Remote or TTL Remote 2.
- 4. Press the control wheel center button to confirm your changes.

To choose the channel on the HVL-F60M, just follow these steps:

- 1. Press the MENU button. The Menu screen appears.
- 2. On Page 1, select the entry to change. Use the control wheel to highlight the entry you want to adjust.
- 3. Select the wireless channel by highlighting WL CH and pressing the control wheel center button. Then use the control wheel to choose Channel 1, 2, 3, or 4. Press the center button again to confirm your choice.
- 4. You can also adjust the protocol if needed. Highlight the WL CTRL entry and press the control wheel center button. Use the wheel to select CTRL+ if you are using only compatible flash units (HVL-F60M, HVL-F43M, HVL-F32M, HVL-F58AM, HVL-F32AM, or HVL-F43AM) or CTRL if you are using other flash units in your setup. Press the Menu button again to confirm your choice.

Setting the HVL-F43M

To choose the group on the HVL-F43M, just follow these steps:

- 1. Press the Fn button. CTRL or RMT will be blinking.
- 2. Press the right direction arrow on the flash as needed to highlight RMT or RMT2.
- 3. Press Fn to confirm your choice.

To choose the Channel on the HVL-F43M:

- 1. Hold down the Fn button for more than three seconds. The first Custom Setting item (CH01 HSS) is displayed.
- 2. Press the flash's left/right direction buttons to change to C02: Wireless Channel.
- 3. Press the up/down buttons to select the channel 1, 2, 3, or 4.
- 4. Press the Fn button again to confirm your choice.
- 5. You can also adjust the protocol, if needed. Hold down the Fn button for more than three seconds and use the left/right buttons to select C03: Wireless Controller Mode. You can choose 1 (CTRL, the old protocol) or 2 (CTRL+, the new protocol). Press Fn to confirm your choice.

Setting Ratios

Once you've set up one or more flash for the RMT group, and more or more for the RMT2 group, you can adjust the ratio used between them.

Ratios with the HVL-F43M

Just follow these steps when using the HVL-F43M as the controller or remote/slave. Remember that all flashes in all remote groups must be set to the same channel, as described previously:

- 1. The easiest way to set ratios is to mount the controller/master and remote/slave units on the camera in turn. With each flash mounted on the camera set to Wireless Flash as described earlier, press the Mode button on the flash to display WL.
- 2. Press the Fn button, then press the left/right directional buttons until CTRL and RATIO are *both* blinking.
- 3. Press the Fn button again. The line at upper right will display (see Figure 13.14):

CTRL RMT RMT1

1:1:1

- 4. Use the left/right directional buttons to move the highlighting to CTRL. When CTRL is highlighted, you can press the up/down buttons to choose the relative power of that flash, compared to the others, from 1, 2, 4, 8, 16, or - (the latter disables the flash). For example, a setting of 16:1:4 would specify that the flash mounted on the camera has 1/16th the power of the RMT group, while the RMT2 group would have 1/4 the power of the RMT group. Selecting - disables that flash or group. You might want to do that so that the on-camera flash doesn't contribute to the exposure, even though it will still fire a pre-flash to trigger the remote/ slave units.
- 5. Press the TTL/M button to display TTL.
- 6. Repeat for each flash.

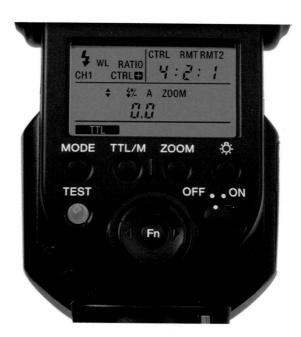

Figure 13.14
Set ratios on the
HVL-F43M

Ratios with the HVL-F60M

Just follow these steps when using the HVL-F60M as the controller or remote/slave. Again, all flashes in all remote groups must be set to the same channel, as described previously:

- 1. You can mount each flash on the camera and set the ratios. Press the Mode button to produce the Mode screen and select WL CTRL.
- 2. Press the Fn button to access the Quick Navi screen and use the control wheel to highlight WL CTRL. Press the control wheel center button to access the dedicated settings screen.
- 3. Use the control wheel to highlight RATIO. Press the center button to access your choices, Ratio: Off (the controller flash does not contribute to the exposure), TTL Ratio, and Manual Ratio. You can highlight TTL Ratio and use the control wheel to choose ON.
- 4. Press the center button to return to the indicator screen.
- 5. Press the Fn button to display the Quick Navi screen and choose the Wireless Lighting Ratio control indicator located at middle left of the screen. Press the control wheel center button, then use the control wheel to change the lighting ratio of each group. Rotate the control wheel to choose the relative power of each flash, compared to the others, from 1, 2, 4, 8, 16, or -. The - setting disables that group. (See Figure 13.15.)
- 6. Press the center button when finished.

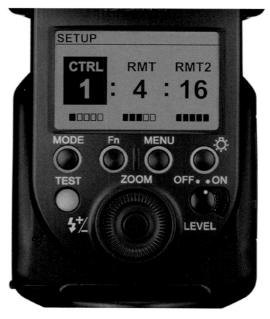

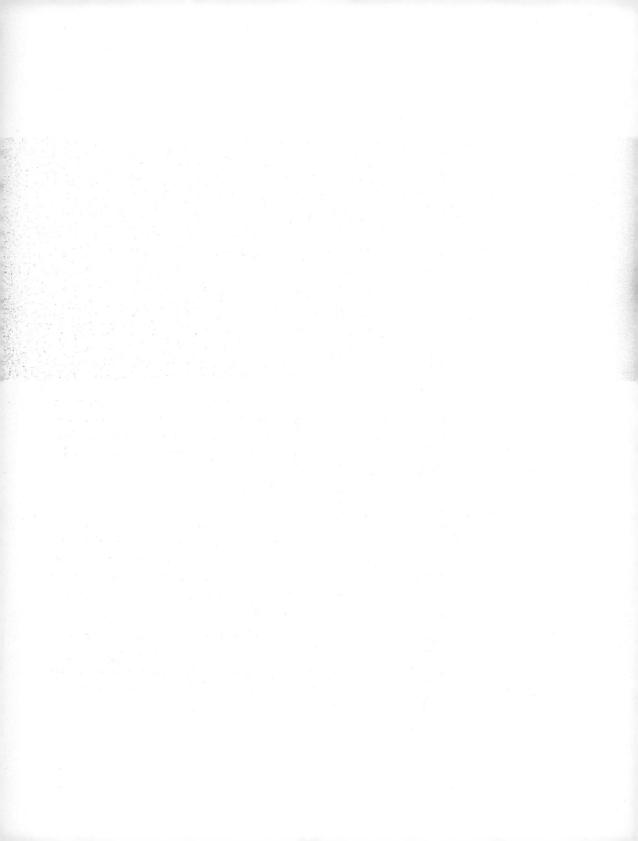

Essential Tips for Your a7R II/a7 II

This chapter is a potpourri that covers two separate but important topics. In the first section, I'm going to offer some tips on troubleshooting your camera to avoid—or fix—some of the most common problems. The second section details some great low-cost accessories for your camera. After sinking thousands into your camera body and complement of lenses, you may be happy to see that some add-ons can give you extra flexibility without breaking the bank.

Troubleshooting and Prevention

One of the nice things about modern mirrorless cameras like the Sony a7R II/a7 II is that they have fewer mechanical moving parts to fail, so they are less likely to "wear out." No film transport mechanism, no wind lever or motor drive, and no complicated mechanical linkages from camera to lens to physically stop down the lens aperture. Instead, tiny, reliable motors are built into each lens (and you lose the use of only that lens should something fail).

Of course, the camera also has a moving physical shutter (which augments the electronic shutter "curtains" as discussed in Chapter 13). It can fail, but the shutter is built rugged enough that you can expect it to last several hundred thousand shutter cycles or more. Unless you're shooting sports in continuous mode day in and day out, the shutter on your Sony a7R II/a7 II is likely to last as long as you expect to use the camera.

The only other things on the camera that move are switches, dials, buttons, and the doors that open to allow you to remove and insert the memory card and battery. I'm not fond of the removable battery door mechanism, which I have to detach each time I mount the battery grip to my camera, but it hasn't failed me yet. Unless you're extraordinarily clumsy or unlucky, there's not a lot that can go wrong mechanically with your Sony a7R II/a7 II.

On the other hand, one of the chief drawbacks of modern electronic cameras is that they are modern *electronic* cameras. Your Sony a7R II/a7 II is fully dependent on two different batteries, the main NP-FW50 that powers most functions, and a smaller inaccessible battery within the camera's innards that stores setup and settings information. Without them, the camera can't be used. There are numerous other electrical and electronic connections in the camera (many connected to those mechanical switches and dials), and components like the color LCD that can potentially fail or suffer damage. The camera also relies on its "operating system," or *firmware*, which can be plagued by bugs that cause unexpected behavior. Luckily, electronic components are generally more reliable and trouble-free, especially when compared to their mechanical counterparts from the pre-electronic film camera days.

Digital cameras have problems unique to their breed, too; the most troublesome being the need to clean the sensor of dust and grime periodically. This chapter will show you how to diagnose problems, fix some common ills, and, importantly, learn how to avoid some of them in the future.

Upgrading Your Firmware

As I said, the firmware in your Sony a7R II/a7 II is the camera's operating system, which handles everything from menu display (including fonts, colors, and the actual entries themselves), what languages are available, and even support for specific devices and features. Upgrading the firmware to a new version makes it possible to add new features while fixing some of the bugs that sneak in.

Official firmware for your Sony a7R II/a7 II is given a version number that you can view by turning the power on, pressing the MENU button, and navigating to Version in the Setup 6 menu. As I write this, the current version is 2.0, a major upgrade that added some important features, such as the ability to specify Phase Detect or Contrast Detect autofocus when using compatible adapted lenses. The first number in the string represents the major release number, while the second and third represent less significant upgrades and minor tweaks, respectively. Theoretically, a camera should have a firmware version number of 1.0 when it is introduced, but vendors have been known to do some minor fixes during testing and unveil a camera with a 1.1 firmware designation. If a given model is available long enough, it can evolve into significant upgrades, such as the current 2.0 or higher designations.

Firmware upgrades are used for both cameras and certain lenses (each listed separately in the Version entry), most frequently to fix bugs in the software, and much less frequently to add or enhance features. The exact changes made to the firmware are generally spelled out in the firmware release announcement. You can examine the remedies provided and decide if a given firmware patch is important to you. If not, you can usually safely wait a while before going through the bother of upgrading your firmware—at least long enough for the early adopters to report whether the bug fixes have introduced new bugs of their own. Each new firmware release incorporates the changes from previous releases, so if you skip a minor upgrade you should have no problems.

WARNING

Don't open the memory card door or turn off the camera while your old firmware is being overwritten. You *should* have sufficient power for the camera while upgrading, because Sony requires you to connect the a7 II–series camera to your computer using a USB cable, and that cable conveys power from the host computer as well as information.

Upgrading your firmware is ridiculously easy. Just follow these steps:

- Search for firmware. Visit the Sony support site for your area, such as esupport.sony.com, and
 navigate to the Drivers and Software page for your camera. It will vary by country, but you can
 quickly click the Drivers and Software link, enter model information about your camera, select
 your operating system, such as Windows 10 64 Bit, and eventually arrive at the Firmware
 download page.
- 2. **Download firmware.** You'll see a message like the following when you reach the download page. Click the Download button.

UPDATE: ILCE-7RM2 System Software Update.

Release Date 10/19/2015

Version 2.00

File Size 236.80MB

[Download]

- 3. **Check USB Connection status.** Make sure the USB Connection entry in the Setup 4 menu is set to Mass Storage. Then turn off your camera.
- 4. **Connect camera to your computer.** Link to a USB port on your Internet-connected computer using the USB cable that came with your camera for use when recharging the battery. Then turn on the camera.

Figure 14.1 The firmware update utility.

- 5. **Open firmware file.** It will have a name like Update_ILCE7RM2V200.exe (for Windows) or Update_ILCE7RM2V200.dng (for Macs).
- 6. Follow the instructions shown on the update utility, pictured in Figure 14.1.
- 7. **Turn off the camera.** When finished, you can turn off the camera. It will have the new firmware installed the next time you power up.

Protecting Your LCD

The color LCD monitor on the back of your Sony a7R II/a7 II almost seems like a target for banging, scratching, and other abuse. Fortunately, it's quite rugged, and a few errant knocks are unlikely to shatter the protective cover over the LCD, and scratches won't easily mar its surface. However, if you want to be on the safe side, there are a number of protective products you can purchase to keep your LCD safe.

Sony itself offers the PCK-LM semi-hard protective sheet. It's inexpensive at around \$15, and includes an anti-fingerprint coating to reduce smudges. Like other such protectors, it fastens securely to the LCD monitor with a residue-free adhesive and can be easily removed by threading a piece of dental floss between the sheet and screen. It's made of polycarbonate (plastic). I prefer the ultra-thin (0.3mm) glass GGS screens available on Amazon and from a variety of other sources for anywhere from around \$8 to \$15 for the deluxe "Larmour" version, which use a strong silicon adhesive for gapless mounting. You can also use simple plastic overlay sheets, or "skins" made for smartphones, cut to fit your LCD.

Troubleshooting Memory Cards

Sometimes good memory cards go bad. Sometimes good photographers can treat their memory cards badly. It's possible that a memory card that works fine in one camera won't be recognized when inserted into another. In the worst case, you can have a card full of important photos and find that the card seems to be corrupted and you can't access any of them. Don't panic! If these scenarios sound horrific to you, there are lots of things you can do to prevent them from happening, and a variety of remedies available if they do occur. You'll want to take some time—before disaster strikes—to consider your options.

All Your Eggs in One Basket?

The "Don't put all your eggs in one basket" myth is one of the most contentious in photography, second only to the "protective" filter myth. Many of us have had a memory card fail and lost—or thought we lost—some photos that we'd rather have kept. That certainly underlines the importance of backing up our pictures to other media at regular intervals, even while traveling. But whether multiple smaller cards offer an additional degree of protection is a separate issue.

Given the 42.4MB images my a7R II produces, I recently upgraded my memory cards to Lexar 128GB 1000X/150 MB/s cards, as they were on sale for about \$50 each in packs of two. The debate about whether it's better to use one large storage device or several smaller ones has been going on since before there were memory cards!

I can remember when computer users wondered whether it was smarter to install a pair of 200 megabyte (not *gigabyte*) hard drives in their computer, or if they should go for one of those new-fangled 500MB models. By the same token, a few years ago, the conventional wisdom insisted that you ought to use 128MB memory cards rather than the huge 512MB versions. Today, most of the arguments involve 16GB cards vs. 32GB cards, with the implication that smaller cards are "better" in this regard. Conventional wisdom is often more conventional than wise.

For professional users, this does make sense. I have professional wedding photographer friends who chortle at the folly of using large memory cards (I've actually witnessed the chortling), and they have special reasons for their preference. Of course, in addition to multiple cards, they use second shooters, copy photos onsite from a full memory card to a laptop, and employ other techniques to avoid having to ask the bride and groom whether it would be possible to restage their wedding. When your living depends on never losing *any* pictures, different rules apply.

But most of us have no cause to fear using larger memory storage technologies. Resorting to lots of small cards instead of fewer large ones may actually increase the chances of losing some. While I don't want to be a pioneer in working with 512GB memory cards (and have no need to do so), I'm perfectly comfortable with my 128GB cards for the following reasons:

■ Memory cards don't magically wait until they are full before they fail. You will not automatically lose 128GB worth of photos if a memory card implodes. If you typically shoot 16GB worth of images on a typical day before you have the chance to back them up to your computer or laptop, then that's the most you are at risk for under average circumstances. Whether you're using a 16GB, 32GB, 64GB, or 128GB card, the number of images you shoot in a *typical* session prior to backup will be the number you actually may lose. The only time I actually fill up my 128GB memory cards is when I am traveling, and in those instances, I have already backed up each day's shooting to multiple additional media. Most of the time, all a larger memory card does is give you greater flexibility when you want to shoot *more* in one session and don't want or don't have time to swap cards.

Many photojournalists and sports photographers change cards when they are 80 percent full to avoid missing a crucial shot. Instead of interrupting your shoot to swap out a 16GB card that becomes full, you can go ahead and shoot 17GB or 18GB on your 32GB card, and change media during lulls in the festivities. In truth, the biggest danger comes from waiting too long—say several days—to back up your images. We all know photographers who have New Year's Eve, July 4, and Thanksgiving images on a single card, and who *never* backup their photos.

- 64GB cards aren't twice as likely to fail as 32GB cards, although many seem to feel that's so. Indeed, I've heard the same advice to use "safer" 256MB cards, 2GB cards, or 4GB cards virtually up the line as capacities have increased. Once a fabrication technology is mature, the reliability of particular sizes is the same across the board. Any easy way to tell is to compare the per-gigabyte costs for the card. Once a particular card is less than twice the cost of a card with half the capacity, you can bet the technology is solid.
- Using multiple smaller cards may increase your odds of losing photos. Memory cards do fail, but that most often happens from user error. The first 128GB card I bought, a Sony model, failed within a few months, because I put it in my wallet for "safekeeping" and accidentally folded it nearly in half. It's also common for photographers to lose cards, put them through a wash and dry cycle, or perform other atrocities unrelated to the reliability of the card itself.

Yes, if you use smaller cards you may lose half as many photos, but you might also find that more cards equates to a higher risk of losing one or damaging one through stupidity. I find it's better to use the minimum number of photo "baskets" and then make sure nothing happens to that basket. If all your images are important, the fact that you've lost 100 of them rather than 200 pictures isn't very comforting.

- When your family goes on vacation, do you split up family members to travel in several smaller cars? After all, in a terrible collision, with multiple cars, you might lose only a *couple* of your kinfolk rather than all of them. Keep in mind that your family is much more important to you than your photos, and the odds of being in a traffic accident is much *greater* than encountering a faulty memory card. Humans are susceptible to the cognitive fallacy "neglect of probability." I've taken hundreds of thousands of pictures and lost two memory cards, and I know three other photographers who've had memory card problems. On the other hand, I've driven hundreds of thousands of miles and been in four traffic accidents and know a dozen people who have had auto mishaps. Should my family be riding around in different cars while I stick to 16GB memory cards?
- The typical memory card is rated for a Mean Time Between Failures of 1,000,000 hours of use. That's constant use 24/7 for more than 100 years! According to the manufacturers, they are good for 10,000 insertions in your camera, and should be able to retain their data (and that's without an external power source) for something on the order of 11 years. Of course, with the millions of cards in use, there are bound to be a few lemons here or there.

So, what can you do? Here are some options for preventing loss of valuable images:

- Internal backup. If you own a camera with dual memory cards (so far, no Sony mirrorless camera has such a feature, which can be found in some A-mount models), when your photos are particularly important, use the Backup feature to write copies to both cards simultaneously. Or, if you're on vacation, copy a day's shots onto another card when you get back to your hotel room.
- External backup. It's easy to physically transfer your images to a laptop, smart device, or other backup storage, particularly when you're on vacation. When I'm traveling, I take a tiny MacBook Air and at least two 1TB portable drives and copy my pictures to them frequently. (See Figure 14.2.) Ideally, one of your backups should be offsite, and that's difficult while traveling. However, offsite can be a DVD you burn and mail home, or a storage site in the cloud.
- **Transmit your images.** Another option is to transmit your images frequently over a network to your laptop or smart device. Or upload them to a cloud drive, such as iCloud, Amazon Cloud, OneDrive, or DropBox. Many cameras have that option.

- Interleaving. You can also interleave your shots. Perhaps you don't shoot weddings, but you do go on vacation from time to time. Take 100 or so pictures on one card. Then, replace it with a different card and shoot another 100. Repeat these steps with diligence (you'd have to be determined to go through this degree of inconvenience), and, if you use four or more memory cards (of whatever capacity), you'll find your pictures from each location scattered among the different media. If you lose or damage one (which, alas, may be more likely because of the use of those multiple cards), you'll still have *some* pictures from all the various stops on your trip on the other cards. That's more work than I like to do, especially when it comes to sorting out the pictures back at home, but it's an option.
- Be smart. If you're having problems, the first thing you should do is stop using that memory card. Don't take any more pictures. Don't do anything with the card until you've figured out what's wrong. Your second line of defense (your first line is to be sufficiently careful with your cards that you avoid problems in the first place) is to do no harm that hasn't already been done. If necessary, decide on a course of action (such as using a data recovery service or software) before you risk damaging the data on your card further. If you take a picture of your business card as the first photo in a session, should the card be lost your odds of having it returned to you are increased.

What Can Go Wrong?

There are lots of things that can go wrong with your memory card, but the ones that aren't caused by human stupidity are statistically very rare. Yes, a memory card's internal bit bin or controller can suddenly fail due to a manufacturing error or some inexplicable event caused by old age. However, if your memory card works for the first week or two that you own it, it should work forever. There's really not a lot that can wear out.

Given the reliability of solid-state memory, compared to magnetic memory, though, it's more likely that your memory problems will stem from something that you do. Memory cards are small and easy to misplace if you're not careful. For that reason, it's a good idea to keep them in their original cases or a "card safe" offered by Gepe (www.gepecardsafe.com), Pelican (www.pelican.com), and others. Always placing your memory card in a case can provide protection from the second-most common mishap that befalls memory cards: the common household laundry. If you slip a memory card in a pocket, rather than a case or your camera bag, often enough, sooner or later it's going to end up in the washing machine and probably the clothes dryer, too. There are plenty of reports of relieved digital camera owners who've laundered their memory cards and found they still worked fine, but it's not uncommon for such mistreatment to do some damage.

Memory cards can also be stomped on, accidentally bent, dropped into the ocean, chewed by pets, and otherwise rendered unusable in myriad ways. It's also possible to force a card into your Sony a7R II/a7 II's memory card slot incorrectly if you're diligent enough. Or, if the card is formatted in your computer with a memory card reader, your Sony a7R II/a7 II may fail to recognize it. Occasionally, I've found that a memory card used in one camera would fail if used in a different camera (until I reformatted it in Windows, and then again in the camera). Every once in a while, a card goes completely bad and—seemingly—can't be salvaged.

Another way to lose images is to do commonplace things with your memory card at an inopportune time. If you remove the card from the Sony a7R II/a7 II while the camera is writing images to the card, you'll lose any photos in the buffer and may damage the file structure of the card, making it difficult or impossible to retrieve the other pictures you've taken. The same thing can happen if you remove the memory card from your computer's card reader while the computer is writing to the card (say, to erase files you've already moved to your computer). You can avoid this by *not* using your computer to erase files on a memory card but, instead, always reformatting the card in your Sony a7R II/a7 II before you use it again.

What Can You Do?

Pay attention: If you're having problems, the *first* thing you should do is *stop* using that memory card. Don't take any more pictures. Don't do anything with the card until you've figured out what's wrong. Your second line of defense (your first line is to be sufficiently careful with your cards that you avoid problems in the first place) is to *do no harm* that hasn't already been done. Read the rest of this section and then, if necessary, decide on a course of action (such as using a data recovery service or software described later) before you risk damaging the data on your card further.

Now that you've calmed down, the first thing to check is whether you've actually inserted a card in the camera. If you've set the camera in the Shooting menu so that Shoot w/o Card has been turned on, it's entirely possible (although not particularly plausible) that you've been snapping away with no memory card to store the pictures to, which can lead to massive disappointment later on. Of course, the No Memory Card message appears on the LCD when the camera is powered up, and it is superimposed on the review image after every shot, but maybe you're inattentive. You can avoid all this by turning the Shoot w/o Card feature off (available in the a7R II only) and leaving it off.

Things get more exciting when the card itself is put in jeopardy. If you lose a card, there's not a lot you can do other than take a picture of a similar card and print up some Have You Seen This Lost Flash Memory? flyers to post on utility poles all around town.

If all you care about is reusing the card, and have resigned yourself to losing the pictures, try reformatting the card in your camera. You may find that reformatting removes the corrupted data and restores your card to health. Sometimes I've had success reformatting a card in my computer using a memory card reader (this is normally a no-no because your operating system doesn't understand the needs of your Sony a7R II/a7 II), and *then* reformatting again in the camera.

If your memory card is not behaving properly, and you *do* want to recover your images, things get a little more complicated. If your pictures are very valuable, either to you or to others (for example, a wedding), you can always turn to professional data recovery firms. Be prepared to pay hundreds of dollars to get your pictures back, but these pros often do an amazing job. You wouldn't want them working on your memory card on behalf of the police if you'd tried to erase some incriminating pictures. There are many firms of this type, and I've never used them myself, so I can't offer a recommendation. Use a Google search to turn up a ton of them. I use a software program called RescuePro, which came free with one of my SanDisk memory cards.

A more reasonable approach is to try special data recovery software you can install on your computer and use to attempt to resurrect your "lost" images yourself. They may not actually be gone completely. Perhaps your memory card's "table of contents" is jumbled, or only a few pictures are damaged in such a way that your camera and computer can't read some or any of the pictures on the card. Some of the available software was written specifically to reconstruct lost pictures, while other utilities are more general-purpose applications that can be used with any media, including floppy disks and hard disk drives. They have names like OnTrack, Photo Rescue 2, Digital Image Recovery, MediaRecover, Image Recall, and the aptly named Recover My Photos.

DIMINISHING RETURNS

Usually, once you've recovered any images on a memory card, reformatted it, and returned it to service, it will function reliably for the rest of its useful life. However, if you find a particular card going bad more than once, you'll almost certainly want to stop using it forever. See if you can get it replaced by the manufacturer, if you can, but, in the case of memory card failures, the third time is never the charm.

Cleaning Your Sensor

There's no avoiding dust. No matter how careful you are, some of it is going to settle on your camera and on the mounts of your lenses, eventually making its way inside your camera to settle in the mirror chamber. As you take photos, the physical shutter movement causes the dust to become airborne and eventually come to rest atop your sensor. There, dust and particles can show up in every single picture you take at a small enough aperture to bring the foreign matter into sharp focus. No matter how careful you are and how cleanly you work, eventually you will get some of this dust on your camera's sensor.

Fortunately, one of the Sony a7R II/a7 II's most useful features is the automatic sensor cleaning system that reduces or eliminates the need to clean your camera's sensor manually. Sony has applied anti-static coatings to the sensor and other portions of the camera body interior to counter charge build-ups that attract dust. The sensor carriage vibrates ultrasonically to shake loose any dust. You can activate sensor cleaning at any time by selecting Cleaning Mode from the Setup 3 menu.

Dust the FAQs, Ma'am

Here are some of the most frequently asked questions about sensor dust issues.

Q. I see a bright spot in the same place in all of my photos. Is that sensor dust?

A. You've probably got either a "hot" pixel or one that is permanently "stuck" due to a defect in the sensor. A hot pixel is one that shows up as a bright spot only during long exposures as the sensor warms. A pixel stuck in the "on" position always appears in the image. Both show up as bright red, green, or blue pixels, usually surrounded by a small cluster of other improperly illuminated pixels, caused by the camera's interpolating the hot or stuck pixel into its surroundings, as shown in Figure 14.3. A stuck pixel can also be permanently dark. Either kind is likely to show up when they contrast with plain, evenly colored areas of your image.

Bad pixels can also show up on your camera's color LCD panel, but, unless they are abundant, the wisest course is to just ignore them.

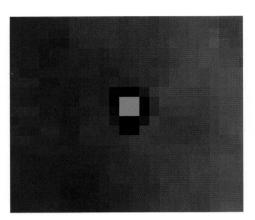

Figure 14.3 A stuck pixel is surrounded by improperly interpolated pixels created by the Sony a7R II/a7 II's demosaicing algorithm.

Figure 14.4 Only the dust spots in the sky are apparent in this shot.

Q. I see an irregular out-of-focus blob in the same place in my photos. Is that sensor dust?

A. Yes. Sensor contaminants can take the form of tiny spots, larger blobs, or even curvy lines if they are caused by minuscule fibers that have settled on the sensor. They'll appear out of focus because they aren't actually on the sensor surface but, rather, a fraction of a millimeter above it on the filter that covers the sensor. The smaller the f/stop used, the more infocus the dust becomes. At large apertures, it may not be visible at all.

Q. I never see any dust on my sensor. What's all the fuss about?

A. Those who never have dust problems with their Sony a7R II/a7 II fall into one of four categories: those for whom the camera's automatic dust removal features are working well; those who seldom change their lenses and have clean working habits that minimize the amount of dust that invades their cameras in the first place; those who simply don't notice the dust (often because they don't shoot many macro photos or other pictures using the small f/stops that makes dust evident in their images); and those who are very, very lucky.

Identifying and Dealing with Dust

Sensor dust is less of a problem than it might be because it shows up only under certain circumstances. Indeed, you might have dust on your sensor right now and not be aware of it. The dust doesn't actually settle on the sensor itself, but, rather, on a protective filter a very tiny distance above the sensor, subjecting it to the phenomenon of *depth-of-focus*. Depth-of-focus is the distance the

focal plane can be moved and still render an object in sharp focus. At f/2.8 to f/5.6 or even smaller, sensor dust, particularly if small, is likely to be outside the range of depth-of-focus and blur into an unnoticeable dot.

However, if you're shooting at f/16 to f/22 or smaller, those dust motes suddenly pop into focus. Dust spots can easily show up in your images if you're shooting large, empty areas that are light colored. Dust motes are most likely to show up in the sky, as in Figure 14.4, or in white backgrounds of your seamless product shots and are less likely to be a problem in images that contain lots of dark areas and detail.

To see if you have dust on your sensor, take a few test shots of a plain, blank surface (such as a piece of paper or a cloudless sky) at small f/stops, such as f/22, and a few wide open. Open Photoshop, copy several shots into a single document in separate layers, then flip back and forth between layers to see if any spots you see are present in all layers. You may have to boost contrast and sharpness to make the dust easier to spot.

Avoiding Dust

Of course, the easiest way to protect your sensor from dust is to prevent it from settling on the sensor in the first place. Some lenses come with rubberized seals around the lens mounts that help keep dust from infiltrating, but you'll find that dust will still find a way to get inside. Here are my tips for eliminating the problem before it begins.

- Clean environment. Avoid working in dusty areas if you can do so. Hah! Serious photographers will take this one with a grain of salt, because it usually makes sense to go where the pictures are. Only a few of us are so paranoid about sensor dust (considering that it is so easily removed) that we'll avoid moderately grimy locations just to protect something that is, when you get down to it, just a tool. If you find a great picture opportunity at a raging fire, during a sandstorm, or while surrounded by dust clouds, you might hesitate to take the picture, but, with a little caution (don't remove your lens in these situations, and clean the camera afterward!), you can still shoot. However, it still makes sense to store your camera in a clean environment. One place cameras and lenses pick up a lot of dust is inside a camera bag. Clean your bag from time to time, and you can avoid problems.
- Clean lenses. There are a few paranoid types that avoid swapping lenses in order to minimize the chance of dust getting inside their cameras. It makes more sense just to use a blower or brush to dust off the rear lens mount of the replacement lens first, so you won't be introducing dust into your camera simply by attaching a new, dusty lens. Do this before you remove the lens from your camera, and then avoid stirring up dust before making the exchange.
- Work fast. Minimize the time your camera is lens-less and exposed to dust. That means having your replacement lens ready and dusted off, and a place to set down the old lens as soon as it is removed, so you can quickly attach the new lens.

- Let gravity help you. Face the camera downward when the lens is detached so any dust in the mirror box will tend to fall away from the sensor. Turn your back to any breezes, indoor forced air vents, fans, or other sources of dust to minimize infiltration.
- **Protect the lens you just removed.** Once you've attached the new lens, quickly put the end cap on the one you just removed to reduce the dust that might fall on it.
- Clean out the vestibule. From time to time, remove the lens while in a relatively dust-free environment and use a blower bulb like the ones shown in Figure 14.5 (*not* compressed air or a vacuum hose) to clean out the mirror box area. A blower bulb is generally safer than a can of compressed air, or a strong positive/negative airflow, which can tend to drive dust further into nooks and crannies.
- Be prepared. If you're embarking on an important shooting session, it's a good idea to clean your sensor *now*, rather than come home with hundreds or thousands of images with dust spots caused by flecks that were sitting on your sensor before you even started. Before I left on my recent trip to Spain, I put both cameras I was taking through a rigid cleaning regimen, figuring they could remain dust-free for a measly 10 days. I even left my bulky blower bulb at home. It was a big mistake, but my intentions were good.
- Clone out existing spots in your image editor. Photoshop and other editors have a clone tool or healing brush you can use to copy pixels from surrounding areas over the dust spot or dead pixel. This process can be tedious, especially if you have lots of dust spots and/or lots of images to be corrected. The advantage is that this sort of manual fix-it probably will do the least damage to the rest of your photo. Only the cloned pixels will be affected.

Figure 14.5Use a robust air bulb for cleaning your sensor.

■ Use filtration in your image editor. A semi-smart filter like Photoshop's Dust & Scratches filter can remove dust and other artifacts by selectively blurring areas that the plug-in decides represent dust spots. This method can work well if you have many dust spots, because you won't need to patch them manually. However, any automated method like this has the possibility of blurring areas of your image that you didn't intend to soften.

Sensor Cleaning

Those new to the concept of sensor dust actually hesitate before deciding to clean their camera themselves. Isn't it a better idea to pack up your Sony a7R II/a7 II and send it to a service center so their crack technical staff can do the job for you? Or, at the very least, shouldn't you let the friendly folks at your local camera store do it?

Of course, if you choose to let someone else clean your sensor, they will be using methods that are more or less identical to the techniques you would use yourself. None of these techniques are difficult, and the only difference between their cleaning and your cleaning is that they might have done it dozens or hundreds of times. If you're careful, you can do just as good a job.

Of course vendors like Sony may not tell you this, but it's not because they don't trust you. It's not that difficult for a real goofball to mess up his camera by hurrying or taking a shortcut. Perhaps the person uses the "Bulb" method of holding the shutter open and a finger slips, allowing the shutter curtain to close on top of a sensor cleaning brush. Or, someone tries to clean the sensor using masking tape, and ends up with goo all over its surface. If Sony recommended *any* method that's mildly risky, someone would do it wrong, and then the company would face lawsuits from those who'd contend they did it exactly in the way the vendor suggested, so the ruined camera is not their fault.

You can see that vendors like Sony tend to be conservative in their recommendations, and, in doing so, make it seem as if sensor cleaning is more daunting and dangerous than it really is. Some vendors recommend only dust-off cleaning, through the use of reasonably gentle blasts of air, while condemning more serious scrubbing with swabs and cleaning fluids. However, these cleaning kits for the exact types of cleaning they recommended against are for sale in Japan only, where, apparently, your average photographer is more dexterous than those of us in the rest of the world. These kits are similar to those used by official repair staff to clean your sensor if you decide to send your camera in for a dust-up.

There are three basic kinds of cleaning processes that can be used to remove dusty and sticky stuff that settles on your dSLR's sensor. All of these must be performed with the shutter locked open. I'll describe these methods and provide instructions for locking the shutter later in this section.

- Air cleaning. This process involves squirting blasts of air inside your camera with the shutter locked open. This works well for dust that's not clinging stubbornly to your sensor.
- Brushing. A soft, very fine brush is passed across the surface of the sensor's filter, dislodging mildly persistent dust particles and sweeping them off the imager.
- Liquid cleaning. A soft swab dipped in a cleaning solution such as ethanol is used to wipe the sensor filter, removing more obstinate particles.

Air Cleaning

Your first attempts at cleaning your sensor should always involve gentle blasts of air. Many times, you'll be able to dislodge dust spots, which will fall off the sensor and, with luck, out of the interior. Attempt one of the other methods only when you've already tried air cleaning and it didn't remove all the dust.

Here are some tips for doing air cleaning:

- Use a clean, powerful air bulb. Your best bet is bulb cleaners designed for the job, like the Giottos Rocket. Smaller bulbs, like those air bulbs with a brush attached sometimes sold for lens cleaning or weak nasal aspirators, may not provide sufficient air or a strong enough blast to do much good.
- Hold the Sony a7R II/a7 II pointed downward. Then look up into the cavity behind the lens mount as you squirt your air blasts, increasing the odds that gravity will help pull the expelled dust downward, away from the sensor. You may have to use some imagination in positioning yourself. (See Figure 14.6.)
- Never use air canisters. The propellant inside these cans can permanently coat your sensor if you tilt the can while spraying. It's not worth taking a chance.
- Avoid air compressors. Super-strong blasts of air are likely to force dust under the sensor filter.

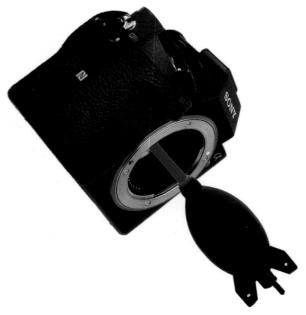

Figure 14.6
Point the camera downward.

Brush Cleaning

If your dust is a little more stubborn and can't be dislodged by air alone, you may want to try a brush, charged with static electricity, that can pick off dust spots by electrical attraction. One good, but expensive, option is the Sensor Brush sold at www.visibledust.com. You need a 24mm version, like the one shown in Figure 14.7, that can be stroked across the short dimension of your Sony a7R II/a7 II's sensor.

Brush cleaning is done with a dry brush by gently swiping the surface of the sensor filter with the tip. The dust particles are attracted to the brush particles and cling to them. You should clean the brush with compressed air before and after each use, and store it in an appropriate air-tight container between applications to keep it clean and dust-free. Although these special brushes are expensive, one should last you a long time.

I like the Arctic Butterfly, shown in Figure 14.8. You activate the built-in motor that spins the brush at high speed to charge it with static electricity. Then, shut the motor off and pass the charged brush *above* the sensor surface so that dust will leap off the sensor and onto the brush.

Ordinary artist's brushes are much too coarse and stiff and have fibers that are tangled or can come loose and settle on your sensor. A good sensor brush's fibers are resilient and described as "thinner than a human hair." Moreover, the brush has a non-conducting handle that reduces the risk of static sparks.

Figure 14.7 A proper brush is required for dusting off your sensor.

Figure 14.8 The motor in the Arctic Butterfly flutters the brush tips for a few minutes to charge them for picking up dust (left). Then, turn off the power and flick the tip above the surface of the sensor (right).

Liquid Cleaning

Unfortunately, you'll often encounter really stubborn dust spots that can't be removed with a blast of air or flick of a brush. These spots may be combined with some grease or a liquid that causes them to stick to the sensor filter's surface. In such cases, liquid cleaning with a swab may be necessary. During my first clumsy attempts to clean my own sensor, I accidentally got my blower bulb tip too close to the sensor, and some sort of deposit from the tip of the bulb ended up on the sensor. I panicked until I discovered that liquid cleaning did a good job of removing whatever it was that took up residence on my sensor.

You can make your own swabs out of pieces of plastic (some use fast-food restaurant knives, with the tip cut at an angle to the proper size) covered with a soft cloth or Pec-Pad, as shown in Figures 14.9 and 14.10. However, if you've got the bucks to spend, you can't go wrong with good-quality commercial sensor cleaning swabs, such as those sold by Photographic Solutions, Inc. (www.photosol.com).

You want a sturdy swab that won't bend or break so you can apply gentle pressure to the swab as you wipe the sensor surface. Use the swab with methanol (as pure as you can get it, particularly medical grade; other ingredients can leave a residue), or the Eclipse solution also sold by Photographic Solutions. Eclipse is actually quite a bit purer than even medical-grade methanol. A couple drops of solution should be enough, unless you have a spot that's extremely difficult to remove. In that case, you may need to use extra solution on the swab to help "soak" the dirt off.

Figure 14.9 You can make your own sensor swab from a plastic knife that's been truncated.

Figure 14.10 Carefully wrap a Pec-Pad around the swab.

Once you overcome your nervousness at touching your Sony a7R II/a7 II's sensor, the process is easy. You'll wipe continuously with the swab in one direction, then flip it over and wipe in the other direction. You need to completely wipe the entire surface; otherwise, you may end up depositing the dust you collect at the far end of your stroke. Wipe; don't rub.

If you want a close-up look at your sensor to make sure the dust has been removed, you can pay \$50 to \$100 for a special sensor "microscope" with an illuminator. Or, you can do like I do and work with a plain old Carson MiniBrite PO-55 illuminated 5X magnifier, as seen in Figure 14.11. It has a built-in LED and, held a few inches from the lens mount with the lens removed from your Sony a7R II/a7 II, provides a sharp, close-up view of the sensor, with enough contrast to reveal any dust that remains. You can read more about this great device at http://dslrguides.com/carson.

Figure 14.11
An illuminated magnifier like this Carson MiniBrite PO-55 can be used as a 'scope to view your sensor.

Add-ons That Don't Cost an Arm or a Leg

After you purchase your camera, a few lenses, and, perhaps, an external flash unit, you may not have a lot of money left for accessories. Even so, you may still have a hankering to explore some areas of photography, such as sports, macro work, landscape photography, or using filters. Don't panic! Some great accessories are available for very little money. All the add-ons I describe in this section can be purchased for \$100 or less, and most of them will cost you no more than half that.

Before we start, I need to point out a couple ground rules/warnings:

■ Don't expect top-line construction. The key to happiness with bargain-basement accessories is to not expect to purchase rugged professional gear. The quality of your images won't suffer in the least if you use a \$25 tripod bracket instead of a \$150 pro version. But don't expect to knock such gear around like the pros do. If you need rugged pro equipment, buy that instead.

■ Your prices may vary. For some add-ons, I won't name specific manufacturers or give exact prices. Vendors for low-priced stuff change all the time, and prices rise or fall depending on supply, demand, and the discovery of a way to make something even more economical. Some accessories are produced by only a small number of companies, and sold by a very large number of importers. As I mentioned in Chapter 12, you may see the exact same lens sold under the Rokinon, Samyang, or Bower name. The same goes for the most popular battery grips for the a7R II and a7 II. What I will do is give you a rough range of prices you can expect to pay, and may mention a few of the better known suppliers.

Battery Grips

Battery grips pre-date digital cameras by many years. When I was a newspaper sports photographer, I had one made for me back in 1970 by an engineer at Goodyear Aerospace, who used a compact but powerful rechargeable battery developed for the Apollo program to supply juice to my film camera's motor drive.

More recently, I've had a love/hate relationship with Sony battery grips ever since I purchased my first a7R back in December 2013. The "hate" part is easy to understand: one of the chief attractions of the Sony full-frame mirrorless cameras is the tiny size and light weight, and an add-on grip nullifies that advantage. You end up with a dSLR-like camera that's as bulky and heavy as some of the Nikon or Canon models many of us are fleeing from.

The price is also easy to hate. The Sony VGC2EM costs roughly \$350, which is a lot to pay for what is basically a battery holder with some extra buttons and dials. Yes, it's a rugged and well-built accessory, but, if you're like me and use the camera "naked" with no add-on grip 80 percent of the time, that's a lot to spend on a component that gathers dust most of the time.

On the other hand, the skimpy battery life of the tiny NP-FW50 in a powerful camera like the a7R II/a7 II means that if you're involved in some heavy-duty shooting, such as sports or event photography, particularly when continuous shooting is involved, you'll be spending a lot of time swapping batteries. I've got eight of them, and sometimes I feel like James Bond feeding clips into his Walther PPK in the middle of a shootout. A grip holding *two* batteries effectively doubles your shooting time between reloads.

When size and weight is not an issue, a vertical grip can actually *improve* the handling of an a7 II—series camera, especially when you swivel the camera to a vertical position for portrait-oriented images. The added bulk fits some hands better, and the vertical controls on the grip (once you're comfortable with using them) prevent some awkward finger-twisting maneuvers.

So, I end up using such a grip when shooting sports and video to gain extended battery life, and for portraits and basketball, where the vertical orientation seems natural. There are indeed types of photography that, once you've gotten used to using a vertical grip, you'll wonder how you ever got along without one. Those who shoot video are special candidates, because I guarantee that, sooner or later, you're going to run out of power while capturing an important scene.

If you're going to use your vertical grip *a lot*, I highly recommend you invest in the Sony VGC2EM grip. It fits any of the a7 II–series cameras, and can stand up to abuse. Those of us with limited budgets and unlimited amounts of equipment lust can be better served by one of the many available third-party grips offered by Vello, Neewer, Meike, and others (although they all are identical and seem to be made by Meike). (See Figure 14.12.)

At around \$80, the price is very attractive. The shell and components include a lot of plastic, but a textured rubber covering on the bottom and part of the front/back surfaces are comfortable to hold. The grip mates easily with your a7 II—series camera and once mounted looks like it belongs. One weak point seems to be the battery door of the camera itself, which has a lever that must be rotated to release the hinge pins so the door can be removed. (See Figure 14.13.) I'd hate to have to remove this door repeatedly, and can only speculate about how inconvenient it would be to purchase a replacement for a lost/broken door from Sony.

Once inserted into the empty battery compartment of the a7R II/a7 II, the slide-out tray supplies juice from a pair of NP-FW50 batteries. The batteries are used by the camera one at a time: when the first is depleted (an indicator appears on the LCD/EVF), the second takes over. In my tests, the tandem of batteries does, in fact, double your shooting time.

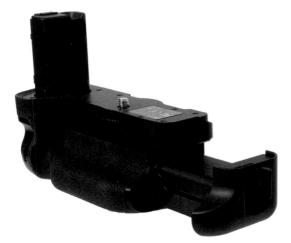

Figure 14.12 A low-cost Meike battery pack/ vertical grip.

Figure 14.13 The camera's battery compartment door must be removed.

Figure 14.14
Control wheels and buttons are easily accessible.

The C1 and C2 buttons of the camera are duplicated on the side of the third-party grip, with the C3 button located on the back, next to the AF/MF button and an On/Off switch that enables/ disables the controls. (If you're shooting exclusively in horizontal orientation, you might want to disable the controls to avoid changing a setting inadvertently.) The C4 button does *not* need to be duplicated, as the camera's C4 button resides directly above the grip. (See Figure 14.14.)

There is no AEL/AF-MF switch; you'll have to use the camera's control to toggle between the two functions. Dials on the front and rear of the grip duplicate the behaviors of the camera's front/rear dials. My biggest beef is that the C1 and C2 buttons are labeled black-on-black, rather than white-on-black like the grip's C3 button and the camera's own custom buttons. I haven't used my Meike grip long enough to determine whether the control wheels and buttons stand up to heavy use or extreme environments. Another plus: these grips come with a 2.4 GHz radio remote control (discussed later).

Tripod Plates and L-Brackets

While 5-axis image stabilization might let you use a tripod slightly less often, when you want absolutely the best possible sharpness when working with telephoto lenses or exposures longer than 1/15th second, a tripod is a must. Because this section deals with *low-cost* accessories, I won't be recommending specific tripods, because they are one component that it's foolish to skimp on. Photo guru Thom Hogan explains why eloquently in a classic 2003 blog posting you can find here: http://www.bythom.com/support.htm. Suffice it to say that I personally never rely on a cheap tripod; even my ultra-compact Gitzo Traveler (which is especially well-suited for a lightweight camera like the a7R II/a7 II) cost \$600 at the time I purchased it; the ball head was another \$300. (Expect to pay more today.)

However, once you've invested in a solid tripod, you'll need a quick-release system to allow attaching/detaching your camera to its support quickly. You need two components: a plate or bracket that attaches to the bottom of your camera, and a matching platform/clamp on your tripod's ball head or video pan/tilt head. Many tripods or their mounting heads already include a built-in quick-release (QR) platform. If the tripod is a decent one, that platform will be Arca-Swiss compatible. (I don't recommend the Manfrotto RC2 or RC4 platforms and plates, which are not as secure.) You'll need to mate the platform/clamp with an Arca-Swiss plate on the camera. You'll find excellent examples from Really Right Stuff (www.reallyrightstuff.com), Kirk Photo (www.kirkphoto.com), and others, at prices from around \$60 to several hundred dollars.

However, for occasional use, I find that third-party black-anodized aluminum platforms (for \$50 or less) and camera plates (\$15 to \$30) do a great job. One platform that may work for you is the Neewer Professional Smooth Round Quick Release Clamp, which I found on Amazon for about \$17.

You can opt for a simple plate that fits on the bottom of the camera for use in horizontal orientation (you'll need to swivel the tripod head to shoot vertically), or an L-bracket. Figure 14.15 shows a \$22 Andoer LB-A7M2 L-bracket designed specifically for the a7 II—series cameras. It fits snugly on the bottom of the unadorned camera, or on the bottom of the grip. The advantage of the L-bracket is you can attach it to an Arca-Swiss-style platform/clamp with the camera in either vertical or horizontal orientation without drastically changing the relative position of the lens.

I also have a selection of simple camera plates in 20, 30, 40, 50, 60, and 70mm sizes that I sometimes use. The 20mm plate lets me travel light and is unobtrusive, but attaches to smaller tripods, especially tabletop models with a small suitable clamp attached.

Figure 14.15
An L-bracket can attach to the tripod clamp in either horizontal or vertical positions.

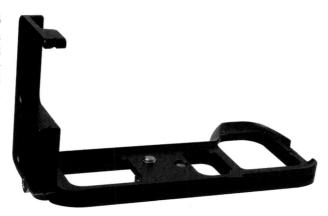

Flash Shoe Adapters

In Chapter 13, I explained how Sony has switched from the old proprietary Minolta flash hot shoe to a new multi-interface shoe that's compatible with the industry standard. Most of you will be purchasing the latest Sony (or, possibly, compatible third-party flash units) that use the multi-interface shoe. However, if you already own one of the older flash units or run across one in good condition used, you can work with an older flash if you mount a shoe adapter, like the one shown in Figure 14.16. They're available under a variety of brand names for \$15 or less, and are *electrically* compatible with the new multi-interface shoe. You'll probably need to use the older flash protocol (CTRL, instead of CTRL+) as I describe in Chapter 13. But the price is right! The adapter adds a little height (good for red-eye control with direct flash) and you should make sure the flash and adapter are locked when mounted.

Figure 14.16 Multi-interface shoe adapter for older Sony/Minolta flash units.

LED Video Lights

If you're paying attention, you already know that you can't use electronic flash bursts when shooting video. Fortunately, as I discuss in Chapter 13, several Sony flash units like the HVL-F32M and HVL-F60M have built-in LED video lamps. You can also use more powerful special-purpose LED video lights that mount on the accessory shoe, like the one shown in Figure 14.17. It's a Neewer 160-LED dimmable panel that cost me all of \$26. It uses six AA batteries (I recommend the same Panasonic eneloop batteries that power my flash units) and comes with colored filter/diffusers to tailor the light to match daylight or tungsten ambient illumination. A rotating intensity wheel lets you adjust the light from soft fill to blinding main light.

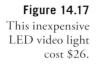

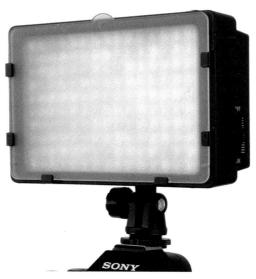

Lighting choices for amateur videographers are a lot better these days than they were a decade or two ago, and won't cost you a lot. An inexpensive incandescent or LED video light, which will easily fit in a camera bag, can be found for less than \$30. Even more expensive LED video lights may sell for less than \$100. Work lights sold at many home improvement stores can also serve as video lights since you can set the camera's white balance to correct for any color casts. You'll need to mount these lights on a tripod or other support, or, perhaps, to a bracket that fastens to the tripod socket on the bottom of the camera.

Much of the challenge depends upon whether you're just trying to add some fill light on your subject versus trying to boost the light on an entire scene. A small video light will do just fine for the former. It won't handle the latter.

Filter Accessories

As your collection of lenses grows, your need for an expanding number of filters will grow as well. Some Sony lenses, like the superb FE 50mm f/1.8 Zeiss, take 49mm filters, quite a few Sony or Minolta lenses use 55mm filters, while the f/4 maximum apertures of the Sony "trinity" discussed in Chapter 12 require 67mm filters (for the 24-70mm f/4 Zeiss) or 72mm filters (for the 70-200mm f/4 and 16-35mm f/4 optics). If you choose to use a "protective" filter, you'll want a separate filter for each lens (I recommend the brass versions of B+W's lineup). But your polarizer, infrared, and neutral-density filters can all be shared among your lenses through the use of inexpensive *step-up* and *step-down* rings. The former allow using larger filters on lenses that have smaller diameter filter threads (say, a 72mm filter on a lens that has a 55mm filter thread), or smaller filters (if they can be used without vignetting) on a lens with a larger filter thread.

I get some use out of a set of Fotodiox anodized aluminum 49-52mm, 52-55mm, 55-58mm, 58-62mm, 62-67mm, 67-72mm, and 72-77mm *step-up rings*, which can be used in combination for multiple "steps." I also have the Fotodiox 77-72mm, 72-67mm, 67-62mm, 62-58mm, 58-55mm, 55-52mm, and 52-49mm *step-down* rings. These come in handy when I want to fit a particular filter on an odd-ball lens. They cost about \$17 a set.

However, I recommend purchasing specific rings that go directly from each lens filter size to the size of your "standard" set of filters. For example, if you wanted to standardize on 72mm filters and owned lenses with 67mm, 55mm, and 49mm filter threads, you'd purchase 67-72mm, 55-72mm, and 49-72mm adapters. Those rings would allow you to avoid combining rings; the more rings in a set, the more likely you are to experience vignetting in the corners of your images. Vignetting is also more likely when using wide-angle lenses that have a larger field of view.

I reduce the traveling size of my filter kit by threading all my 72mm filters together into a stack. Then a threaded "stack cap" set with a male threaded screw in 72mm front cap and female threaded 72mm rear cap allows carrying. If I'm traveling with just my "trinity," I screw the 67-72mm step up ring into the back of the stack and use a 67mm rear cap instead. (See Figure 14.18.)

What do you do if your filter stack is stuck? Or if you have screwed a filter onto the front of your lens too tightly and can't remove it? What you need is a handy filter remover band, like the one shown in Figure 14.19. It's an elastic latex band that you can wrap around the filter edge and grip the filter tightly enough that it can (usually) be easily removed. The band is compact, and eliminates the need for a filter "wrench." Best of all, it's probably the least expensive accessory covered in this chapter. It's actually a strip from a tourniquet band, and you can probably get one for free the next time you donate blood. Non-latex versions are usually on hand for those with allergies.

Figure 14.18 Step-up and step-down rings, and a set of "stack caps" can streamline your use of filters.

Figure 14.19 An elastic band can help you loosen a stubborn filter.

Remotes

You can always use a self-timer to start an exposure, but a remote control of the wireless or wired variety may be a better choice. I use a generic \$10 wired remote that plugs into the USB terminal of my a7R II most of the time, because it's lightweight and mindlessly easy to operate. You simply press the button to take a picture, or slide the button forward to lock it when shooting bulb exposures. No batteries are required.

That's not true for the Sony RMT-DSLR2 wireless remote control (around \$23 and shown in Figure 14.20), which uses a CR2025 battery, but has a great deal more flexibility. It's a multifunction remote control you can use to remotely release the camera's shutter, or release the shutter with a delay in order to include yourself in the photo without needing to activate the camera's self-timer. You can stop/start video recording and control playback on an external monitor.

My Meike vertical grip, discussed earlier, came with its own radio remote control/intervalometer (shown in Figure 14.21). I use it primarily for its intervalometer features, and even then I have to fish the manual out of the box I keep the remote in, because the various settings are not the sort of thing you'll remember how to do if you haven't used the controller for a while.

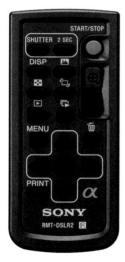

Figure 14.20 Sony RMT-DSLR2 wireless remote control.

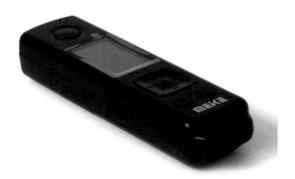

Figure 14.21 Meike radio remote.

Macro Gear

Close-up photography doesn't have to be expensive. While a lens with macro-focusing capabilities will give you the best results, you may already own a lens that can be coaxed into focusing closer than you thought possible. I purchased a Fotodiox Pro automatic macro extension tube kit for about \$32. The tubes include electrical contacts to preserve autofocus and autoexposure functions.

The kit comes with 10mm and 16mm tubes, and if you wanted to splurge you could purchase a second set and theoretically get 20mm, 26mm, 32mm, 36mm, 42mm, and 52mm extension combinations. I mean to test this in the future, but until I do I can't promise that all auto functions will survive working with more than two or three tubes simultaneously. Of course, with the a7 II–series' short flange-to-sensor distance, 10mm and 16mm provide a significant amount of extension when used with E-mount lenses. These tubes are made of plastic, but they are sturdy enough for occasional use (again, with advice to use caution with using heavy lenses and multiple extension tubes). (See Figure 14.22.)

Another macro accessory I find invaluable when using manual focus is a focusing rail. These let you mount your camera and rail on a tripod and use the rail's adjustments to move the camera back and forth or from side to side in small increments. For example, you can set your lens to its closest focus distance, then slide the camera closer or farther away until the exact plane you want to be in sharp focus is locked in. Figure 14.23 shows a Neewer Pro four-way macro focus rail slider that I paid all of \$24 for. It has *two* Arca-Swiss clamps built in and can be used as shown, or disassembled into a pair of separate one-way focusing rails. In the figure, it's shown mounted on my Neewer tripod clamp discussed earlier, which has a bubble level built in.

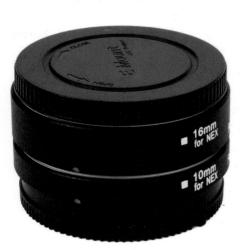

Figure 14.22 Extension tubes let you focus closer.

Figure 14.23 A focusing rail allows precision manual focus.

Index

Numbers AF area. See also Display Continuous AF Area setting 1/2 (Memory Recall) mode, 19 Center Lock-On AF, 249-251 3:2 aspect ratio preference, 52-53 Face Detection and Eye AF, 248–249 4K setting, 245-251 Output Selection options, 174-175 AF Drive Speed (Movies) camera setting, Still Image PB playback options, 164 18-percent "myth," 194 AF illumination, 30, 40, 42, 70 AF menu items, 254–255 A AF Micro Adjustment setting, 126, 337 A (Aperture Priority) mode, 20, 199–200, AF modes, 240 283 AF System (Stills) custom setting, access point, selecting manually, 141–145 130 - 131accessibility features, Exposure Settings AF Track Sensitivity (Movies) camera Guide, 113 setting, 71–72 action, stopping, 259-263 AF w/Shutter setting, 120. See also shutter ADI (advanced distance integration) release technology, 322 AF-A (Automatic AF) mode, 22, 67, 245 Adobe RGB vs. sRGB, 96 AF-C (Continuous AF) mode, 21, 68, 245 AE Lock, 40, 42 AF/MF/AEL switch/button, 34–35, 136 AEL (autoexposure lock) functions, AF-S (Single-shot AF) mode, 21, 67, 244 assigning to keys, 135-136 Airplane mode, 40, 43 AEL w/Shutter setting, 120–121. See also A-mount lenses shutter release features, 327–329 AF (autofocus). See also Focus modes fine-tuning focus of, 335–339 automating, 116–117 using, 126 and continuous shooting, 270

Anti Motion Blur shooting mode, 19, 231 aperture

in Display All Info screen, 40, 42 in exposure triangle, 186

Aperture Priority (A) mode, 20, 199–200, 283

Application menu options, 49

Application List, 149–150 Current Sony Apps, 154–157 Introduction, 150 NFC (Near Field Communications), 157–158

Working with Applications, 150–153 application software, downloading, 9

apps

downloading, 152–153 from Sony, 154–157

APS-C sensor, 125, 316 Area Setting options, 177 aspect ratio

considering for video, 306–307 options, 52–53

Aspect ratio/Image size, 40–41 Audio Level Display custom setting, 108–109

Audio Out Timing camera setting, 98–99 audio recording

in Display All Info screen, 40, 43 for video, 298–299

Audio Signals options, 168–169 Auto HDR, 216–217 Auto Mode camera setting, 92
Auto Object Framing setting, 40, 43, 92
auto racing, focus guidelines for, 257
Auto Recording camera setting, 97–98
Auto Review custom setting, 108–109
Auto shooting mode, 17–18, 231–232
Auto Slow Shutter camera setting, 96–97
autofocus (AF). See also Focus modes

automating, 116-117 and continuous shooting, 270

Autofocus modes

AF-A (Automatic AF), 245 AF-C (Continuous AF), 245 AF-S (Single-shot AF), 244

autofocus system

circles of confusion, 241–242 contrast detection, 234–235 focus modes and options, 239–240 hybrid components, 237–239 phase detection, 235–237 summary, 255–256 turning on for video, 282

Autofocus/Manual focus/Autoexposure lock button/Index, 34 Automatic AF (AF-A) mode, 22, 67, 245 Autumn Leaves Creative Style, 277 AVCHD bit rates, 288

AWB (Auto White Balance) option, 76-77, 271-273

D	DSI (back-side illuminated) EAMOR R
back button focus, 120, 253-254. See also	sensor, 4–5
AF (autofocus); focus	buttons
back of camera, 33-39	assigning functions to, 135
barrel distortion, 128–129	deactivating, 134
batteries, 10-11	redefining, 35
charging, 10-11	B/W Creative Style, 276
checking in box, 7	
compartment door, 46	C
minimizing consumption of, 170-171	cables, Micro B USB-2.0, 7
tip for external electronic flash, 375	Camera 1 button, 44–45
using, 9–10	Camera Settings menu options, 49
battery charger, checking in box, 7, 10–11	AF Drive Speed (Movies), 71
battery grips, 402–404	AF Illuminator (Stills), 70
battery status, 40–41	AF Track Sensitivity (Movies), 71–72
BC-VW1 external charger, 7, 10–11	Aspect Ratio, 52-53
BIONZ digital image processor, 54, 88	Audio Out Timing, 98–99
birds in flight, focus guidelines for, 257	Auto Mode, 92
bit rates, for video, 287–288	Auto Object Framing, 92
Bluetooth vs. NFC, 157	Auto Recording, 97–98
bokeh, 327, 333–334	Auto Slow Shutter, 96–97
bottom of camera, 46	Bracket Settings, 65
Bracket Order custom setting, 124	Center Lock-On AF, 89–90
Bracket Pro app, 155	Color Space, 95–96
Bracket Settings camera setting, 65	Creative Style, 79–80
bracketing. See also exposure bracketing	Drive Mode, 63–64
Continuous option, 64	DRO/Auto HDR, 79
and Merge to HDR, 217–220	Dual Video Record, 63
brightness	Exposure Compensation, 72
checking, 104-105	Exposure Step, 72
of monitor, 166–167	File Format (Movies), 61–62
of viewfinder, 168	Flash Compensation, 65–66
	Flash Mode, 65
	Focus Area, 68–69
	Focus Magnifier, 86–87
	Focus Mode, 67–68

chromatic aberration, 127-128

Cinematic Photo app, 156

Focus Settings, 69–70 circles of confusion, 241–242 Image Size, 51–52 Cleaning Mode options, 171 ISO, 73–75 cleaning sensors, 393, 397-401 Long Exposure NR/High ISO NR, Clear Creative Style, 276 87 - 89close-ups, 294-295 Memory, 101-102 Cloudy white balance setting, 77 Memory Recall, 99–101 Color Space camera setting, 95–96 Metering Mode, 76 color temperature Movie, 93 adjusting for finder, 168 Panorama, 57-61 setting white balance by, 274 Picture Effect, 80–82 and white balance, 271 Picture Profile, 82-83 colors, indicating for peaking, 112 Quality, 53-57 composition, considering in movie RAW File Type, 57 making, 292-295 Red Eye Reduction, 67 compressed vs. uncompressed RAW, 55 Scene Selection mode, 93 concerts, focus guidelines for, 257 Smile/Face Detection, 90–91 connection plate cover, 46 Soft Skin Effect, 91 Continuous AF (AF-C) mode, 21, 68, 245 SteadyShot, 94 continuous bracketing, 209-210 White Balance, 76–78 continuous shooting, 266-270 Wind Noise Reduction, 99 contrast, indicating in histogram, Zoom, 84-86 224-226 CCTV lenses, 334 control wheel, 34, 37 CDAF (contrast detection autofocus), 233, Copyright Info options, 177–178 237-239 Creative Styles, 36, 40, 42, 79-80 Center focus area, 22 modifying, 277–278 Center Lock-On AF setting, 89–90, using, 275-278 249-251 crop factor Center metering option, 20, 196, 198 considering for video, 305–307 Center/OK button, 34, 39 and lenses, 316-318 Certification Logo options, 182 C.Temp/Filter/Custom/Custom Setup charge lamp, 32-33 white balance setting, 77 charger, checking in box, 7, 10-11 curtains in focal plane shutter, 357-358

Custom buttons, 44–45

Custom Key Settings, 133–137

Custom Settings menu options, 49

AEL w/Shutter, 120-121

AF Micro Adjustment, 126

AF System (Stills), 130-131

AF w/Shutter, 120

APS-C Size, APS-C/Super 35, 125

Audio Level Display, 108-109

Auto Review, 108-109

Bracket Order, 124

Custom Key Settings, 133–137

Dial Ev Comp, 137–138

Dial Setup, 137

Dial/Wheel Lock, 138

DISP Button, 109-112

Display Continuous AF Area, 115

e-Front Curtain Shutter, 122

Exp. Comp. Set, 123

Exposure Settings Guide, 113

Eye-Start AF, 116–117

Face Registration, 124–125

FINDER/MONITOR, 117

Focus Magnifier Time, 106

Function Menu Set, 131–133

Grid Line, 106-107

Lens Compensation, 126-129

Live View Display, 113–114

Marker Display, 107

Marker Settings, 107–108

MF Assist, 106

MOVIE Button, 138

Peaking Color, 112–113

Peaking Level, 112

Phase Detect. Area, 115

Pre-AF, 115

Priority Set in AF-S/Priority Set in AF-C, 118–119

Release w/o Card, 118

Release w/o Lens, 118

Reset EV Comp., 124

Silent Shooting, 121

Superior Auto Image Extract, 122–123

Video Light Mode, 131

Zebra, 104-105

Zoom Ring Rotate, 137

Zoom Setting, 116

D

DAR (Display Aspect Ratio), 306 database indicator, 40, 43. *See also* image database

Date/Time Setup options, 177

Daylight white balance setting, 77, 272

Deep Creative Style, 276

default functions, reassigning, 136. See also functions

Delete Confirm options, 170

Delete playback options, 159–160

deleting images, 26

Demo Mode options, 171–172

Dial Ev Comp custom setting, 137–138

Dial Setup custom setting, 137

dials. See front dial; mode dial; rear dial

Dial/Wheel Lock custom setting, 138

diffraction, 186

digital noise, dealing with, 211. See also

NR (noise reduction)

diopter adjustment, 13, 34-35

Direct Manual Focus (DMF) mode, 21,

68. See also M (Manual) mode

Direct Upload app, 154

directional buttons, 34, 37

E DISP button, 25, 38, 109-112 Display Continuous AF Area setting, 115. e-Front Curtain Shutter setting, 122. See See also AF area also rear curtain sync Display Media Information options, 181 electrical contacts, 30-31 display options, choosing, 109-112 electronic flash. See also external Display Quality options, 170 electronic flash: Flash modes Display Rotation playback options, avoiding sync-speed problems, 360-361 161-163 vs. continuous illumination, 352-356 distortion, 128-129 determining exposure, 365 DMF (Direct Manual Focus) mode, 21, e-Front Curtain Shutter, 359 68. See also M (Manual) mode electronic shutter, 359 DOF (depth-of-field), 344 function of, 357-359 Down ghost images, 362-363 button, 34 rear curtain sync, 357-358 key, 38 Red Eye Reduction, 368 Drive mode slow sync, 364-365 described, 39, 42 Enlarge Image playback options, 164 displaying, 36, 40 equivalent exposure, 190–191. See also and self-timer, 23 exposure setting, 63-64 establishing shot, 293 DRO (Dynamic Range Optimizer). See EV (exposure value) changes, making, also HDR (High Dynamic Range) 202-203 and Auto HDR, 36, 79 EVF (electronic viewfinder). See also bracketing, 210 FINDER/MONITOR setting; using, 213-215 Viewfinder Brightness options dual recording, activating for movie activating, 33-34 making, 282 changing settings for, 13 Dual Video Record camera setting, 63 showing scrolling scale on, 113 dust, dealing with, 394-397 switching to, 13 Dynamic Range Optimizer/HDR, 40, 42 EV/stops, separating exposures with, 219 Exp. Comp. Set custom setting, 123 Expand Flexible Spot focus area, 23

exposure. See also equivalent exposure; fast exposures; long exposures	external meters, calibration of, 193. See
calculation of, 191–194	also Metering modes
determining for flash, 365	Eye AF, 249
and ISO, 194–195, 206–207	eye sensors, 34
and light, 188–189	Eye-Fi memory cards, 28. See also
process of, 358	memory cards
separating with EV/stops, 219	eyepiece cup
triangle, 185–186	checking in box, 9 described, 34–35
exposure bracketing, 186–187, 207–210.	eyesight accessibility option, 113
See also bracketing	Eye-Start AF custom setting, 116–117
exposure compensation, 36, 40, 42. See	Lyc start III custom setting, 110–117
also flash exposure compensation;	F
Multiple Exposure app	-
dial, 44-45	Face Detection and Eye AF, 91, 248–249
saving settings for, 124	Face Registration custom setting, 124–125
setting, 72	FAR (Frame Aspect Ratio), 307
exposure evaluation. See histograms	fast exposures, 259–263. See also exposure
exposure grading, 122	Fast ISO change, 136. See also ISO
exposure modes	settings
A (Aperture Priority), 199–200	Fast-forward and -reverse controls,
M (Manual), 204–207	accessing, 25
P (Program auto), 202	file format, choosing for movie making,
S (Shutter Priority), 201–202	61–62, 281
Exposure Settings Guide custom setting,	File Number options, 179
113	files, transferring to computers, 27-28
Exposure Step camera setting, 72	film frame icon, 50
Exposures remaining, 40-41	filter accessories, 407-408
external electronic flash. See also	Finder Color Temperature options, 168
electronic flash; Flash modes	FINDER/MONITOR setting, 13, 117,
battery tip, 375	136. See also EVF (electronic
cable connections, 369–370	viewfinder); Viewfinder Brightness
guide numbers, 369	options
hot shoes, 369–370	Fine Quality preference, 53
HSS (High-Speed Sync), 372	firmware, upgrading, 384-386
HVL models, 370–375	Flash charge in progress, 40, 42
using, 368	

flash exposure compensation, 36, 40–41, 65-66, 367-368. See also exposure compensation Flash modes, 36, 40, 42, 65, 365–367. See also electronic flash; external electronic flash; wireless flash flash shoe adapters, 406 Flash white balance setting, 77 flat lighting, 296, 298 Flexible Spot AF Area, 22, 282 Flickr Add-On app, 154 Fluorescent white balance setting, 77, 272 Fn button, pressing, 49. See also functions focal length equivalent, 316 focal peaking, 112 focus. See also AF (autofocus); back button focus; Manual Focus guidelines, 257 indicator, 40, 42, 243-244 Focus Area modes, 22-23, 36, 40, 43, 68-69, 240 focus frame, moving, 248 Focus Magnifier settings, 86-87, 106 Focus modes, 21–22, 36, 40, 43, 67–68, 239-240 focus points Autofocus modes, 243-245 circles of confusion, 241-242 Focus Settings camera setting, 69–70 focus test chart, 337-338

Focus Settings camera setting, 69–70 focus test chart, 337–338
Folder Name options, 180 folders. See also storage folder creating, 180 switching, 181

football, focus guidelines for, 257 For Viewfinder/Quick Navi screen, 41 Format options, 178-179 formatting memory cards, 15-16 Fotodiox website, 327 frame boundaries, checking for video, 107 frame guides, considering for video, 307-308 frame rates, 40-41, 285-287 freezing action, 259-263 front dial, 30, 44-45 front of camera, 30-33 f/stops adjustment of, 186 and shutter speeds, 190 Fujian lenses, 333–334 Function Menu Set custom setting, 131-133 functions. See also default functions: Fn button assigning buttons to, 135 assigning pairs of, 137 Function/Send to Smartphone button, 34,

G

36

gamma curve, considering for video, 311–314 ghost images, 362–363 "ghoul lighting," 297 Graphic Display option, 110–111 Grid Line custom setting, 106–107

Н	I
Hand-held Twilight shooting mode, 19,	icons, types of, 50
231	illumination
HD (high-definition) video, 147-148	vs. electronic flash, 352–356
artifacts and distortion, 285	for video, 295–298
vs. UHD, 309	Illustration Picture Effect, 82
HDMI (high-definition multimedia	image database, recovery options, 181–
interface)	182. See also database indicator
micro terminal, 32	Image Index playback options, 161
settings, 173–174	image quality, 40–41. See also Quality
HDR (High Dynamic Range), 188, 210.	options
See also DRO (Dynamic Range	image sizes, 40, 51-52
Optimizer); exposures	images. See also photos
working with, 216–220	deleting, 26
HDR Painting Picture Effect, 82	magnifying, 164
headphone terminal, 32	reviewing, 25–27
help feature, accessing, 17	reviewing automatically, 108
High Contrast Monochrome Picture	rotating on screen, 25
Effect, 82	transferring to computers, 27-28
high ISO noise, 4, 88, 211–213. See also	viewing on TV, 147–148
ISO (International Standards	zooming into, 26
Organization)	imaging software, downloading, 9
highlight levels, checking, 104	Incandescent white balance setting, 77
histograms	index screen, viewing, 161
activating, 111	Info-Lithium NP-FW50 batteries, 7
and contrast, 224–225	instruction guide, downloading, 9
explained, 223–224	Intelligent Auto mode, 18, 122–123, 229
RGB channels, 228	interlaced scanning, 286
shape of, 227–228	IP Address Setting for access point, 142
tonal range, 222–223	IRE (Institute of Radio Engineers), 104
types of, 221	IS (image stabilization), 319–323
working with, 226–228	ISO (International Standards
Hogan, Thom, 404	Organization), 194–195. See also
HSS (High-Speed Sync), 372	high ISO noise
HVL electronic flash units, 370–375	

hybrid components, comparing, 237-239

ISO Auto, using, 207–208	Left key/Drive mode button, 39
ISO button, 34, 39	Left/Drive button, 34
ISO level, adjusting, 23	Lens Compensation
ISO sensitivity, in exposure triangle, 186	app, 156
ISO settings, 36, 40, 42, 73-75. See also	custom setting, 126–129
Fast ISO change	lens mount
	index, 30-31
J	release button, 30–31
JPEG compression, 54-57, 220	release pin, 30–31
•	lenses. See also Release w/o Card and Lens
K	settings
KEH Camera website, 327–328	bayonet mount, 30–31
keys	capabilities, 340–342
customizing, 133–137	CCTV, 334
freeing up, 137	checking in box, 6
kids, focus guidelines for, 257	choosing, 323–324
Kirk Photo website, 405	crop factor, 316–318
	DOF (depth-of-field), 344
L	focal length equivalent, 316
_	Fujian, 333–334
L image size preference, 51	kit, 6
LA-EA adapters, 126, 331–332	LA-EA series adapters, 331–332
Landscape	Mitakon, 330
Creative Style, 276	A-mount, 327–329
focus guidelines, 257	mounting, 11–12
option for SCN position, 18	recommendation, 6
shooting mode, 230	resetting values for, 340
Language options, 176–177 L-brackets and tripod plates, 404–405	Samyang/Rokinon, 330
LCD monitor screen, 33–34	Sony FE, 324–327
	SteadyShot, 319–323
display options, 109–112	telephoto and tele-zoom, 348–350
protecting, 386–387	third-party vendors, 332–334
showing scrolling scale on, 113	for video, 299–301
tilting, 37	Voigtlander, 330
LCD panel data displays, 39–43	wide-angle, 343–348
LED video lights, 405–406. See also	Zeiss Loxia and Batis, 329–330
lighting for video	

David Busch's Sony α a7R II/a7 II Guide to Dig
Motion Shot app, 157 mount adapters, LA-EA2 and LA-EA4, 126
mounting lenses, 11-12
Movie
button, 31-32, 138
setting, 93
movie making, 24-25. See also video
audio, 298–299
bit rates, 287–288
close-ups, 294–295
composition, 292–295
establishing shot, 293
Flexible Spot AF Area, 282
frame rates, 285–287
lenses, 299–301
medium shot, 293
over-the-shoulder shots, 295
preparing for, 280–283
Program Auto preference, 93
shutter speeds, 289–290
steps during, 284–285
tips, 290–291
transitions in editing, 291
"two" shots, 295
Movie mode, 19
Movie Playback and Still, switching
between, 26–27
Movie recording setting, 40–41

MP4 bit rates, 288 File Format preference, 61–62

Multi Frame Noise Reduction app, 154. See also NR (noise reduction)

Multi metering option, 20, 196 multi-interface shoe, 44 Multi/Micro USB terminal, 32-33. See also USB-2.0 cable Multiple Exposure app, 156. See also exposure compensation

N neck strap, using, 8 Neutral Creative Style, 276 neutral-density filters, 265 New Folder options, 180 NFC (Near Field Communications), 31-32, 40-41, 139, 145, 157-158 **Night Portrait** option for SCN position, 19 shooting mode, 230 **Night Scene** Creative Style, 277 option for SCN position, 19 shooting mode, 230 NO CARD warning, displaying, 14 noise. See digital noise; high ISO noise; visual noise Novoflex lens options, 332–333 NP-FW50 Info-Lithium batteries, 7

NR (noise reduction), 73, 88. See also digital noise; Long Exposure NR/ High ISO NR setting; Multi Frame Noise Reduction app; Wind Noise Reduction NTSC/PAL Selector options, 171

U	Playback menu options, 49
object framing, 40, 43	4K Still Image PB, 164
OK button, 34, 39	Delete, 159–160
OLED (organic LED) display, 33-34	Display Rotation, 161–163
On/Off switch, locating, 13, 44-45	Enlarge Image, 164
options. See settings	Image Index, 161
outdoor lighting, 297	Protect, 165
overexposure, 192	Rotate, 163–164
•	Slide Show, 163
P	Specify Printing, 165
P (Program Auto) mode, 20, 202	View Mode, 161
Panorama settings, 57–61. See also Sweep	Playback mode, 26-27, 38
Panorama mode	PlayMemories Camera Apps, 146,
PAR (Pixel Aspect Ratio), 306	150–151
Partial Color Picture Effect, 80	PMB (Picture Motion Browser) software,
Pause/Resume control, accessing, 25	287
PCs, transferring images to, 28	Pop Color Picture Effect, 80
PDAF (phase detection autofocus),	port covers, 32
235–239	Portrait
Peaking Color and Level settings,	Creative Style, 276
112–113	focus guidelines, 257
people, making invisible, 265	for SCN position, 18
performance, focus guidelines for, 257	shooting mode, 230
pets, focus guidelines for, 257	Portrait Lighting app, 157
Phase Detect. Area custom setting, 115	Posterization Picture Effect, 80
Photo Retouch app, 155	power, turning on, 13
photos. See also images	Power Save Start Time options, 170–171
sending to smart devices, 145	power switch, locating, 2
transferring to computers, 146–147	Pre-AF custom setting, 115
Picture Effect, 40, 42, 80-82, 154	printing, specifying, 165
Picture Profile, 40, 43, 82-83, 311, 314	Priority Set in AF-S/Priority Set in AF-C
pictures. See images	custom setting, 118–119
pincushion distortion, 128–129	Program Auto (P) mode, 20, 93, 202
pitch, roll, and yaw, 321	program shift, 191
Playback button, accessing, 25, 34, 37	progressive scanning, 286
, 2 27 37 37	Protect playback options, 165

Q

Quality options, 53–57. See also image quality

Quick Navi screen, 41, 43

R

Rainbow Imaging website, 327 RAW files, 54-57, 220 Really Right Stuff website, 405 rear curtain sync, 357-358. See also e-Front Curtain Shutter setting rear dial, 34 recalling settings, 100 record setting, choosing for movie making, 282-283 recording audio. See audio recording Recover Image Database options, 181 Red Eye Reduction, 67, 368 Release w/o Card and Lens settings, 118. See also lenses; memory cards Remote Control options, 173, 409 remote sensor, 30-31 Reset EV Comp. custom setting, 124 resetting camera, 183 resolution and aspect ratio, 52 Retro Photo Picture Effect, 80 reviewing images, 25–27, 108 RGB color gamut, 96, 228 Rich-tone Monochrome Picture Effect, 82 Right key/ISO button, 39 Right Panorama: Direction preference, 57 Right/ISO button, 34 roll, pitch, and yaw, 321 Rotate options, 25, 161–164

S

S (Shutter Priority) mode, 20, 201–202 SAM (Smooth Autofocus Motor), 327 Samyang/Rokinon lenses, 330 saved settings, activating, 100 scene modes, accessing, 17 Scene Selection mode, 17–18, 93, 231–232 SCN setting, 17 SD (Secure Digital) cards, types of, 14 Select REC Folder options, 179 self-timer, using, 23–24, 39 Send to Smartphone button, 34, 36 sensor focal plane, 44 sensors, 304-305 BSI (back-side illuminated) EXMOR R, 4-5cleaning, 383, 397–401 front-illuminated, 5 full-frame, 5 locating, 30 and video, 304-305 Sepia Creative Style, 277 sequential scanning, 286 Setting Effect, 40, 43 Setting Reset options, 183 settings adjusting with front dial, 30 confirming, 13 library, 100 recalling on memory cards, 100

selecting, 21

storing in memory, 19

Setup menu options, 49 Shade white balance setting, 77 4K Output Selection, 174–175 shoe cap, checking in box, 9 Area Setting, 177 Shooting modes, 36, 38-40 Audio Signals, 168–169 Auto and Scene, 229-231 Certification Logo, 182 for movies, 283 Cleaning Mode, 171 selecting, 16-20 Copyright Info, 177-178 Sweep Panorama, 231–232 Date/Time Setup, 177 shooting script, using for video, 290 Delete Confirm, 170 Shutter Priority (S) mode, 20, 201-202 Demo Mode, 171-172 shutter release. See also AEL w/Shutter Display Media Information, 181 setting; AF w/Shutter setting Display Quality, 170 button, 44–45 File Number, 179 options, 118-119 Finder Color Temperature, 168 Silent Shooting options, 121 Folder Name, 180 shutter speeds, 40, 42. See also sync-speed Format, 178-179 problems HDMI Settings, 173-174 in exposure triangle, 186 Language, 176-177 and f/stops, 190 Mode Dial Guide, 170 for movie making, 289-290 Monitor Brightness, 166–167 for stopping action, 259-263 New Folder, 180 Silent Shooting custom setting, 121 NTSC/PAL Selector, 171 single bracketing, 210 Power Save Start Time, 170-171 Single-shot AF (AF-S) mode, 21, 67, 244 Recover Image Database, 181 skin, softening, 91 Remote Control, 173 Slide Show playback options, 163 Select REC Folder, 179 S-Log2 gamma curve, 313-314 Setting Reset, 183 slow sync, 364-365 TC/UP Settings, 173 Slow-forward and -reverse controls, 25 Tile Menu, 169 smart devices, sending photos to, 145 Upload Settings, 169 Smart Remote Embedded app, 155 USB Connection, 175 Smile/Face Detection, 40, 43, 90-91 USB LUN Setting, 175-176 Soft Focus Picture Effect, 82 USB Power Supply, 176 Soft High-key Picture Effect, 80 Version, 182 Soft Skin Effect camera setting, 91 Viewfinder Brightness, 168 software, downloading, 9 Volume Settings, 168 Sony apps, 154–157

Sony Entertainment Network website, 149 Sony FE lenses, 324–327 sound volume, adjusting for movies, 25 speaker, locating, 44 Specify Printing playback options, 165 sports, image size recommendations, 56 sports action

focus guidelines, 257 option for SCN position, 18 shooting mode, 230

Spot metering option, 20, 197–198 sRGB preference, 95 SSM (SuperSonic motor), 327 Standard

Creative Style, 276 Quality option, 53

SteadyShot stabilization, 40, 42, 94, 319–323, 344

stereo microphones, 44. *See also* microphone terminal

Still and Movie Playback, switching between, 26–27

storage folder, creating, 179. See also folders

storyboards, using for video, 290–291 streaks, creating, 264–265 street photography, focus guidelines for, 257

Sunset

Creative Style, 276 option for SCN position, 19 shooting mode, 230

Superior Auto settings, 18, 92, 122–123, 229–230

Sweep Panorama mode, 19, 231–232. See also Panorama settings
sync-speed problems, avoiding with flash

sync-speed problems, avoiding with flash, 360-361. See also shutter speeds

T

309–310 TC/UP Settings options, 173 telephoto and tele-zoom lenses, 348–350

TC (Time Code), considering for video,

telephoto and tele-zoom lenses, 348–350 three-point lighting, 296–297 thumbnail images, displaying, 26 Tile menu

bypassing, 49 options, 169

Time Lapse app, 156 top of camera, 44–45 Toy Camera Picture Effect, 80 track events, focus guidelines for, 257 transferring files to computers, 27–28 tripod

plates and L-brackets, 404-405 socket, 46

troubleshooting and prevention, 383–384 TV, viewing images on, 147–148 "two" shots, 295

U

UB (User Bits), considering for video, 309-310 UHD, vs. HD video, 309

Uncompressed RAW preference, 57 underexposure, 193–194

Underwater Auto white balance setting, 77–78

Up key/DISP button, 38 Up/DISP button, 34 upgrading firmware, 384–386 Upload Settings options, 169

USB (Universal Serial Bus)	vignetting, 127–128
Connection options, 175	visual noise, source of, 4
LUN Setting options, 175–176	Vivid Creative Style, 276
Power Supply options, 176	Voigtlander lenses, 330
USB-2.0 cable, checking in box, 7. See also	Volume Settings options, 168
Multi/Micro USB terminal	o options, 100
	W
/	
Version options, 182	Watercolor Picture Effect, 82 waterfalls, blurring, 265
ibration reduction, 319	WB presets, 271–272
rideo. See also movie making	websites
aspect ratios, 306–307	Cowboy Studio, 332
checking frame boundaries for, 107	focus test chart, 339
crop factor, 305–307	Fotodiox, 332
frame guides, 307–308	KEH Camera, 327
gamma curve, 311–314	Kirk Photo, 405
guide markers, 307–308	lenses, 332
HD or UHD, 309	Metabones, 332–333
lighting for, 295–298	noise reduction, 213
picture profiles, 311, 314	Novoflex, 332–333
sensor size, 304–305	Rainbow Imaging, 332
Time Codes and User Bits, 309-310	Really Right Stuff, 405
ideo capture	Sony Entertainment Network, 149
interlaced scanning, 286	tripod plates and L-brackets, 404–405
Marker Settings options, 107	wheel lock, 138
progressive scanning, 286	white balance, 36, 40–41
ideo clips, viewing, 25	adjusting, 23
ideo Light Mode custom setting, 131	bracketing, 210
iew Mode playback options, 161	color temperature scale, 271
iewfinder Brightness options, 168. See	customizing, 275
also EVF (electronic viewfinder);	fine-tuning presets, 273–274
FINDER/MONITOR setting	setting, 76–78
	setting by color temperature, 274
	8 - / temperature, 2/4

Wide focus area, 22, 115 Wide Panorama:Size preference, 57 wide-angle lenses, 343–348 Wi-Fi connection, 139–144 Wi-Fi functions

sending photos to smart devices, 145 settings, 144 transferring photos to computers, 146–147 viewing images on TVs, 147–148

Wind Noise Reduction, 99, 299. See also NR (noise reduction) wireless file transfer, 28

wireless flash. See also Flash modes

channels and remote groups, 378–379 concepts, 376–378 ratios, 379–381 using, 376

Wireless menu, icon, 49 WPS Push, using, 140–141 wrinkles and blemishes, minimizing, 91 X

XAVC bit rates, 288

Y

yaw, roll, and pitch, 321

Z

Zebra custom setting, 104–105
Zeiss lenses, 324–327, 329–330
Zone focus area, 22, 115
zoom, 40, 43
Zoom camera setting, 84–86
Zoom Ring Rotate custom setting, 137
Zoom Setting custom setting, 116
zooming

into images, 26 and video, 300-301

Don't close the book on us yet!

Interested in learning more on the art and craft of photography? Looking for tips and tricks to share with friends? For updates on new titles, access to free downloads, blog posts, our eBook store, and so much more visit rockynook.com/information/newsletter